Facing History

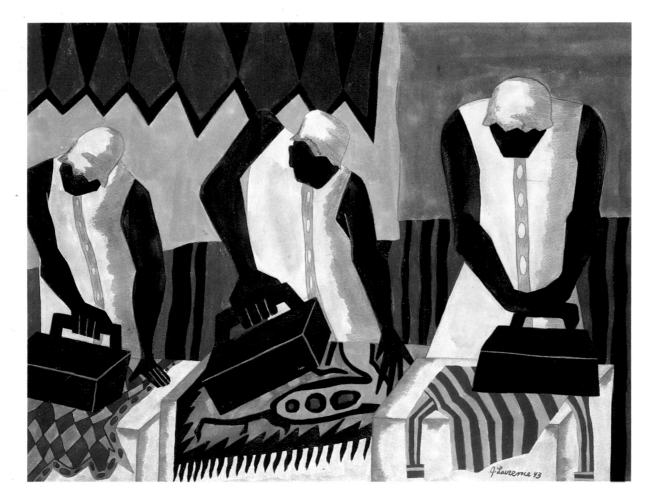

Jacob Lawrence, *Ironers*, 1943.

Facing History
The Black Image in American Art 1710-1940

Guy C. McElroy
with an essay by Henry Louis Gates, Jr.

and contributions by
Janet Levine, Francis Martin, Jr., and Claudia Vess

edited by Christopher C. French

Bedford Arts, Publishers
in association with
The Corcoran Gallery of Art

This book has been published in conjunction with the exhibition *Facing History: The Black Image in American Art 1710-1940*, organized by The Corcoran Gallery of Art, and serves as the catalogue for the exhibition.

The Corcoran Gallery of Art
Washington, D.C.
January 13 through March 25, 1990

The Brooklyn Museum
Brooklyn, New York
April 20 through June 25, 1990

Both the book and the exhibition have been generously supported by the District of Columbia Commission on the Arts and Humanities, the Rockefeller Foundation, the National Endowment for the Arts, the Philip L. Graham Fund, the Washington Post Company, and *The Washington Post* newspaper.

Facing History is published by Bedford Arts, Publishers, in association with The Corcoran Gallery of Art.

Bedford Arts, Publishers
301 Brannan Street, Suite 410
San Francisco, CA 94107-1811

The Corcoran Gallery of Art
Seventeenth Street & New York Avenue, N.W.
Washington, D.C. 20006-4899

Editor/publication manager: Christopher C. French
Text and production editor: Gail Larrick
Art management: Nancy Huvendick and Pamela Lawson

Ownership of artworks is indicated within each entry. Credits for art reproductions and photographs appear in "Photography Credits" at the end of the book.

Library of Congress Cataloging-in-Publication Data
McElroy, Guy C.
Facing History: The Black Image in American Art 1710-1940 / Guy C. McElroy; with an essay by Henry Louis Gates, Jr., and contributions by Janet Levine, Francis Martin, Jr., and Claudia Vess; edited by Christopher C. French. Catalogue of an exhibition held at The Corcoran Gallery of Art, January 13-March 25, 1990, and The Brooklyn Museum, April 20-June 25, 1990.

p. cm.

Bibliography
1. Afro-Americans in art – Exhibitions. 2. Art, American – Exhibitions. I. Gates, Henry Louis. II. French, Christopher C. III. Title.
N8232.M44 1990
704.9'499730496073 – dc20

ISBN 0-938491-38-5 (paper)
ISBN 0-938491-39-3 (cloth)

Printed in Japan
Second printing

cover John Singleton Copley, *Head of a Negro*, 1777-1778. Oil on canvas, 21 × 16¼ (53.3 × 41.3). The Detroit Institute of Arts, Founders Society Purchase, Gibbs-Williams Fund

frontispiece Jacob Lawrence, *Ironers*, 1943. Gouache on paper, 21½ × 29½ (54.6 × 74.9). Private Collection

Contents

In Memoriam

Guy McElroy 1946 - 1990

Guy McElroy died on May 31, 1990, five months after the initial
publication of *Facing History: The Black Image in American
Art 1710-1940.* His sudden death was a tragedy that, ironically,
came while the exhibition *Facing History* was concluding its
tour at the Brooklyn Museum to enthusiastic reviews and a
warm reception by the general public.

Guy had been researching *Facing History* for several years when
he found the terms of engagement dramatically changed: a seri-
ous car accident left him paralyzed and confined to a wheelchair.
Initially preoccupied with the concise exposition of an intricate
and controversial subject, he was now further challenged to tol-
erate the interloping presence of others as the awkward but nec-
essary facilitators of thoughts that his mind could readily gener-
ate but his hands could no longer make concrete. He resorted to
humor to defuse the additional stereotype a wheelchair present-
ed to the complexities of his African-American individuality. His
acute sense of irony served all involved in the project well, even
as he fought obstinately for the retention of a particular word or
phrase or a work of art that was proving difficult to obtain. As
tragic as the fact of his death is, it gives me great pleasure to see
Facing History being readied for a second printing.

Guy McElroy's unshakable conviction, that comprehending
stereotype is the first step toward human understanding, is
expressed throughout this book. It serves well as his abiding
testament.

Christopher French
August 1, 1990

Lenders to the Exhibition

Allentown Art Museum
Amon Carter Museum, Fort Worth, Texas
The Art Museum, Princeton University
Bowdoin College Museum of Art, Brunswick, Maine
Brandywine River Museum, Chadds Ford, Pennsylvania
The Brooklyn Museum
The Chrysler Museum, Norfolk, Virginia
Cincinnati Art Museum
Cooper-Hewitt Museum, the Smithsonian Institution's National Museum of Design
The Corcoran Gallery of Art
The Detroit Institute of Arts
The Fine Arts Museums of San Francisco
Gallery of Art, Howard University, Washington, D.C.
Gene Autry Western Heritage Museum, Los Angeles, California
Irwin Goldstein, M.D.
The Henry Francis du Pont Winterthur Museum
Herbert F. Johnson Museum of Art, Cornell University
The Historic New Orleans Collection, Museum/Research Center
The Historical Society of Pennsylvania
Illustration House, Inc.
Joslyn Art Museum, Omaha, Nebraska
Ira and Nancy Koger
Library Company of Philadelphia
Library of Congress, Washington, D.C.
Lyman Field and United Missouri Bank of Kansas City, N.A., Co-Trustees of the Thomas Hart Benton and Rita P. Benton Testamentary Trusts
The Maryland Historical Society
Memorial Art Gallery of the University of Rochester
The Metropolitan Museum of Art
Leonard L. Milberg
Missouri Historical Society, St. Louis
The Montclair Art Museum, Montclair, New Jersey
The Morris Museum of Art, Augusta, Georgia
Mrs. C. S. Mott
Angelo R. Mozilo
Dr. and Mrs. Mark Noble Mueller
Museum of the City of New York

Museum of Fine Arts, Boston
The Museum of Modern Art, New York
The Museums at Stony Brook
Muskegon Museum of Art, Muskegon, Michigan
National Gallery of Art, Washington, D.C.
National Museum of American Art, Smithsonian Institution
The New-York Historical Society, New York City
New York State Historical Association, Cooperstown
North Carolina Museum of Art, Raleigh
Norton Gallery of Art, West Palm Beach, Florida
Pennsylvania Academy of the Fine Arts, Philadelphia
The Phillips Collection, Washington, D.C.
Richard York Gallery, New York
The Rose Art Museum, Brandeis University, Waltham, Massachusetts
The Saint Louis Art Museum
San Francisco Museum of Modern Art
The Schomburg Center for Research in Black Culture, The New York Public Library, Art & Artifacts Division
Springfield Art Association, Springfield, Ohio
Stratford, Connecticut, Historical Society
United States Department of Interior, National Park Service, Saint-Gaudens National Historical Site, Cornish, New Hampshire
Russell P. Vaughn
Virginia Historical Society
Virginia Museum of Fine Arts
Wadsworth Atheneum
The Walters Art Gallery, Baltimore, Maryland
The Warner Collection of Gulf States Paper Corporation, Tuscaloosa, Alabama
Eugenia Weathersby
Weil Brothers
Whitney Museum of American Art, New York
T. W. Wood Art Gallery, Montpelier, Vermont
Yale University Art Gallery

Anonymous Lenders

Director's Foreword

The wealth of depictions of African-Americans that informs *Facing History: The Black Image in American Art 1710-1940*, whether in painting, sculpture, or drawing, offers a panorama that illuminates the ways American society has conceptualized the identity of black people, from slave to full citizen. Consolidating concepts developed in the 1960s, the scholarship of *Facing History* provides convincing evidence of how projections of racial identity remain rooted in societal assumptions. Most important, the exhibition and the book that serves as its catalogue convey how vital this subject remains for a country still in many ways unwilling finally to lay to rest what Guy C. McElroy describes as "the most malodorous of many lingering ghosts." Whether our generation can acknowledge and come to terms with our difficult racial heritage will shape its ability to perform the most basic of human functions — to understand different peoples.

This theme is central to the American identity. It is appropriate that the exhibition from which this book is drawn is presented in the nation's capital, and that The Corcoran Gallery of Art, with its long history of dedication to the work of American artists, should be its organizer. Guy C. McElroy's able research for The Corcoran has been underwritten by several organizations. The generosity of the District of Columbia Commission on the Arts and Humanities, the Rockefeller Foundation, the National Endowment for the Arts, the Philip L. Graham Fund, the Washington Post Company, and *The Washington Post* newspaper has made the realization of this project possible. The early commitment of Mary Bellor, Manager of Corporate Affairs for the Washington Post Company, and Peggy Cooper-Cafritz, Director Emeritus of the District of Columbia Council for the Arts and Humanities, is also gratefully acknowledged. James Gibson and Alberta Arthurs of the Rockefeller Foundation have been especially supportive of this exhibition and its educational outreach; their sponsorship of an important meeting hosted by the Rockefeller Foundation on January 27, 1989, helped to solidify some of the critical ideas supporting this exhibition. The contributions of the participants in the Rockefeller Foundation meeting — Claudine Brown, Kinshasha Conwill, Peggy Cooper-Cafritz, Linda Ferber, Helen Ferulli, Henry Louis Gates, Jr., Jane Livingston, Robin Rosenbluth, and Deborah Schwartz — are especially appreciated. I would also like to express my gratitude to the generosity of the many museums, galleries, and private collectors who lent work to *Facing History*. Their willingness to share these images with the public has allowed The Corcoran Gallery of Art to bring this comprehensive exhibition together.

This book would not have been possible without the editing and management skills of Christopher French and the cooperation of our co-publishers, Bedford Arts, Publishers.

Every department of The Corcoran Gallery of Art contributed in some way to bring this project to fruition. Jane Livingston, Chief Curator and Associate Director, coordinated all aspects of this exhibition, and Franklin Kelly, Curator of Collections, contributed important scholarship. William Bodine, Assistant Director for Curatorial Affairs, handled many of the organizational details of *Facing History*, and Barbara Moore, Curator of Education, coordinated interactive programming. Rebecca Gregson, Cindy Rom, and Lisa Luedtke, of the Registrar's Office, dealt with the logistics of crating, shipping, and insurance; Pamela Lawson and Nancy Huvendick, curatorial assistants, and Ann Maginnis, librarian, provided invaluable support. Clyde Paton and Jon Mason helped achieve The Corcoran's handsome exhibition installation. Finally, I would like gratefully to acknowledge the staff of The Brooklyn Museum.

Christina Orr-Cahall

Acknowledgments

This exhibition is built on a firm foundation of previous scholarship that has been shaped by many hands. Alain Locke's *Negro Art: Past and Present* (1936) pioneered the analysis of black themes in the visual arts; his study was the first to observe the potential of art to close the rupture between the races. Most important, it acknowledged the manner in which representation of black identity is related to social and political status within a culture. However, it was not until the 1970s that Locke's hopes for a thorough analysis of black representation in the arts would be realized. Sidney Kaplan has published two exhibition catalogues. *Portrayal of the Negro in American Painting* (1967) and *The Black Presence in the Era of the American Revolution, 1770-1800* (1973), which, more than any other recent sources, have stimulated scholarly interest in what had previously been a poorly understood subject. Kaplan's approach brought works of art to the fore as a rich source for understanding the events and personalities that shape racial identities. Similarly, Ellwood C. Parry's *The Image of the Indian and the Black Man in American Art, 1590-1900* (1974) broke new ground by analyzing the representation of African and Native Americans in terms of the developing sociopolitical importance of racial self-awareness.

For almost twenty years the Menil Foundation, through the generous philosophical and financial support of its Image of the Black in Western Art Project, has been the prime supporter of efforts to document, analyze, and interpret the black presence in the visual arts. Recent Menil publications, such as the fourth volume of *The Image of the Black in Western Art* (1989), by the English art historian Hugh Honour, and *Winslow Homer's Images of Blacks* (1988), by Karen C. C. Dalton and Peter Wood, offer startling insights that have dramatically revised our understanding of how white artists and audiences have historically viewed black subjects. Innovatively researched and exhaustively annotated, their work establishes a model that future researchers in any field will seek to emulate. Finally, the work of Ann Uhry Abrams and Albert Boime has been essential in revising commonly shared assumptions about many of the hows and whys of black representation. Their studies on the work of John Singleton Copley firmly establish the intricate web of subtle interconnections between images of blacks, revolutionary politics, and the economic interests of the slave trade.

Many individuals and institutions have generously contributed their energies, factual information, philosophical ideas, or scholarly encouragement to this project. The insightful contributions of Henry Louis Gates, Jr., W. E. B. Du Bois Professor at Cornell University, establish just how difficult the critical issue of self-determined identity has become for black Americans in this century. Similarly, the scholarship of Francis Martin, Jr., Professor of Art at the University of Central Florida, and research assistants Janet Levine and Claudia Vess can be seen throughout this book. The assistance and encouragement provided by curatorial assistants Pamela Lawson and Nancy Huvendick has encompassed all aspects of *Facing History*. A special debt of gratitude is also extended to catalogue editor and publication manager Christopher C. French, whose appreciation for the right word in the right context has transformed many difficult ideas into cogent statements. The creative talents and technical expertise of Stephen Vincent, Director, Gail Larrick, Production Editor, and the staff of Bedford Arts, Publishers, have helped to shape this book into a handsome and accurate document. Linda

Ferber, Chief Curator of The Brooklyn Museum, and Barbara Galatti, Associate Curator of American Painting and Sculpture of The Brooklyn Museum, have facilitated many of the complicated details of the exhibition. The patient, wholehearted support of Corcoran Gallery of Art Director Christina Orr-Cahall, who helped bring this project to completion, has been especially important.

Many individuals have aided this project through a host of gestures that added greatly to the success of this exhibition. Karen M. Adams, James Edward Fox, and Francis Martin, Jr., very graciously made their doctoral research available for study. Other individuals and organizations, by establishing provenance or locating obscure works, have provided the intricate bits of information that often formed the linchpin for understanding: their help has been greatly appreciated. I would like particularly to thank the following individuals and institutions: Maclyn Le Bourgeois, of The Historic New Orleans Collection; Robert P. Coggins, M.D., of The Coggins Collection of Southern American Art; Trevor Fairbrother, Associate Curator of Contemporary Art, Museum of Fine Arts, Boston; Kenneth Finkel, Curator of Prints, Library Company of Philadelphia; Catherine Hoover Voorsanger, Research Associate, and Richard J. Shwartz, Research Associate, Department of American Decorative Arts, The Metropolitan Museum of Art; Carlotta Owens, Associate Curator of Prints, National Gallery of Art; Nancy Rivard Shaw, Curator of American Art, The Detroit Institute of Arts; Carol Troyen, Associate Curator of American Paintings, Museum of Fine Arts, Boston; and Arthur K. Wheelock, Curator of Northern and Baroque Painting, National Gallery of Art. The staffs of the Boston Atheneum, the Free Library of Philadelphia, the New Orleans Historical Association, the Pennsylvania Historical Society, and the research libraries of the National Museum of American Art and the Library of Congress were especially instrumental in locating obscure sources of information. I would also like to thank Bruce Chambers of Berry-Hill Gallery; Marjorie Crow; Lawrence Fleischman, of Kennedy Galleries; Robert M. Hicklin, Jr.; Janet Marqusee, of Marqusee Fine Arts; Rebecca Fralin Parrish; M. P. Naud of Hirschl and Adler Galleries; Abbot W. Vose, of Vose Galleries; and Eric Widing, of Richard York Gallery. Charles Williams and Michael Wachloz provided moral support and intellectual encouragement in moments of duress.

I am indebted to David C. Driskell, Professor of Art at the University of Maryland, and Elizabeth Johns, Professor of American Art and holder of the Silfen Term Chair at the University of Pennsylvania, for planting many of the seeds of this exhibition. The constant resourcefulness and innovative foresight of Peggy Cooper-Cafritz, Director Emeritus of the District of Columbia Council for the Arts and Humanities, made the germination and growth of this exhibition possible. Finally, I would like to dedicate this book to Jane Livingston, Associate Director and Chief Curator at The Corcoran Gallery of Art. Her encouragement at every stage of this project has been indispensable in making *Facing History* a reality.

G.C.M.

Introduction: Race and Representation

Guy C. McElroy

The ways that America's leading visual artists have portrayed the African-American — as slave or freedman, servant or member of the middle class, minstrel performer or wartime hero, ridiculous stereotype or forceful leader — form an index that reveals how the majority of American society felt about its black neighbors. Naming is a form of power, and visual images have the persuasive power to identify and define place and personality. Whether through portraiture, genre scenes, allegorical history painting, or narrative realism, the work of artists of differing races and ethnic groups has detailed the prevailing negative as well as the rarer positive opinions that one race held for another.

Facing History: The Black Image in American Art 1710-1940 documents comprehensively the variety of ways artists created a visual record of African-Americans that reinforced a number of largely restrictive stereotypes of black identity. The aim of *Facing History* is to provide a panorama that illuminates the shifting, surprisingly cyclical nature of the images white men and women created to view their black counterparts. The repeated use of these pictorial images gave them the powerful immediacy of symbols. Prosperous collectors created a demand for depictions that fulfilled their own ideas of blacks as grotesque buffoons, servile menials, comic entertainers, or threatening subhumans; these depictions were, for the most part, willingly supplied by American artists. This vicious cycle of supply and demand sustained images that denied the inherent humanity of black people by reinforcing their limited role in American society. More fundamentally, these images expressed an inability to comprehend a people whose appearance and behavior were judged to be different from their own, and thus inferior.

The history of African-Americans on the North American continent encompasses the entire history of the United States. Slavery and freedom, the initial optimism and the subsequent brutalities of Reconstruction, the transition of the United States from a rural agrarian economy to an urban industrial nation: the often turbulent history of this country is accurately reflected in the ways that visual artists have chosen to represent black people in their art. In his pioneering study *The Negro in Art* (1941), Alain Locke observed the potential of the visual arts to heal the rupture between the races:

The deep and sustained interest of artists . . . in the Negro subject, amounting in some instances to a preoccupation with this, seems to run counter to the barriers and limitations of social and racial prejudice, and evidences appreciative insights which, if better known, might prove one of the strongest antidotes for prejudice.

In the 1700s, Africans who had been forcibly removed from their native cultures were portrayed in some of the earliest surviving examples of colonial art. Justus Engelhardt Kühn's *Henry Darnall III as a Child* (ca. 1710) established an artistic convention emulated by generations of eighteenth and nineteenth century artists. The servant exists in Kühn's portrait not as a fully realized human being but as the chattel of the son of a wealthy slave owner. He is an accoutrement who embodies the material status of the landed Maryland gentry who were Kühn's primary clientele. Kneeling at the side of the planter's son, he wears the silver collar of servitude. His suppliant position is typical of the image of African-Americans — forcibly uprooted and brought to America — that held sway over the well-to-do elite of landed colonial America.

Strikingly, Kühn's painterly formulation existed simultaneously with a radically different tradition in colonial America. Charles Zechel's portraits testify to the wide popularity painted portraits enjoyed in colonial families of all races. The pretensions of middle-class prosperity inherent in Zechel's miniatures hint at the existence of a small but self-sufficient black middle class in colonial America, most probably composed of free blacks, mulattoes, and servants who were adequately compensated for their work as laborers or domestics. Both Kühn's stylized portraits of wealth and Zechel's straightforward records relate depictions of race to economic status. Kühn's commissioned portraits were enormously popular with the landed gentry of his adopted Maryland, while Zechel's inexpensive portrait mementos were commissioned by a much wider audience. These two divergent means of recording black men and women were shaped in no small part in terms of social class and economic status. Similar attitudes of class and economics would, in turn, inform many of the subsequent artistic expressions of African-Americans in eighteenth and early nineteenth century America.

With the movement of colonial America toward revolution, the issue of slavery was often enlisted in the service of arguments for or against independence. The operatic tableau created by the expatriate American John Singleton Copley in *Watson and the Shark* (1778) and the romanticized conception of equality envisioned in Samuel Jennings's *Liberty Displaying the Arts and Sciences* (1792) were breathtaking innovations in the nascent American arts. Copley's and Jennings's divergent ideas about the nature of African-Americans served as propaganda that illustrated the ideological arguments then coalescing about the correct economic and social place of black people in America.

Copley's *Watson and the Shark* (fig. 1) introduced polemic overtones into the drama of an actual historical event, skillfully fashioning a morality play with a black man at its emotional apex and black identity as its subtext. Commissioned by Brook Watson, the painting was meant to serve as a forceful warning to colonial activists in America and Whig opponents in England who favored freedom for the white colonists but tolerated or supported the practice of slavery; the black man in *Watson* is a complex, multidimensional character in the service of a conservative polemic (figs. 2-4). Samuel Jennings's *Liberty Displaying the Arts and Sciences*, on the other hand, reflected the abolitionist sentiments that formed a large part of the highly vocal intellectual community of postrevolutionary Philadelphia. Unlike the historical event depicted in *Watson*, the composition of this, America's first history painting on an abolitionist theme, provides a schema to enunciate the ideas and values of the Philadelphia abolitionists. However, despite the allegory of its overtly stated abolitionist theme, *Liberty Displaying the Arts and Sciences* avoids outlining black identity by portraying blacks as individual people. Jennings's passive subjects are, by position, action, and characterization, the

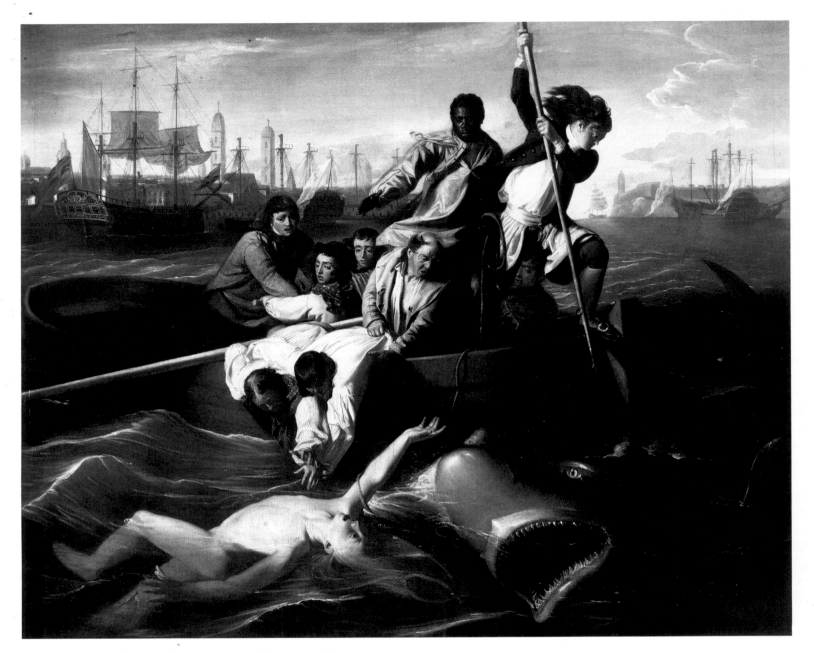

fig. 1 John Singleton Copley, *Watson and the Shark*, 1778. Oil
on canvas, 71¾ × 90½ (182.1 × 229.7). National Gallery of Art.
Ferdinand Lammot Belin Fund

grateful recipients of the benevolent enlightenment of their white superiors.

In the first quarter of the nineteenth century the United States continued to consolidate its status as a nation, and after the defeat of the British forces in the War of 1812, public self-confidence slowly began to coalesce into a national identity. One of the significant aspects of this new nation was a rural, primarily (but by no means exclusively) Southern-based plantation economy. The minstrel performers who suddenly developed and flourished in the first two decades of the nineteenth century exploited the status of blacks within plantation society, reinforcing hardening perceptions of racial inequality. Minstrelsy provided a type that denied the factual details of the lives that many African-Americans led as self-sufficient individuals, providing an image that contradicted the reality much of the public experienced in both urban and rural communities (*figs. 5-9*).

Performed by white men disguised in facial paint, minstrelsy relegated black people to sharply defined dehumanizing roles. Skin the color of coal, ruby lips stretched around an outsized exaggeration of a toothy grin, and the tattered clothing and mawkish behavior of such notable pioneers as T. D. Rice and Daniel Emmet created a convenient label – blacks as buffoons. Music-making, the minstrel performer's one definable skill, reduced the depth of black characterization to that of entertaining clown. The servile mannerisms of the generally rural minstrel bumpkin, or "comic darkey," were sometimes juxtaposed with the natty elegance of a dandy shyster – the Zip Coon character. These characters, seen in widely popular stage productions, objectified the distinctive individuality of African-American communities flourishing in cities such as Boston, Philadelphia, Atlanta, and New Orleans. This lack of individuality could, in turn, be used to justify the maintenance of an economy supported to a large extent by the labor of an indentured rural black underclass.

John Lewis Krimmel's enthusiastic embodiment of the comic darkey stereotype in *Quilting Frolic* (1813) (*figs. 10-11*) established a precedent that future artists, seeking to label their scenes as distinctly American, would either wholeheartedly or unthinkingly emulate. Basing his art on English and Dutch genre conventions, Krimmel sought to popularize his scenes by his use of readily identifiable details and stock characters. His minstrel-type banjo player was given a clearly defined position on the margins of the composition. Aside from the overt mannerisms of Krimmel's characterizations, the forceful repetition of black people as absurdly comic entertainers – musically adept but otherwise unskilled – reinforced in the fine arts a harshly restrictive stereotype that would in turn be further promulgated by Currier and Ives and other producers of popular images.

In the developing genre tradition historically associated with the optimism and burgeoning nationalism of the Jacksonian era, African-American subjects would be regularly associated with humorous activities and musical merriment but otherwise depicted as persons who existed outside the social order. The emergence of such a single-minded notion of black identity was not coincidental. These representations were one manifestation of the artistic academy developing in New York City in institutions such as the National Academy of Design and the American Art-Union. The educational, economic, and exhibition opportunities these institutions afforded allowed for a density of artists who, working in close proximity to each other, often influenced one another's work. Their style exceeded the influence and importance of other developing conventions centered in regional centers such as Boston and Philadelphia, where abolitionist sentiments were a much more vocal faction of the intellectual discourse.

The New York School had two main components. Landscape painters, such as Thomas Cole and Asher B. Durand, tried to capture in the American landscape the essence of a philosophical sublime – what is now known as the Hudson River School. Building on Krimmel's successful example, genre painters, such as William Sidney Mount, refined materialist philosophy as a central aspect of American painting through the meticulous inventorying of the minute details of everyday life. Within this philosophy, black men and women were characterized by physical appearance or stereotypical behavior that emphasized their "otherness" rather than by a full spectrum of emotional and intellectual activities. Mount's early work used black subjects as caricatures to establish the particularly American characteristics of a scene, but his mature art, based on observation, evolved into much more personal descriptions of personality and appearance. Throughout his career, Mount expressed profoundly ambivalent feelings about the proper relationship between the races, and in many ways his contradictory attitudes toward the true identity and proper place of African-Americans exemplified the sentiments of his contemporaries in the face of growing racial tensions.

The first work that Mount exhibited at the National Academy of Design, *Rustic Dance After a Sleigh Ride* (1830), consolidated the conventions introduced in Krimmel's *Quilting Frolic*. Images of the antics of African-American men who fiddled for the pleasure of white audiences also evoked highly personal memories for Mount: Anthony Hannibal Clapp, a favorite slave on the Hawkins-Mount plantation, was revered for his musical abilities, and Mount's uncle Micah Hawkins was a composer of popular songs performed by black-faced minstrels. However, the strongly conceived female figure in *Eel Spearing at Setauket* (1845) is one of the rarest heroic portrayals – that of a nurturing woman – of an African-American to be included in painting before the Civil War. Mount's use of a woman in *Eel Spearing* is especially ironic, because it was a black man, not a woman, who taught him the subtleties of spear fishing in the shallows of Long Island Sound. While the artist's memories of his childhood experiences with his fishing companion stimulated the subject for this landscape commission, his pragmatism dictated that the inclusion of a black man in the intimate and powerful position of teacher was an unacceptable risk for a commissioned work. Mount's substitution generated an image of nurturing womanhood that displays all the strengths of what was then one of the few acceptable roles for black women – nanny, kitchen servant, maid – in short, "mammy."

The attitudes of this powerful but inherently conflicted painting would be fully contradicted in Mount's late work. The sketch for the allegory *Politically Dead* (ca. 1867) (*figs. 12-15*) shows how Mount, a stridently conservative Democrat, viewed Emancipation and Reconstruction as moral and political failures. His approach to portraying black people, which began as unthinking cliches

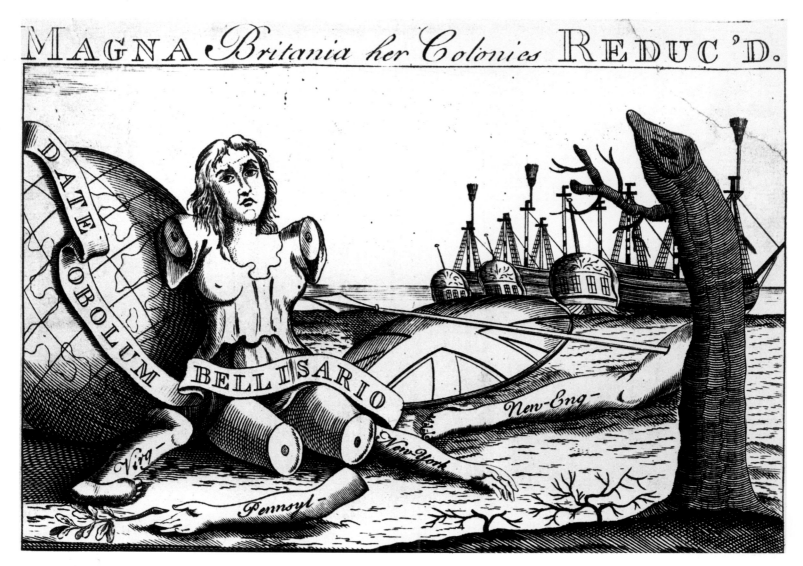

fig. 2 Anon, *MAGNA Britania her Colonies REDUC'D.*
Engraving, 1768. Library Company of Philadelphia

figs. 2-4 The political subtext of *Watson and the Shark*
illustrated in the popular arts

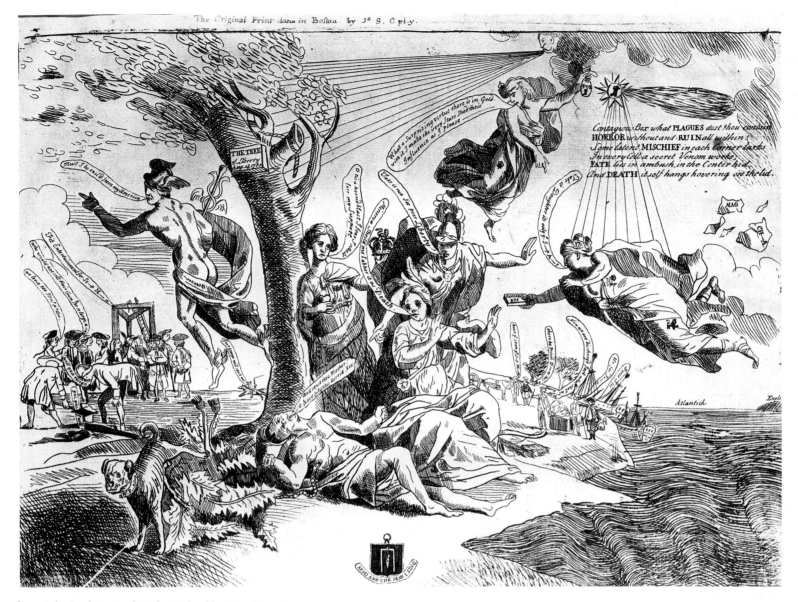

fig. 3 John Singleton Copley, *The Deplorable State of America*.
Engraving, 1765. Library Company of Philadelphia

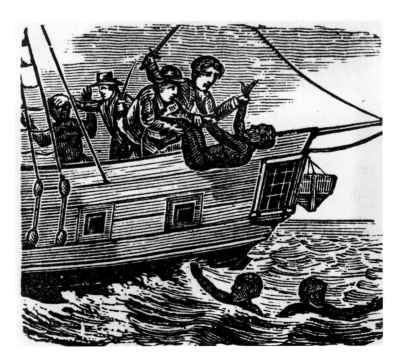

fig. 4 *Sailors Throwing Slaves Overboard*, 1862. Woodcut
from Mrs. A. M. French's *Slavery in South Carolina*. Library of
Congress

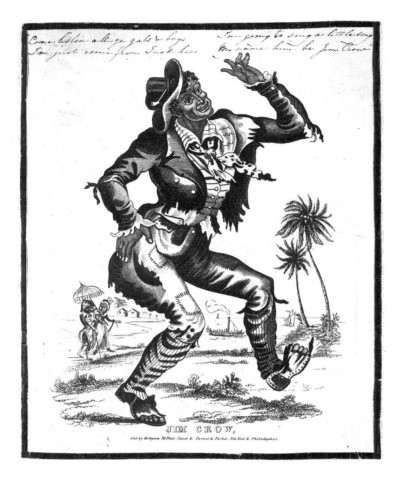

fig. 5 *Jim Crow*, ca. 1820s–1830s. Engraving. Menil Collection, Houston

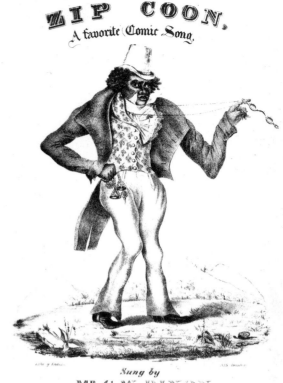

fig. 6 *Zip Coon, A Favorite Comic Song*, n.d. (Sung to the tune of *Turkey in the Straw*). Sheet music illustration. Published by J. L. Hewitt & Co. Lester S. Levy Collection of Sheet Music, Milton S. Eisenhower Library. The Johns Hopkins University

and matured into complex, multidimensional portrayals, congealed finally into the bitterness of a separate-but-equal philosophy, and the popularity of his work suggests that the majority of white Americans shared similar uncertainties about both the nature and place of African-Americans in society.

The successful consolidation of Krimmel's ideas in Mount's work confirmed the validity of genre as an appropriate subject for successive generations of artists. Their work reflects the diverse spectrum of sentiment regarding black people that ranged throughout the population before the Southern rebellion. James Goodwyn Clonney's *Waking Up* (1851) (*figs. 16-18*) continues the conventions of distorting physiognomy and behavior for comic or moral effect. Clonney's sleeping fisherman being teased awake by mischievous white children wholeheartedly emulates Mount's use of a recumbent black figure in *Farmers Nooning* (1836). But while Mount was dedicated to the artistic value of faithfully recording observed reality, Clonney's cartoonish darkey found its inspiration in crude images developed by popular media and minstrel entertainment. *Farmers Nooning* is redolent with a multiplicity of meanings, but Clonney single-mindedly circumscribed the character of his black figure, reinforcing his servile status by reducing him to the plaything of children.

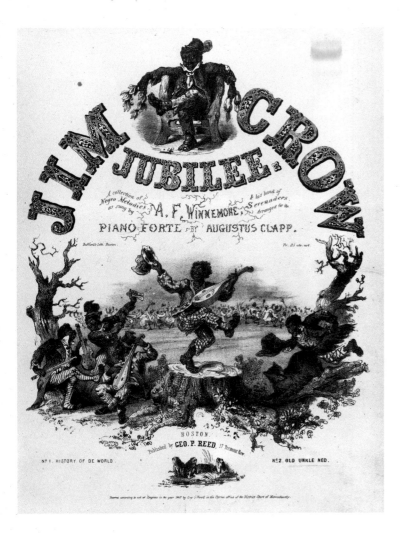

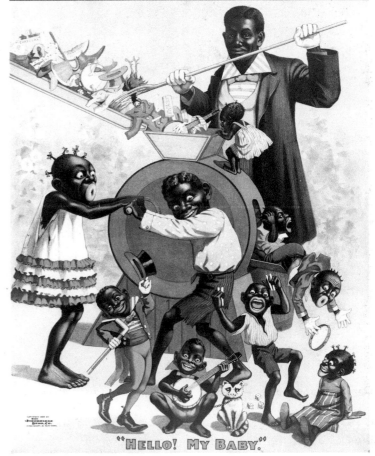

fig.7 *Jim Crow Jubilee*, 1847. Sheet music illustration by
Bufford's Lithographers, Boston. Published by Geo. P. Reed.
Library of the Boston Atheneum

fig.8 *George Thatcher's Greatest Minstrels, "Hello My Baby,"*
1899. Lithographic poster. The Strobridge Litho Company.
Library of Congress

A positive expression of the autonomy of the African-American
community can be seen in Christian Mayr's *Kitchen Ball at
White Sulphur Springs* (1838), which, while maintaining the
detailed contextual observation typical of the American genre
artist, presents a black community in the midst of what is most
probably the joyful celebration of a wedding. While reminiscent
of *Rustic Dance After a Sleigh Ride*, Mayr's dancers and revelers
suggest the diverse life of a black middle class. The graceful social
interaction in this group of well-dressed men and women (perhaps
servants who worked for wealthy landowners) is recorded by the
artist in a rich variety of finery and action; in this sense *Kitchen
Ball* records one of the most compelling realities of nineteenth
century African-American life. However, Mayr's scene is a notable
exception to an American genre tradition of depicting black
people as comic stereotypes that continued uninterrupted until
the outbreak of civil war.

With the onset of national conflict, more realistic representa-
tions of black people were introduced into the visual arts to
further the arguments of the abolitionist cause. For the most part
painters avoided describing the events of the war or their effects
on society (in sharp contrast to the vivid reportorial drawings,
often based on photographic evidence, created by graphic artists

to illustrate the accounts of battle and army life that filled the journals and newspapers of the day). Still, their work clearly indicated their feelings concerning abolitionism. The 1861 passage of the Confiscation Act added incentive for Southern slaves to defect from the Confederate war effort they were often forcibly committed to support: upon reaching Union lines, they were designated as contrabands of war and granted immediate freedom. Eastman Johnson's *The Ride for Liberty – The Fugitive Slaves* (ca. 1862), Theodor Kaufmann's *On to Liberty* (1867), and Edwin Forbes's *Contrabands Escaping* (1864) were all based on events the artists witnessed while serving in combat or accompanying Union forces to the front. Whether stylized as noble savages after the French Academic tradition in Kaufmann's version, given the religious overtones of the flight of the Christ child in Johnson's dramatically composed account, or laconically reported by Forbes, black fugitives were portrayed with a new nobility that recognized both the valor required in their escapes and the growing importance of abolitionist sentiment in white society (*fig. 19*).

Some of the most dramatically heroic descriptions of African-Americans during the Civil War were created by sculptors. Probably because of the influence of prevailing European neoclassical styles on American sculptors, black men and women were often idealized in a manner similar to John Quincy Adams Ward's *The Freedman* (1863). Ward's reliance on convention and stylization lent his subject the unusual status of heroic idealism associated with the noble struggles for freedom by ancient Greek and Roman citizens, creating an appealing symbol of the fight for black freedom. John Rogers, on the other hand, rejected neoclassicism for a vigorous, almost exaggerated realism that translated some of the primary concerns of genre painting, such as accurate detailing and narrative description, into sculptural idioms. Rogers's *The Wounded Scout, Friend in the Swamp* (1864) presented a heroic but politically acceptable image that confirmed the validity and common appeal of abolitionist sentiments. Mass produced in the form of plaster casts and widely circulated through catalogue sales, Rogers's sculptures were his vocal contribution to a cause in which he firmly believed.

Postwar Reconstruction saw a brief flourishing of equality in America, and the first artists to address this subject responded enthusiastically. Kaufmann's *Hiram R. Revels* (ca. 1870) (*fig. 20*), commissioned by Louis Prang Company for reproduction as a mass-circulation print, offers a vivid example of the great strides that some black men and women attained during Reconstruction. Revels, the first African-American to serve in the United States Senate, was elected by the state of Mississippi to fill the same seat that had been occupied by Jefferson Davis prior to the war, and Prang viewed the portrait of the first black official to gain high public office after the passage of the Fourteenth Amendment as a salable subject with possibilities for broad public distribution. Kaufmann's depiction of Revels reveals a man of upstanding character and intelligence, the kind of man who, justifying Frederick Douglass's admonition that every family should purchase a copy of the print for its home or place of business, could reinforce the pride and idealism surging in black communities.

More general in subject, Thomas Waterman Wood's *American Citizens (To the Polls)* (1867) uses genre conventions to commemorate the 1866 elections – the first opportunity for Southern black men to participate in national elections. Wood's ensemble presents four characters – a Yankee, an Irishman, a Dutchman, and an African-American – who manifest what were popularly understood to be their ethnic traits. Staging a variety of types across the shallow space of his canvas, Wood documented the democratization that had suddenly occurred in the United States, noting nevertheless that a pecking order continued to exist in American culture, and, despite the black man's recent receipt of the franchise, he still came last. Wood's watercolor, which is more a vision of the dream of equality than a study of individual identity, maintains the tradition of artists relying on racial and ethnic types to communicate the values of their society.

By the middle of the 1870s the gains black people had made following Emancipation were being sharply challenged by an increasingly violent segment of Americans dissatisfied with the premise of equality enforced by law and determined to limit the rights of blacks, by force if necessary (*figs. 21-23*). Poll taxes made voting difficult or impossible in many Southern states, and the 1883 repeal of the Civil Rights Act by the Supreme Court effectively returned the majority of African-Americans to the status of second-class citizens. The increasing disillusionment of the public with Reconstruction was often openly supported in the pages of the popular press. Cartoonists and print artists supplied caustic images that openly embraced racist sentiment or encouraged a view of black citizens as separate and different from their white counterparts. Alfred R. Waud's *The Bug Man at Pine Bluff, Arkansas* (ca. 1871) represents one of the milder examples by print artists who returned with obvious gusto to pre-Civil War ideas of black people as extremely compliant, servile, or painfully antic characters.

In the fine arts the end of Reconstruction optimism meant a return to an art heavy with romantic nostalgia for an America that was more imaginary than real. Richard Norris Brooke said his *A Pastoral Visit* (1881) "was my first decided success and unfortunately fixed my reputation as a painter of negro subjects." The sentimental scene Brooke recorded in *A Pastoral Visit* was typical of how postwar artists responded to the demand for nostalgic views of the idealized stability of America before the Civil War. Brooke's highly popular painting catalogued types of uplifting black human beings – the preacher, the musician, the laborer, the nurturing woman, the delightful children – that reflected the condescending perspective the white majority often adopted as its members viewed African-Americans from a limited vantage point. Southern born and bred, William Aiken Walker drew on the life and landscape of his environment to create a meticulous but one-sided record of black life and livelihood, and his *Plantation Economy in the Old South* (ca. 1884) expresses a profound nostalgia for a return to prewar plantation life. Although the all-encompassing economic structure of plantation society had been severely shaken by the Civil War, its influence on American society remained pervasive. Walker's landscape, based on his conception of black identity through a radically limited definition of place and activity, literally relegated its subjects to

work in the cotton fields, substituting the impoverishment of contract labor for slavery.

As the prevailing tendencies in American art expressed identity through symbols of romantic idealization or subtly degrading nostalgia, painting that accurately described the corporeal reality observed by the artist produced a significant rethinking of how a black person could be personified and what that description could signify. Winslow Homer began his career as a sketch artist for mass-circulation publications such as *Harper's Weekly* (*figs. 24-27*). Unlike his contemporary Alfred R. Waud, Homer's approach to African-American subjects matured as his ability to master complex subjects evolved. Based on physical observation, a painting such as *Dressing for the Carnival* (1877) expressed the artist's romantic appreciation of the pride and strength of character of a familial group he observed intently preparing for the festival variously known as Jonkonnu or Jonkeroo, a traditional end-of-year festival that after the Civil War became a celebration of the freedom granted slaves by the Emancipation Proclamation. Whether in ensemble interactions or in narrative scenes, Homer diligently probed the psychological as well as the physical manifestations of his subjects, reinvigorating the increasingly academic genre tradition with a metaphoric approach to imagery that gave the subtleties of his essentially genre characterization a complex and full voice.

Another philosophical approach to figuration can be seen in the work of Thomas Eakins. *Will Schuster and Blackman Going Shooting (Rail Shooting)* (1876) portrays a boatman who knowledgeably plies his trade for a well-to-do class of sportsmen in a way that conveys physical strength, intellectual acumen, and the instincts of a disciplined professional. Eakins was European trained; his approach to painterly subject matter reflected his disciplined, steadfast neutrality. His scientifically rigorous realism demanded that all subjects – white or black – should be recorded objectively irrespective of race, class, or caste. Through both visual image and title, *Will Schuster and Blackman* records the economic and social disparity between two individuals linked only by a business transaction. The sportsman, the probable customer for this painting, is named, while the black man remains anonymous, described only in terms of skin color. The mature works of Eakins and Homer combine sensitive recording of the uniqueness of individual identity with a rigorous description of all aspects of human activity; in this sense they represent a high water mark in nineteenth century artistic expression of African-American identity, offering an alternative to the penchant for typing that, with a precious few exceptions, marked the development of American art.

By the beginning of the twentieth century, the urbanization of the United States had resulted in a dramatic alteration of the social fabric. The migration of rural populations to urban areas fostered a new, socially conscious form of realism in American art. Rejecting the influence of such persuasive European styles as impressionism, Robert Henri adopted expressionistic representation to paint what he termed "my people" – the largely poor working class of all races who populated America's urban areas. Through the example of his art and the lifelong advocacy of his teaching, Henri exerted a profound impact on a generation of young artists.

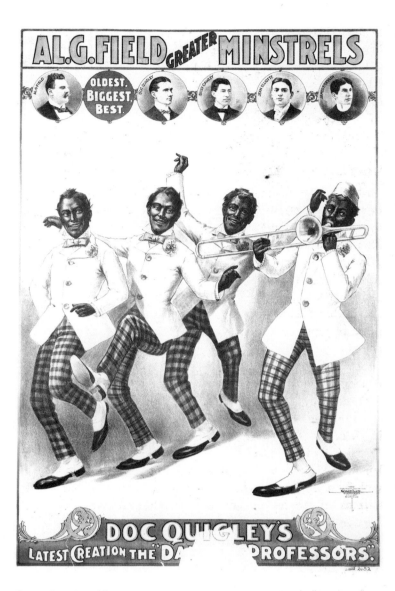

fig. 9 *A. L. G. Field Greatest Minstrels, Doc Quigley's Latest Creation The "Darkey Professors,"* 1900. Lithographic poster. Courier Company. Library of Congress

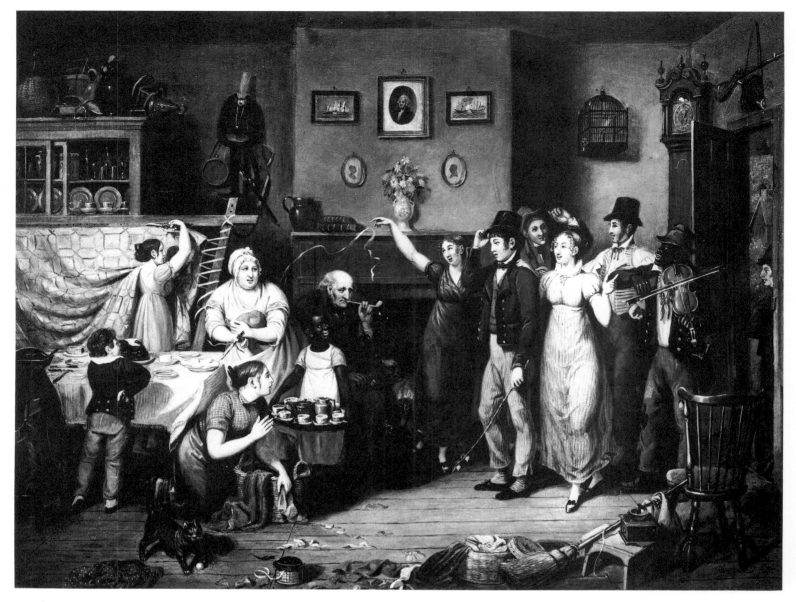

fig. 10 John Lewis Krimmel, *Quilting Frolic*, 1813. Oil on
canvas, 16⅞ × 22⅜ (42.8 × 56.8). The Henry Francis du Pont
Winterthur Museum

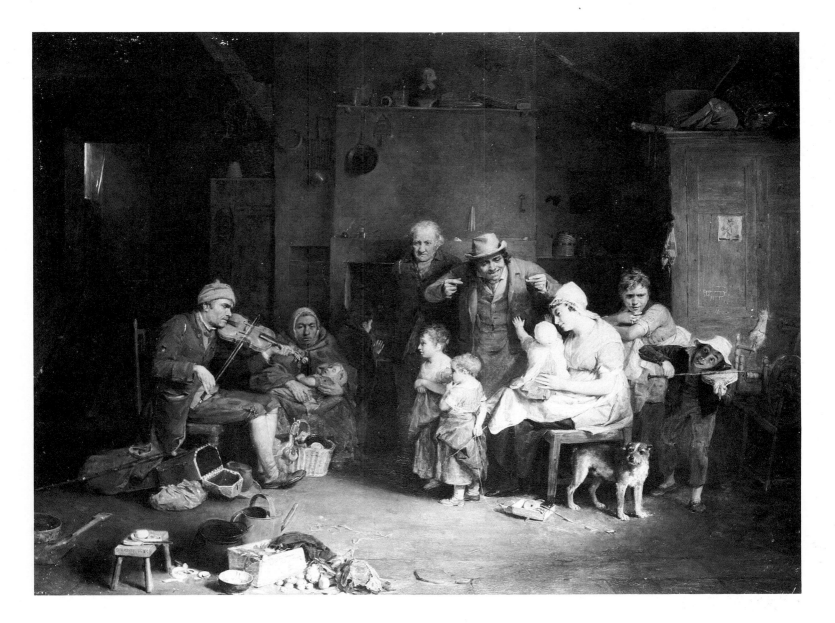

fig. 11 The English precedent for Krimmel's genre configurations. Sir David Wilkie, *The Blind Fiddler*, 1806. Oil on
wood panel, 22.7 × 31.2 (57.8 × 79.4). The Tate Gallery, London

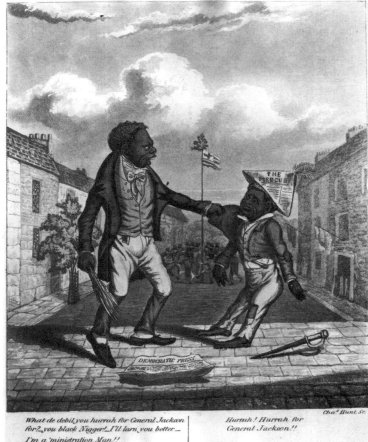

fig. 12 Charles Hunt, after an image by Edward W. Clay. *Life in Philadelphia*, ca. 1832-1837. Aquatint. Published by Harrison Isaacs, London. The Henry Francis du Pont Winterthur Museum

fig. 13 Currier and Ives, *"The Nigger" in the Woodpile*, 1860. Lithograph. American Antiquarian Society, Worcester, Massachusetts

Conservative painters such as Wayman Adams responded to Henri by emulating his painterly approach to vigorously conceived portraiture without digesting the philosophical underpinnings of his beliefs in social and racial equality. Although free, the woman described in *New Orleans Mammy* (ca. 1920) is typed by a distancing appellation rather than by the humanizing distinction of name. In both dress and title, the artist links his subject to an economic caste that has a strictly circumscribed societal role. Painted in the twentieth century, Adams's work, which reveals his conception of black identity, is based on nineteenth century patterns — his subject could just as easily have been a plantation slave or domestic servant.

A second, quite different response to Henri's artistic example can be found in the work of social realists such as Reginald Marsh. Marsh's *Tuesday Night at the Savoy Ballroom* (1930) (*fig. 28*) employs a host of expressive, almost cartoonish distortions to make pointed commentary on the racial prejudice that continued to be subtly enforced in New York despite the apparent gains of the Harlem Renaissance. Intermingling blacks and whites in a densely packed social setting, Marsh's splashily sophisticated crowd is awash with a variety of undercurrents — the fear of racial miscegenation, the desire for continued cultural isolation, the unspoken but constantly present possibility that the premise of the melting pot was flawed — that were still realities despite much of the vibrancy of Harlem culture.

By the time Marsh painted *Tuesday Night at the Savoy Ballroom*, social realism was merely one form of painting in competition with a variety of other, frequently abstract means of artistic expression. With an increasing objectivity that can be traced directly to the introduction of photography as an accepted means of reproducing reality for a mass audience, different ways of thinking about representation, such as social realism, gained legitimacy as valid forms of artistic expression. More important, multiracial organizations such as the National Association for the Advancement of Colored People (NAACP) and the Urban League, through prolonged and vocal, well-organized protests at racial prejudice, dramatically increased public consciousness of the need for racial equality. Depictions of black people can no longer rely on gross distortions of physiognomy or character to achieve racially motivated humor, but the symbolic power of visual images remains insidious. Jim Crow, Uncle Tom, Mammy, the Comic Darkey, and Zip Coon no longer dominate images of African-Americans in painting and sculpture, but their ghosts live on in a host of popular mediums, most notably in the violence of action serials and the stereotyped behavior of television sitcoms.

One of the hallmarks of genre painting was the development of conventions and stereotypes for portraying all manner of ethnic and racial distinctions, and many of those stereotypes continue to resonate through our culture. However, the economic and social underpinnings of this country have dictated that greater wealth meant the freedom to digress from type by increasing the distinctions of individual personality. Each racial and ethnic group, with the exception of the African-American, has had the opportunity to shed the overt characteristics of a group identity in favor of an identity based on individuality of choice. While strikingly different, the images of blacks in Justus Engelhardt Kühn's ostentatious

portrait of plantation wealth and Charles Zechel's painted equivalent of a photographic portrait both employ economic viewpoints – one authoritarian, one laissez-faire – to justify racial distinctions. Too often in this country's history, the relentless poverty that until recently has been the fate of many African-Americans has been a primary determining factor in the generation of racial stereotypes.

Acknowledging some of the underlying assumptions that have shaped the abundance of images that we daily digest limits their power over us. Whether based on assumptions of colonial society (*Henry Darnall III as a Child*), the Revolutionary War (*Watson and the Shark*), burgeoning nationalism (*Rustic Dance After a Sleigh Ride*), the extreme trauma of the Civil War (*The Ride for Liberty – The Fugitive Slaves*), or the optimistic racial equality that briefly flourished during postwar Reconstruction (*American Citizens [To the Polls]*), the work of the artists included in *Facing History* recorded more than the superficial dimensions of place and the overt characteristics of physical identity. Political beliefs, economic assumptions, and philosophical or religious credos form the structure that gives these representations continuing credibility, just as similar beliefs initially motivated the creation of the work. However, images need not automatically assume negative connotations or rigid limitations. Although strikingly different in formulation and execution, John Singleton Copley's *Watson and the Shark* and Winslow Homer's *Dressing for the Carnival* vividly show that a visual identity can serve as a tool that heightens perceptions by encouraging self-awareness. Perhaps, from our vantage point at the end of the twentieth century, we can finally begin to recognize the economic and social underpinnings of our racial stereotypes and bury some of the most malodorous of many lingering ghosts.

The late Guy C. McElroy served for ten years as curator and assistant director at Bethune Museum and Archives, National Historic Site. He was coauthor of African-American Artists 1880-1987: Selections from the Evans-Tibbs Collection *(1989), and author of* Robert S. Duncanson: A Centennial Exhibition *(1972).*

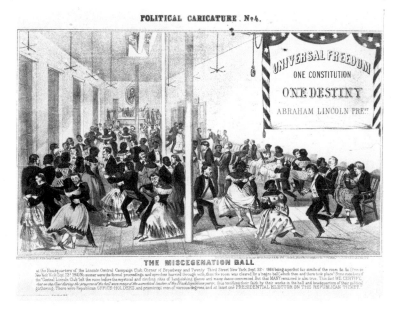

fig. 14 Bromley & Company, *The Miscegenation Ball*, 1864. Lithograph. Smithsonian Institution

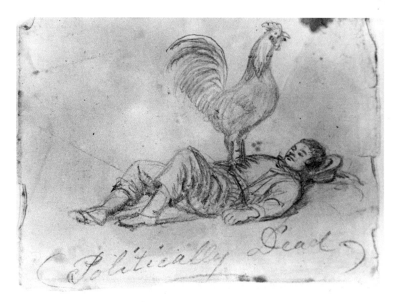

fig. 15 William Sidney Mount, Preliminary sketch for *Politically Dead*, ca. 1867. Pencil on paper, 3 ¼ × 4 (8.3 × 10.2). The Museums at Stony Brook. Museum Purchase

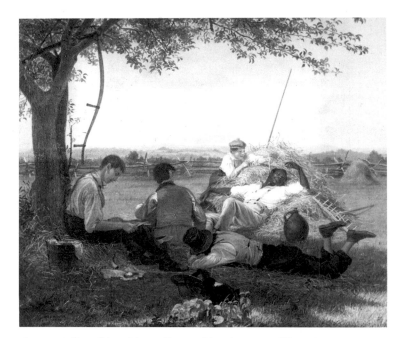

fig. 16 William Sidney Mount, *Farmers Nooning*, 1836. Oil on
canvas, 20¼×24½ (51.5×61.5). The Museums at Stony
Brook. Gift of Mr. Frederick Sturges, Jr.

figs. 16-18 The evolution and popularization of an image of
sloth

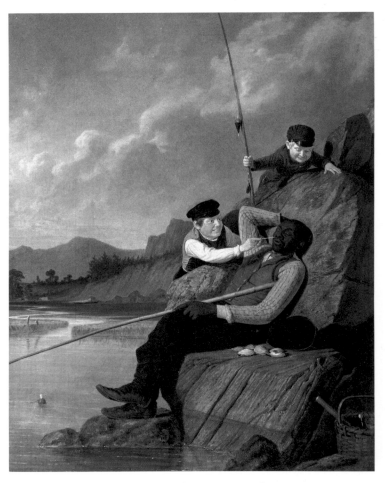

fig. 17 James Goodwyn Clonney, *Waking Up*, 1851. Oil on
canvas, 27×22 (68.6×55.9). Museum of Fine Arts, Boston.
Bequest of Martha C. Karolik for the Karolik Collection
of American Paintings, 1815-1865

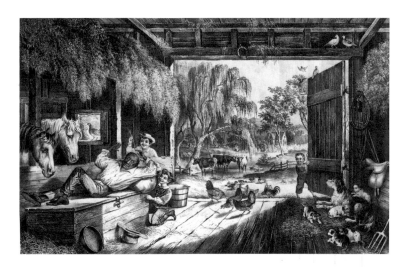

fig. 18 Currier and Ives, *Holidays in the Country*, 1868.
Lithograph. Library of Congress

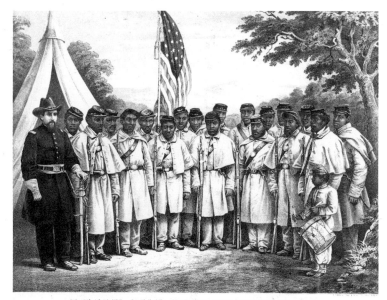

fig. 19 *Come and Join Us Brothers*, ca. 1864. Lithographic poster. The Supervisory Committee for Recruiting Colored Regiments. Smithsonian Institution

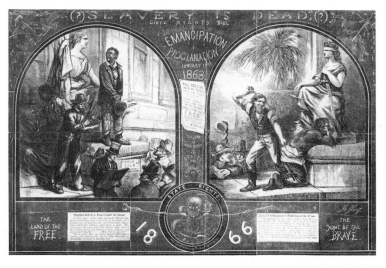

fig. 21 *Slavery Is Dead*, 1866. Lithograph. The Historic New Orleans Collection

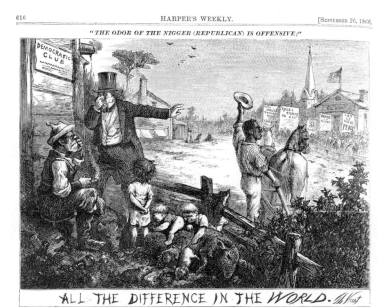

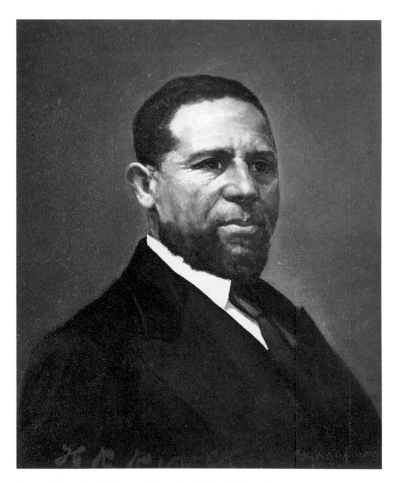

fig. 20 Theodor Kaufmann, *Portrait of Hiram R. Revels*, ca. 1870. Oil on millboard, 12 × 10 (30.5 × 25.4). Herbert F. Johnson Museum of Art, Cornell University

fig. 22 *All the Difference in the World*, 1868. Engraving. *Harper's Weekly* (September 26, 1868). Huntington Library, Art Collections and Botanical Gardens

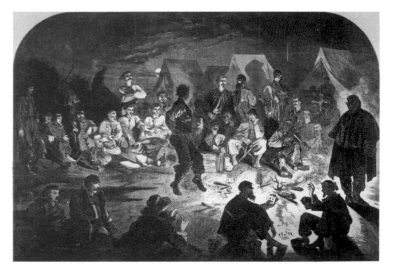

fig. 24　*A Bivouac Fire on the Potomac*, 1861. Wood engraving,
13 13/16 × 20 1/16 (35.4 × 51.2). The Museum of Fine Arts, Houston.
The Mavis P. and Mary Wilson Kelsey Collection of Winslow
Homer Graphics

figs. 24-27　The evolution of Winslow Homer's conception of
African-Americans

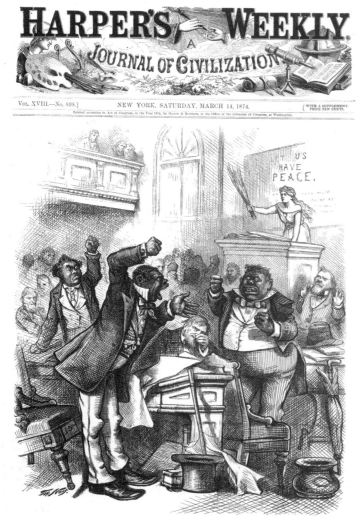

COLORED RULE IN A RECONSTRUCTED (?) STATE.—[See Page 242.]
(THE MEMBERS CALL EACH OTHER THIEVES, LIARS, RASCALS, AND COWARDS.)
COLUMBIA. "You are Aping the lowest Whites. If you disgrace your Race in this way you had better take Back Seats."

fig. 23　*Colored Rule in a Reconstructed (?) State*, 1874.
Engraving. *Harper's Weekly* (March 14, 1874). Huntington
Library, Art Collections and Botanical Gardens

figs. 21-23　Three images of Reconstruction by Thomas Nast

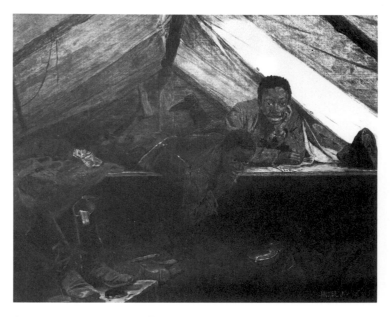

fig. 25　*Army Boots*, 1865. Oil on canvas, 14 × 18 (35.6 × 45.7).
Hirshhorn Museum and Sculpture Garden, Smithsonian
Institution. Gift of Joseph H. Hirshhorn, 1966

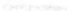

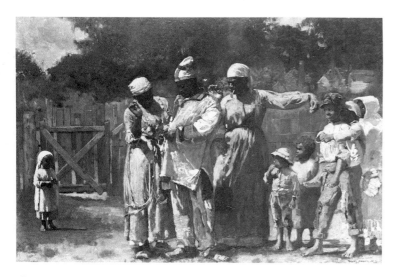

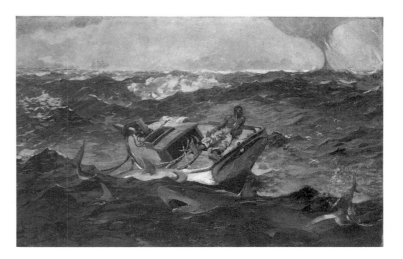

fig. 26 *Dressing for the Carnival*, 1877. Oil on canvas, 20 × 30 (50.8 × 76.2). The Metropolitan Museum of Art, Amelia B. Lazarus Fund, 1922

fig. 27 *The Gulf Stream*, 1899. Oil on canvas, 28 ⅛ × 49 ⅛ (71.4 × 124.8). The Metropolitan Museum of Art. Wolfe Fund, 1906

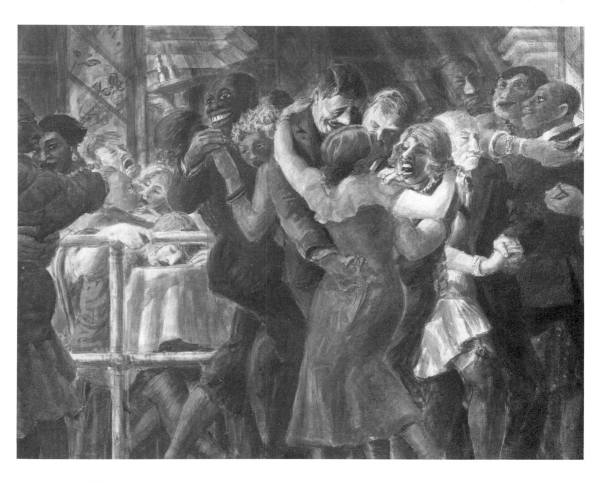

fig. 28 Reginald Marsh, *Tuesday Night at the Savoy Ballroom*, 1930. Tempera on composition board, 36 × 48 ⅛ (91.4 × 122.2). The Rose Art Museum, Brandeis University, Waltham, Massachusetts. Gift of the Honorable William Benton, New York

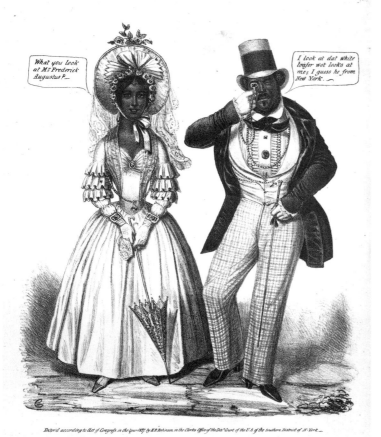

fig. 1 *Philadelphia Fashions*, 1837. Lithograph. Published by
H. R. Robinson, New York. Library Company of Philadelphia

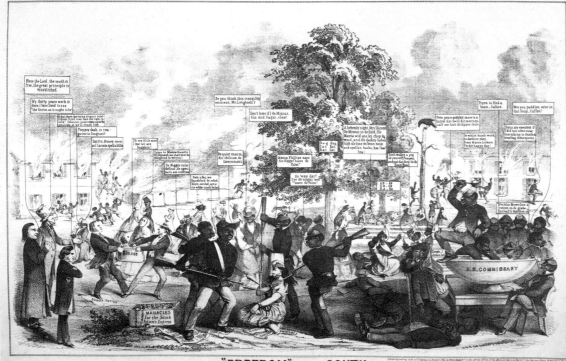

fig. 2 *The "Freedom" of the South*, 1865. Lithograph. Published
by Bromley & Co., New York. The New York Public Library.
Miriam and Ira D. Wallach Division of Art, Prints and
Photographs

The Face and Voice of Blackness

Henry Louis Gates, Jr.

I

> A stereotype is an already read text.
> – Barbara Johnson, *A World of Difference*

The complex relationship between race and representation in American art created between 1710 and 1940 can be thought of as an attempt by American society to fabricate a set of images of the African-American that objectified her or his status. The majority of images included in this book represents blacks as, first, slaves, and, second, ciphers whose semblance to actual historical persons cannot be recognized. Public policy decisions affecting African-Americans were often predicated upon such fictitious black citizenry created by white painters, sculptors, writers, and illustrators, rather than on the face and voice created by their black contemporaries. The "public Negro mind," as the black historian Carter G. Woodson put it, for white Americans was a thing vacuous and animalistic, subhuman and sterile. The public fiction of the Negro in art and literature was capable of expressing only two emotions, humor and pity, robbing the African-American of the privilege and the right of "running the gamut of his full humanity," as Ralph Ellison would say of his protagonist in *Invisible Man* (1952). When white Americans confronted their black brethren in any meaningful way, they did so through the filter of a web of racist images that they placed over the black face of humanity like a mask over an actor. Black people were expected to function in society in ways that conformed to a public image – a white fiction of blackness. If they did not, the results were often discrimination, hardship, or even extreme physical violence.

Guy C. McElroy, in his introduction to *Facing History*, has identified four general types into which the representation of the African-American in art can be configured. These include depictions as "grotesque buffoons, servile menials, comic entertainers, and threatening subhumans." Similarly, the African-American literary critic Sterling A. Brown, in his pioneering essay "Negro Character as Seen by White Authors" (1933), identified seven distinct types in American literature. The Contented Slave, Wretched Freeman, Comic Negro, Brute Negro, Tragic Mulatto, Local Color Negro, and Exotic Primitive became conventions that further limited the already constricted range of possible representations available for the configuration of black subjects in American art forms. By the beginning of this century, with Jim Crow segregation solidly in place, tens of thousands of what I like to term "Sambo" caricatures were printed in cartoons and on trading cards, postcards, tea cosies, salt and pepper shakers, children's games, dolls – in short, on virtually every conceivable form of consumer goods advertised and mass marketed for the American lower and middle classes. The Sambo image was not only a highly visible symbol, it was also a highly marketable commodity (*figs.* 1-6).

What shocks us today about the paintings, drawings, and sculptures from the decades that spanned the end of the nineteenth century and the beginning of the twentieth is their failure to capture the full range of the African-American personality. Apart from notable exceptions in the work of Thomas Eakins and Winslow Homer, conceptions of blacks in the visual arts became more simplistic, both qualitatively and quantitatively, after the collapse of Reconstruction. However, the images in this exhibition seem polite, almost proper, when contrasted with the worst of the lurid postwar popular images. Like their more pervasive "low art" counterpoints, the visual arts of this period relied on conceptions of blacks as debased, dehumanized figures. The large number and variety of inherently racist images in American culture attest to a particularly American preoccupation with marginalizing black Americans by flooding the culture with an Other Negro, a Negro who conformed to the deepest social fears and fantasies of the larger society. If the complexity of African-Americans or their status as fully endowed human beings could be openly denied in the popular arts, and bracketed within the margins of formal art, then the African-American could be easily relegated and confined to the margins of society. To begin to escape, each black person would have to dig himself or herself out from under the codified racist debris of centuries of representations of blackness as absence, as nothingness, as deformity and depravity.

The black person was rarely dignified with individuality in works of art, because depictions of individuals would attest to the full range and variety of human characteristics and abilities. Ralph Ellison described this phenomenon from personal experience:

This mask, this willful stylization and modification of the natural face and hands, was imperative for the evocation of that atmosphere in which the fascination of blackness could be enjoyed, the comic catharsis achieved. The racial identity of the performer was unimportant; the mask was the thing (the "thing" in more ways than one), and its function was to veil the humanity of Negroes thus reduced to a sign, and to repress the white audience's awareness of its moral identification with its own acts and with the human ambiguities pushed behind the mask.

African-Americans understood this view very well. Their central task, in the face of their negative or diminished depictions in art and literature, was to transform themselves from objects to subjects, a process that was essential to effect before they could assume the prerogatives of full American citizenship. But how could this complicated process be realized? In the first decades of the nineteenth century, the few prominent blacks who obtained access to the middle and upper classes commissioned paintings, and later photographs, of themselves, so that they could metaphorically enshrine and quite literally perpetuate the example of their own identities. Their goal was to commission the human face of blackness, and to signify to society that their images stood, as any art image does, as "representative" of their kinsmen. *Portrait of a Man* by Joshua Johnson, *Daniel Dashiel Warner* by Thomas Sully, and *Hiram R. Revels* by Theodor Kaufmann, in this book, offer eloquent public testimony to the ability of African-Americans to gain access to individuality when accorded unbiased representation.

However, the rareness of existing portraits of prominent black figures is both a telling commentary on the singular number of these figures in nineteenth and early twentieth century American society and an effective critique of the visual arts as a medium for constructing images of black identity. Painting and sculpture are

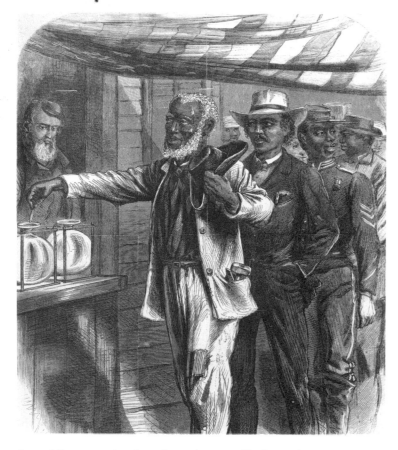

fig. 3　A Reconstruction viewpoint on the acceptable classes of
black men: the artisan, the business man, and the soldier.
Alfred R. Waud, *The First Vote*. Engraving. *Harper's Magazine*
(November 16, 1867). Library of Congress

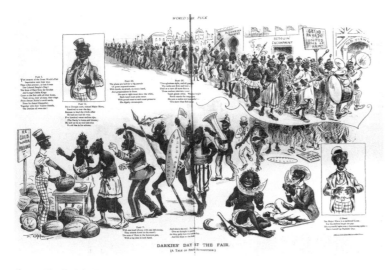

fig. 4　Frederick Opper, *Darkies' Day at the Fair (A Tale of
Poetic Retribution)*. *World's Fair Puck*, 1893. Engraving.
Library of Congress

not mediums that produce products that are either affordable
or easily disseminated to a broad audience. Rather, the traditional
role of the decorative or "fine" arts has always been a preoccupa-
tion of institutions and an elite of wealthy individuals. For a black
to choose a career in the visual arts in this country has always
been a tenuous proposition. The extremely limited numbers of
black artists who managed to obtain a margin of success in
eighteenth and nineteenth century America is startling. More-
over, such talented black artists as Joshua Johnson, Robert Scott
Duncanson, Mary Edmonia Lewis, Henry Ossawa Tanner, and
Edward Mitchell Bannister achieved success not by developing a
repertoire of African-American imagery but by emulating devel-
oping American artistic conventions, which were in turn based on
European models. It is a telling comment on the slowly developing
importance of the visual arts for black identity that such a talented
contemporary of Thomas Eakins as Henry Ossawa Tanner
would have to reject life in America and pursue an expatriate
existence in order to obtain his success.

As early as 1760, however, blacks narrated and wrote autobi-
ographies. These authors sought to declare the existence of the
black voice by imitating, revising, and perfecting narrative strate-
gies taken from other American and English authors, as a way of
creating, in words, a portrait of a human being – a human being
as unlike their public representation by whites as a postcard is
from an actual environment. Their individual histories charted
their passage from chattel slave to human being, from property/
object to citizen/subject, by registering the timbres of the African-
American narrative voice. In other words, black authors sought
to chart the contours of their faces, the very face of blackness.

Two paintings in this exhibition graphically depict the impor-
tance of the relationship between blacks and the enlightening
power of the written word. The main figure in Samuel Jennings's
Liberty Displaying the Arts and Sciences (1792) (*fig. 7*) is a
classically figured and benignly supportive Liberty, who seems to
be holding out the very human possibility of the Enlightenment
itself, referred to metaphorically by the symbolic accoutrements
of "the arts and sciences," to the African slaves who crouch or
kneel before her. However, the gap between the acquisition of
"the arts and sciences" by the slaves at Liberty's feet and the
severe legal restrictions that prevented the education or training
of slaves gives this painting a special irony. Seen in this light,
Liberty's pose seems as intent upon creating awe as sincerely
offering instruction. Reinforcing the uniqueness of the enlighten-
ment of blacks in this scenario, only a few members of the slave
community are extended the opportunity of education, while the
bulk of their countrymen entertain themselves in festive outdoor
events.

Tangled amid tormented insinuations of black sloth signified
by a wedge of watermelon, Winslow Homer's *The Watermelon
Boys* (1876) (*fig. 8*) offers another white perspective on the value
of black education. Painted at the close of Reconstruction, the
boys in Homer's youthful trio have abandoned their bundled
schoolbooks in favor of temporal pleasures. Homer based this
painting on his experiences in Petersburg, Virginia, reflecting
a black value system which stressed education, along with suf-
frage, as the best means of attaining individual rights and group
advancement. Including books as accoutrements discarded in

favor of the pursuit of pleasure, Homer has tellingly stated his ambivalence about the viability of education as the means of salvation for freedmen.

Nevertheless, the pursuit of the "arts and sciences" remained the obsessive preoccupation of black intellectuals before and after Emancipation. Henri Christophe (1767-1820), the Emperor of Haiti, summed up this preoccupation in a royal proclamation of 1816:

Descendants of Africans, my brethren, the friends of humanity have asserted that we are susceptible of improvement like the whites; our traducers affirm the contrary; it is for us to decide the question. It is by the wisdom of our conduct, our success in the arts and sciences, that we shall secure the triumph of our respected and illustrious patrons, and confound, forever, the malice and unfounded assertions of our implacable enemies.

Freedom was embodied in literacy precisely because the ability to create forms through language use was one of the critical mainstays of the Enlightenment and well beyond. To many, it was the most visible embodiment of reason itself, and if one were "reasonable," then one's humanity could not easily be denied. The voice and face of reason could perhaps be expressed best, among all of the nascent American art forms, in literature, because in literature blacks found the means to create their own images of themselves.

Precisely because American visual art forms were so concerned with depicting blacks as devoid of reason, some of the greatest nineteenth century African-American figures, such as Frances Ellen, Watkins Harper, Mary Prince, William Wells Brown, Harriet Jacobs, and Frederick Douglass, metaphorically wrote themselves to freedom by articulating the complexity of their human subjectivity. We can begin to understand the complex relation between visual images of African-Americans and their own attempts to create a self-image that would allow them to partake of their full status as Americans by examining the "New Negro," a concept which blacks began to formulate at the end of the nineteenth century as a reaction against their visual and literary debasement in American art.

2

> . . . a class of colored people, the "New Negro," . . . have arisen since the War, with education, refinement, and money. – *Cleveland Gazette*, June 29, 1895

Frederick Douglass, the great nineteenth century writer and orator, was widely advertised during his lifetime as "the representative colored man of the United States." Douglass liked the designation; indeed, he seems to have encouraged its use. What a curious manner by which to be known, or by which to be recalled: the representative colored man of the United States. But in what sense could Frederick Douglass be considered "representative"? Certainly not as a self-made man of great learning, author of three masterful autobiographies and hundreds of speeches and essays. Douglass could not be mistaken as representative of the mode or median of recently emancipated African-American citizenry of the nineteenth century. But Douglass was the representative colored man in the United States precisely because he appealed to white audiences. And he was so presentable because he established his public identity through a mastery of oratory

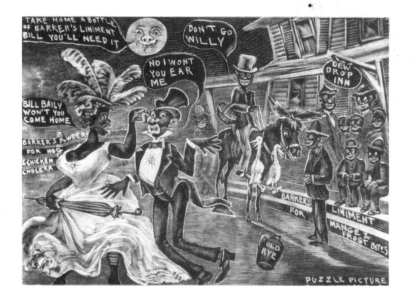

fig. 5 Anonymous Artist, *Advertisement*, ca. 1890. Caption reads in part: "It does not look like a question for debate as to whether Bill Bailey will go home or not by the meat-axe-look of his best girl, and the hold she has on his ear. Williams will get there, and no mistake, it is more than likely that before Billy goes to bed he will have occasion to use *Barker's Nerve and Bone Liniment*.

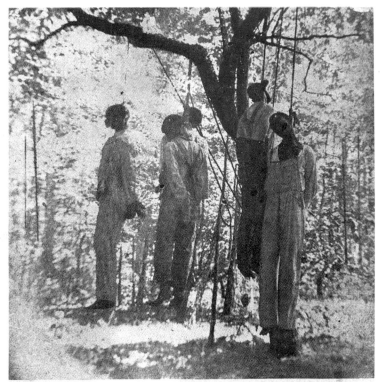

SCENE IN SABINE COUNTY. TEXAS, JUNE 15, 1908.

The Dogwood Tree.

This is only the branch of the Dogwood tree;
 An emblem of WHITE SUPREMACY.
A lesson once taught in the Pioneer's school,
 That this is a land of WHITE MAN'S RULE.
The Red Man once in an early day,
 Was told by the Whites to mend his way.

The negro, now, by eternal grace,
 Must learn to stay in the negro's place.
In the Sunny South, the Land of the Free,
 Let the WHITE SUPREME forever be.
Let this a warning to all negroes be,
 Or they'll suffer the fate of the DOGWOOD TREE.

Copyrighted — *Pub. by Harkrider Drug Co., Center, Tex.*

fig. 6 *"U.S. Postcard,"* 1908

and writing. Douglass was the most representative colored man of a number of gifted black Reconstruction figures both because he was elegantly eloquent and because he represented black people's great opportunity to restructure racist ideas in the court of public opinion. Black Americans sought to re-present their public selves in order to reconstruct their public, reproducible images. This sense of representation as reconstruction brought about the concept of the "New Negro." When Douglass spoke or wrote, he sought, as an individual speaking for a group, to recreate the public face of the Negro.

The word "reconstruction" and the concepts that it connotes are so familiar to American historians and to scholars of African-American Studies that we tend to forget the word's complex layers of etymology and meaning. Reconstruction is the proper name for "the process by which after the Civil War the States which had seceded were restored to the rights and privileges of the Union." Although historians have marked the beginning of Reconstruction with the onset of Civil War in 1861, or with Lincoln's Emancipation Proclamation in 1863, this period commenced officially with the passage, over President Andrew Johnson's veto, of the Reconstruction Act of 1867, and ended with what is known popularly as the Hayes-Tilden Compromise of 1876. Postwar Reconstruction, then, endured officially for a mere nine years, to be replaced by a dark period in American history known as Redemption, which Sterling Brown once said lasted in the South from 1876 "to yesterday!" By the turn of the century, Southern Redemption had become so fused with black disenfranchisement and the White Supremacy movement that J. K. Vardaman of Mississippi could gain the governorship (and later a seat in the United States Senate) by blatantly campaigning on a racist platform:

I am just as opposed to Booker T. Washington as a voter, with all his Anglo-Saxon reenforcements, as I am to the coconut-headed, chocolate-colored, typical little coon, Andy Dotson, who blacks my shoes every morning. Neither is fit to perform the supreme function of citizenship.

But reconstruction also signifies "the manner in which a thing is artificially constructed or naturally formed; structure, conformation, disposition." This definition, coupled with the bitter experience of political Reconstruction, helped shape the two antithetical images of African-Americans that still inflect the ways black people are perceived in this country. I speak specifically of the curious heritage of the "New Negro" and his doppelganger, the black Sambo, and their complex and antithetical relationship as surrogates in a simmering but undeclared race war.

The image of the black in "Sambo art" has served various generations of white racists as a sign of lack and degeneration that expressed and reinforced the truly negated absence of black individual identity. On the other hand, the image of a "New Negro" was successively recreated by generations of black intellectuals as a sign of plenitude and regeneration that offered the goal of a truly reconstructed presence in the face of white hostility. These two sets of figures can also be said to have a certain cause-and-effect relation, with the fiction of a Negro American (who is now somehow "new" or different from an "old" Negro) generated to counter the popular image of blacks as devoid of the characteristics that separate lower forms of human life from more

highly evolved forms. Subsequent changes of name, such as Black, Afro-American, and African-American, are extensions of this urge to reforge reality by re-encoding the public identity of a group.

Blacks seem to have felt the need to reconstruct their image since 1619, when the first boatload of slaves disembarked in Virginia. African-Americans commenced their cultural lives in this hemisphere as veritable deconstructions, so to speak, of all that Western culture so ardently wished to be. Almost as soon as blacks gained literacy, they set out to redefine – against already solidified stereotypes – who and what a black person was, and how unlike a racist stereotype black men and women indeed were. To counter racist stereotypes, both white *and* black writers erred on the side of nobility, positing a series of equally fictitious black archetypes, from James Fenimore Cooper's Abraham Freeborn in *The Pioneers* (1823) to Alex Haley's Kunta Kinte in *Roots* (1976). The first serious efforts at black intellectual reconstruction commenced in the antebellum slave narratives, published mainly between 1831 and 1861, and climaxed with the New Negro Renaissance of the 1920s. This period, rather than the politically defined period between 1867 and 1876, marked the crux of black intellectual reconstruction (*figs.9 and 10*). With the right of suffrage, postwar Reconstruction was characterized by a dramatic upsurge of energy in the black body politic, but a survey of the black literature and visual art that emerged after the Civil War shows that the arts clearly enjoyed no similar vitalization. Between 1867 and 1876, for example, black people published only two novels, one in 1867 and one in 1871. On the contrary, blacks published more novels between 1853 and 1865, when they were fighting slavery, than they did in the period when they were at least nominally free. Between 1895 and 1925, at the height of racially inspired violence towards African-Americans, however, black writers published at least 64 novels.

In one of the paradoxes of black intellectual history, one of the most important contributions to literature for the black person during Reconstruction came not from black authors, but from Mark Twain's *A True Story* (1874), which purports to describe "Aunt Rachel's" oral narration of her own enslavement, rendered entirely in "dialect." The great and terrible subject of black slavery did have a momentary attraction for visual artists when blacks were freed, but it found no immediate literary counterpart. Instead, once Redemption had degenerated into a new form of strictly legislated, de facto enslavement for blacks, African-Americans pursued a public voice much more stridently than even during slavery.

If Reconstruction did not produce a black renaissance of letters, the period between 1895 and 1925 was an era that witnessed the creation of the New Negro, a mythic figure in search of a culturally willed myth. The New Negro was a paradoxical metaphor that combined a concern with history and cultural antecedents with a deep concern for an articulated racial heritage that would establish once and for all the highly public faces of a once-subjugated but now proud race. This figure, which combines implicitly an eighteenth century vision of intellectual utopia with nineteenth century ideas concerning optimistic progress, climaxed by the end of the nineteenth century in the dream of a self-made, coherent, and powerful identity signified by the upper case

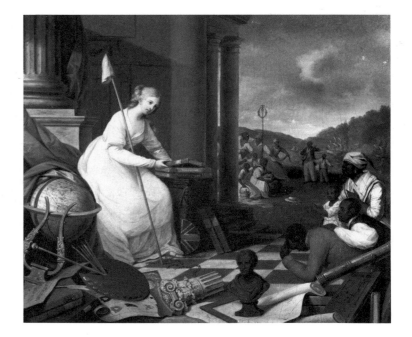

fig.7 Samuel Jennings, *Liberty Displaying the Arts and Sciences*, 1792. Oil on canvas, 60¼ × 73⅛ (153 × 185.4). Library Company of Philadelphia

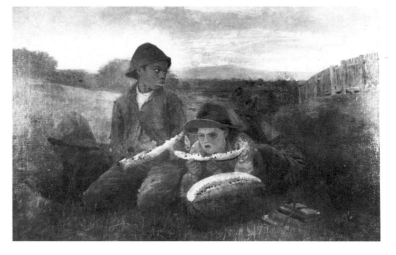

fig.8 Winslow Homer, *The Watermelon Boys*, 1876. Oil on canvas, 24⅛ × 38⅛ (61.3 × 96.8). Cooper-Hewitt Museum, the Smithsonian Institution's National Museum of Design

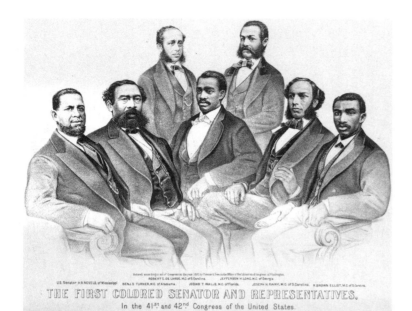

fig. 9 Currier and Ives, *The First Colored Senator and Representatives in the 41st and 42nd Congress of the United States*, 1872. Lithograph. Library of Congress

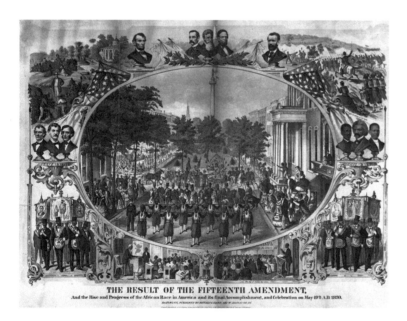

fig. 10 *The Result of the Fifteenth Amendment*, 1870. Lithograph. Maryland Historical Society

"Negro" and the belated introduction of the adjective "New." The paradox of the self-willed beginning of the New Negro is that the "success" of this image depended fundamentally upon self-negation, upon turning away from the labyrinthine memory and societal patterns of the enslaved "old" negro, offering in his place the register of a "New Negro," a self-sufficient, powerfully creative black self. Precisely because it is at worst a non sequitur abstraction, and at best a powerfully suggestive but purely rhetorical figure, this image of a willed, ideal state of being offered a form of neological utopia and renewal which could exist only in what the late linguist and philosopher Michel Foucault termed "the non-place of language." "Utopia" signifies "no-place," and the "New Negro" came to signify a "black person who lives at no place," and at no time. This bold and audacious act of language, signifying the will to power, dared to recreate a race by renaming it.

Frank E. and Fritzie P. Manuel, in *Utopian Thought in the Western World* (1979), aptly characterize the latent content of all utopian thought:

The great utopia startles and yet is recognized as conceivable. It is not a sleeping or bizarre vision but one that satisfies a hunger or stimulates the mind and the body to the recognition of a new potentiality. . . . It can be studied as a reflection of the specific crises that it presumes to resolve . . . It may capture the anguish of an epoch in a striking metaphor.

The weary dream of a perfected state of being, with no history, the dream of naming a second, new self, is emblematic of the anguish of much of the African-American tradition. This naming ritual is also prefigured in the autobiographical texts of ex-slaves published before 1865. African-Americans, at least since the creation in 1827 of the first black newspaper, *Freedom's Journal*, have displayed consistent, and perhaps undue, concern for both the racial name and the personal name by which they were known. Frederick Douglass called himself by three surnames before he stumbled upon Douglass. Sojourner Truth strongly recalled naming her newly-freed self, attributing that art to the grace of God:

. . . my name was Isabella; but when I left the house of bondage, I left everything behind. I wan't goin' to keep nothin' of Egypt on me, an' so I went to the Lord an' asked him to give me a new name. An' the Lord give me Sojourner, because I was to travel up an' down the land, showin' the people their sins, an' bein' a sign unto them. Afterward I told de Lord I wanted another name, 'cause everybody else had two names; an de Lord give me Truth, because I was to declare the truth to de people.

Booker T. Washington confirms Sojourner Truth's declaration of the name as a sign of the self, even if a less natural relationship prevailed between the sign and its referent for him than it did for her:

After the coming of freedom there were two points upon which practically all the people on our place were agreed, and I find that this was generally true throughout the South: that they must change their names, and that they must leave the old plantation for at least a few days or weeks in order that they might really feel that they were free.

From instances such as these, what applied to the individual was multiplied and applied to the whole. The turn-of-the-century

debate over the name black people should use to identify themselves took place in a host of black publications, from *Alexander's Magazine*, *Voice of the Negro*, and *Colored American Magazine*, to *New York Age*. It is fair to conclude that the idea that the race's public perception turned largely upon the connotations of its name is as germane to black intellectual history as is the idea of a direct relation between "black art" and the realization of black political power. Nowhere in African-American history is this complex reaction more evident than in the New Negro Renaissance of the 1920s.

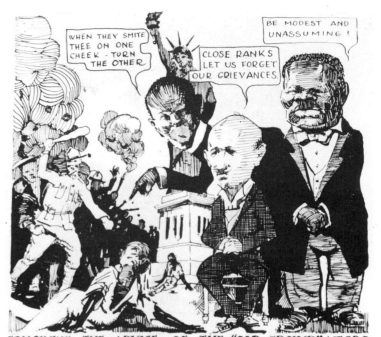

fig. 11 Anonymous Artist, *Following the Advice of the "Old Crowd" Negro. Messenger* (September 1919)

3

 . . . what is socially peripheral is so frequently symbolically central. . . . The low-Other is despised and denied at the level of political organization and social being whilst it is instrumentally constitutive of the shared imaginary repertoires of the dominant culture.
 – Peter Stallybrass and Allon White, *The Politics and Poetics of Transgression*

The phrase "New Negro" was compelling enough to one eighteenth century writer that he felt called upon to define it for his 1745 readership of *London Magazine*: "So they [the blacks] call those slaves," he wrote, "just brought from Africa." What is curious even about this early definition of the metaphor is that, as it would in the twentieth century, the name already connotes both a temporal order of succession and the ahistorical dimensions of the American experience. The phrase also denotes a direct spatial association with Africa, implying a state of consciousness that is perhaps a form of racial dignity or integrity, an "organic community," that is no longer possible to aspire to in the enslavement of the new world. However, this early usage, while suggestive, remained an isolated example.

 The varying definitions of the New Negro as the symbol of a new racial self, the Public Negro, apply most directly to the New Negro Renaissance during the Jazz Age. This overtly racial identity did not exist as a political body or group of entities but rather as a coded system of signs, complete with masks and mythology – in short, as a credible fiction. In usages after 1895, the name has implied a tension between strictly political concerns and strictly artistic concerns: Alain Locke's appropriation of the name in 1925 for his literary movement represents a measured co-opting of the term from its fairly radical political connotations.

 As defined in black newspapers and magazines such as the *Messenger*, the *Crusader*, the *Kansas City Call*, and the *Chicago Whip*, in a number of bold essays and editorials printed during the post-World War I race riots, however, the New Negroes were those African-Americans who rather ably defended themselves from fascist mob aggression. Indeed, this tension between definitions is readily gleaned in the drastic difference between the "Old Crowd Negro – New Crowd Negro" cartoon (*figs. 11 and 12*), printed in the *Messenger* of 1920, and "The New Negro," by Allan R. Freelon (*fig. 13*), which served as a frontispiece to the 1928 issue of *Carolina Magazine*. Heavily influenced by Locke's

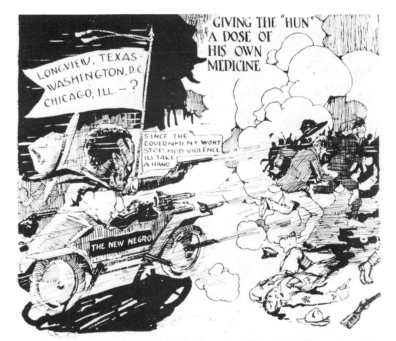

fig. 12 Anonymous Artist, *The "New Crowd Negro" Making America Safe for Himself. Messenger* (September 1919)

fig. 13 Allan R. Freelon, *The New Negro. Carolina Magazine*, 1928

writings, *Carolina Magazine* was devoted to exploring this feminine image of the New Negro. By 1928 the radical self-defense inherent in the *Messenger*'s "New Crowd Negroes" has turned on itself in Freelon's drawing: two lynched figures in the lower left of the drawing offer only ironic echoes of "New Crowd Negroes." The white mob fleeing the New Negro's guns is also ironically restated in the three white crosses on a distant hill, perhaps too directly associating the martyrdom of Calvary with the black deaths at the hands of militant Klansmen. However, Freelon's nude, supple black female, in a posture of arrested motion, is an artfully idyllic creature, silhouetted against a ritual mask of African descent that is complete with cowrie shells. She is framed by a transcending rainbow and set against the background of the cosmos.

In less than ten years, then, the figure of the New Negro has undergone changes of the most profound sort. The poles of this drastic transformation, however, are inherent even in the earliest uses of the phrase "New Negro." The sheer resonating power that these two words suggested for young blacks can be gleaned from the fact that Alain Locke and his fellow writers saw fit to graft onto its postwar connotations of aggressive self-defense the mythological and primitivistic defense of the artistic racial self that was the basis of the literary movement better known as the Harlem Renaissance.

An editorial in the *Cleveland Gazette*, on June 29, 1895, celebrating the passage of the New York Civil Rights Law, spoke of "a class of colored people, the 'New Negro,' who have arisen since the war, with education, refinement, and money." In marked contrast with their enslaved or disenfranchised ancestors, these New Negroes demanded that their rights as citizens be vouchsafed by law. Significantly, these New Negroes were to be identified by their "education, refinement and money," strongly implying that property rights would be the hallmark of those who would demand political rights. "Property," in this sense, is only one of a list of rights required for the creation of the New Negro. "Education" and "refinement" — to speak properly was to be proper — along with the security of property, helped ensure one's rights as a black American. J. W. E. Bowen, in a speech entitled *An Appeal to the King* delivered to the Atlanta Exposition later that same year, again defined the New Negro, but here in terms only of racial "consciousness" and its relation to "civilization." Bowen's New Negro leads directly to the Renaissance, for it was above all through literature that both "a racial personality" and "the blaze of a new civilization" would manifest themselves. Presumably, he would go on to create an art that was both racial and universal in its implications.

Booker T. Washington, Fannie Barrier Williams, and N. B. Wood compiled *A New Negro for a New Century* (1900), an elaborately constructed compendium of excerpted black histories, slave narratives, journalism, biographical sketches, and extended defenses of the combat performances of black soldiers from the American Revolution and "the Rebellion," to the Spanish-American War in general, to the actions of "Regulars in the Philippines" and "Regulars in Cuba." Subtitled *An Accurate and Up-to-Date Record of the Upward Struggles of the Negro Race, A New Negro* clearly intended to shift the new century's image of the black away from stereotypes based on plantation fictions,

black-face minstrelsy, vaudeville, racist pseudo-science, and vulgar social Darwinism. Black intellectuals seemed to believe that their racist treatment at the hand of whites merely imitated their racist "treatments" in art. Accordingly, if life did indeed imitate art, if reality imitated the image, then to manipulate the image of the black was, in a sense, to manipulate reality. The Public Negro Self, therefore, was an entity that had to be crafted. The task was an enormous one, especially since blacks had only the most minimal control over the mass production and dissemination of information.

Washington and his fellow editors attempted to do just that. *A New Negro* offers 60 portraits which, taken together, stand as a complex signal of both the individual achievements of black men and women as abolitionists, soldiers, artists, and as important symbols for the "progressive" classes of the black race, who are identified, among other accomplishments, by their ability to form numerous self-help institutions such as "Colored Women's Clubs," considered key indicators of the African-American's "capacity" for "elevation." These intertwined metaphors, which echo the myriad versions of the folk phrase, "we is risin'," fully embody the eighteenth century terminology related to the Enlightenment concept of a great vertical chain of being, upon which both individuals and races self-consciously "rose" from the lowest levels of the animal kingdom, aspiring toward the most sublime examples of humanity (most frequently identified as Newton and Milton). At its worst, "capacity" deteriorated into the obscure limitations determined by the physical cranial measurements of phrenologists. Within the dialogue over the New Negro, however, it quickly became an optimistic metaphor for the potential of human intelligence. The following lines from Frances Allen Watkins Harper, quoted in Mrs. Booker T. Washington's essay on "The Club Movement Among Negro Women," in J. D. Nichols and William H. Crogman's 1902 edition of *The New Progress of a Race*, indicate these origins clearly:

> There is light beyond the darkness,
> Joy beyond the present pain;
> There is hope in God's great justice
> And the Negro's rising brain.

The repeated use of the keyword "progressive" in *A New Negro* relates directly to another eighteenth century notion, the ideal of perfectability through progress. Booker T. Washington's New Negro, then, stood at a point on the great chain of progress that was civilization, at a point that was head and shoulders above the ex-slave, freed now for only thirty-five years. As the authors stated in their Introduction:

This book has been rightly named A New Negro for A New Century. *The negro of today is in every phase of life far advanced over the negro of thirty years ago. In the following pages the progressive life of the Afro-American people has been written in the light of achievements that will be surprising to people who are ignorant of the enlarging life of these remarkable people.*

Of the anthology's eighteen chapters, fewer than seven are histories of black involvement in American wars, while six chapters "unmask" slavery. Rather creatively, a large part of this material is reprinted from the writings of black historians such as George Washington Williams, William C. Nell, and William Grant Still. "Heroes and Martyrs" to the race include John Brown, Calvin

fig. 14 *Mrs. Booker T. Washington*

fig. 15 *Mrs. Lulu Love.* Prominent Teacher of Physical Culture in the Public Schools of Washington, D.C.

fig. 16 Fannie Barrier Williams. Member of the Chicago Woman's Club, Newspaper Correspondent and Author

Fairbanks, William Lloyd Garrison, and Elijah P. Lovejoy, while two men and two women – Frederick Douglass, Touissaint L'Ouverture, Phillis Wheatley, and Sojourner Truth – are accorded the ironic privilege of being called "Fathers to the Race." Two chapters treat the "Club Movement Among Colored Women," and one charts educational progress. Booker T. Washington's portrait forms the frontispiece of the volume, while Mrs. Washington's portrait concludes the book (*figs. 14-17*). This powerful couple stands as a framing symbol that encompasses and illustrates the ideal of black bourgeois progress. Between this handsome pair are portraits of military figures Antonio Maceo, Maximo Gomez, Charles E. Young, and John H. Alexander; creative writers Paul Laurence Dunbar, T. Thomas Fortune, Charles Chesnutt, and Frederick Douglass; scholars, including W. S. Scarborough, H. T. Kealing, S. Laing Williams, and W. E. B. Du Bois; and notable women, such as Mary Church Terrell, Anna J. Cooper, Dr. Ida Grey Nelson, Miss Lulu Love, and Fannie Barrier Williams.

The anthology's apparent emphasis on military accomplishments seems to be an effort to refute claims made by Theodore Roosevelt in *Scribner's Magazine* in 1899 advocating mandatory command of black soldiers by white officers because of inherent racial weaknesses which prevented black officers from commanding effectively. Almost the whole of Sergeant Presley Holliday's rebuttal, printed initially in *New York Age* in 1899, appears in *A New Negro*, along with examples of black valor in every American war. The tone of these essays is fairly represented by Holliday's claim that black soldiers in the Civil War "turned the tide of war against slavery and the Rebellion, in favor of freedom and the Union." To have fought nobly was clearly seen (as it has been seen by whites since the beginning of this country) as a legitimate argument for the rights of full citizenship.

However, despite an unprecedented emphasis on black histories written by black historians, the New Negro's relation to the Old Negro is problematical. "Let us smother all the wrongs we have endured," urges one essayist; "Let us forget the past." This aspect of "the past" is not only forgotten in *A New Negro*, it is buried beneath all of the faintly smiling bourgeois countenances of the New Negroes awaiting only the new century to escape the recollection of enslavement. Fannie Barrier Williams's essay on the "Club Movement Among Colored Women" is pertinent evidence of an urge to displace racial heritage with an ideal based on sexual bonding. "To feel that you are something better than a slave, or a descendant of an ex-slave," she writes, "to feel that you are a unit in the womanhood of a great nation and a great civilization, is the beginning of self-respect and the respect of your race." It is this direct relationship between the self and the race, between the part and the whole, which is the underlying premise of *A New Negro*. As important as denying and transforming white racist images of blacks was *A New Negro's* intention of restructuring the ways blacks regarded themselves. In Williams's words, "the consciousness of being fully free has not yet come to the great mass of the colored women in this country," in part because "the emancipation of the mind and spirit of the race could not be accomplished by legislation." This call to "progress" and "respectability," therefore, was meant to marshal the masses of the race into the regiments of the New Negroes who, of course,

would command them. And if "Zip Coon," "Sambo," and "Mammy" were the stereotyped figments of racist minds, just enough lingering doubt remained about black capacities for progress for Washington and his collaborators to structure a manifesto as much for the benefit of sensitive, intelligent, and wealthy whites as for the promotion of black self-identity.

Fannie Barrier Williams, writing in Crogman's 1902 edition of *Progress of a Race*, again in an essay called "Club Movement Among Colored Women," places the black woman at the center of the New Negro's philosophy of self-respect. "The Negro woman's club of today," she maintains, "represents the New Negro with new powers of self-help." Professor John Henry Adams, Jr. (*fig. 17*), in an essay in *Voice of the Negro* titled "Rough Sketches: A Study of the Features of the New Negro Woman" (*figs. 18-19*), concurred with Williams's assessment of the central role of the African-American woman in the New Negro movement and even went so far as to reproduce images of seven ideal New Negro women so that other women might pattern themselves after these prototypes. One photograph bears the following caption:

An admirer of Fine Art, a performer on the violin and the piano, a sweet singer, a writer — mostly given to essays, a lover of good books, and a home making girl, is Gussie.

Undaunted, two months later Adams published the male response to his earlier essay. "Rough Sketches: The New Negro Man" appeared in the October 1904 issue of *Voice of the Negro*. Again, Adams is eager to chart the unpainted features of this New Negro, but unlike the New Negro Woman, for whom Women's clubs were expected to fulfill both a social and political function, The New Negro Man found his identity through individual achievements in work and creative expression:

Here is the real new Negro man. Tall, erect, commanding, with a face as strong and expressive as Angelo's Moses and yet every whit as pleasing and handsome as Rubens's favorite model. There is that penetrative eye about which Charles Lamb wrote with such deep admiration, that broad forehead and firm chin. . . Such is the new Negro man, and he who finds the real man in the hope of deriving all the benefits to be got by acquaintance and contact does not run upon him by mere chance, but must go over the paths of some kind of biography, until he gets a reasonable understanding of what it actually costs of human effort to be a man and at the same time a Negro.

As he had done in his essay on the New Negro Woman, Adams prints seven portraits of the New Negro Man, so that readers might be able to recognize and emulate him (*figs. 20-21*).

Adams's stress on the "features" of the New Negro is important. While attempting to break with history Adams continues the tradition of drawing a correlation between the specific character-istics of individual depiction and the larger characteristics of a race. Because the features of African-Americans — mouth shape and lip size, the unique shape of the head (which especially concerned phrenologists), skin color, kinky hair — had been caricatured and stereotyped so severely in popular American art, black intellectuals seemed to feel that nothing less than a full face-lift could cause a complete break with associations of black enslavement and could begin to ameliorate the social conditions of the modern black American. While this concern with features

fig. 17 *Prof. John Henry Adams, Jr.*, of Morris Brown College. He is considered the rising Negro artist of the South. The *Atlanta Constitution* pronounces him "nothing short of a genius," and says that "he may some day startle the world with his paintings." *Voice of the Negro* (October 1904)

fig. 18 You cannot avoid the motion of this dignified counte-nance. College training makes her look so. "Rough Sketches: A Study of the Features of the New Negro Woman," *Voice of the Negro* (August 1904)

would suggest or imply concern with visual depictions, it was the precise structure and resonant cadences of the black voice which were to enunciate the new face by which African-Americans would be known and would finally be fundamentally recon-structed. First to develop and then to maintain this black voice, a virtual literary renaissance was called for.

This impulse is clearly announced in an essay printed in *The A. M. E. Church Review* in 1904. Incredibly, it is entitled "The New Negro Literary Movement," which until recently had been assumed to be a phrase first introduced into black letters in the 1920s. Citing the minutes of a literary club meeting of 1892, W. H. A. Moore quotes Anna J. Cooper (author of *A Voice from the South*, 1892) as demanding that "We must begin to give the character of beauty and power to the literary utterance of the race." This urge, Moore continues, finally assumed a form in the writings of Dunbar, Chestnutt, Du Bois, and others, which taken together constitute a literary movement, a movement of New Negro voices which could recreate the stereotypic figure of the black as Sambo. The metaphor of voice appears in Moore's first sentences:

The New Negro Literary Movement is not the note of a reawak-ening; it is a halting, stammering voice touched with sadness and the pathos of yearning. Unlike the Celtic revival it is not a potent influence in the literature of to-day; neither is it the spirit of an endeavor to recover the song that is lost or the motive of an aspiration to reclaim the soul-love that is dead. Somehow it can not be measured by the standard of great achievement; and yet it possesses an air of distinction and speaks in the language of promise. It is the culminating expression of a heart growth the most strange and attractive in American life. To most of us it is as oddly familiar as though it breathed and spoke in the jungle of its forebearers.

In this new Negro voice, Moore concludes, a voice epitomized by Du Bois's *The Souls of Black Folk* (1903), "we are going a long way in the direction of reaching a true understanding of the highest precept and purpose of the final democracy."

What a curious phrase, "the final democracy"! This final stage of democracy could be realized only by registering the cadences of the black literary voice. This idea has a long and intricate history in black letters; W. H. A. Moore received it from ideas enumerated by writers such as E. Fortune, Jr., who published an essay on "The Importance of Literature: Its Influence on the Progress of Nations" (1883), and in turn found his ideas echoed in essays such as a *New York Age* editorial entitled "Dearth of Afro-American Writers" (1905), in which T. Thomas Fortune argued that "the capacity of a race is largely measured by the achievements of its writers, in whom its natural vigor and perspicuity of intellect, its highest moral revelations and its most delicate and beautiful emotions should reach consummation." These two statements reflect only a small sampling of this sentiment. A New Negro would signify his presence in the arts, and this impulse would lead to the New Negro Renaissance of the 1920s.

The trope of the New Negro did not disappear between 1904 and the 1920s, when it resurfaced as the sign of the literary movement that contained the new black voice. Ray Stannard Baker outlined his idea of the New Negro in *Following the Color Line* (1908). Late in that same year, S. Laing Williams published

his formulation of the shape of the New Negro in *Alexander's Magazine*. Leslie Pinckney Hill defined the New Negro in an essay called "Race Ideals" (1913), published in the *Journal of Race Development*. William Pickens published a book of essays entitled *The New Negro* (1916), and two years later *The "New Negro" Magazine*, edited by August Valentine Berneir, made its brief appearance. Between January 24, 1920, and March 20, 1920, *New York Age* published an open forum entitled "The New Negro – What is He? Does the New Negro Differ from the Negro of the Past?" In the *Messenger* of December 1919, A. Phillip Randolph published an essay entitled "The New Philosophy of the [New] Negro," followed in 1920 by three more essays with similar titles. Randolph's view of the new Negro is best summarized in his August 1920 statement that the New Negro's "social methods are: education and physical action in self-defense. That education must constitute the basis of all action, is beyond the realm of question. And to fight back in self-defense, should be accepted as a matter of course. No one who will not fight to protect his life is fit to live." Randolph's New Negro was a militant, card-carrying, gun-toting socialist, who refused to turn the other cheek. For W. A. Domingo, writing three months later in an essay entitled "A New Negro and a New Day," a New Negro was he or she who realized that "Labor is the common denominator of the working class of the world. Exploitation . . . [is] the common denominator of oppression everywhere." A New Negro is he or she who has "grievances against those who profit from the present system which operates against the interests of all workers." A New Negro, finally, is she or he who "speaks the language of the oppressed" to defy the "language of the oppressor."

This ideal differs remarkably from the image of the New Negro espoused by Booker T. Washington at the end of the nineteenth century. Just as Randolph feared, the militancy of the reconstructed image of his figure of the New Negro was both too potent to be acceptable to white intellectuals and too problematical to dominate the black intelligentsia. In 1925 Alain Locke edited a special number of *Survey Graphic*, entitled *Harlem: Mecca of the New Negro*, which served both to codify and to launch a second New Negro literary movement. But Locke's New Negro served even more than this: it transformed black militancy and translated it into an apolitical movement within the arts. Locke's New Negro was a poet, and it was through the sublimities of the fine arts, not through political action or protest, that white Americans would at last embrace the Negro. Locke's New Negro was ahistorical, a Negro who was "just like" every other American, a Negro more deserving than the Old Negro because he had been reconstructed as an entity somehow "new." Locke could well have quoted S. Laing Williams's 1908 essay on "The New Negro" to express the relation between the Negro scholar's obsession with the interconnected perceptions of his reconstructed image and the failure of Reconstruction. Standing between these extremes was the remarkably complex and problematic figure of the New Negro:

The ignorant, uncivilized and empty-handed man of 1865 has become a man of culture, a man of force and a man of independence. We shall have to look to this man to complete the great work of reconstruction.

In 1925, Heywood Broun told a New York Urban League audi-

fig. 19 An admirer of Fine Art, a performer on the violin and the piano, a sweet singer, a writer mostly given to essays, a lover of good books, and a home making girl, is Gussie. "Rough Sketches: A Study of the Features of the New Negro Woman," *Voice of the Negro* (August 1904)

fig.20 Charles L. Harper, A.B. Mr. Harper is one of the strong young men in the government service of Atlanta. He is paving the way for himself for higher things in life. "Rough Sketches: The New Negro Man," *Voice of the Negro* (October 1904)

ence that "a supremely great Negro artist, who could catch the imagination of the world, would do more than any other agency to remove the disabilities against which the Negro now labors." Broun concluded by saying that this artist-redeemer could come at any time and asked his audience to remain silent for ten full seconds to imagine his coming! In response to a seemingly rigid and fixed set of racist representations of the black as the ultimate negated "Other" – as all that white culture feared about its "nether" side – black writers attempted to rewrite the established texts that were used by others to define their lives. Well before 1925, blacks were indeed the "already read text" that Barbara Johnson has defined as a stereotype. Locke and his followers, appropriating the New Negro from the radical black socialists, supplanted the militant content of that image with their own emphasis on creative fulfillment. They sought not only to rewrite the term black, they also sought to rephrase and recast perceptions created in texts by white authors. However, the New Negroes of the Harlem Renaissance sought to erase their image by conforming to the conventions of the Western tradition. By doing so, they erased or ignored much of the best of their cultural unique-ness, imitating instead literary forms and mannerisms that they often least resembled in a frustrating effort to demonstrate the full intellectual potential of the black mind.

Sadly, there was no new world a-coming, as Alain Locke so ardently hoped. The movement of black Americans looked not, as Countee Cullen would have it, to *The Song of the Lark* but toward *The Waste Land*, as prefigured in the voice of Bessie Smith. Locke remained a radical Reconstructionist, believing that while the Negro's

greatest rehabilitation may possibly come through such channels [as Garveyism] . . . for the present, more immediate hope rests in the revaluation by white and black alike of the Negro in terms of his artistic endowments and cultural contributions, past and prospective.

Locke's intention in editing *The New Negro* is most clearly stated by James Weldon Johnson. "Black writers," he wrote, "are helping to bring about an entirely new conception of the Negro, are helping to place him in an entirely new light before himself. They have helped to change many of the connotations of the very word 'Negro.'"

Despite its stated premises, the New Negro movement remained polemical and propagandistic, aiming its message of reconstruction both within and outside of the black community. While claiming to be above and beyond protest and politics, the New Negro movement sought nothing less than to reconstruct the very idea of who and what a Negro was, or could be. Claiming that as cultured, upper-class men and women they represented the best potential of the black community, these intellectuals imitated such non-native forms as Anglo-American poetry, "translating," as they put it, the art of untutored folk into a "higher," more formally standard mode of English expression that was deemed more compatible with Western traditions than vernacular forms. Declaring that they had realized an unprece-dented level of Negro self-expression, black intellectuals created a body of literature which even the most optimistic historians now find sadly academic when compared to blues and jazz composi-tions by such figures as Bessie Smith and Duke Ellington, to name

fig. 21 *Dr. J. D. Hamilton.* Much has been added to the dental
profession of Atlanta, in the person of Dr. Hamilton. He is rather
socially inclined, but he knows the value of "sticking to busi-
ness." His office shows the enterprise of the new Negro man.
"Rough Sketches: The New Negro Man," *Voice of the Negro*
(October 1904)

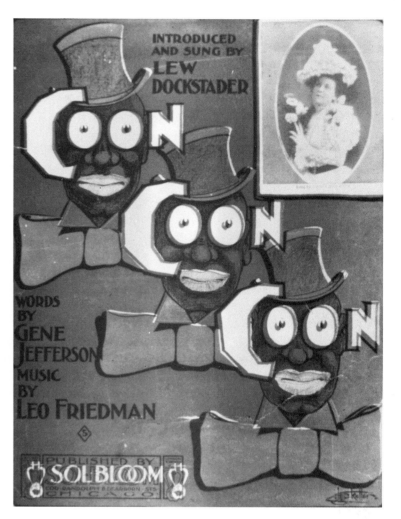

fig. 22 *Coon, Coon, Coon,* 1901. Sheet music illustration.
Published by Sol Bloom, Chicago. Collection of Brooke Baldwin

but two of the most brilliant black artists who were not often invited to perform in the salons of the New Negro. For all of the energetic optimism with which black intellectuals promoted the idealization of the New Negro, neither the visual images propagated by whites nor the literary counterattacks of the black elite finally realized a profound reconfiguring of the image of the black American. Rather, the creators of blues and jazz, whose works of art were most often subsidized not by the black intelligentsia but by their working-class counterparts, helped shape a new definition of blackness suited to the quickening pace of a new era.

The visual essay that the works in this book comprise helps us to understand why black intellectuals rejected the premise of visually structuring a black identity, and why the idea of a New Negro fulfilled so many of their yearnings, and eventually came to be the embodiment of the stereotype of "reconstruction." Simply put, the extent to which black people have been stereotyped in the visual arts of this country is remarkable (*figs. 22-24*). By 1900, when Booker T. Washington called for *A New Negro for a New Century*, it was possible for a middle-class white American to see Sambo images everywhere he or she looked – from toaster and teapot covers on breakfast tables, to advertisements in magazines, to popular postcards in drug stores – and all of these images were negative. One of the ironies of the New Negro is that words, not the tactics of visual representation, were the tools blacks used to assert their self-image. Until the 1920s there was virtually no black counterpoint to the hegemony of racist visual images that dominated the popular arts and more subtly infiltrated the fine arts. And as long as the decorative mediums of painting and sculpture remained inherently conservative in their positive or negative configurations of black identity, a career in the fine arts remained an extremely tenuous proposition for a black man or woman (*fig. 25*).

Henry Louis Gates, Jr., is W. E. B. Du Bois Professor of Literature at Cornell University.

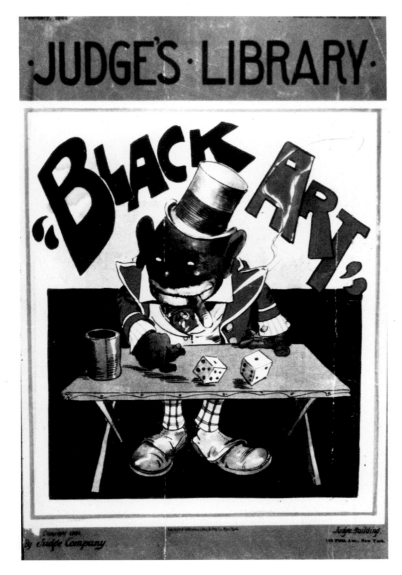

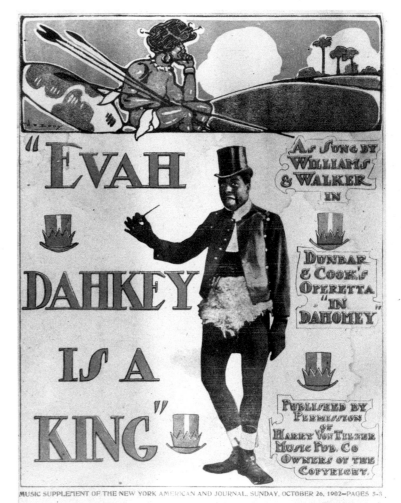

fig. 23 *Black Art*, 1901. Magazine cover illustration. *Judges Library* (February 1901). Collection of Brooke Baldwin

fig. 24 *"Evah Dahkey Is a King,"* 1902. Sheet music illustration. Published by Harry Von Tilter, Music Publishing Company. Collection of Brooke Baldwin

fig. 25 Jacob Lawrence, Excerpts from the *Frederick Douglass Series*, 1938-1939.

Part 1, The Slave, No. 10. Casein on hardboard, 17⅞ × 12. Hampton University Museum, Hampton, Virginia. The master of Douglass, seeing he was of a rebellious nature, sent him to a Mr. Covey, a man who had built up a reputation as a "nigger breaker." A second attempt to flog Douglass by Covey was unsuccessful. This was one of the most important incidents in the life of Frederick Douglass: he was never attacked again by Covey. His philosophy: a slave easily flogged is flogged oftener; a slave who resists flogging is flogged less.

Part II, The Free Man, No. 30. Casein on hardboard, 17⅞ × 12. Hampton University Museum, Hampton, Virginia. An appointment to any important and lucrative office under the United States Government usually brings its recipient a large measure of praise and congratulations on the one hand and much abuse and discouragement on the other. With these two conditions prevailing, Frederick Douglass was appointed by President Rutherford B. Hayes, United States Marshall of the District of Columbia, 1877.

Checklist of Illustrations

Justus Engelhardt Kühn, *Henry Darnall III as a Child*, ca. 1710

John Singleton Copley, *Head of a Negro*, 1777-1778. *Watson and the Shark*, 1778

Samuel Jennings, *Liberty Displaying the Arts and Sciences*, 1792

Unknown Artist, *Flora*, 1796

Joshua Johnson, *Portrait of a Man*, ca. 1805-1810

Charles Zechel, *Portrait of a Negro Girl*, n.d. *Portrait of a Negro Boy*, 1807

John Lewis Krimmel, *Quilting Frolic*, 1813

Francis Guy, *Winter Scene in Brooklyn*, ca. 1817-1820

David Claypoole Johnston, *Bee Catching*, ca. 1818

Robert Street, *Children of Commodore John Daniel Danels*, ca. 1826

William Sidney Mount, *Rustic Dance After a Sleigh Ride*, 1830. *Farmers Nooning*, 1836. *Eel Spearing at Setauket*, 1845. *The Bone Player*, 1856. Preliminary sketch for *Politically Dead*, ca. 1867

John Quidor, *The Money Diggers*, 1832

Charles Deas, *The Turkey Shoot*, 1836. *The Devil and Tom Walker*, 1838

Edward Troye, *Richard Singleton*, ca. 1835

Attributed to Charles Winter, *Minstrel Show*, ca. 1830s-1840s

William Matthew Prior, *William Whipper*, 1835. *Three Sisters of the Coplan Family*, 1854

Christian Mayr, *Kitchen Ball at White Sulphur Springs*, 1838

Nathaniel Jocelyn, *Cinque*, 1839

Nicolino Calyo, *Negro Dancer and Banjo Player*, 1835. *George Cousin, The Patent Chimney Sweep Cleaner*, 1840-1844. *The Hot Corn Seller*, 1840-1844

James Goodwyn Clonney, *Militia Training*, 1841. *Waking Up*, 1851. Drawing for *In the Woodshed*, ca. 1838. Drawing for *In the Cornfield*, ca. 1844

John William Hill, *View of Richmond*, 1847

Richard Caton Woodville, *Old '76 and Young '48*, 1849

Eyre Crowe, *Slave Market in Richmond, Virginia*, 1852-1853

Robert Scott Duncanson, *Uncle Tom and Little Eva*, 1853

Francis William Edmonds, *All Talk and No Work*, 1855-1856

Thomas Waterman Wood, *Moses, the Baltimore News Vendor*, 1858. *Market Woman*, 1858. *American Citizens (To the Polls)*, 1867

John Antrobus, *Plantation Burial*, 1860

Lilly Martin Spencer, *Dixie Land*, 1862

John Quincy Adams Ward, *The Freedman*, 1863

Eastman Johnson, *The Ride for Liberty – The Fugitive Slaves*, ca. 1862. *Fiddling His Way*, 1866

Thomas Sully, *Daniel Dashiel Warner*, ca. 1864. *Edward James Roye*, 1864

John Rogers, *The Wounded Scout, Friend in the Swamp*, 1864. *The Fugitive's Story*, 1869

Edwin Forbes, *Contrabands Escaping*, 1864. *Mess Boy Asleep*, 1867

Thomas Nast, *Entrance of the Fifth-fifth Massachusetts (Colored) Regiment into Charleston, South Carolina, February 21, 1865*, 1865

Thomas Hovenden, *Ain't That Ripe?*, ca. 1865

Attributed to David Norslup, *Negro Boys on the Quayside*, ca. 1865

Thomas Ball, *Emancipation Group*, 1865

Thomas Satterwhite Noble, *Margaret Garner*, 1867. *The Price of Blood*, 1868. *The Last Sale of Slaves in Saint Louis*, 1870

Mary Edmonia Lewis, *Forever Free*, 1867

Theodor Kaufmann, *On to Liberty*, 1867. *Portrait of Hiram R. Revels*, ca. 1870

Edward Mitchell Bannister, *Newspaper Boy*, 1869

William Henry Holmes, *Free Enterprise and the Law*, ca. 1871

Alfred R. Waud, *Sunday Cockfighting, New Orleans*, ca. 1871. *The Bug Man at Pine Bluff, Arkansas*, ca. 1871

Winslow Homer, *Busy Bee*, 1875. *A Visit from the Old Mistress*, 1876. *The Watermelon Boys*, 1876. *Dressing for the Carnival*, 1877. *Upland Cotton*, 1879-1895

Thomas Eakins, *Will Schuster and Blackman Going Shooting (Rail Shooting)*, 1876. *The Poleman in the Ma'sh*, ca. 1881. *Negress*, ca. 1900

William Harnett, *Attention, Company!*, 1878

Horace Bonham, *Nearing the Issue at the Cockpit*, 1878

Thomas Anshutz, *The Way They Live*, 1879. *The Chore*, ca. 1880

Richard Norris Brooke, *A Pastoral Visit*, 1881

William Aiken Walker, *Plantation Economy in the Old South*, ca. 1876

John George Brown, *The Card Trick*, 1880s

Augustus Saint-Gaudens, *Head of a Young Man*/Study for a
 soldier in *The Shaw Memorial*, ca. 1884-1897
Joseph Decker, *Our Gang*, 1886
Edward Lamson Henry, *Kept In*, 1888
Frederic Remington, *Captain Dodge's Colored Troopers to the
 Rescue*, ca. 1890. *Leaving the Canyon*, ca. 1894
Charles T. Webber, *The Underground Railroad*, 1891 or 1893
Henry Ossawa Tanner, *The Banjo Lesson*, 1893
Harry Roseland, *Wake Up, Dad*, ca. 1896
Edward Potthast, *Brother Sims's Mistake*, 1899
Arthur Burdett Frost, *Stan' Up!*, 1905
George Wesley Bellows, *Both Members of This Club*, 1909
Robert Lee MacCameron, *New Orleans Darkey*, ca. 1910
Robert Henri, *The Failure of Sylvester*, 1914
John Sloan, *Artist's Model*, n.d.
Charles Demuth, *Negro Jazz Band*, 1916
John Singer Sargent, *Nude Study of Thomas McKeller*, 1917.
 Standing Male Nude, Orpheus, 1917-1920
Wayman Adams, *New Orleans Mammy*, ca. 1920
John Steuart Curry, *Head of a Negro*, 1927. *The Mississippi*, 1935
Andrée Ruellan, *Black Youth*, 1929
James Chapin, *Ruby Green Singing*, 1928
Edward Kemble, *Black Man with Pipe*, 1929
Augusta Savage, *Gamin*, 1930
Charles Burchfield, *Souvenir of South Carolina*, 1930
Reginald Marsh, *Tuesday Night at the Savoy Ballroom*, 1930.
 Negroes on Rockaway Beach, 1934
Sargent Johnson, *Forever Free*, 1933
Thomas Hart Benton, *Ploughing It Under*, 1934
Paul Cadmus, *To the Lynching!*, 1935
Archibald J. Motley, Jr., *Barbecue*, ca. 1935
Ben Shahn, *Willis Avenue Bridge*, 1940
Jacob Lawrence, *No. 1 During the World War there was a great
 Migration North by Southern Negroes, The Migration of the
 Negro* Series, 1940-1941. *No. 3 In every town Negroes were
 leaving by the hundreds to go North to enter into Northern
 industry, The Migration of the Negro* Series, 1940-1941.
 Ironers, 1943

Note to the Reader

Measurements of the artworks are provided throughout in inches, followed by centimeters in parentheses. Height precedes width, which precedes depth.

Entries have been arranged chronologically by the dates of the works of art. Exceptions to this chronology are artists represented by more than one work; their artworks are juxtaposed chronologically to show the progression of ideas throughout an artist's career. Entries have been compiled by Janet Levine, Guy C. McElroy, Francis Martin, Jr., and Claudia Vess. Initials at the end of each entry identify authorship.

The following paintings have been included in this book but are not part of the exhibition:
George Wesley Bellows, *Both Members of This Club*
Winslow Homer, *A Visit from the Old Mistress*
Nathaniel Jocelyn, *Cinque*
Jacob Lawrence, *Ironers*
William Sidney Mount, *Rustic Dance After a Sleigh Ride* and *Eel Spearing at
 Setauket*
John Rogers, *The Fugitive's Story*
John Singer Sargent, *Nude Study of Thomas McKeller*
Henry Ossawa Tanner, *The Banjo Lesson*

Facing History

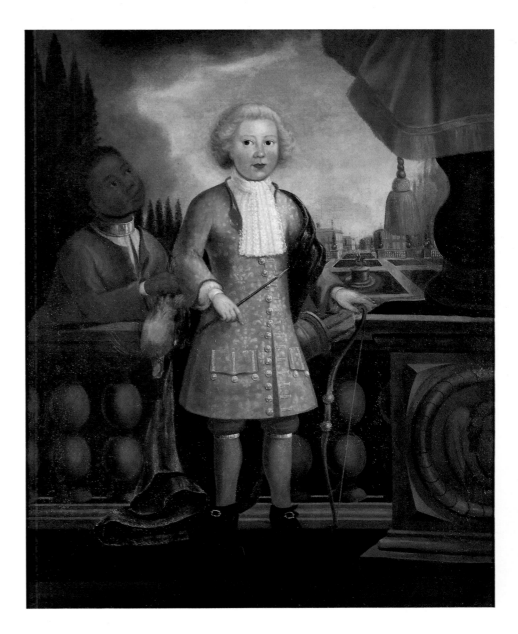

Justus Engelhardt Kühn 16??-1717

Justus Engelhardt Kühn was a native of Germany; his name first appears in the American colonies in a 1708 application for naturalization filed in Annapolis the year the city was chartered. Kühn was active in Annapolis from 1708 to 1717, and his stiffly formal interpretation of European grand portraiture attracted a steady clientele of successful immigrants seeking to memorialize their status and wealth.

Henry Darnall III as a Child, ca. 1710
Oil on canvas, 54¼ × 44¼ (137.8 × 112.4). Unsigned. The Maryland Historical Society. Bequest of Miss Ellen C. Daingerfield

Henry Darnall III as a Child is a study in class and race that reflects the pretensions of affluent colonists in the developing landed aristocracy. Henry Darnall is dressed in a brocaded coat and lace scarf, jewelled platform shoes and a cape of lush fabric — finery that befits his wealth and status. Adopting the conventions of the international baroque to satisfy the need of his clientele to see themselves as transplanted European gentry, Kühn used costume, physical accoutrements, and the palatial dwellings that serve as a backdrop to suggest a wealth that was in fact rarely seen in eighteenth century America.

Kühn's painting is the earliest known depiction of an African-American subject in American painting. Well-dressed, but marked by a silver collar symbolic of servitude, the attendant is a necessary detail in the artist's account of his sitter's status. Kneeling in a position of obeisance, he holds a bird that his master has apparently felled with his bow. His humble expression, inferior position within the composition, and the obvious disparity in rank vividly illustrate the chasm that existed between the landed white aristocracy and the African-Americans whose enforced servitude allowed this system to flourish.

G.C.M.

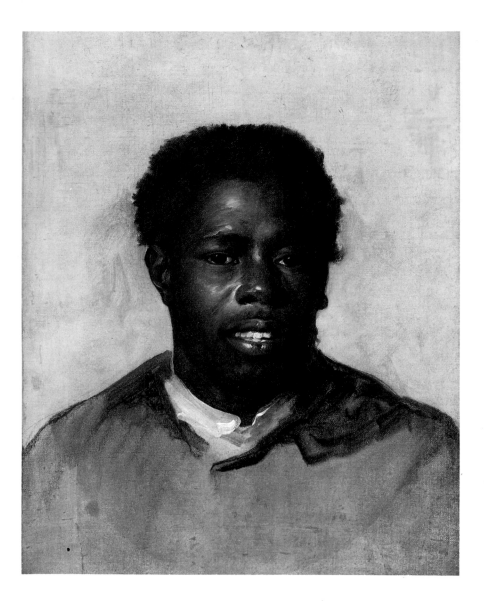

John Singleton Copley 1738-1815

John Singleton Copley was born in Boston to Irish émigrés. Following the death of his father in 1748, his mother married Peter Pelham, an engraver, portraitist, and school teacher; Pelham's example undoubtedly influenced Copley's decision to pursue a career as an artist. As a young man he worked as a professional painter and engraver, and his exceptional skill at portraiture resulted in numerous commissions that earned him a reputation as the most distinguished painter of colonial America.

In 1765 Copley submitted *Boy with a Squirrel* to the Royal Academy in London. This portrait of his half-brother Henry Pelham won overwhelmingly positive acclaim, including praise from Sir Joshua Reynolds and the American expatriate Benjamin West. Copley had married Susanna Farnham Clarke, the daughter of one of the leading tea importers in Boston; the Clarke family was strongly shaken by the vehement outrage directed at them in the escalating social unrest that culminated in the Boston Tea Party (1773). Copley and his relatives fled Boston the following year, eventually traveling to London.

English nobility quickly sought Copley out for portrait commissions that were distinguished by their rich, subtly contrasting coloration and skillfully structured forms. Despite his success as a portrait painter, however, Copley was intent on following the example of Benjamin West, whose large-scale historical paintings had won him the title of History Painter to the King of England. He devoted considerable energy to dramatic contemporary subjects that he could invest with the pathos, melodrama, and high moral purpose accorded history painting by academic theorists, and he found a willing subject in a prominent merchant and Tory leader, Brook Watson.

Copley and Watson chose an experience from Watson's youth as an appropriate message-bearer for an allegorical subtext concerning the evils that would arise from the dismemberment of the British Empire. *Watson and the Shark* established Copley's reputation for artistic excellence and innovation, and he seemed personally drawn to the image, painting two other versions, one of which remained in his possession until his death. Subsequent works, such as *The Death of the Earl of Chatham* (1779-1780) and *The Death of Major Pierson* (1783-1784), confirmed his preeminence as a painter of historical subjects. Exhibition fees and sales of engraved reproductions of these works broadened his artistic reputation and made Copley a wealthy man. However, unlike West or Reynolds, who maintained large ateliers run by a host of students and apprentices, Copley accepted no students or apprentices. As a result, his style of historical allegory did not influence the developing aesthetics of younger American artists, with the notable exception of John Trumbull.

Head of a Negro, 1777-1778
Oil on canvas, 21 × 16 ¼ (53.3 × 41.3). Unsigned. The Detroit Institute of Arts. Founders Society Purchase, Gibbs-Williams Fund

The influence of Rubens is clearly evident in the romantic tones of this expressively painted portrait. Copley painted the study during the same period he completed *Watson and the Shark*; the model for this study and the black man who appears in the lifeboat in *Watson* may have been the same person. Copley's ingenuous portrait ranks with Reynolds's *Study of a Black Man* (1770) in the way its completely self-assured execution meshes with the portrayal of a black individual. Like Reynolds, Copley chose subjects that followed traditions established by Rubens and Rembrandt in their consideration of the exoticism and unique picturesqueness of the African. *Head of a Negro* remained with other items in the artist's studio until 1864, when it was sold at auction; at the time of sale it was identified as: "*Head of a Favorite Negro*. Very fine. Introduced in the picture of 'The Boy Saved from the Shark.'" The sale title intimates that Copley was quite familiar with his subject, who may possibly have been a servant from the Copley household. While the difference in appearance between this portrait and the black figure in *Watson* may be attributed to the dramatic expression necessary for Copley's operatic historical composition, no single explanation satisfactorily accounts for the rather pronounced differences in appearance in *Watson* and *Head of a Negro*.

Watson and the Shark, 1778

Oil on canvas, 71¾ × 90½ (182.1 × 229.7). Inscribed inside the stern of the skiff: *J. S. Copley P, 1778*. National Gallery of Art, Washington, D.C. Ferdinand Lammot Belin Fund

The unidentified black man in *Watson and the Shark* remains justly celebrated as one of the most eloquent portrayals of an African-American by an American artist. Brook Watson was a wealthy merchant and Tory leader whose business interests were strongly connected to the slave trade. A sizable amount of his income was derived from exchanging remaindered lots of broken salted fish at Caribbean markets in exchange for rum. Considered unfit for general consumption, the broken fish was used by slavers to feed slaves awaiting sale or shippage. Copley's painting recreated an event in Watson's youth: while swimming in Havana Harbor in 1749, he was repeatedly attacked by a shark, an assault that cost him his leg.

Copley's inclusion of political motifs as a subtext for an event in Watson's life experiences was not coincidental. After the onset of revolution Copley strenuously claimed political neutrality; however, his marriage into the Clarke family – one of the leading tea importers in the Boston area – and the impact of the pointed activism of the Boston Tea Party sufficiently moved him to break permanently with his native country in favor of England. The subject matter of Watson's youthful indiscretion was meant to serve as a moral warning to colonial activists in America and Whig opponents in England who favored freedom for the white colonists while approving or tolerating the practice of slavery.

After viewing Copley's preparatory drawings for *Watson and the Shark*, which contained a white figure in the position now occupied by the African-American, Watson may have specified that a black figure occupy the central location. Absorbed in the drama of the scene after accomplishing the task of throwing a line to the helpless Watson, this figure clearly fulfills an emblematic role that activates Copley's operatic design, acting, as the historian Hugh Honour has noted, as a self-contained "Greek chorus"

for Watson's travails. This anonymous man is linked to Watson by the literal device of a rope and by the subliminal echo between Watson's upraised arm and the mirror image of the outstretched arm of the black man. Literally and metaphorically, the two figures mirror each other.

Watson's desire to include a black man in such a pivotal position in the composition precisely served the allegory he wished to illustrate. As Albert Boime has established, the triangle among shark, slave, and trader allowed Copley to set in motion a complicated group of highly nuanced metaphors. By placing Watson at the bottom of the composition in a position of risk and inserting a black figure in accordance with Watson's request for "accuracy," Copley has inverted the pyramidal social order that placed wealthy white men on the top and indentured blacks on the bottom. Slaves who died en route to the Americas were routinely "thrown to the sharks"; in a few gruesome cases dead slaves were used to bait sharks when foodstocks ran low. In a stunning reversal of roles, the white man, not the black, is in the water with the sharks; in Watson's polemic of mutual dependency, the black man serves as his silent *doppleganger*. *Watson and the Shark* also plays on images of dismemberment that were routinely employed by artists to warn of the loss of power that would result from the impending revolt of colonial territories from the British empire. A succinct reference to the loss of trade that would follow colonial independence can be found in Watson's severed leg.

The black figure is, like the other figures in Copley's composition, an overdressed player in an allegorical set piece. More important, however, he is a multi-dimensional individual who shares causal equality with a white man. In a stunning innovation that would not be fully repeated until the paintings of Winslow Homer, Copley's black figure does not exist to provide the set dressing that establishes material wealth or a particularly American setting but acts instead as an integral component of a dialogue that encompasses political intrigue, business practice, and even the psychological identity of individuals within a historical life-and-death context.

G.C.M.

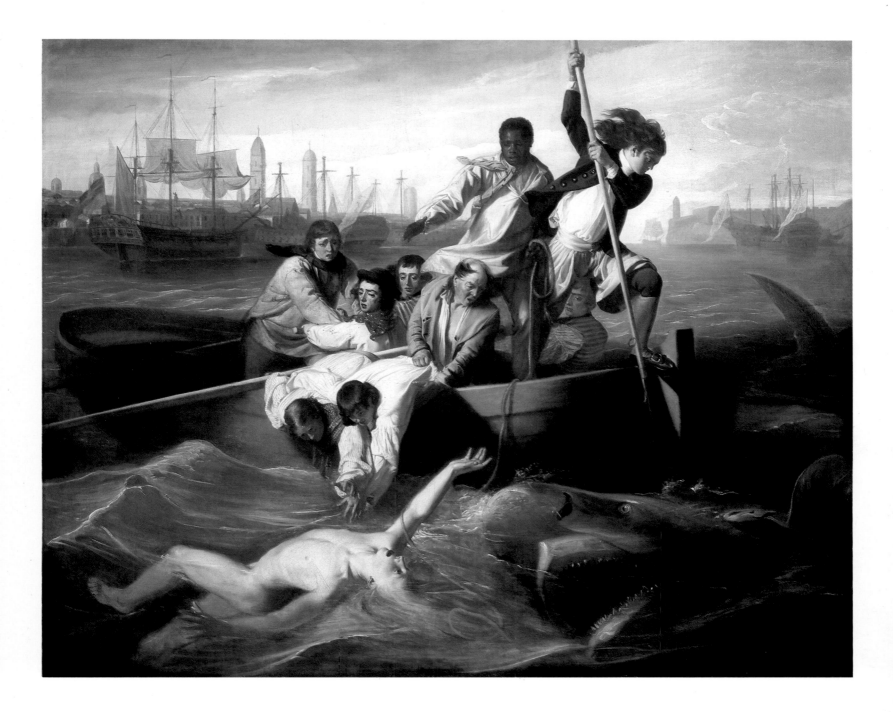

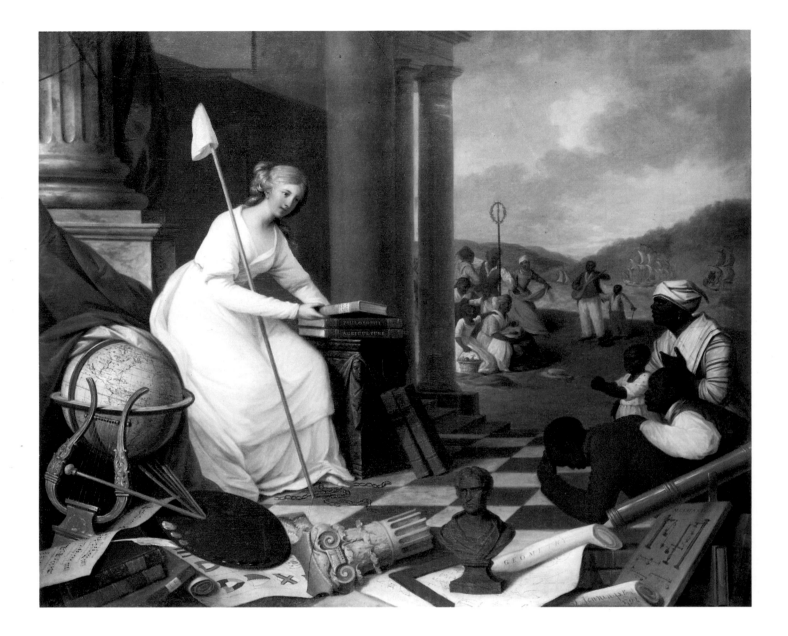

Samuel Jennings ca. 1755–after 1834

Samuel Jennings executed this country's first history painting on an abolitionist theme. Born in Philadelphia, a highly vocal center for abolitionists, he was introduced early in life to the issue of black freedom through his association with the Philadelphia Society of Friends. Jennings attended the University of Pennsylvania and was active as a painter of miniatures, portraits, and allegorical works. At the end of the 1780s Jennings moved to London to pursue further artistic studies; by 1789 he was exhibiting at the Royal Academy and the British Institution. Jennings remained active in England through 1834; although the details of his later history are unclear, he probably never returned to the United States.

Liberty Displaying the Arts and Sciences, 1792
Oil on canvas, 60¼ × 73⅛ (153 × 185.4). Inscribed on a roll of paper, lower right: *S. Jennings Pinxt 1792*. Library Company of Philadelphia

Jennings conceived *Liberty Displaying the Arts and Sciences* in 1790, when the Free Library of Philadelphia began building a new library. He proposed an instructive moral composition that he thought suitable for the noble aspirations of the Free Library: a symbolic representation featuring either Clio, Calliope, or Minerva. Responding to his proposal, the Committee of the Library Company specifically requested that he portray the Goddess of Liberty displaying the symbolic emblems of the arts for a group of free black Americans, who would appear "resting on the earth or in some attitude expressive of ease and joy." The motivation for these strong abolitionist sentiments undoubtedly came from the Library Company's membership, which counted such notable individuals as Benjamin Franklin as founding members.

In Jennings's painting the Library Company members found a means of affirming their patriotism while symbolically restating their strong distaste for the practice of slavery in America. Depicted as a white noblewoman clothed in contemporary rather than Greco-Roman dress, Liberty is seated before a classical facade, surrounded by symbols of the arts and sciences and some of the notable texts of modern literature. Across her shoulder rests a pole that displays a Liberty cap. Flanked by volumes labeled "Agriculture" and "Philosophy," she holds a text identifiable as the catalogue of the Free Library. Beneath her feet lies a severed chain that demonstrates her opposition to slavery. Resting on the floor before her among these attributes is a classical bust that appears to display the likeness of Henry Thornton, a well-known abolitionist leader of the period.

The gestures of gratitude on the faces of the freed slaves kneeling to the front right of Liberty suggest the happiness with which they anticipate access to the full life of free citizens. In the middle distance of an allegorical landscape Jennings has placed a group of blacks who have erected a Liberty Pole, while in the far distance boats suggest the everyday concerns of commerce. In spite of the well-intentioned benevolence of Jennings's composition, *Liberty Displaying the Arts and Sciences* avoids presenting images that describe individual black people. Nor does it suggest the capacity of blacks for defining their own destinies. Jennings's idealized heraldic scheme flies in the face of the severely restricted rights and debilitating working conditions that confronted most African-Americans in the new nation.
G.C.M.

Unknown Artist

The artist who created this haunting image was probably untrained; the drawing, sketched to accompany a bill of sale for a slave transaction (perhaps for Flora herself) appears to be a drawing or a silhouette traced from a candle shadow and shaded with ink.

Flora, 1796
Silhouette, cut-paper and brown ink with bill of sale, 14 × 13 (35.56 × 33). Unsigned. The Stratford, Connecticut, Historical Society

Little is known regarding this mysterious profile drawing. According to a bill of sale dated 1796, Margaret Dwight of Milford in the County of New Haven and State of Connecticut sold Flora, a nineteen-year-old slave, to Asa Benjamin of Stratford in Fairfield County, Connecticut, for the sum of twenty-five pounds sterling. An account book kept by a relative of Mrs. Benjamin records Flora's death on "31 August" in a list of "people who died in 1815."
J.L.

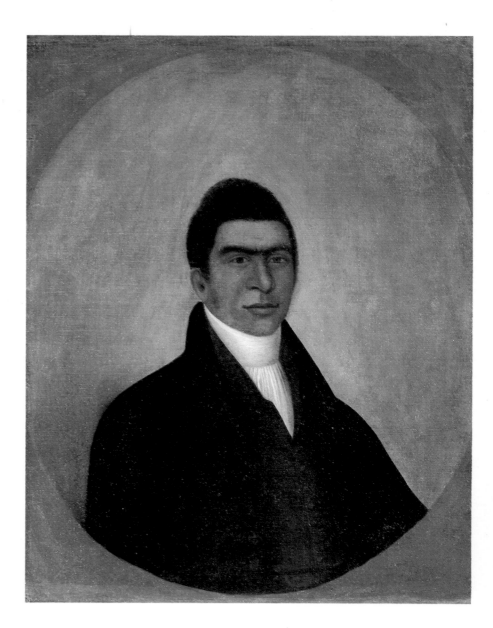

Joshua Johnson ca. 1770–after 1825

Listed in the 1816 Baltimore city directory as a "free householder of Colour," Joshua Johnson was the first black artist to gain prominence in America. He is believed to have immigrated from the West Indies; by 1798 he was advertising his skills as a "self-taught genius" in the *Baltimore Intelligencer*. Johnson's close ties to Baltimore abolitionists probably helped him attract a wide range of patronage. From the late 1790s through the first quarter of the nineteenth century he produced competent likenesses of a diverse sampling of Baltimore's middle classes that included merchants, military leaders, businessmen, and seamen. Although he advertised himself as self-taught, it is likely that he studied the paintings of Charles Peale Polk, Rembrandt Peale, and Charles Willson Peale; these painters were active in Baltimore during the 1790s and displayed their work at the Peale Museum, located near Johnson's residence at Hanover and German streets.

Portrait of a Man, ca. 1805–1810
Oil on canvas, 28 × 22 (71.1 × 55.8). Unsigned. Bowdoin College Museum of Art, Brunswick, Maine

Johnson's flat, limnerlike portraits usually present his sitters in three-quarters or half-length poses in front of backgrounds of drapery or idealized landscapes framed by windows. Meticulous attention is paid to lace, buttons, and jewelry and to identifying attributes such as books or work implements. Highly geometric oval faces, almond eyes, and the articulation of form through layers of thinly applied pigment are also characteristics of his style. *Portrait of a Man* is one of only two surviving portraits of blacks by Johnson. The unidentified subject was originally believed to be a Baltimore clergyman because his high collar suggests religious service, but the high collar is now believed to have been widely fashionable in Johnson's day. Nineteenth century Baltimore sustained a thriving black middle class, and the lack of a successor to Johnson can probably be traced to the rise of Black Codes, progressively restrictive economic limitations placed on blacks in many American cities as early as the 1820s.
G.C.M.

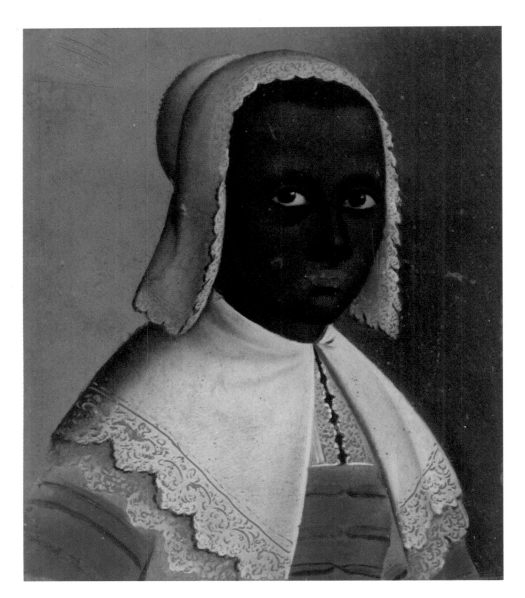

Charles Zechel dates unknown

The tradition of miniature painting was firmly established by the founding of the American republic. Often working as traveling artisans, the earliest portrait painters were largely untrained, and most remain anonymous. They found a ready audience for their painted mementos until about 1850, when the camera made family portraits accessible to virtually every segment of American society. Throughout the first half of the nineteenth century, however, families often commissioned group or single portraits of their children and spouses, much as contemporary families sit for group or individual portrait photographs. Portraits were also an important part of household decoration, serving as important symbols of middle-class achievement and status. The most common and least expensive forms of portrait miniatures were silhouettes made of cut paper or painted with color on paper.

Other, more skilled artists specialized in full-face watercolor portraits. The most costly miniatures were painted in watercolor on ivory; these were most often framed in gold lockets and worn on neck chains or placed in cases and displayed in the home.

Portrait of a Negro Girl, n.d.
Oil on glass, 3¾ × 3 (9.1 × 7.6). Unsigned. The Art Museum, Princeton University. Gift of Mrs. Gerald Wilkinson

Portrait of a Negro Boy, 1807
Oil on glass, 3¾ × 3 (9.1 × 7.6). Signed on backing paper: *Carolus Zechel/Anno 1807.* The Art Museum, Princeton University. Gift of Mrs. Gerald Wilkinson

Portrait of a Negro Boy bears the name of Carolus Zechel and a date of 1807. While this name is of little value other than as an attribution, the artist displayed considerable skill in naturalistically rendering the features of his sitters. His emphasis on bright colors and attention to decorative detail, particularly in the elegant lace collar and buttoned yoke of the girl in *Portrait of a Negro Girl,* reflects an interest in the detail associated with folk art traditions.
J.L.

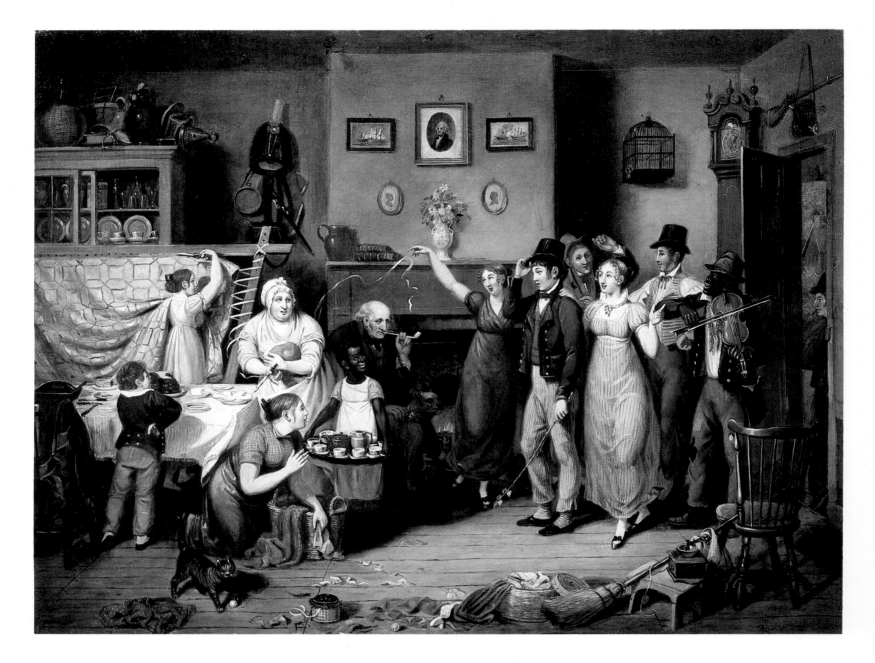

John Lewis Krimmel 1786-1821

Born in Ebingen, Germany, John Lewis Krimmel studied art in Stuttgart with the academician and genre painter Johann Baptist Seele. He immigrated to Philadelphia in 1810 after his family suffered a series of economic reverses. Krimmel's earliest works describe sentimental memories of Germany, but he soon began to specialize in scenes of everyday life in his adopted country while supporting himself as a portraitist. He became a prominent figure in Philadelphia art circles, gaining membership in the city's chapter of the Society of Artists of the United States and the Philadelphia chapter of the Association of American Artists. From 1813 until his premature death by drowning in 1821, Krimmel exhibited regularly at the Pennsylvania Academy of the Fine Arts and the Society of Artists of the United States.

Quilting Frolic, 1813
Oil on canvas, 16⅞ × 22⅜ (42.8 × 56.8). Inscribed on the back, *J. L. Krimmel PINX/PHILA.1813*. Courtesy The Henry Francis du Pont Winterthur Museum

Although Krimmel has been referred to as the "American Hogarth," the rustic scenes of David Wilkie had the most pronounced impact on his art; he exhibited a copy of Wilkie's *The Blind Fiddler* along with *Quilting Frolic* in 1813. The well-dressed gentlemen and women in *Quilting Frolic* are accompanied by a fiddler dressed in tattered, patched clothing. In contrast to the finely detailed observations that Krimmel invests in his portrayals of the country revelers, however, he represents blacks stereotypically, choosing the darkest shade of color for the fiddler and the young serving girl. Shabbily dressed, each wears a toothy smile that is framed by oversized red lips.

Krimmel was one of the first American artists to utilize physiognomical distortions as a basic element in the depiction of African-Americans; his comic portrayal was probably meant to establish a good-natured humorous scenario, but it profoundly reinforced developing ideas regarding the humorous, even "debased" appearance of African-Americans. It also marked the beginnings of the near-constant association of blacks with music and music-making in the fine arts.
G.C.M.

Francis Guy 1760-1820

Francis Guy, a painter of eccentric landscapes and seascapes during the eighteenth and early nineteenth centuries, was, along with Krimmel, one of the first artists regularly to include African-Americans in his genre paintings. Born in the Lake District of England, Guy began artistic studies as a child, but he acquiesced to the demands of his parents and entered into the family trade of dyer and calender, eventually becoming dyer to the Queen of England. Arriving in the United States around 1795, Guy lived briefly in New York and Philadelphia; by 1798 he had settled in Baltimore, where he developed a steady clientele for landscapes of the country estates of Baltimore's wealthy mercantile class. Paintings such as *Perry Hall* (ca. 1805) and *Perry Hall's Slave Quarters with Field Hands at Work* (ca. 1805) matter-of-factly include African-American workmen within the landscape as staffage, probably as a reflection on the relative wealth of each landowner. Guy later gained notoriety for colorful views of the Baltimore area that are unusual for their use of paired figures to represent the everyday activities of Baltimore's citizenry.

Winter Scene in Brooklyn, ca. 1817-1820
Oil on canvas, 58¾ × 75 (149.2 × 190.5). Inscribed on a sign within the painting: *To Be Seen/A View [illegible]/Brooklyn/By/ Guy.* The Brooklyn Museum. Gift of the Brooklyn Institute of Arts and Sciences

Winter Scene in Brooklyn was the first of several works on this theme executed by the artist. Based on the view of Front and Ferry streets, it captures the artist's friends and neighbors as they went about their daily lives. Among those represented is Thomas Birdsall, a close friend and patron of Guy. The African-Americans included are servants of well-known Brooklyn citizens; in Guy's conception of the urban neighborhood of the nineteenth century, black people are an accepted, although not very important, part of the social fabric.

G.C.M.

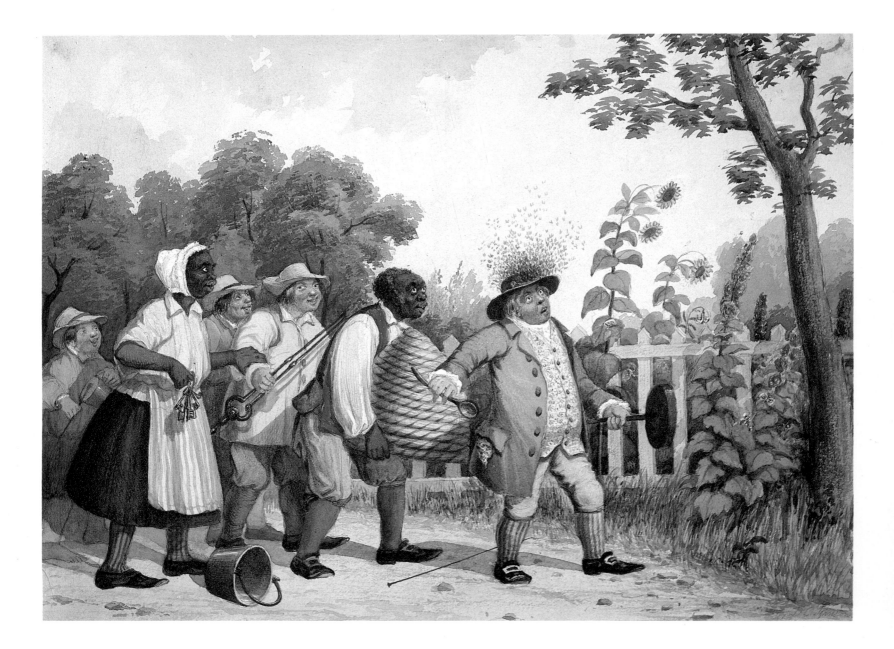

David Claypoole Johnston 1799-1865

Painter, engraver, and lithographer David Claypoole Johnston was best known for caustic satirical prints of leading figures in the political and social life of Philadelphia – his birthplace – and Boston. He apprenticed as an engraver; by 1819 he was already known for his witty caricatures. When his prints had increasingly negative effects on his career, Johnston joined the Boston Theater Company but returned his full attentions to the graphic arts in 1826.

Johnston prepared illustrations for numerous publications and illustrated a diverse range of literature, including works by Shakespeare, Cervantes, Pope, Trollope, and contemporary Americans such as Micah Hawkins and Ebenezer Mack. Johnston also published his own books of etchings, wood engravings, and lithographs, *Charcoal Sketches* (1838), *Yankee Notions* (1838), and *Daw's Doings* (1842); his most successful comic caricatures appeared in his satirical annual *Scraps* (1828-1849). Changes in the developing taste of nineteenth century America and the development of new approaches to printing in the 1850s cost

Johnston much of his popularity as an artist; and when he died in 1865 he was more widely known as an educator.

Bee Catching, ca. 1818
Watercolor on paper, 9¾ × 13⅜ (24.7 × 33.9). Signed in the lower right: *D. C. Johnston*. Collection of Russell P. Vaughn

The traditional association of bees with industry may link the moral of *Bee Catching* to the perceived idleness of bankers and wealthy merchants; scorn is clearly heaped on the wealthy burgher, who, crowned with a bonnet of bees, seems so helplessly distracted that he is nearly ready to hit himself on the head with a skillet. The well-dressed livery servant dutifully follows his master, but the housemistress, signified by her keys, conspiratorially exchanges a knowing glance with her neighbor. Johnston's cartooning, patterned after the work of Sir David Wilkie and George Cruikshank, uses standard approaches to extremes of physiognomy to distort the races equally, describing blacks without resorting to stereotyped behavior.
G.C.M.

Robert Street 1796-1865

Robert Street was born in Germantown, Pennsylvania. Few details of his life are known, but his exhibitions at the Pennsylvania Academy of the Fine Arts begin in 1815, and an 1822 advertisement for a studio in the Peale Museum locates him in Baltimore. Two years later he exhibited in Washington, D.C., and painted a portrait of President Andrew Jackson that later hung in the White House. Street exhibited widely throughout his life; records of his exhibitions exist in New York City and in several locations in Philadephia.

Children of Commodore John Daniel Danels, ca. 1826
Oil on canvas, 69½ × 59¾ (176.5 × 151.7). Unsigned. The Maryland Historical Society. Bequest of Elinor Douglas Wise de Richelieu

Unsigned, *Children of Commodore John Daniel Danels* was originally attributed to Rembrandt Peale, and later thought to be the work of Sarah Miriam Peale, who maintained a studio at the Peale Museum in Baltimore after 1825. The positioning of the second black youth echoes Charles Willson Peale's *Portrait (Staircase Group)*, which Street would have seen in Philadelphia. The influence of the Peales is evident in the elaborate composition, drapery, and clothing. However, based on facial types, coloration, tonality, and compositional style, this work is now attributed to Street.

The setting for the Danels children's portrait is the house Commodore Danels built in 1825 on Albemarle Street, a locus of the Baltimore shipping industry and home to many free blacks. Danels was a wealthy privateer who later joined the Colombia Navy during that South American country's struggle for freedom from Spain. *Children of Commodore John Daniel Danels* is a rarity in African-American representation, a black subject who is portrayed on an equal footing with his white peers. The inclusion of the youth reclining in the foreground blowing bubbles conveys an intimacy within the Danels family that suggests the lad's status as a favored servant or a free black who lived with the Danels.
C.V.

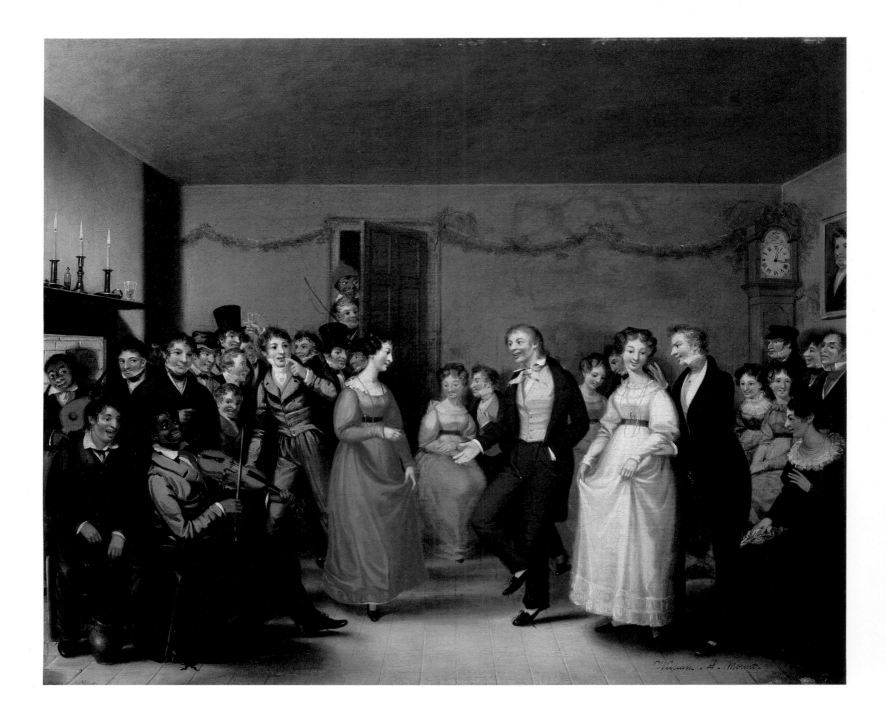

William Sidney Mount 1807-1868

William Sidney Mount's comic genre pieces and depictions of Long Island country life established painterly conventions that generations of nineteenth century American artists emulated. Mount was born in Setauket, Long Island; his early experiences instilled profoundly Yankee values that remained remarkably consistent throughout his life. In 1824 Mount moved to New York City to apprentice to his brother as a sign painter, but he soon enrolled in the newly founded National Academy of Design; by 1830 he had found his metier as a chronicler of everyday life. From 1829 to 1836 he exhibited and worked in New York City, but after 1837 he returned to Long Island, where he found ready subjects in the agrarian life of the island's rural communities.

Mount's earliest genre painting, *Rustic Dance After a Sleigh Ride* (1830), established a model for his career. Exhibited at the National Academy of Design and the American Institute of the City of New York, it was widely praised for its authenticity and its ability to evoke the energy and humor of American rural life. The success of *Rustic Dance* gained Mount the position of Associate of the National Academy of Design in 1831; he became a full Academician the following year. Mount refused offers to travel in Europe, adhering instead to a firm belief in the validity of nationalistic themes. His association with William Schaus, the American representative for Goupil and Company, gave him access to a broad European audience without his ever traveling to Europe.

Mount's early portrayals of blacks define them as stock characters with very dark skin, outsized red lips, and shabby, worn clothing. Such stereotypes were heavily influenced by, and quite possibly based on, imagery developed by minstrel performers such as Dan Emmett and T. D. Rice, whom Mount would have quite probably seen in the 1820s and 1830s. However, by 1836, when Mount painted *Farmers Nooning*, he had begun to abandon such clichéd, unblinkingly conventional imagery. The recumbent black figure that is the focal point of this painting is realized without the aid of comic exaggerations and distortions. By the 1840s Mount had begun to create works that recast existing formulas regarding black physiognomy and habits.

While Mount's paintings do repeat and enlarge into nearly mythological status the common belief about the compelling effect of music on the African, they nevertheless present black subjects without the insinuations of exaggerated features. Mount's placement of the listening black in *The Power of Music* suggests the artist's very personal identification with the exultation of music and his view of himself as an outsider. Mount's political views on race remained remarkably consistent: as a conservative Democrat, his stance was both anti-abolitionist and anti-war. Throughout Mount's lifetime his art and activities proclaimed a double message: his portrayals dignify the African-American from a white perspective but steadfastly maintain the limitations of conventional attitudes about race.

Rustic Dance After a Sleigh Ride, 1830
Oil on canvas, 22 × 27 ¼ (55.9 × 69.2). Signed and dated in the lower right: *William S. Mount. 1830.* Courtesy, Museum of Fine Arts, Boston. Bequest of Martha C. Karolik for the Karolik Collection of American Paintings, 1815-1865

Rustic Dance After a Sleigh Ride set a tone for the inclusion of black Americans in genre painting that would persist in the work of generations of American painters. The seated fiddler, with his grinning face, dark skin, and wide-eyed visage, is a racial type – the comic musician – that was popularized by minstrel performers such as T. D. Rice and Dan Emmett. The other two blacks in attendance are similarly portrayed; unlike the fiddler, the bellows-man and the driver are present not as celebrants but as workers. Mount's choice of subject matter was inspired by the work of John Lewis Krimmel and his awareness of the rustic and humorous compositions of the English artist David Wilkie, which had been popularized in America as early as 1809 in widely circulated engravings. Both Krimmel's *Dance at a Country Tavern* (1813) and Mount's *Rustic Dance After a Sleigh Ride*, painted seventeen years later, share compositional affinities with Wilkie's *The Blind Fiddler* (1806). Each of these paintings structures dancing figures around a seated fiddler within a shallow, boxlike space.

Mount enlarges the crowd of revellers in his rural scene, establishing two themes that ran concurrently throughout his oeuvre: nostalgia for an already vanishing agrarian style of life, and love of music and music-making. Both of these themes were based on his childhood memories of life on Long Island, when Anthony Hannibal Clapp, a slave belonging to the Hawkins and Mount families, had a considerable influence on Mount. The artist's abiding predilection for both musical and comic themes relating to black Americans may also have been influenced by Mount's uncle, Micah Hawkins, who was the composer of "Massa George Washington and General Lafayette" (1824), a song popularized by blackfaced minstrels.

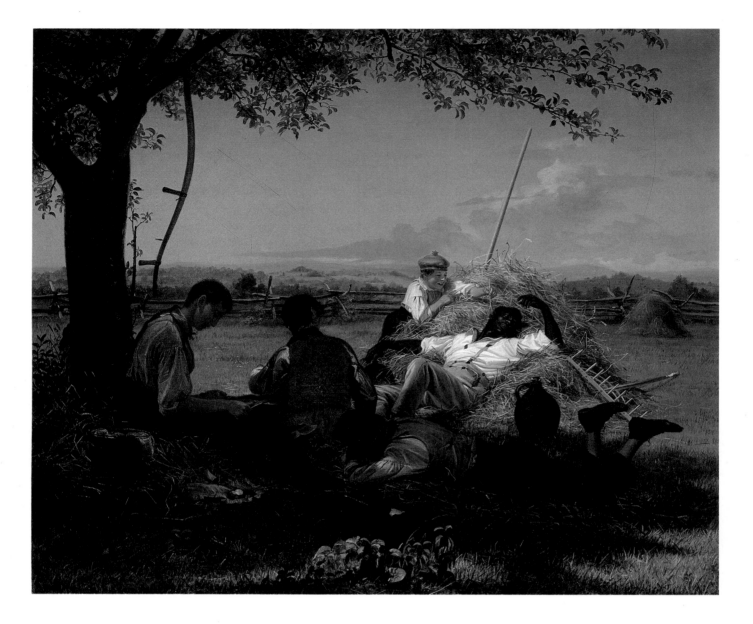

Farmers Nooning, 1836
Oil on canvas, 20¼ × 24½ (51.5 × 61.5). Inscribed in the lower
left: *Wm.S. Mount 1836.* The Museums at Stony Brook. Gift of
Mr. Frederick Sturges, Jr., 1954

Farmers Nooning was Mount's first masterpiece as a genre
painter, and his most complex depiction of black Americans in
his early career. The focal point of the five-figure composition is a
recumbent black man that is strongly reminiscent of the classical
Roman sculpture *Barberini Faun*. Contemporary critics referred
to this work in especially salutatory terms. The black figure
was described by one reviewer as "the masterpiece of the compo-
sition." Mount had depicted blacks in *Schoolboys Quarreling*
(1830) and *Rustic Dance After a Sleigh Ride* (1830), following
conventions established by John Lewis Krimmel. In *Farmers
Nooning* Mount breaks with that tradition; the recumbent figure
is painstakingly rendered, with no apparent caricature in appear-
ance. Mount wrestled with feelings of being an outsider and was
constantly tormented by the lack of Yankee industriousness

that he perceived in his own character; historians have identified
Mount's use of African-Americans in this and other paintings
as covert self-portraits. This image is one of the earliest affirmative
portrayals of a black person in American art, and, although
Mount's painting conveys a moral regarding sloth and industry,
the portrayal of the sleeping figure indicates the artist's growing
awareness that African-Americans were subjects with which both
the artist and his audience could identify.

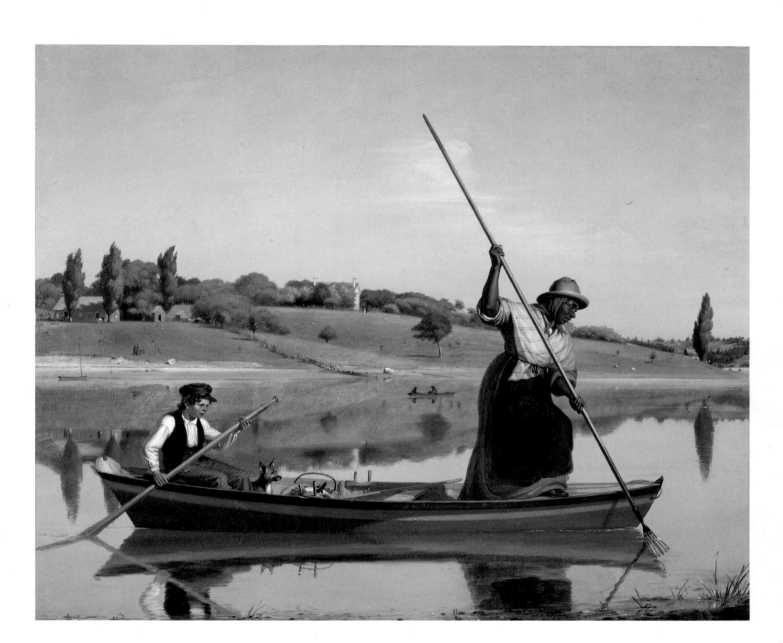

Eel Spearing at Setauket, 1845

Oil on canvas, 29 × 36 (73.7 × 91.4). Signed in the lower right: *Wm. S. Mount.* New York State Historical Association, Cooperstown

As Hugh Honour has noted, *Eel Spearing at Setauket*: *suggests the fusion of a duality of visions: what he saw in 1845 superimposed on his memories of childhood days – some quarter of a century earlier – when he had sat like the boy who paddles the boat and had been taught to fish by "an old Negro by the name of Hector."*

Mount's journal entries detail how the composition of *Eel Spearing* evolved from memories of fishing lessons with Hector. However, he deemed an image of a black man teaching a white youth too great a risk in a commissioned painting; substituting an anonymous woman for Hector, Mount satisfied his own proscriptions against images of assertive African-American men. Distinguished by the colorful design of her homemade clothing, which contrasts sharply with the child's store-bought fashions, and by an impassive profile that is concentrated in anticipation of action, this woman is a monumental figure, who, like the black man

in *Watson and the Shark*, is accorded an individual complexity defined both by her task and her physical bearing.

Commissioned by George W. Strong, a New York collector, the figurative subject of this dream-like landscape was set by Mount in a landscape that includes an obscured view of the Strong family house in the distance. Mount subtitled his painting: *Recollections of early days. Fishing along shore – with a view of the Hon. Selah B. Strong's residence in the distance, during drought at Setauket, Long Island.*

The impressive stillness of *Eel Spearing*, which the artist expressed in both the frozen poses of the figures and the too-perfect reflections in the placid river, illustrates the intensity with which Mount cherished his Long Island childhood. *Eel Spearing* breaks with predominant associations of black activity (indigence, laziness, skillful comical or musical entertainment); taking advantage of the lack of pictorial conventions for the depiction of black women, Mount drew on popular attitudes that associated black women with nurturing and strength to create a surrogate character that could convey the lasting impact of Hector's fishing lessons.

The Bone Player, 1856
Oil on canvas, 36 × 29 (91.4 × 73.6). Signed in the lower right:
Wm.S. Mount 1856. Courtesy, Museum of Fine Arts, Boston.
Bequest of Martha C. Karolik for the Karolik Collection of
American Paintings, 1815-1865

The Bone Player is one of a series of five works on musical themes
commissioned by William Schaus of Goupil and Company for
lithographic reproductions for the European market. Inspired by
the demand for black American subjects before the Civil War,
Mount's handsome, well-dressed figures exude an air of confi-
dence while engaging in the business of making music. Despite
the élan that enriches Mount's portraits, however, they present an
African-American type that would be clearly identifiable to
collectors in both the United States and Europe. The bone player
is a character with strong ties to the minstrel stage, and his spirited
persona affirms the artist's own belief in the compelling power of
music while reinforcing widely held ideas concerning the strong
effect of music on African-Americans.

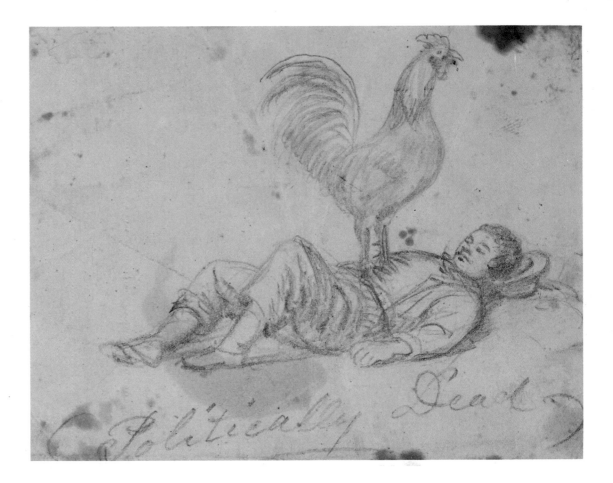

Preliminary sketch for **Politically Dead,** ca. 1867
Pencil on paper, 3 ¼ × 4 (8.3 × 10.2). Inscribed at the bottom:
Politically Dead. The Museums at Stony Brook. Museum
Purchase

Mount's views of African-Americans were informed by two
strikingly divergent sources. His fondly remembered youthful
experiences with slaves on the Hawkins family farm formed one
half of his conception, and throughout his life he displayed a
benignly supportive attitude for blacks who retained their
assigned position within the social structure. They were, in his
words, "fine in their place." This attitude, stated in his diary,
recalls a pleasurable skating scene where blacks skated at one
place and whites at another, creating what Mount saw as an ideal
situation.

The other forces shaping Mount's beliefs about race were
political: a vehemently conservative Democrat, his attitudes
about the social status of blacks were profoundly ambivalent. He
could not abide the idea of black equality and firmly believed in
repatriation or segregation as solutions to America's racial
problems. These views were summed up in *Politically Dead*
(1867), a painting executed shortly before the artist's death. The
preparatory sketch for *Politically Dead* illustrates Mount's belief
that the issue of slavery was now moot, postulating this concept
through the bulk of a sleeping African-American who remains
unaware of or insensitive to the crowing rooster of radical Repub-
licanism. Mount's diaries clearly reveal his sympathy for a sepa-
rate but equal philosophy and record his sharp denunciation of
the Civil War as an unfortunate loss of white lives for what he
perceived to be a black cause.
G.C.M.

John Quidor 1801-1881

John Quidor specialized in bizarre, sometimes hauntingly romantic images that illustrate the stories of Washington Irving and James Fenimore Cooper. Quidor was born in Tappan, New York; his family moved to New York City when he was a child. Little is known of his early artistic training, although he is reported to have apprenticed unhappily to the portraitist John Wesley Jarvis between 1814 and 1822. Quidor first exhibited in 1828 at the National Academy of Design, showing works inspired by literary sources; one surviving painting, *Ichabod Crane Pursued by the Headless Horseman of Sleepy Hollow*, was inspired by the popular Washington Irving story. After living in Illinois for several years he returned to New York in 1836, where he continued to illustrate Irving's novels, including *A History of New York* (1809) and *The Sketchbook of Geoffrey Crayon, Gent.* (1820).

The Money Diggers, 1832
Oil on canvas, 16 5/8 × 21 1/2 (42.2 × 54.6). Signed in the right center: *J. Quidor Pinxt/N.York June, 1832*. The Brooklyn Museum. Gift of Mr. and Mrs. Alastair Bradley Martin

Quidor's predilection for humorous scenes and his love of plebian subject matter often meshed perfectly with his literary sources. Inventively illustrative, his paintings are dominated by a nervous, agitated intensity that is sustained by the highly expressionist postures of figures captured in the midst of staccato movements or exaggerated facial expressions. *The Money Diggers* introduces a black American as an auxiliary character with wildly comic or sinister overtones that are dramatically revealed in a sudden flash of light. Characteristically, Quidor has distorted each of his figures into grotesque approximations of Irving's characters. His portrayal of the black figure, Sam, remains faithful to Irving's text while making reference to buffoonish racial stereotypes. However, while the African-American's face is a distorted mask of terror, his appearance is wholly consistent with the exaggerated treatment Quidor reserved for the other characters in Irving's tale.
G.C.M.

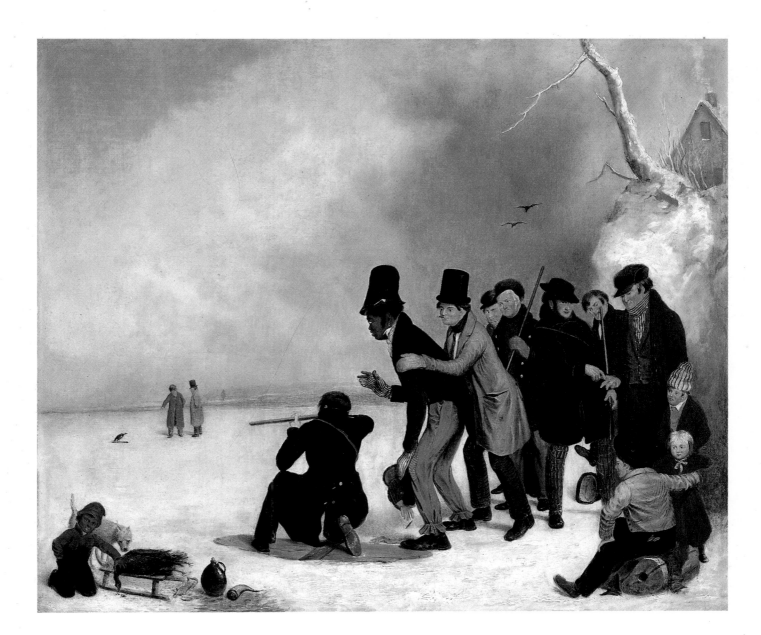

Charles Deas 1818–1867

Son of a prominent Revolutionary War family, Charles Deas was successful as a portraitist, genre painter, and chronicler of the American West. Inspired by frequent visits to the Pennsylvania Academy of the Fine Arts and the studio of Thomas Sully, Deas began painting in his youth, possibly at the Cleremont Academy under the instruction of John Sanderson. He studied briefly at the National Academy of Design in New York, producing genre scenes with such descriptive titles as *Hudibras Engaging the Bear-Baiters* and *Shoeing a Horse by Lamplight*. By 1837 he had begun to travel throughout the Western Territories, documenting his travels in his paintings. Deas patterned his paintings on the American Indian Gallery of George Catlin, which he saw exhibited in Philadelphia in 1837 or 1838. Deas's work, which at the time rivaled Catlin's in popularity, was known for its wealth of carefully observed detail and for its accurate depiction of the accoutrements and daily routines of Native Americans.

The Turkey Shoot, 1836
Oil on canvas, 24¼ × 29½ (61.5 × 75). Unsigned. Virginia Museum of Fine Arts. The Paul Mellon Collection

Like John Quidor, Deas based his paintings on the literature of his American contemporaries, specifically the writing of James Fenimore Cooper and Washington Irving. *The Turkey Shoot* illustrates a passage from *The Pioneers, or Sources of the Susquehanna, a Descriptive Tale* (1823), by James Fenimore Cooper. Deas illustrates the comic antics of Abraham Freeborn, a free black who arranged a turkey shooting contest for profit. Freeborn, Edward Effingham, and Natty Bumpo are among the characters arranged in a frieze-like display set in a snowy winter scene. With its Brueghelesque characters, wintery settings, and low horizon line, *The Turkey Shoot* shares many affinities with Dutch seventeenth century painting, but the popularity of minstrel performers and the idiosyncrasies of local package designs (which frequently bore images of dancing or grinning African-Americans) also influenced Deas's conception of Abraham Freeborn. His illustrative style remains faithful to its literary sources, depicting this scene in a manner wholly consistent with Cooper's narrative. Abraham Freeborn is a stock type that draws on caricatures of African-Americans; he is a comic "darkey" who stands in stark contrast to the heroically idealized figure of Natty Bumpo.

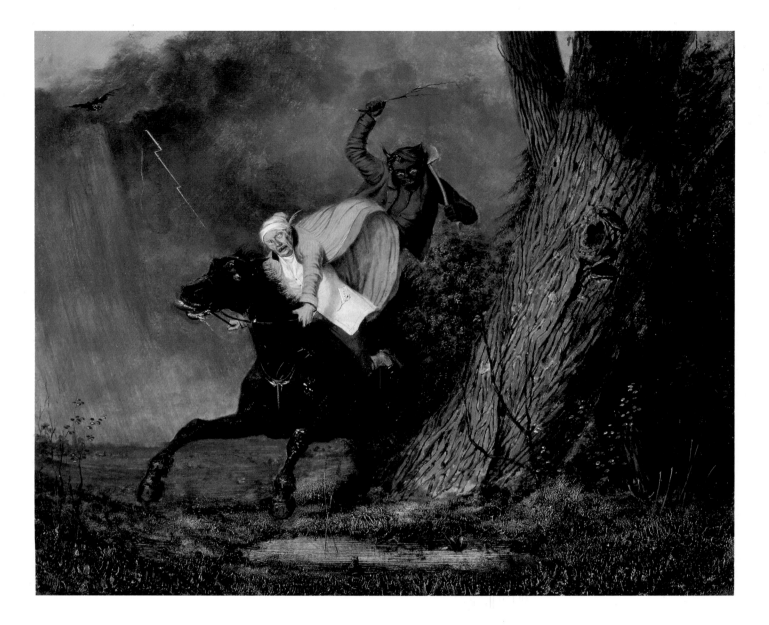

The Devil and Tom Walker, 1838
Oil on canvas, 17 × 21 (43.2 × 53.3). Signed in the lower right:
C.D./1838. Private Collection

Illustrating a story of the same title in Washington Irving's *Tales of a Traveler, The Devil and Tom Walker* represents the devil appearing to Tom Walker in a storm. Revealed in a flash of lightning, an obviously terrified Walker flees astride a black horse. While Irving's description does not specifically describe the devil, Deas's figure, with its dark skin and negroid features, appears to be an African-American, a black devil with horns and

great glowing eyes. Choosing a black male to represent the devil, the artist plays on associations of blacks with sinister or sinful characters. The cursed state of the black race was supported during Deas's life by theologians, who, quoting scripture (particularly the curse of servitude on the descendants of Ham in the book of Genesis) extended this punishment to include the mark of dark skin as an indicator of evil. Deas's image not only captures the essence of Irving's tale, it also reflects the effects of religious tradition in reinforcing racial prejudice.
G.C.M.

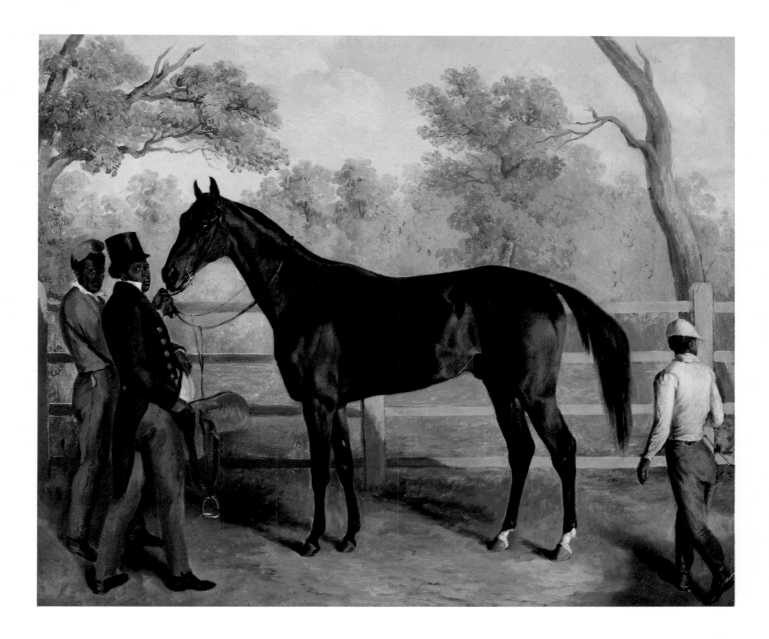

Edward Troye 1808-1874

Born Edouard de Troy in Lausanne, Switzerland, Edward Troye was the son of a Huguenot sculptor who secured a series of commissioned works throughout England. A friend of his father, Jacques-Laurent Agasse, was active as a painter of animals and may have provided an example for Troye. However, in a pamphlet written by the artist in 1857, he cited the stylistic influences of two of eighteenth century England's most famous animal portraitists, George Stubbs and John Nost Sartorius. Troye immigrated to Philadelphia in 1828; three of his paintings were exhibited for the first time in America in 1832 at the Pennsylvania Academy of the Fine Arts in Philadelphia.

In 1833, he traveled to Charleston, South Carolina, and announced himself via an advertisement in the *Charleston Mercury* as a "Painter of Animals." He quickly established himself as a specialist in thoroughbred race horses, which he prepared by drawing detailed sketches from life, often resorting to a tape measure to ensure the exact relationships of his observations on size and proportion. It is believed that Troye did not paint from photographs, but he did permit his paintings to be photographed to promote his career. Hand-colored in oil, they served as illustrations for parts I and II of his 1867 publication *The Race Horses of America*.

Richard Singleton, ca. 1835
Oil on canvas, 24 ½ × 29 ½ (62.3 × 75). Unsigned. Virginia Museum of Fine Arts. The Paul Mellon Collection

Many of Troye's works include the trainers, jockeys, and grooms who tended to his primary subjects, describing them with a wealth of intricately realized detail. Most often black men and boys, they were often recorded in clothing that designated their stature or position, and are often named. Richard Singleton was a prize-winning thoroughbred owned by Captain Breckenridge ("Willa") Viley of Scott County, South Carolina. Captain Viley

27

was also the owner of Harry, the trainer; Charles, the groom; and Lew, the jockey. Troye stages a detailed double portrait of Richard Singleton and the three men most responsible for his considerable achievements before an idealized landscape. Richard Singleton is meticulously described in top racing form, sleek and glowing. His trainer, attired in a formal silk top hat and green frock coat adorned with brass buttons, is similarly recorded, described in Troye's sharply focused full-length portrait as a proud, handsome man. Harry had been purchased by Viley for the sum of fifteen hundred dollars and was given his freedom and a yearly annuity of five hundred dollars to serve as the horse's trainer. Charles, the groom, stands behind Harry, his face somewhat softened by shadow. To the right stands Lew, the jockey, dressed in his racing silks.

J.L.

Attributed to Charles Winter ca. 1822-1860s

The inscription *Phila* suggests that this painting might have been the work of Charles Winter, an obscure portrait artist who was born in Louisiana. Winter's oldest daughter was born near Philadelphia, and he is last mentioned in the 1860 New York census. This connection establishes a tentative period, between the 1830s and the 1850s, during which *Minstrel Show* could have been painted.

Minstrelsy, which had its roots in plantation entertainment, began to emerge regionally as slavery was becoming a national political issue. Its popularization helped develop and solidify a number of exaggerated stereotypical characterizations, such as the pompous, overdressed dandy and the empty-headed country bumpkin, that served to distance black individuality. Minstrelsy emerged in the 1820s, developed theatrical conventions by the 1840s, and reached a zenith of popularity in the decade preceding the Civil War, although it survived in a variety of forms until the beginning of the twentieth century.

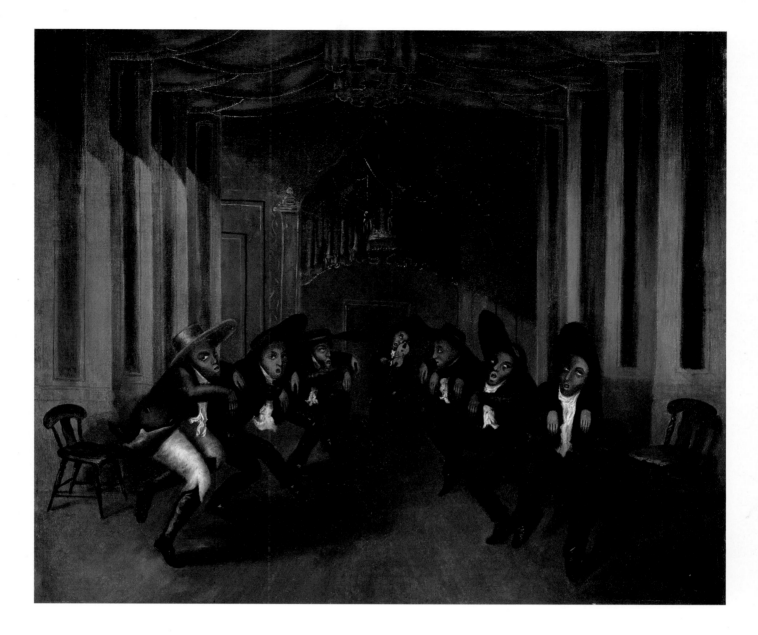

Minstrel Show, ca. 1830s-1840s
Oil on canvas, 25 ¼ × 50 (64.1 × 127). Signed in the lower right:
C. Winter/Phila. Courtesy, Museum of Fine Arts, Boston. Bequest
of Martha C. Karolik for the Karolik Collection of American
Paintings, 1815-1865

The faces of the performers in *Minstrel Show* reflect no distinctive
variations in physiognomy, suggesting that the painting was
created from memory. Each performer's face proclaims an oval
mouth, evidence that this scene is a musical number sung to
the accompaniment of the painting's lone fiddler. By the 1840s
minstrel bands usually consisted of four instruments – fiddle,
banjo, tambourine, and bone castanets – and this detail suggests
an earlier dating of the painting. The flat, wide-brimmed hats,
long coats, cravats, breeches, and stockings worn by the interlocu-
tor also suggest that *Minstrel Show* was painted in the 1830s.

The fly-wing stage, complete with inset panels, overhead
curtains, gold fringe, and painted illusionistic backdrop, indicates
a performance in a professional theater. In Philadelphia in the

1820s two theaters hosted performances in drama, musical
comedy, concerts, and minstrelsy; by the 1840s there were at least
eight. While the majority of minstrel performers were whites in
blackface, Philadelphia maintained an active minority of black
minstrel performers. However, it is highly unlikely that the per-
formers in *Minstrel Show* were African-Americans, because black
performers were severely restricted: even in the vocally abolition-
ist city of Philadelphia Black Codes prohibited blacks from
performing in most theaters.
c.v.

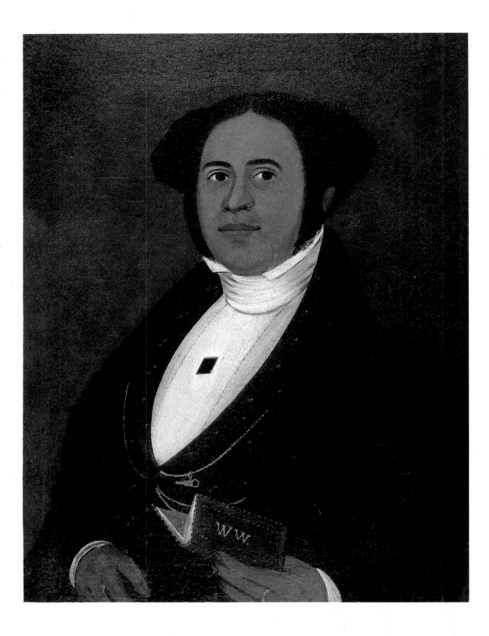

William Matthew Prior 1806-1873

William Matthew Prior was an itinerant portraitist whose business took him from Maine to Baltimore. While little is known of his early training, he is believed to have begun painting as a child in Maine. He opened a portrait studio in 1824 in Bath, Maine; throughout the 1820s and early 1830s he advertised his services as a portrait, ornamental, fancy, and sign painter, supplementing his income with the more practical arts of bronzing, gilding, varnishing, and japanning. Prior became well known for flat, limnerlike portraits executed in tempera with a minimum of detail. In 1828 he married into the Hamblen family, prominent Maine painters and glaziers, and in the early 1830s moved to Portland, Maine. Prior's works of the 1840s, executed in New Bedford, Fall River, and Sturbridge, Massachusetts, reflect an emerging dichotomy in his work – a flatly painted, stylized technique, and a more fully developed portrait style based on a broad range of color and modulation of tonality.

Traveling along the eastern seaboard, Prior stopped briefly in New Bedford, Boston, Newport, and Baltimore. During his travels he became involved in the Adventist Movement and painted the Movement's founder, William Miller. Prior became a devout Millerite, publishing two books on Adventist theories and the abolitionist cause. Prominent abolitionist leaders such as Reverend William Lawson and William Whipper sought out Prior's services, and the number of Prior's surviving portraits depicting African-American subjects indicates that middle-class blacks formed a significant part of his clientele.

William Whipper, ca. 1835
Oil on canvas, 24¾ × 20⅛ (62.9 × 51.2). Unsigned. The New York State Historical Association, Cooperstown

William Whipper was a prominent businessman in the Philadelphia area. A vocal reformer, he authored *Non-Resistance to Offensive Aggression*. Prior's straightforward frontal presentation, combining limner technique with rudimentary modeling and shadow, offers an intriguing image of an affluent member of the nineteenth century black American upper-middle class. Whipper's stylish frock coat and high-collared shirt, as well as his direct, dignified expression, suggest his solid status in his community. The existence of a number of similar portraits of members of the nineteenth century African-American middle class suggests that affluence and autonomy were components of the black community in the Northeast before the Civil War. While unsophisticated in terms of technique, the egalitarian view apparent in Prior's portraits strongly counters both the cartoon images of genre painters such as Krimmel and Mount and the widespread stereotypes of African-Americans developing in popular culture.

Three Sisters of the Coplan Family, 1854
Oil on canvas, 26¾ × 36¼ (67.9 × 92.1). Signed on the back:
*W. M. Prior/36 Trenton Street (third section)/East Boston/Sept.
1854.* Courtesy, Museum of Fine Arts, Boston. Bequest of Martha
C. Karolik for the Karolik Collection of American Paintings,
1815-1865

In contrast to the idealized, largely two-dimensional image of
William Whipper, the broad, masklike faces of *Three Sisters of the
Coplan Family* reflect Prior's later style, where modulations of
light and dark struggle to convey dimensionality. Prior has
memorialized the children of a pawnbroker active in Boston's
North End and Chelsea sections; when the conventions in this
portrait are compared with the work of artists who specialized in
depicting the white middle class, a striking similarity is apparent
between black and white middle-class tastes. Eliza, Nellie, and
Margaret are elegantly attired and suitably beribboned. Two girls
hold flowers and fruit, reinforcing their status as progeny; the
other holds a book, suggesting education, an often repeated
convention in portraits by nineteenth century artists.
G.C.M.

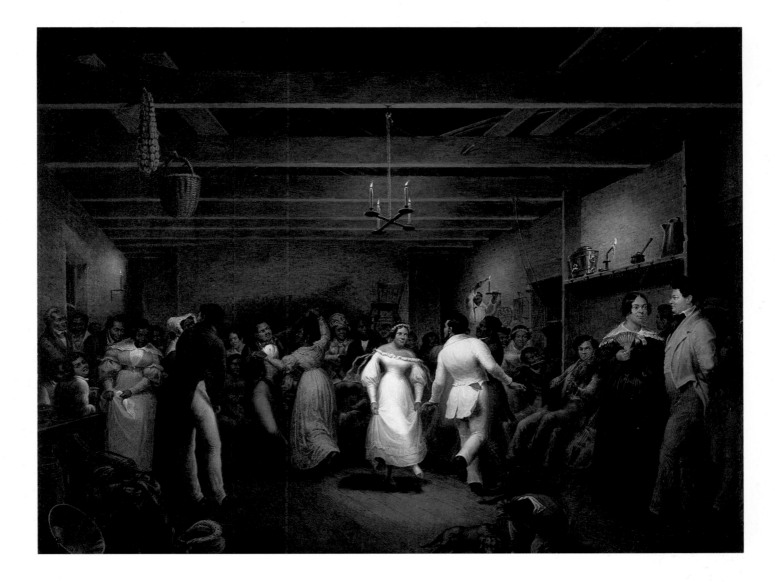

Christian Mayr 1805-1851

A native of Germany, Christian Mayr probably immigrated to the United States by the middle of the 1830s. Little is known of his early life or artistic training: his first professional notice was his appointment as an associate at the National Academy of Design in 1836. Mayr specialized in genre scenes, "fancy pieces," and historical pictures; in his later years he was a successful daguerrotypist.

Kitchen Ball at White Sulphur Springs, 1838
Oil on canvas, 24 × 29½ (61 × 74.9). Inscribed in the lower center: *C. Mayr, White Sulphur Springs, 1838.* Inscribed later on the back: *C. Mayr from New York, N.A.* The North Carolina Museum of Art, Raleigh. Purchased with funds from the State of North Carolina

Kitchen Ball at White Sulphur Springs shares many similarities with John Lewis Krimmel's *Quilting Frolic* (1813) and William Sidney Mount's *Rustic Dance After a Sleigh Ride* (1830), but this relaxed view of life among the African-American serving class is a pronounced break with the comic, stereotypical genre tradition introduced by Krimmel and developed by Mount. Mayr empha-

sizes the rustic normalcy of his setting: the fiddle player, the boy playing with the dog, and the profusion of household items, kitchen utensils, and casually arranged clothing all contribute to a sense of homey intimacy. Other figures chat or dance, dressed in finery that suggests a relatively comfortable life-style despite their status as servants.

The elegance of the two central figures – the woman's white dress and floral headband, and the immaculate white suit of the male figure – are evidence that the crowd celebrates them as newlyweds. *Kitchen Ball* affords a rare glimpse into the private lives of black people during the middle of the nineteenth century. Mayr presents his subjects in a simple, straightforward manner, recording individual features while reflecting variations in economic and social status comparable to the variety of classes in white society.

G.C.M.

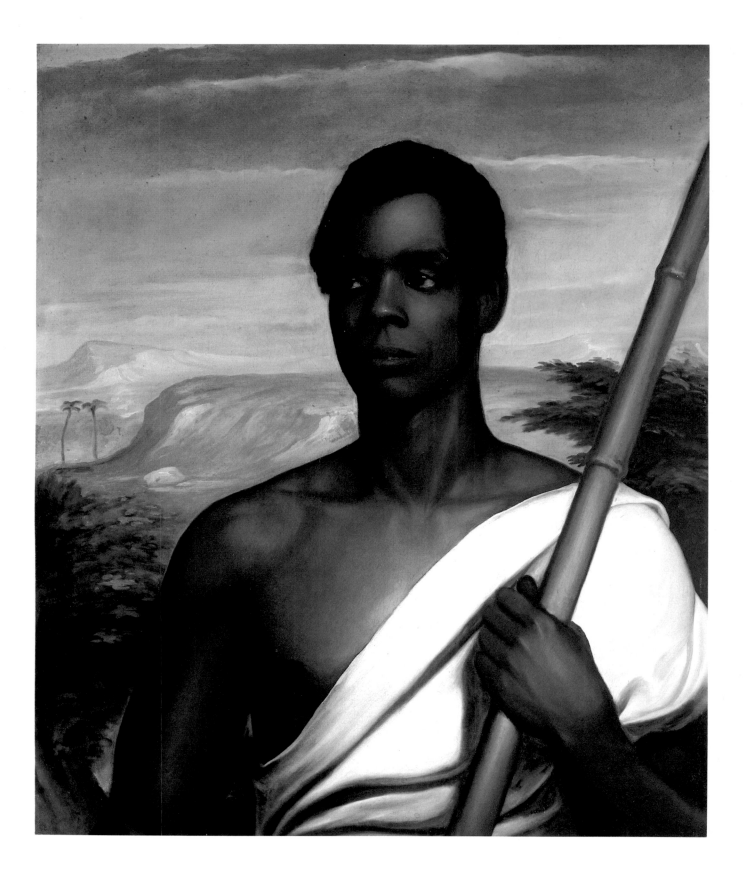

Nathaniel Jocelyn 1796-1881

Born in New Haven, Connecticut, Nathaniel Jocelyn followed his father's example and trained as an engraver and watchmaker. In 1813 he apprenticed to George Munger, an engraver who allowed him to produce his own prints. At 21 Jocelyn joined the Hartford Graphic and Bank Note Engraving Company. However, Jocelyn quickly tired of engraving and by 1820 had increasingly preoccupied himself with painting. By 1822 he had established himself as a portraitist and had begun to make a name for himself in the New Haven area. Jocelyn then began an intensive period of self-study to strengthen his technical abilities, which culminated in an 1826 exhibition at the National Academy of Design.

Following this success Jocelyn traveled abroad, touring England and France, where he studied the works of classical and modern masters. Returning to the United States, he opened studios in New York and New Haven. In 1846 he was elected an Academician in the National Academy of Design, but despite his success Jocelyn did not remain a painter. A disastrous fire in his New Haven studio destroyed much of his equipment and many of his stored paintings, and Jocelyn abandoned painting for a job with the engraving firm of Toppan, Carpenter & Co. The remainder of his career was spent as an engraver for various bank companies.

Cinque, 1839
Oil on canvas, 30¼ × 25½ (76.8 × 64.8). Unsigned. The New Haven Colony Historical Society. Gift of Dr. Charles B. Purvis, 1898

Cinque commemorates the 1839 mutiny aboard the Spanish slaver *La Amistad*. The melodramatic story of the slave uprising began with the seizure by Spanish slavers of 53 men and women in the Mendi region of Africa and their subsequent shipment to Cuba, in violation of a Spanish treaty that expressly forbade slave trading in British waters. In Havana slave markets, traders purchased the Africans for later resale and hired a captain to conduct *La Amistad* to Principe, Puerto Rico. After four days at sea the slaves, organized and led by Cinque, revolted. Murdering the ship's captain and cook and taking their former captors hostage, the mutineers demanded safe return to Africa. Secretly steering the ship westward at night to counteract the day's easterly travels, the crew, after months at sea, brought the boat to Long Island where it was boarded by American forces who arrested the mutineers and freed the slavers. Brought ashore in New Haven, the slaves became a *cause célèbre* at a critical juncture in the abolitionist movement.

Prominent abolitionists Lewis Tappan, Roger Sherman Baldwin, and former president John Quincy Adams all championed the cause of the *Amistad* mutineers throughout the United States. After two years of suits in lower courts, the Supreme Court agreed with arguments in favor of acquittal by Adams and Baldwin, and ruled that Cinque and his compatriots had been illegally seized. After a tour of the Northeast, where they were celebrated as heroes at anti-slavery meetings, the surviving members of the group, including Cinque, returned to Africa in November 1841.

Jocelyn was sympathetic to the abolitionist cause, and he portrayed Cinque as a paragon of nobility and strength of character while highlighting the exotic aspects of his sitter to romanticize and dramatize his portrait. Contemporary accounts vividly suggest the excitement that the *Amistad* rebellion generated, and their accounts of the attributes of Cinque are particularly compelling. He was referred to as "of magnificent physique, commanding presence, forceful manners, and commanding oratory." Transforming a studio portrait into an idealized landscape setting, Jocelyn clothed his subject in a toga instead of his colorful native Mendi dress. This not-so-subtle connection between a contemporary event and the ancient struggles for freedom by Greek and Roman peoples was a technique often employed by painters of historical subjects, and Jocelyn probably used this device in a portrait format to idealize his subject for maximum public appeal. Jocelyn's depiction, with its high brow and dramatically shaped cranium, may have also conformed to the claims of phrenologists, whose careful analysis of Cinque's head led to extravagant explanations for his exceptionally courageous behavior. One report noted that the shape of the head indicated "great vigor of body and mind" as well as having "ambition, independence, firmness, pride, love of liberty. . . ."

G.C.M.

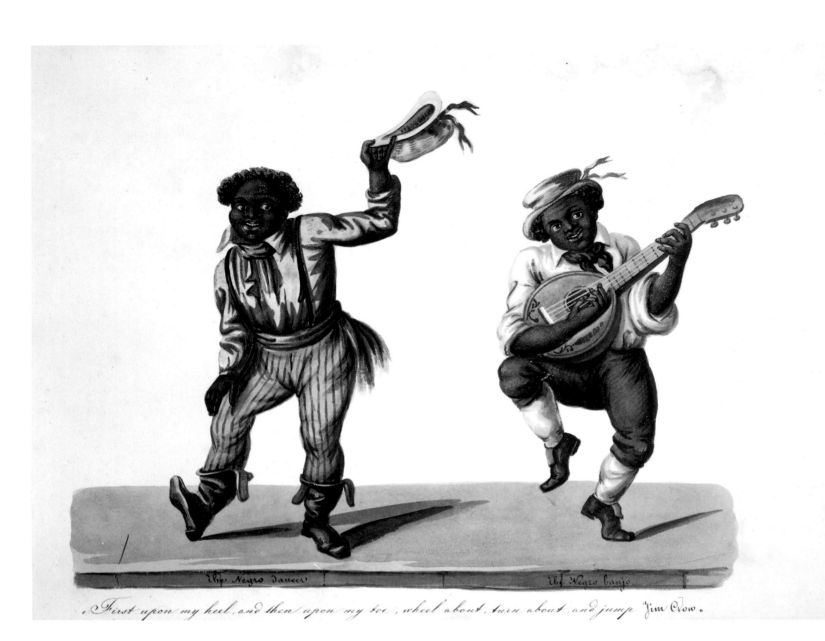

The Negro Dancer The Negro banjo

First upon my heel, and then upon my toe, wheel about, turn about and jump Jim Crow.

Nicolino Calyo 1799-1884

Born in Naples, Nicolino Calyo left Italy in 1821 as a result of his involvement in political activities. Little is known of his education, but evidently he traveled and studied in a number of cities throughout Europe before settling in Spain in 1829 or 1830. With the onset of civil war in Spain in 1833 Calyo emigrated to Baltimore, and moved two years later to New York. He immediately gained widespread fame for a series of paintings describing a disastrous New York fire that raged for two days in December 1835. Throughout the 1830s Calyo documented the colorful variety of people who populated New York; selections were published in 1840 as *Cries of New York*.

Negro Dancer and Banjo Player, 1835
Watercolor on paper, 10 × 14 (25.4 × 35.6). Unsigned. Collection of Leonard L. Milberg

By the middle of the 1830s, when Calyo painted *Negro Dancer and Banjo Player*, minstrelsy had become a widely popular form of theatrical entertainment with rapidly developing conventions. As a result, artists, especially illustrators and graphic artists, began to include images of minstrelsy in their designs for sheet music, advertisements, and magazine cartoons. Calyo recorded his subject's features, dress, and movements with an observant eye for detail, noting in an inscription "First upon my heel and then upon my toe I wheel about, turn about and jump Jim Crow." The rhythm of the inscription captures the importance of music in minstrel performances, while the lone musician suggests earlier minstrel conventions.

George Cousin the patent chimney sweep Cleaner

George Cousin, The Patent Chimney Sweep Cleaner,
1840-1844
Gouache on paper, 14 × 10¼ (35.6 × 26). Unsigned. Museum of
the City of New York, Prints and Photographs Collection. Gift of
Mrs. Francis P. Garvan in memory of Francis P. Garvan

This study is typical of the illustrations in *Cries of New York* and
provides an early example of an African-American at work in
an urban American setting. While a small percentage of free
blacks attained success as merchants, lawyers, doctors, and in
other professional occupations, most northern blacks found
employment only as menial laborers. Before the advent of gas and
electricity, a chimney sweep was a common and very necessary
occupation. George Cousin's clothing is tattered and patched; he
carries the tools of his trade as a walking advertisement.

The Hot Corn Seller

The Hot Corn Seller, 1840-1844
Gouache on paper, 14 × 10¼ (35.6 × 26). Unsigned. Museum of
the City of New York, Prints and Photographs Collection. Gift of
Mrs. Francis P. Garvan in memory of Francis P. Garvan

The anonymous woman in *The Hot Corn Seller* works as a street
vendor, one of the lowest forms of urban labor, but also one of the
most accessible for poor or unemployed blacks. Calyo's reporter's
scrutiny of the lower classes stylistically links his work with that
of the English artist George Cruikshank. Calyo's watercolors
exemplify the distinctive street life that flourished in developing
Northeastern and Middle Atlantic cities such as New York,
Philadelphia, and Baltimore throughout the first half of the
nineteenth century.
G.C.M.

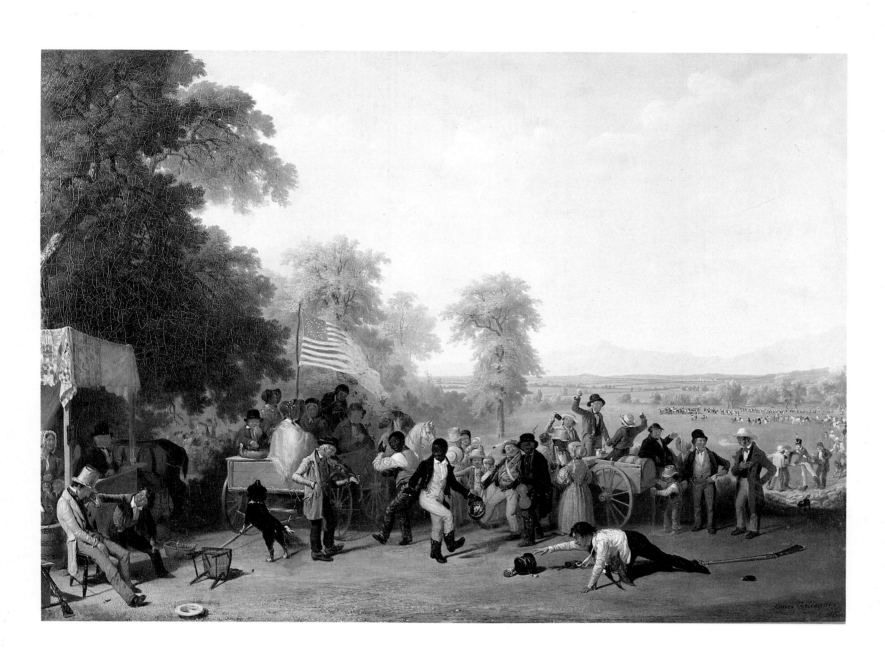

James Goodwyn Clonney 1812-1867

James Goodwyn Clonney's humorous vignettes of scenes from everyday life codified the conventions and mannerisms established in the enormously popular genre scenes of William Sidney Mount. A native of England, Clonney came to the United States, probably from Liverpool, toward the end of the 1820s. Early in his career he worked as a lithographer; by 1834 Clonney was named an Associate of the National Academy of Design, and he exhibited miniatures, landscapes, and portraits there until 1852. He also exhibited regularly at the American Art-Union and the Pennsylvania Academy of the Fine Arts. By 1841, with the exhibition of *Militia Training*, Clonney had narrowed his attention to genre subjects, a focus that was influenced by the exhibitions of William Sidney Mount at the National Academy of Design, and through prints circulated by Goupil and Company.

Militia Training, 1841
Oil on canvas, 28 × 40 (71.12 × 101.6). Signed in the lower right: *James G. Clonney / 1841*. Courtesy, Pennsylvania Academy of the Fine Arts, Philadelphia. Bequest of Henry C. Carey (The Carey Collection)

Militia Training wholeheartedly continues the development of the black male as jovial entertainer. Based on a story by John Frost, the painting, which offers a comic representation of the muster of the village militia, is consistent with the artist's penchant for outdoor settings. Exhibited in 1841, *Militia Training* was praised for its "decided merit" by a reviewer in *The Knickerbocker*, but it was also criticized for having "something too much of the vulgar, however in the subject, as here portrayed." Clonney's depictions of blacks were also praised by the same reviewer, who observed that "The negroes are painted with great truth." The success of *Militia Training* was the determining factor in Clonney's decision to pursue narrative painting as a specialty.

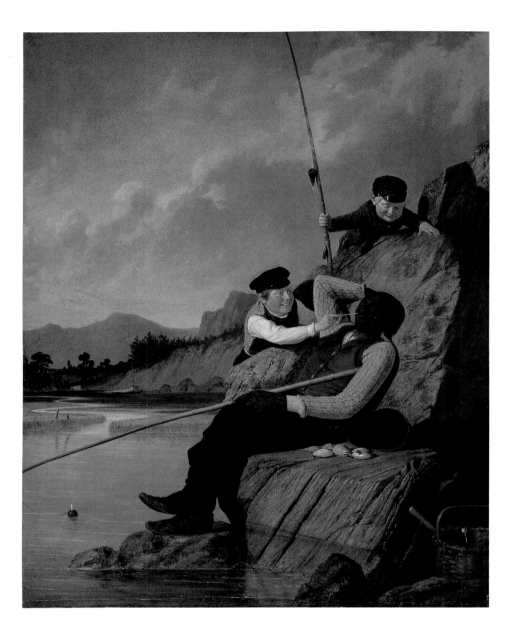

Waking Up, 1851
Oil on canvas, 27 × 22 (68.6 × 55.9). Signed and dated in the lower right: *Clonney 1851*. Courtesy, Museum of Fine Arts, Boston. Bequest of Martha C. Karolik for the Karolik Collection of American Paintings, 1815-1865

Clonney's choice of a sleeping black man as subject has a direct precedent in William Sidney Mount's *Farmers Nooning* (1836). However, while Clonney has wholeheartedly adopted Mount's subject – a sleeping African-American teased by a white youth – the two paintings are poles apart in terms of execution and intent. Mount's carefully described subject possesses a naturalistic beauty, while Clonney's depiction places the slumbering fisherman as the object of teasing provocation from two urchins who, having discovered him asleep, are determined to rouse him to wakefulness.

A contemporary review referred to *Waking Up* as "a broad farce by Clonney." Clonney's "farce" is a by-product of the growing hostility that was displayed by many toward African-Americans in the decade preceding the Civil War. This work straightforwardly echoes the images of idleness and sloth widely promulgated through minstrel performances as early as the 1820s and 1830s, images that were incorporated within a fine art context by Krimmel and Mount.

Drawing for **In the Woodshed,** ca. 1838
Pencil on buff-gray paper heightened with white chalk and
touches of black chalk, 7 ¹/₂ × 6 (19 × 15.2). Unsigned. Courtesy,
Museum of Fine Arts, Boston. M. and M. Karolik Collection

This study for *In the Woodshed* is one of two surviving sketches
by the same title: this version presents a seated figure who appears
in the foreground of the painting, while the second version depicts
the farmer who stands with his arm upraised. The quizzical look
on the seated pipesmoker and his exaggerated features – especially
his large lips – demonstrate Clonney's reliance on distorting
physiognomy to depict the racial characteristics of facial expres-
sion. A comparison between this study and the finished painting
reveals the artist's tendency to push his figuration progressively
toward caricature, especially when interpreting African-American
subjects.

Drawing for **In the Cornfield,** ca. 1844
Graphite, heightened with white, on buff paper, 9 ¼ × 12 ⅜
(23.5 × 31.4). Signed on box in lower corner. Courtesy, Museum
of Fine Arts, Boston. M. and M. Karolik Collection

This drawing served as a preparatory sketch for a painting of the
same title that was exhibited in 1844 at the American Art-Union,
and later circulated by the Art-Union in a series of prints.
Clonney's approach in this study is direct and objective, and a
comparison with the painting demonstrates his increasingly
stereotypical interpretations of the black youth's facial character-
istics to emphasize his race. Clonney's composition suggests that
social parity was at least sometimes acknowledged in pre-Civil
War American depictions of race.
G.C.M.

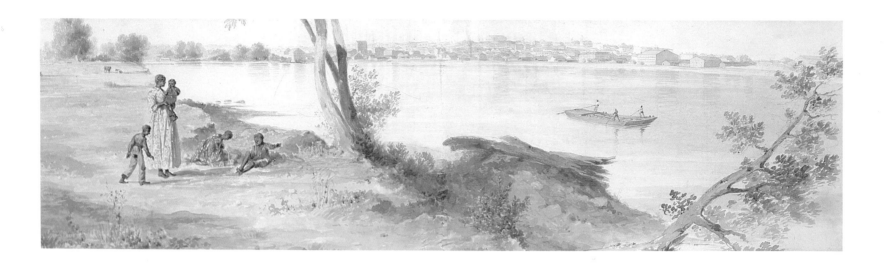

John William Hill 1812-1879

John William Hill emigrated from London to Philadelphia as a child to join his father, a successful engraver of "picturesque views." The family resettled in New York City in 1822, and Hill began a seven-year apprenticeship with his father. In 1828 he exhibited at the National Academy of Design and was subsequently elected an Associate Member in 1833. Hill began sketching and painting watercolor landscapes of upstate New York, collaborating with his father to produce prints such as *Catskill Mountains near Hudson* and *Manhattenville, New York* (both 1834).

From the late 1840s to 1855, Hill worked for Smith Brothers of New York City, painting panoramic watercolors of American cities that were issued in series as hand-colored engravings and lithographs. In 1855 he abandoned this successful career, decrying what he termed the "various mannerisms and mechanical tricks used by conventional landscapists" in favor of the naturalism espoused in John Ruskin's *Modern Painters*. Both Hill and his son, the painter John Henry Hill, were founding members of the Society of Truth in Art, a group of American pre-Raphaelite artists heavily influenced by the writings of Ruskin.

View of Richmond, 1847
Watercolor on paper, 8 × 26 ½ (20.3 × 67.3). Signed in the lower left: *John W. Hill. 1847.* Virginia Historical Society

View of Richmond reflects Hill's earlier, more commercial style. The Richmond skyline is recorded with fidelity – the State Capitol Building can be seen on the center of the horizon, and a prominent landmark, Galego Mills, stands in the foreground; along the diagonal delineation of the James River a young black woman and her four children play quietly. Hill's use of African-American subjects combines the nineteenth century landscape tradition of using human figures to establish scale with genre conventions that used blacks to identify uniquely American scenes. In 1852, on a second trip to Richmond, Hill painted *View of Richmond from Manchester*, which was published as a Smith Brothers selection in 1853. Painted from farther upstream, the second *View* offers only a slightly different vantage point; in deference to the growing racial polarization in the United States, it does not feature the black family group.

J.L.

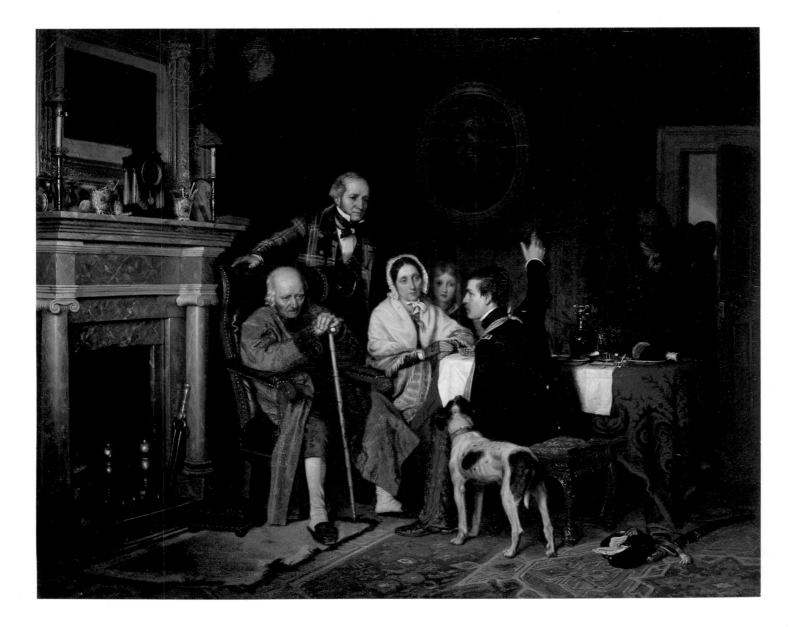

Richard Caton Woodville 1825-1855

Born to a prominent Baltimore banking family, Richard Caton Woodville is believed to have studied art at St. Mary's College in Baltimore before studying privately with Baltimore painter Alfred Jacob Miller. From 1845 to 1851 Woodville lived in Germany, spending one year at the Düsseldorf Academy and five years as the private student of Carl Ferdinand Sohn. From 1851 to 1855 he divided his time between Paris and London. Although he was an expatriate, Woodville obtained American success by exhibiting his works at the National Academy of Design and the American Art-Union in New York City. Reproduced as engravings, his images reached a broad American audience before his career was abruptly cut short by an overdose of morphia.

Old '76 and Young '48, 1849
Oil on canvas, 21 × 26⅞ (52.3 × 68.2). Signed in the lower left: *R.C. Woodville, 1849*. The Walters Art Gallery, Baltimore, Maryland

Woodville's work evolved in three directions: intimate interiors representing humorous or sentimental exchanges between closely grouped figures, nostalgic recreations of scenes from history, and portraiture. Most of Woodville's images of African-Americans present them as peripheral figures on the fringe of the composition, in a manner similar to the early work of William Sidney Mount. Benign witnesses to the central pictorial action, they function in purely supportive roles, identifying the setting as uniquely American. The servants in *Old '76 and Young '48* form a discretely respectful audience for a gentle comedy of manners that contrasts the youthful exuberance of a recent inductee for service in the Mexican-American War with the reflective nature of an older veteran of the Revolutionary War. Painted in Düsseldorf, this work was exhibited in New York in 1859 at the Art-Union, where it was admired by Walt Whitman for its vivid sense of directness.
G.C.M.

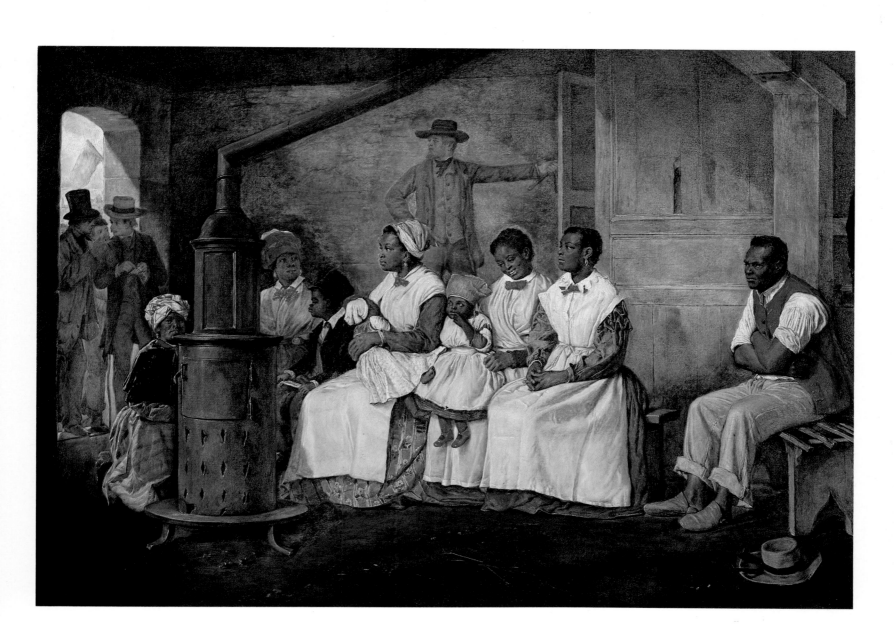

Eyre Crowe 1824-1910

Eyre Crowe was born in Chelsea, London. As a youth he gained access to English artistic and literary circles through the influence of his father, the writer Eyre Evans Crowe. After studying in Paris with Paul Delaroche, Crowe returned to London in 1844 to serve as amanuensis for the writer William Makepeace Thackeray. From 1852 to 1853 the two traveled in America, Thackeray to lecture and Crowe to write and illustrate an account of their travels. Crowe returned to England after this lecture tour to continue his painting, exhibiting as a member of the Royal Academy until his death in London in 1910. His memoir, *With Thackeray in America*, was published in 1893.

Slave Market in Richmond, Virginia, 1852-1853
Oil on canvas, 20¾ × 31½ (52.7 × 80). Signed in the lower right: *E. CROWE*. Private Collection

Slave Market in Richmond, Virginia was based on a sketch Crowe made as he sat inside the Richmond slave warehouse waiting for an auction to begin; a detailed account of this event was recorded in *With Thackeray in America*. Crowe's visit to the slave auction may have been prompted by the newspaper serialization and subsequent publication of Harriet Beecher Stowe's *Uncle Tom's Cabin*. Stowe's harsh criticisms of the slave system included a vivid description of the New Orleans slave market, where human goods were presented as neat, clean, and well-fed to improve their prices for prospective buyers. Crowe renders the slaves as individuals with realistically conveyed emotions, and the sense of quiet resignation that pervades *Slave Market* serves to magnify the enormity of the impending sale of human beings.
J.L.

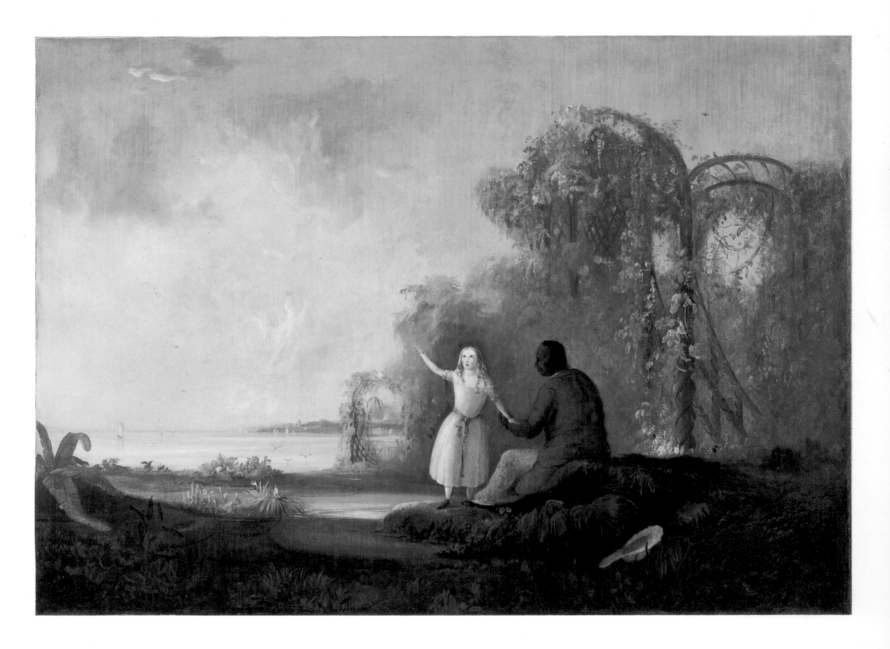

Robert Scott Duncanson 1821 or 1822-1872

Robert Scott Duncanson was the first African-American artist to gain international stature. Born in Seneca County in New York to a Scotch-Canadian father and an African-American mother, Duncanson spent his youth in a free black settlement in Wilberforce, Ontario. In 1841 he moved to Mt. Healthy, a small town outside Cincinnati, Ohio, and quickly gained patronage among abolitionist circles through an exhibition of still lifes and "fancy pieces" sponsored by The Society for the Promotion of Useful Knowledge.

Cincinnati was then a base for the prominent landscape painter Thomas Cole, and Duncanson was influenced by the meticulous detail and luminous atmosphere achieved by Cole and local artists William Louis Sonntag, Worthington Whittredge, and Godfrey Frankenstein. By the 1860s his work centered on spiritual reveries inspired by the writing of Alfred Lord Tennyson, Sir Thomas More, and Sir Walter Scott. With the aid of funds from the Anti-Slavery League and private patrons, Duncanson was able to visit Europe in 1852, 1865, and 1870. During each trip he immersed himself in European landscape

traditions, synthesizing such diverse influences as Claude Lorraine and J. M. W. Turner into his own brand of romantic realism, and received audiences with such luminaries as Tennyson and the Duchess of Sutherland.

Uncle Tom and Little Eva, 1853
Oil on canvas, 27 ¼ × 38 ¼ (69.22 × 97.16). Inscribed in the lower left: *R. S. Duncanson 1853*. The Detroit Institute of Arts. Gift of Mrs. Jefferson Butler and Miss Grace R. Conover

In spite of his early abolitionist patronage, Duncanson produced only two paintings featuring African-American subjects. *A View of Cincinnati from Covington, Kentucky* (1851) presents a black farm family examining property across the river from Cincinnati, while *Uncle Tom and Little Eva* (1853) illustrates a scene from Harriet Beecher Stowe's popular abolitionist novel. Commissioned by James Francis Conover, editor of the *Detroit Tribune*, the painting depicts Eva St. Clare reading to Uncle Tom. Duncanson captures the maudlin sentimentality and the powerful emotion that were the contrasting poles of Stowe's recently published and quite controversial novel, but by faithfully conforming to Stowe's characterizations his painting fails to represent the individuality of either of his subjects. G.C.M.

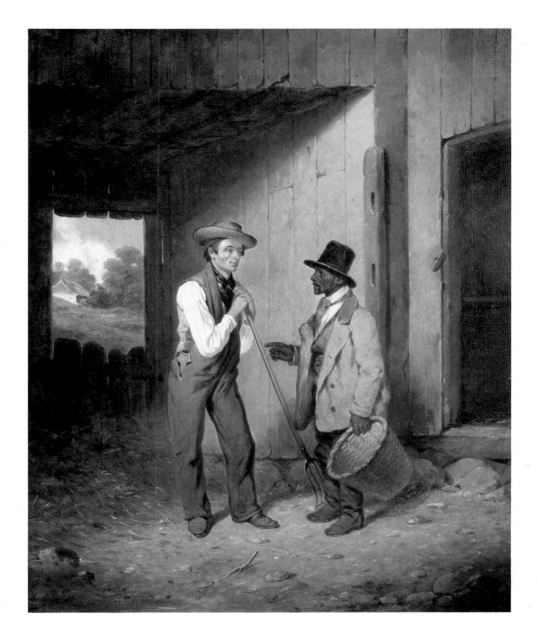

Francis William Edmonds 1806-1863

Strongly influenced by the paintings of William Sidney Mount, Francis William Edmonds specialized in humorous or everyday events from the life of the nineteenth century white urban middle class. Edmonds was born in Hudson, New York; by 1826 he was attending classes at the National Academy of Design, where he met several artists who would become important influences, including Mount and William Page. In 1829 Edmonds exhibited his first painting at the National Academy of Design. A literary piece entitled *Hudibras*, it received considerable praise. Edmonds adopted the alias E. F. Williams while exhibiting at the Academy in 1836, 1837, and 1838, probably to protect his positions as cashier at the Hudson River Bank in Hudson and the Leather Manufacturers Bank in New York City. In 1839, employed by the Mechanics Bank, he returned to signing his paintings with his own name, and the following year was granted the rank of Academician in the National Academy of Design. Edmonds prospered as a painter and businessman; respected for his business acumen, he served as treasurer for the Apollo Association (later the American Art-Union) and as an officer in the Century Association and the New York Historical Society.

All Talk and No Work, 1855-1856
Oil on canvas, 24 × 20 1/16 (61 × 51). Signed in the lower left: *FWE*.
The Brooklyn Museum. Carll H. De Silver Fund

All Talk and No Work was one of Edmonds's most successful genre compositions. In format, choice of subject, and psychological characterization, it is reminiscent of Mount's *Bargaining for a Horse* (1835) and James Goodwin Clonney's *In the Woodshed* (1844). Edmonds captures an exchange between a white farmer and a poor black laborer, but instead of recreating existing types by representing his black subject as a buffoon with distorted features, he portrays a friendly discussion between workmates. The two men view each other directly; no condescension is communicated through compositional position or physical characterization. Edmonds's characters share their complicity in breaking from the routine of work; however, the relative difference in economic status is apparent in the farmer's neat coveralls, shirt, neckerchief, and hat in contrast to the rumpled and outsized clothing of the black man.
G.C.M.

Thomas Waterman Wood 1823-1903

Although less well known than William Sidney Mount, Eastman Johnson, and George Caleb Bingham, Thomas Waterman Wood was a celebrated chronicler of nineteenth century America. His career, spanning half a century, provides a rich catalogue of American experience. Born in Montpelier, Vermont, Wood probably studied with Chester Harding in Boston, but he did not devote his full energies to art until 1850, when he married, moved to New York City, and opened a portrait studio. In the middle of the 1850s he left New York to travel as an itinerant portraitist, visiting Quebec, Kingston, Toronto, and Washington, D.C., before finally settling in Baltimore, where his focus shifted to genre subjects.

Throughout the 1860s and early 1870s Wood received widespread respect for his work, gaining the rank of Academician in the National Academy of Design. However, as public taste shifted toward European painting in the 1880s, the demand for Wood's genre works significantly diminished, and his paintings became progressively saccharine. By the 1890s Wood was known primarily for his portraits.

Wood often used friends and associates as models, a practice that lends an air of authenticity and frankness to his figures. He was fascinated by the mixture of ethnic groups that populated the United States during the latter half of the nineteenth century, and his paintings present individuals from a variety of nationalities and walks of life. Most notably, they reflect the aspiration toward middle-class morals and ideals that dominated Reconstruction. Throughout his career, Wood matter-of-factly included African-Americans in his depictions, and while he usually avoided specific commentary on social conditions, his paintings nevertheless suggest an awareness of the limited status of black Americans. In his later works Wood revived more conventional caricatures of African-Americans to take advantage of nostalgia for the imagined tranquility of pre-Civil War America.

Moses, the Baltimore News Vendor, 1858

Oil on canvas, 24 1/8 × 15 (61.3 × 38.1). Inscribed in lower right: *T. W. Wood 1858*. The Fine Arts Museums of San Francisco. Mildred Anna Williams Collection

Moses, the Baltimore News Vendor was the first genre subject that Wood submitted to the National Academy of Design. Moses sold the *Baltimore American* newspaper, and Wood probably observed him during his sojourn in Baltimore in 1856. He emerges from a dark background with stark contrasts of highlight and shadow, suggesting Wood's indebtedness to the precedent of the Düsseldorf Academy, examples of which he saw exhibited in New York at the Düsseldorf Gallery. Wood records a self-sufficient denizen of a major American city who, like the majority of nineteenth century African-Americans, found their economic opportunities restricted by Black Codes, laws that proscribed entry into certain professions and limited the ownership of businesses.

Market Woman, 1858

Oil on canvas, 23⅜ × 14½ (59.4 × 38.8). Inscribed on wall at lower right: *T. W. Wood 1858*. The Fine Arts Museums of San Francisco. Mildred Anna Williams Collection

Painted as a pendant to *Moses, the Baltimore News Vendor*, the brightly highlighted features of this working woman emerge from a dark ground; she is candidly recorded in the process of accomplishing her daily chores. In a number of works of comparable sentiment and subject matter, such as *On the Ferry* and *The Faithful Nurse*, Wood accurately details the limited working realities of most nineteenth century black women. Wood's paintings do not include representatives of the material success occasionally achieved by free blacks before the Civil War. Like most of his contemporaries, Wood simply did not acknowledge the lives of successful African-Americans who lived in such major American cities as Baltimore, Boston, and Washington, D.C.

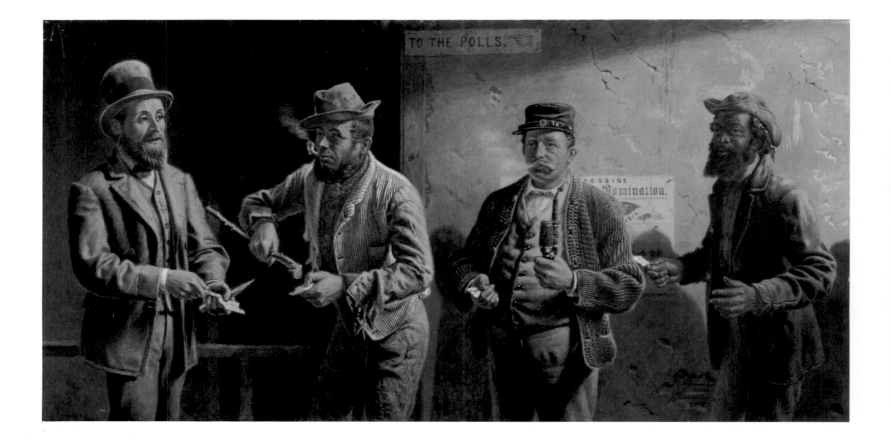

American Citizens (To the Polls), 1867
Watercolor on paper, 17 ½ × 35 ½ (44.5 × 90.2). Signed and dated
in the lower left corner: *T. W. Wood/1867*. T. W. Wood Art Gallery

American Citizens (To the Polls) commemorates the 1866 national
elections – the first opportunity for Southern blacks to vote.
Wood's ensemble of a Yankee, an Irishman, a Dutchman, and an
African-American manifests an optimistic conception of the
American ethnic melting pot. Dressed in coat and top hat, the
Yankee is affluent and shrewd, as befits the group that dominated
nineteenth century American society. The Irishman, in his working
class costume, is the epitome of drollness. Dressed in the garb of a
public transportation worker, the Dutchman conveys the dress
and demeanor of a bourgeois everyman. Having only recently
received the franchise, the African-American stands last in the
voting queue. Dressed in clothing that reflects neither trade nor
social standing, his face nevertheless bears a look of inspiration
that acknowledges his status as free citizen. Exhibited at the
American Society of Painters in Watercolor, *American Citizens
(To the Polls)* was praised at the time for celebrating the demo-
cratic nature of American society. However, while Wood's view of
nineteenth century democracy accurately depicts the divergent
groups that comprised America, its implication of harmony and
respect between differing races and classes obscures the very real
tensions of nineteenth century America – the white mainstream's
bias against the Irish, or the often violent encounters between
blacks and other minorities as they competed for positions within
a wildly fluctuating labor market.
G.C.M.

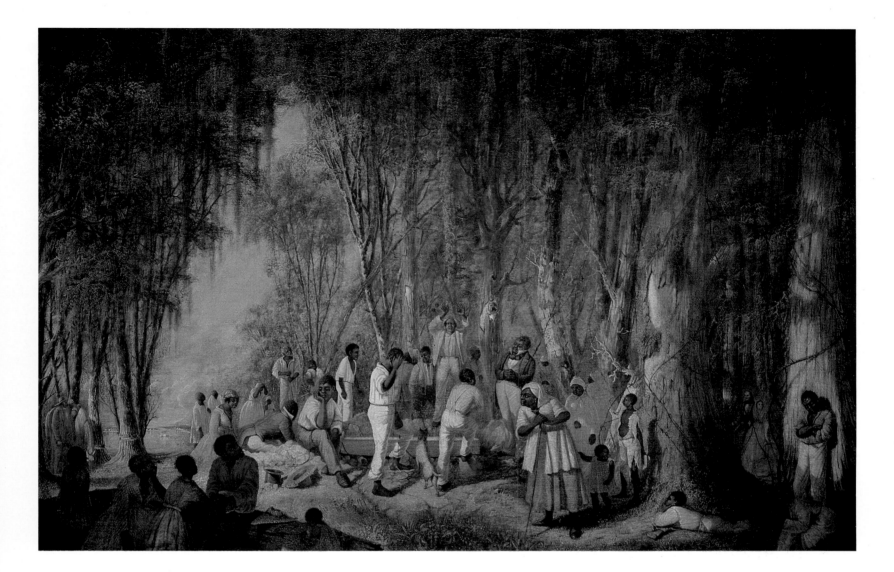

John Antrobus 1831-1907

John Antrobus was born in Warwickshire, England; little is known of his early artistic training. He immigrated to Montgomery, Alabama, around 1850, and by 1855 advertised himself as a painter of portraits. Antrobus soon moved to New Orleans; in 1859 he announced in an article in the *New Orleans Daily Crescent* his plan for a series of twelve canvases celebrating the landscape and social life of the South. Only *Cotton Picking* and *Plantation Burial* were completed before Antrobus's military service in the Confederate Army interrupted the cycle. After the war Antrobus sojourned in Chicago and Washington, D.C., before returning to New Orleans; he married and settled permanently in Detroit around 1875, where he contributed articles to local newspapers and was locally recognized as a leading landscapist and portrait painter.

Plantation Burial, 1860
Oil on canvas, 52¾ × 81⁵⁄₁₆ (133.9 × 206.5). Signed: *J. Antrobus/ 1860.* The Historic New Orleans Collection, Museum/Research Center, 1960.46

Set in northern Louisiana, *Plantation Burial* adopts the viewpoint of slave society to record plantation life. All of the central figures are African-Americans; the white couple to the right (presumably the plantation owner and his wife) stand at a discreetly respectful distance; at the far left another man (perhaps the foreman) watches near his horse. While Antrobus's approach to figuration is stylized and stiff, the well-dressed elders and the young, strongly muscled field workers who have shouldered the coffin are described as individuals rather than as stereotypes. Unlike the sentimentalized or generalized view of African-Americans that dominated antebellum genre painting, *Plantation Burial* records the ceremony of a religious rite with unusual realism, neither idealizing nor making commentary on plantation life.
J.L.

Lilly Martin Spencer 1822-1902

Born Angelique Marie Martin in Exeter, England, to expatriate French intellectuals, Lilly Martin Spencer immigrated with her family to New York in 1830. Moving to Marietta, Ohio, to escape the 1832 cholera epidemic, she was educated by her parents in Shakespeare and the classics; by seventeen she had decorated the plaster walls of the family home with charcoal murals that included full-length portraits of family members. Martin soon exhibited her paintings in Cincinnati and began her first formal art instruction with local painters James Beard and John Insco Williams.

In 1844 she married Benjamin Rush Spencer; throughout her career the sale of her paintings supported her family. Moving to New York in 1848, she exhibited at the National Academy of Design, and after taking classes in drawing and perspective at the Academy, was elected an honorary member. From 1855 through 1860 Spencer's style and subject matter proved highly popular, and several of her paintings were purchased by the Cosmopolitan Art Association for commercial distribution as prints; however,

by 1880 Spencer's style and subject matter had fallen from fashion.

Dixie Land, 1862
Oil on canvas, 20 × 24 (50.8 × 60.9). Signed in the lower right: *L. M. Spencer 1862*. Courtesy of the Richard York Gallery, New York

Spencer specialized in lush, highly stylized images that romanticized American home life. She included African-American subjects only infrequently, and when she did, usually burlesqued either their appearance or their behavior. The near-tropical landscape of *Dixie Land*, with its overt stylistic similarity to the work of Fragonard and Watteau, suggests that the setting of this portrait was specified by the parents of the child. Similarly, the dress and manner of the nursemaid stresses the rich elegance at the expense of the realities of her status. Spencer later included this same figure group within a much larger painting, *The Picnic on the Fourth of July*, subtitled *A Day To Be Remembered* (1864). Reproduced as an engraving, it was offered as a subscription premium for *Demorest's Monthly Magazine* in 1865 and became one of Spencer's best-known works.

J. L.

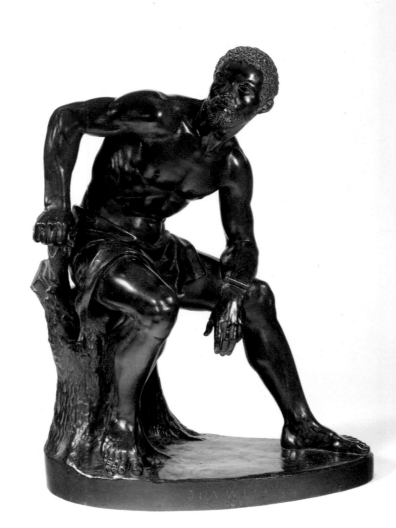

John Quincy Adams Ward 1830-1910

John Quincy Adams Ward was a key figure in the transition of
American sculpture from European neoclassicism to the expres-
sive naturalism of the late nineteenth century. Ward was born
on a farm near Urbana, Ohio, and began modeling in a neighbor's
pottery workshop. Through the aid of a sister in Brooklyn, Ward
arranged an apprenticeship with Henry Kirke Brown, a careful
craftsman who rejected a career as a neoclassical sculptor in Italy
to concentrate on American themes. Leaving his studio in 1856,
he supported himself for the next eight years by modeling busts
and presentation pieces. Ward decided against enlisting for Civil
War service but found ready commissions from Northern generals
desiring ornamental sword handles; he exhibited a plaster model
of *The Freedman* at the National Academy of Design in 1863
and was elected a full member the same year. Both *The Freedman*
and an enlarged bronze casting of *The Indian Hunter* were
exhibited at the 1867 Paris Exposition.

The Freedman, 1863
Bronze, 20 × 9¾ × 15¾ (50.8 × 24.8 × 40). Inscribed on the front
of the pedestal: *J. Q. A. Ward. Sc./1863.* The Metropolitan
Museum of Art. Gift of Charles Anthony Lamb and Barea Lamb
Seeley in memory of their grandfather, Charles Rollinson Lamb,
1979

Ward probably began *The Freedman* in response to Lincoln's
initial announcement of the Emancipation Proclamation (Sep-
tember 22, 1862). In contrast to the popular neoclassical allegory
found in Hiram Power's *The Greek Slave*, *The Freedman* directly
addresses a major political issue in moral terms. In a gesture
inspired by the *Belvedere Torso*, this realistically modeled figure
seems ready to stand and be counted. Writing in 1864, American
critic James Jackson Jarves noted that *The Freedman* "symbolizes
the African race of America – the birthday of a new people"; he
recommended that it be cast in "heroic size" and placed as the
"companion of the Washington of our nation's Capital, to com-
memorate the crowning virtue of democratic institutions in
the final liberty of the slave."
C.V.

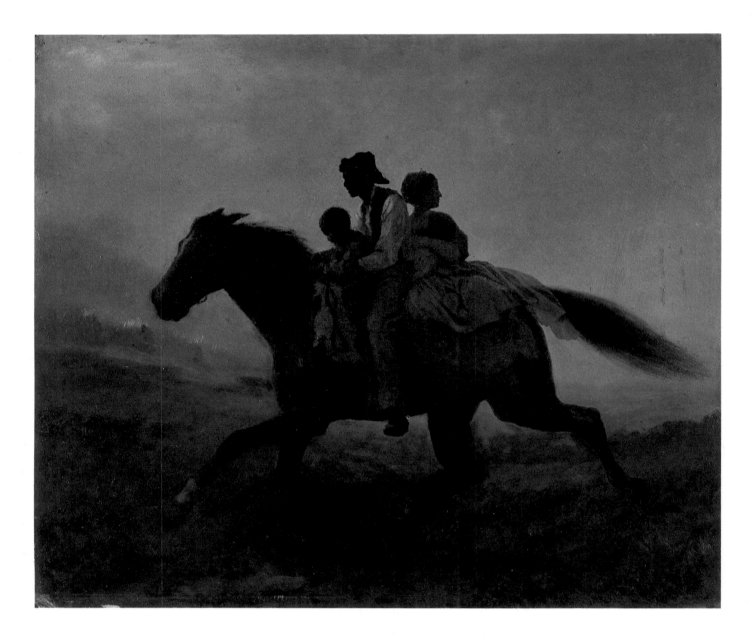

Eastman Johnson 1824-1906

Eastman Johnson's career spanned a period marked by the Civil War, Reconstruction, and America's transition from an agrarian to an industrial society. Johnson was born to a prominent political family in Lovell, Maine. Recognizing his son's artistic talent, his father sent him to apprentice with the Boston lithographer John H. Bufford. Following the failure of this short-lived apprenticeship, Johnson decided to devote his energies to portraiture, and for the next seven years produced pencil and crayon portraits of individuals from the middle and upper middle classes in Maine, Massachusetts, Rhode Island, and Washington, D.C. Johnson traveled extensively in Europe, studying at The Hague, in Düsseldorf under Emanuel Leutze, and in Paris under Thomas Couture. Returning to the United States in 1855, he painted in Wisconsin, Ohio, and Washington, D.C., before settling in 1858 in New York City.

Johnson's career can be divided into three distinct bodies of work: paintings from the 1860s that center on the activities of rural farmers in Fryeburg, Maine; idealized depictions of transient cranberry pickers, from the 1870s; and portraits of wealthy and powerful New York families, the focus of his activities during the 1880s and 1890s. His interest in African-American subject matter coincided with the onset of the Civil War, and his paintings first embrace and then transcend the conventions and stereotypes set forth by William Sidney Mount. The exhibition of *Negro Life at the South* at the National Academy of Design resulted in Johnson's election to the Academy as Academician in 1860. However, despite the fact that *Negro Life at the South* marked a notable departure from the overt stereotyping of black Americans that dominated nineteenth century American painting, it nevertheless subtly sentimentalized the all too tawdry details of poverty and servitude that shaped their lives.

Building on the success of *Life at the South*, Johnson often substituted images of genteel privation for overt poverty. *Washington's Kitchen in Mount Vernon* (1860) and *The Freedom Ring* (1860) avoid the controversial issues of slavery and abolition in favor of nostalgic recreations of a bygone era where blacks flourish under the generosity of benevolent whites. As the Civil War progressed, however, Johnson began to break with such romantic conventions. In *The Ride for Liberty – The Fugitive Slaves* (ca. 1862) and other wartime works the artist provides forceful images of black people confronted with the overwhelming changes brought about by the radical juncture of the Civil War. Ever sensitive to the changing fashionability of black subjects, Johnson's late works mirror popular nostalgia for the stable social order of pre-war life.

The Ride for Liberty – The Fugitive Slaves, ca. 1862
Oil on board, 22 × 26 ¼ (55.8 × 66.6). Signed in the lower right: E.J. The Brooklyn Museum. Gift of Miss Gwendolyn O. L. Conkling

When Eastman Johnson abandoned sentimental or cliched conventions his portrayals of blacks were both technically complex and emotionally dramatic. Among the most notable of these works is *The Ride for Liberty – The Fugitive Slaves*, which depicts the desperate courage of a black family's attempt to reach the comparative safety of Union lines. *The Ride for Liberty* is one of the most heroic of Johnson's depictions of black subjects. With its overtones of the flight of Jesus, Mary, and Joseph into Egypt, it was idealized as an icon of abolitionist doctrine.

Escape to Union Lines occurred frequently during the Civil War, especially after the passage of the 1861 Confiscation Act, which designated escaped slaves as contrabands of war and granted them freedom upon reaching territories held by Union forces. Like a number of artists, Johnson attached himself to elements of the Union Army to observe war firsthand. He did not fight but observed at least three important battles. At the Battle of Bull Run (1862) he witnessed the scene that formed the basis for *The Ride for Liberty*. Johnson painted two other versions of this subject; on the reverse of this version he inscribed the following: "A veritable incident of the Civil War seen by myself at Centerville in the morning of McClelland's advance to Manassas, March 2, 1862."

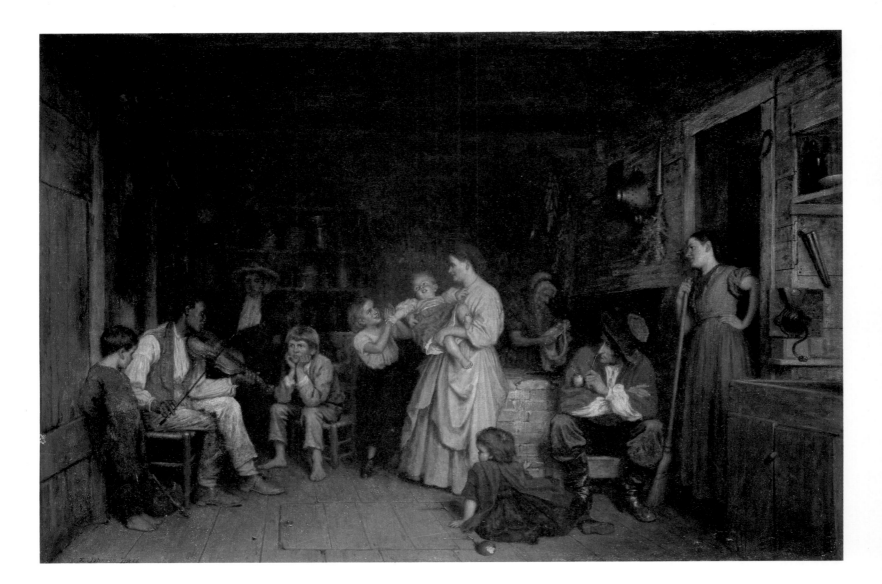

Fiddling His Way, 1866
Oil on canvas, 24 ¼ × 36 ¼ (53.9 × 92.1). Signed in the lower left: *E. Johnson 1866*. The Chrysler Museum, Norfolk, Virginia

Fiddling His Way highlights the visit of an itinerant black musician to a white family farm, reversing the scenario of Johnson's earlier *Life at the South (The Old Kentucky Home)*. This genre subject has precedents in paintings by Wilkie, Krimmel, and Mount, but while Johnson's use of a fiddler continues the theme of the music-making African-American, his forthright portrayal avoids the worst stereotypes of either character or physical appearance.

Johnson details the paraphernalia of everyday farm life with a sharp eye; more important, he binds his ensemble together compositionally and emotionally through the skillful use of overlapping forms and interconnecting glances and gestures. While the seated fiddler is portrayed sympathetically, his stance and position within agrarian society is not greatly different from Krimmel's and Mount's more obvious caricatures of music-making African-Americans. Celebrating country life, *Fiddling His Way* avoids the difficult issues of the unsettled status of African-Americans at the close of the Civil War.
G.C.M.

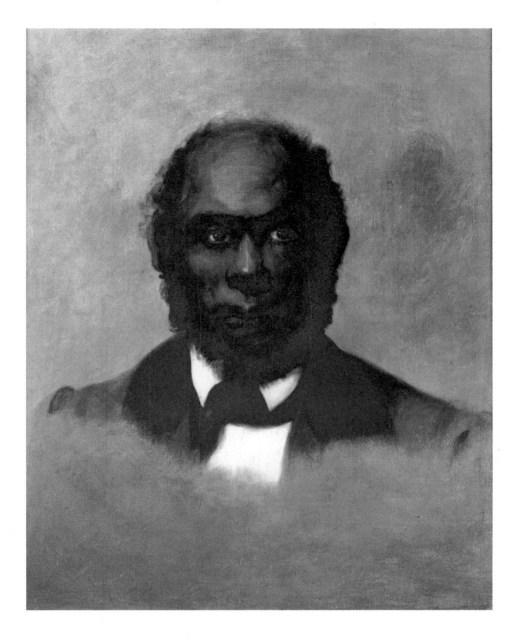

Thomas Sully 1783-1872

Thomas Sully was one of the leading portrait painters of the first half of the nineteenth century. Born at Horncastle, Lincolnshire, England, to a family of actors, he immigrated to Charleston, South Carolina, in 1792, where he received his first lessons in painting from a schoolmate, Charles Fraser. In 1799 he moved to Richmond to apprentice to his older brother Lawrence as a miniaturist, painting small ivories in watercolor before being allowed to work in oil. In 1806 Sully moved to New York; after gaining some success as a portrait painter, he resettled in Philadelphia in 1809. Sully opened a successful gallery and studio in Philosophical Hall in 1812, and, with the death of Charles Willson Peale in 1827, had no serious rivals in Philadelphia.

Sully exhibited his works at the Pennsylvania Academy of the Fine Arts, the Boston Atheneum, and the National Academy of Design. Eager to encourage his style, he compiled a detailed treatise entitled *Hints to Young Painters*, which was published a year after his death. He produced more than 2,000 recorded portraits and more than 400 subject pieces in a career that spanned more than seventy years. His register of sitters catalogues some of the most famous statesmen and heroes of his day: Presidents Washington, Jefferson, Madison, and Jackson, and prominent Europeans, such as General Lafayette and Queen Victoria, were among his sitters.

Daniel Dashiel Warner, ca. 1864
Oil on canvas, 23¾ × 19½ (60.4 × 49.5). Unsigned. The Historical Society of Pennsylvania

In 1823 Daniel Dashiel Warner moved with his family from Maryland to Monrovia, Liberia, to take part in the early colonization movement. Warner planned and built a large shipyard and rose through the ranks of government to become president of Liberia in 1861. To commemorate Warner's elevation to the presidency, The Pennsylvania Colonization Society commissioned Sully to paint the Liberian president's portrait. This bust-length, three-quarter study leaves the shoulders unfinished in the manner of Gilbert Stuart's *"Atheneum" Portrait* of George Washington (1796). Working from a photograph of Warner, Sully highlighted his pensive eyes, softening the otherwise somber and somewhat brooding countenance of his subject.

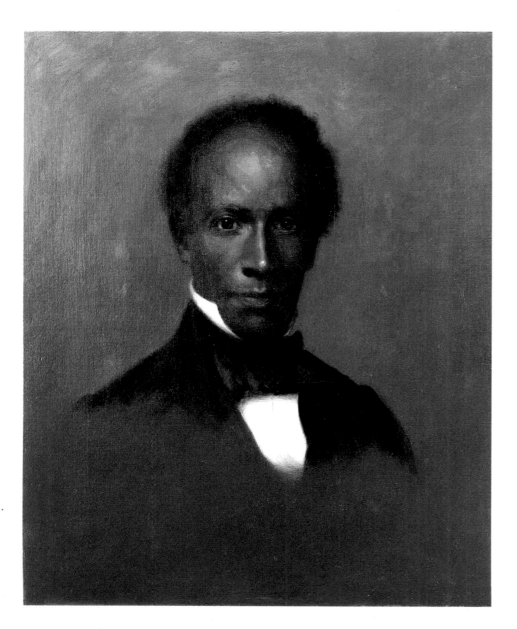

Edward James Roye, 1864
Oil on canvas, 24 × 20 (60.9 × 50.8). Signed and dated on verso:
TS/1864. The Historical Society of Pennsylvania

In 1820 the United States Congress appropriated land and funds
to allow the American Colonization Society to establish the
colony of Liberia in Africa as a homeland for free African-
Americans and emancipated slaves seeking freedom from racial
oppression. Edward James Roye was born in Ohio in 1815, and
he taught in that state's public schools and worked as a trader and
merchant before emigrating to Liberia in 1846. Roye quickly
became a highly successful businessman and began a career in

politics that saw him become chief justice of the Supreme Court
of Liberia in 1865. He assumed the Liberian presidency in 1871,
but his financial and political policies proved highly unpopular,
and after he attempted to extend his term by edict he was deposed
and imprisoned. Roye escaped from prison but drowned while
attempting to escape the country before his trial. Commissioned
by the Pennsylvania Colonization Society, the refined features that
Sully recorded were based on a photographic portrait Roye had
made in a New York studio when he visited America in 1864.
J.L.

John Rogers 1829-1904

John Rogers's genre sculptures celebrated humorous scenes from everyday life, illustrated the characters from classical literature, and even restaged popular sporting events. Rogers was born in Salem, Massachusetts. Yale-educated, he qualified as an engineer but resorted to work as a mechanic and machinist because of failing eyesight; as a young man he supervised the railroad repair shops at Hannibal, Missouri. Drawn to the visual arts as a pastime, Rogers attracted attention with a series of humorous sculptures that he modeled in his spare time. By 1858 he had decided on a career as a sculptor, and he traveled to Europe to study in Paris and Rome. Working in the ateliers of Dantin and Spence, he was introduced to the neoclassical style, which precipitated an artistic crisis that resulted in his forceful rejection of neoclassicism.

In 1859 Rogers returned to the United States, establishing a studio in New York where he began marketing the first of his small figurative ensembles. Eschewing the popularity of neoclassical style in both Europe and America, he developed a naturalistic narrative approach that combined psychological nuance with intricately realized homespun detail. He exhibited regularly at the National Academy of Design; in 1863 he was granted the status of Academician. Touching on every aspect of American life, his work enjoyed the same broad popular appeal as the prints of Currier and Ives. Rogers patented his designs and mass-produced them as plaster casts through a highly successful national mail-order business – between 1859 and 1893 more than eighty of his sculptures were patented and more than 80,000 were sold throughout the United States.

Rogers was sympathetic to the abolitionist cause; one of his earliest ensembles, *The Slave Auction* (1859), sold poorly, probably because its strong abolitionist sentiments were not appreciated by audiences not yet preoccupied by the Civil War. Later works such as *The Wounded Scout* (1864), *Uncle Ned's School* (1866), and *Freedman's Memorial* (1873) explored the details of black experience without provoking controversy and were popular items in Rogers's mail-order catalog. Widely circulated, they were primarily bought by middle-class audiences who embraced the concepts of postwar Reconstruction.

The Wounded Scout, Friend in the Swamp, 1864
Bronze, 23 × 10½ × 8½ (58.4 × 26.7 × 21.6). Signed: *John Rogers/ New-York*. Courtesy of The New-York Historical Society, New York City

During the Civil War Rogers produced a series of vignettes of African-American subjects to incorporate popular support for the war effort within his repertoire. This dramatic tableau of a black man aiding a wounded Union soldier simplified a host of controversial contemporary issues into a comfortably clear-cut moral. The first of a series of works that Rogers executed in a new and larger format, it was considered by the artist to be one of his most successful works and was praised by the abolitionist poet Lydia Maria Childs as "a significant lesson of human brotherhood for all the coming ages."

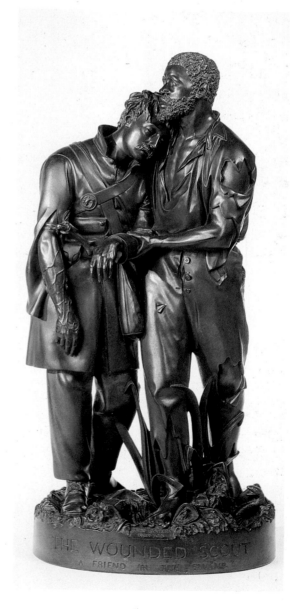

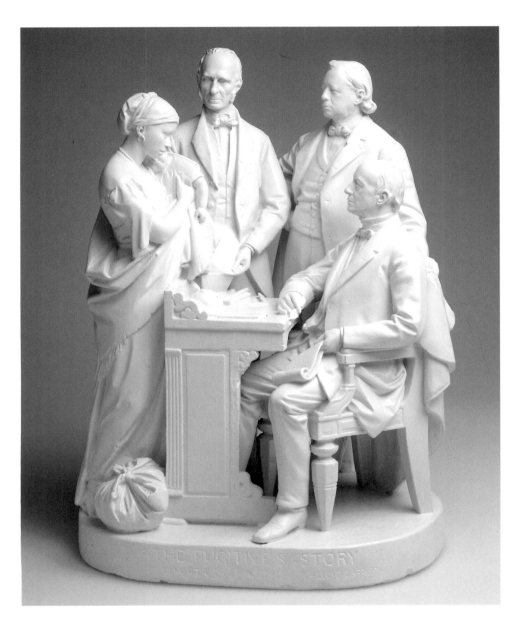

The Fugitive's Story, 1869

Plaster, 21⅞ × 15¹⁵/₁₆ × 12 (55.5 × 40.5 × 30.5). Signed: *John Rogers/New York/The Fugitive's Story/John G. Whittier/H. W. Beecher/William Lloyd Garrison*. The Cincinnati Art Museum

Rogers's commitment to the cause of African-American freedom was manifested in this recapitulation of this popular Civil War theme. Rogers arranged the leading proponents of the antislavery movement – Henry Ward Beecher, William Lloyd Garrison, and John Greenleaf Whittier – as an audience for the fugitive's tale. Rogers strikes a middle ground, encompassing the pain of the slave and the compassion of the abolitionist leaders without indulging in undue controversy or overt sentimentality.
G.C.M.

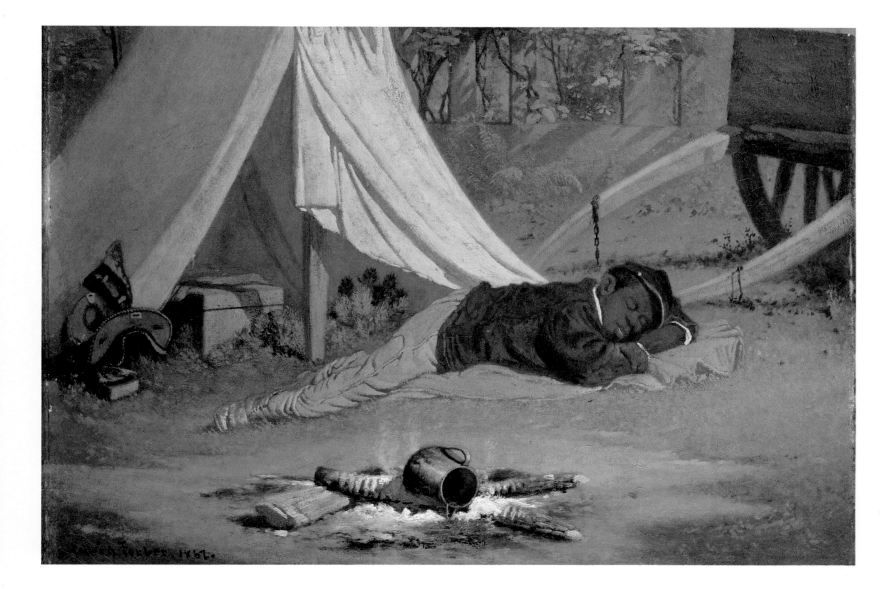

Edwin Forbes 1839-1895

Edwin Forbes was one of the most talented visual war reporters to emerge during the Civil War. Forbes began studying art in 1859 under Arthur F. Tait, a painter who specialized in genre and landscape subjects. From 1861 to 1865 he contributed drawings and prints to *Frank Leslie's Illustrated Newspaper*; traveling extensively with the Army of the Potomac, he was present at events ranging from the occupation of Manassas in 1862 to the siege of Petersburg in 1864. After the conclusion of the Civil War Forbes returned to New York but continued to travel frequently in the West and South. With fellow "special artist" Alfred R. Waud he contributed illustrations to *Beyond the Mississippi* (1867), a volume of observations on the West. In 1876 he published ninety-two etchings based on war sketches as *Life Studies of the Great War*, and in 1878 he established a Brooklyn studio and devoted himself to painting war themes. He exhibited frequently in the New York area in his later years; in 1891 he published *Thirty Years After: An Artist's Story of the Great War*, which included over 300 illustrations based on his war sketches.

Mess Boy Asleep, 1867
Oil on canvas, 14 × 20¼ (35.6 × 51.4). Signed in the lower left: *Edwin Forbes 11.1.1867*. Wadsworth Atheneum, Hartford, Connecticut. The Ella Gallup Sumner and Mary Catlin Sumner Collection

Like Homer, Forbes was interested not only in great battles and portraits of generals but also in the day-to-day existence of the enlisted man in the Union Army. His only surviving paintings recreate or illustrate the events he witnessed in the Civil War, and the African-American is an occasional subject in these paintings. *Mess Boy Asleep* (1867) reflects Forbes's experiences during the early years of the Civil War, when the bravery and competence of blacks in battle was so questioned by Union generals that they were prohibited from active combat roles and relegated to support positions. Only in the later years of the conflict, after blacks had proved their mettle in some of the bloodiest fighting of the war, would they begin to be regarded as heroic soldiers.

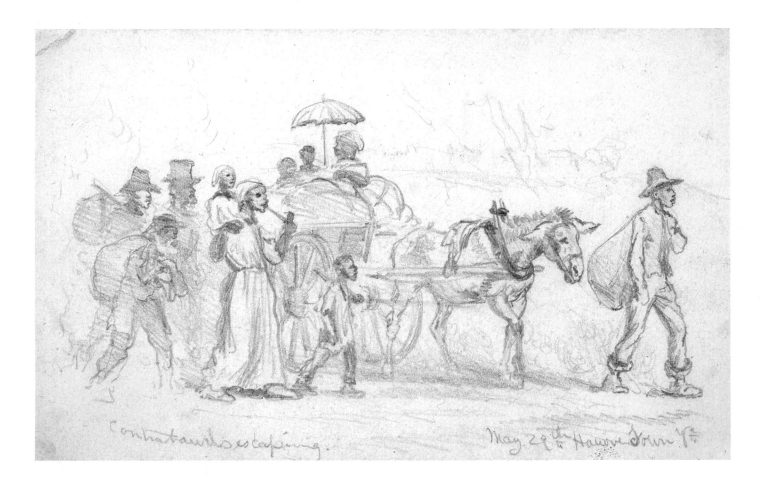

Contrabands Escaping / May 29th / Hanover Town

Contrabands Escaping, 1864
Pencil drawing, 4½ × 7¼ (11.6 × 18.6). Inscribed across the
bottom: *Contrabands Escaping/May 29th/Hanover Town.*
Library of Congress

In sharp contrast to the themes of danger and family that dominate
the dramatic portrayals of escaping slaves in Eastman Johnson's
The Ride for Liberty – The Fugitive Slaves (ca. 1862) and Theodor
Kaufmann's *On to Liberty* (1867), *Contrabands Escaping*
approaches the same subject with a reporter's practiced eye.
Forbes's laconic description provides a glimpse at the often harsh
realities facing blacks who managed to gain refuge with Union
troops. No longer slaves, they nevertheless still lacked many basic
rights and, with few resources, often followed the path of the
Union Army as itinerant scavengers to achieve a subsistence
survival. F.M.

Thomas Nast 1840-1902

Thomas Nast defined the basic structure of the American political
cartoon. Inventing such symbols as the Democratic donkey, the
Republican elephant, and the modern-day Santa Claus, he was
one of the first American artists to realize fully the power of mass-
circulated visual icons. Nast emigrated from Germany to New
York with his family in 1846. He briefly studied art with the
German immigrant painter Theodor Kaufmann and later entered
the National Academy of Design. At fifteen, he was hired by
Frank Leslie's Illustrated Weekly, where he received additional
training from Alfred Berghaus and Sol Eytinge, Jr. In 1859 he
signed with the *New York Illustrated News*, which sent him
abroad to cover Garibaldi's election campaign in Italy. He
returned to New York in 1859, and by the summer of 1862 he was
contracted by *Harper's Weekly* to cover the Civil War. Including
pungent pro-Union opinions in his war reportage, Nast began to
realize his ability to shape public sentiment. Lincoln praised the
effectiveness of Nast's cartooning, calling him "our best recruiting
sergeant."

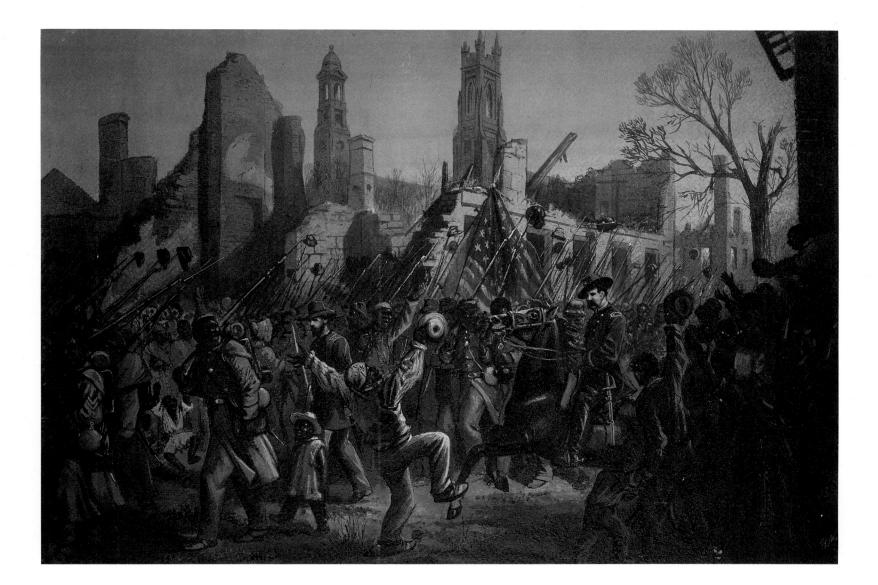

Entrance of the Fifty-fifth Massachusetts (Colored) Regiment into Charleston, South Carolina, February 21, 1865, 1865
Pencil, neutral wash, and oil, heightened with white, on board, 14¼ × 21¼ (36.2 × 53.9). Inscribed in the lower right: *Th. Nast.*
Courtesy, Museum of Fine Arts, Boston. M. and M. Karolik Collection of American Watercolors and Drawings, 1800-1875

Nast possessed an uncanny ability to react incisively to any social issue. His Reconstruction-era drawings for *Harper's Weekly* begin by summing up the initial triumphs of Reconstruction and conclude by viewing Reconstruction as a tragic experience. He commented pointedly and often bitterly on the rise of organized violence by the Ku Klux Klan and the "White Leagues" during the 1870s, and he welcomed the Civil Rights Acts of 1875 as the proper recognition of the rights of black citizens. However, after the rejection of the Civil Rights Act in 1880, perhaps because of his own increasing distrust of the premise of racial equality, Nast almost completely abandoned black subjects.

During the first years of the Civil War blacks who enlisted in the Union army were employed behind the front lines, as laborers or support troops. However, as the war progressed army leadership slowly began to allow the formation of all-black units (most often under the leadership of white generals). Many volunteer units, such as the Fifty-fifth Regiment from Massachusetts, distinguished themselves in some of the bloodiest fighting of the war. Nast's *Entrance of the Fifty-fifth Massachusetts (Colored) Regiment into Charleston, South Carolina, February 21, 1865* records the celebrated triumphal entry of one of the most famous African-American army units into the devastated city of Charleston at the conclusion of the Civil War. Probably based on a photograph, Nast's grisaille painting is a notable exception to prevailing artistic attitudes concerning the role of black soldiers in the Civil War; this theme went largely unrecorded in postwar American art.

F.M.

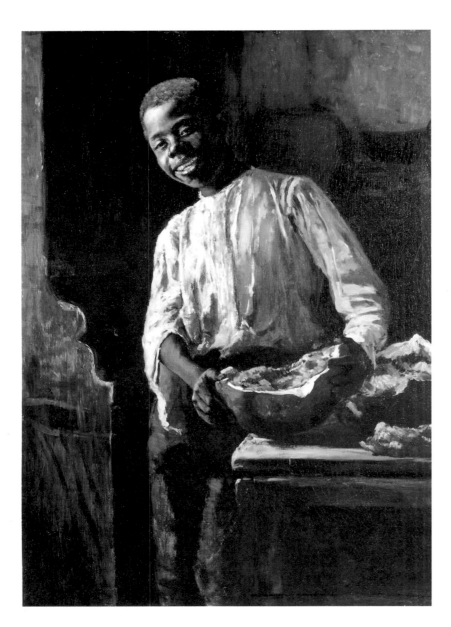

Thomas Hovenden 1840-1895

Born in County Cork, Thomas Hovenden lost both his parents as a young child and was raised in an orphanage. He apprenticed as a carver and gilder before emigrating from Ireland to New York in 1863. After attending night classes at the National Academy of Design, Hovenden painted in the Baltimore area until 1874, when he moved to Paris to study briefly with Jules Breton and Alexandre Cabanel at L'École des Beaux-Arts. Hovenden eventually joined an artists' colony at Pont-Aven, Brittany; he exhibited at the Paris Salon of 1876 and the International Exhibition of 1878. After returning to the United States in 1880, he was eventually appointed as an instructor at the Pennsylvania Academy of the Fine Arts, where Robert Henri was one of his most notable students.

Ain't That Ripe?, ca. 1865
Oil on canvas, 21 $^{15}/_{16}$ × 15 $^{15}/_{16}$ (55.7 × 40.5). Unsigned. The Brooklyn Museum. Gift of the Executors of the Estate of Colonel Michael Friedsam

Ain't That Ripe? describes a young black man whose image radiates physicality and personality, but Hovenden's linkage of blacks and watermelon employs what had already become a popular convention in minstrelsy. His use of such a recognizable motif suggests his willingness to absorb commercial and fine art conventions to create salable images of African-Americans.
J.L.

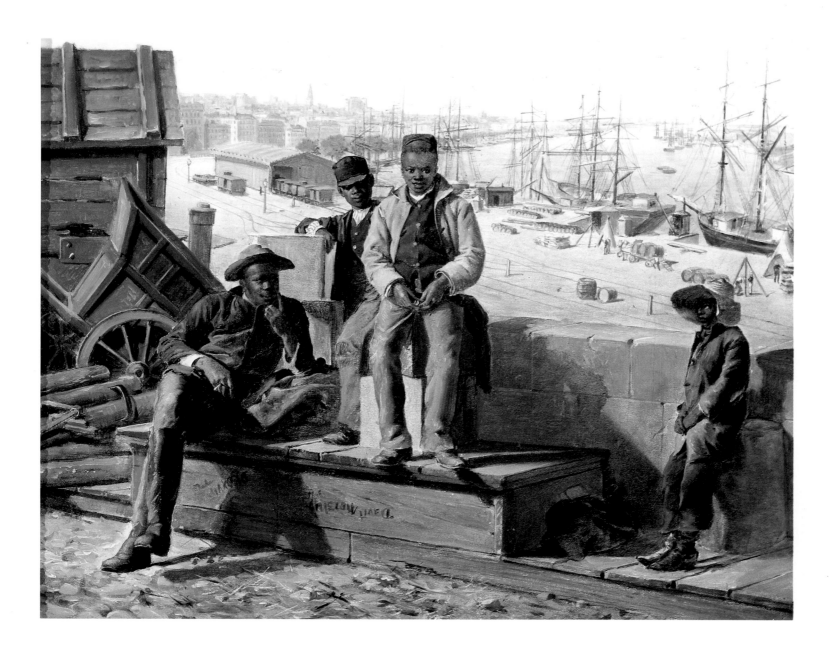

Attributed to David Norslup

Several unanswered questions surround the origin of *Negro Boys on the Quayside*. Although the painting is unsigned in any traditional manner, on one of the packing boxes there is inverted lettering that can be read as *David Norslup, Norslip,* or *Marslur*. To the left of the box, less easily read, are what appear to be the letters *DVD. XVIII* and *TC* or *TL*. Based on the details of the painting, a date immediately after the Civil War is possible. The major details in *Negro Boys on the Quayside* are not consistent with any single port city described in maps and records of the time, and it may be a composite view based on photographs or drawings of cities the artist visited during his travels in the South.

Negro Boys on the Quayside, ca. 1865
Oil on panel, 15⅞ × 19½ (40.3 × 49.5). Possible inverted inscription in lower center of canvas. The Corcoran Gallery of Art. Gallery Fund and William A. Clark Fund

The youths in *Negro Boys on the Quayside* wear the cast-off uniforms and cavalry boots of the Union Army; the image of black people lounging in an urban area in a relaxed and open manner also supports a postwar dating. The artist's treatment of African-American youths is far removed from the sentimental, nostalgic, or comic stereotypes favored by prominent mid-nineteenth century painters of African-Americans, but it is full of curious juxtapositions. While the nature of the gesture that the central figure makes is not clear, both sexual and comic overtones make the nonchalant reaction of his companions unsettling. Clearly, Norslup's matter-of-fact depiction pointedly contrasts urban and rural blacks; the idleness of the central figures, juxtaposed with the new-to-town curiosity of the figure on the right, establishes a moral polemic in the guise of objective naturalism. Such painted commentaries were rare in Reconstruction American art, and rarely well received.

J.L.

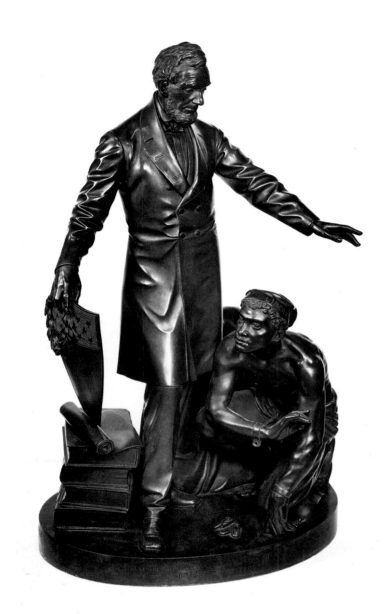

Thomas Ball 1819-1911

Born in Charlestown, Massachusetts, Thomas Ball was encouraged to pursue the arts by his father, a "house, sign and fancy painter." After his father's death he worked at the old New England Museum, where he soon began cutting silhouettes and painting miniatures. He opened a portrait miniature studio as a young man and by the 1840s was exhibiting in Boston and New York. Struggling to support himself, Ball discovered he was adept at modeling portraits in clay. In 1854 Ball traveled to Italy, where he continued to refine a naturalistic style that differed sharply with the prevailing neoclassical style favored by other American and European artists. Returning to Boston in 1857, he received his first major equestrian portrait commission, a statue of George Washington for the Boston Public Gardens. Ball divided his time between the United States and Italy until 1897, when he returned to the United States and settled in Montclair, New Jersey.

Emancipation Group, 1865
Bronze (cast in 1873), 34½ × 21 × 13 (87.6 × 53.3 × 33). Signed and dated on the base. Collection of The Montclair Museum. Gift of Mrs. William Couper

Ball was living in Florence when he heard of the assassination of Lincoln. He modeled his first study of *Emancipation Group* after hearing of Lincoln's death, using himself as a model for the crouching slave. Several years later Dr. William Greenleaf Eliot, a Unitarian clergyman who had advocated the establishment of the Western United States Sanitary Commission (a Civil War-era precursor of the Red Cross), visited Ball's studio and found the model appropriate for the Western Commission's subscription campaign, largely funded by freedmen, for a monument to Lincoln. The Western Commission subsequently suggested that the idealized slave be made more realistic, and Ball altered the head after photographs of Archer Alexander, said to be the last slave taken under the Fugitive Slave Act. The *Emancipation Monument* was dedicated on April 11, 1876, the eleventh anniversary of Lincoln's death. The monument proved extremely popular and was copied and dedicated for the city of Boston in 1879.
C.V.

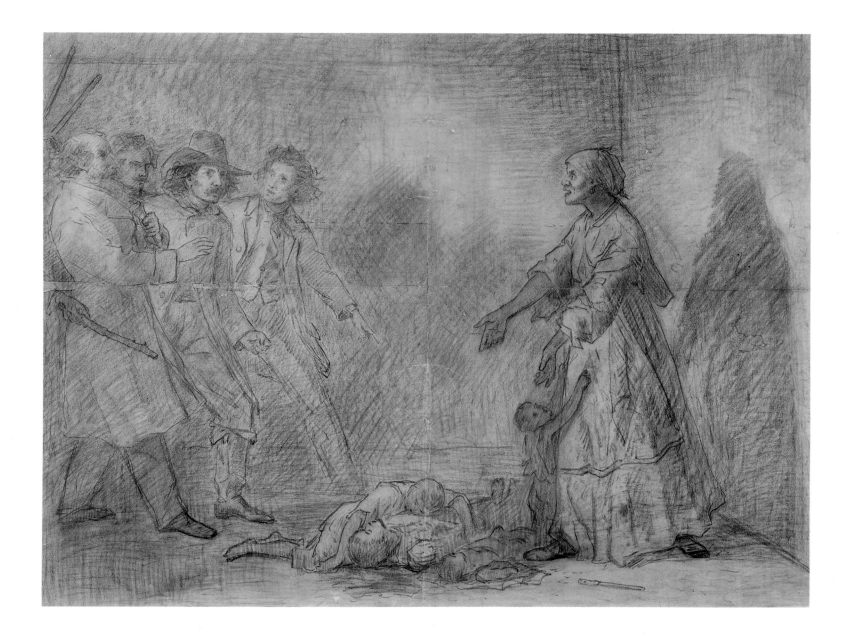

Thomas Satterwhite Noble 1835-1907

Thomas Satterwhite Noble was one of the most prominent post-Civil War American artists to regularly include African-Americans as a basic part of his subject matter. Born in 1835 in the border state of Kentucky, he was the son of a wealthy hemp plantation owner and rope manufacturer in Lexington, then the center of the state's slave trade. In 1856 he traveled to Paris to study with Thomas Couture, arriving at a time when the French master's own work moved away from grandiose history paintings toward an abundantly detailed genre style. Noble wholeheartedly adopted Couture's genre style, adapting it to themes relating to his American heritage. Returning to St. Louis in 1859, he enlisted in the Confederate Army despite his reservations about the ownership of slaves. Noble survived the war and moved to Cincinnati in 1869; his war experience, coupled with his exposure to slavery during his youth, resulted in a series of paintings depicting the horrors of slavery, emphasizing slavery's disruption of the black family.

Margaret Garner, 1867
Pencil on paper, 29 ½ × 39 (74.9 × 99.1). Unsigned. Collection of Dr. and Mrs. Mark Noble Mueller

In 1856, Simeon and Margaret Garner crossed the frozen Ohio River (the border between Kentucky and Ohio) with their four children. Fugitive runaways, they were apprehended in Cincinnati. Rather than see them returned to slavery under the Fugitive Slave Act, Margaret Garner attempted to kill her children and succeeded in stabbing one to death. The forcefulness with which Noble illustrates Garner's extreme action poignantly demonstrates his belief in the necessity of her willful break with the history of servitude. Noble painted two versions of this drawing, exhibiting the larger one at the National Academy of Design in 1867.

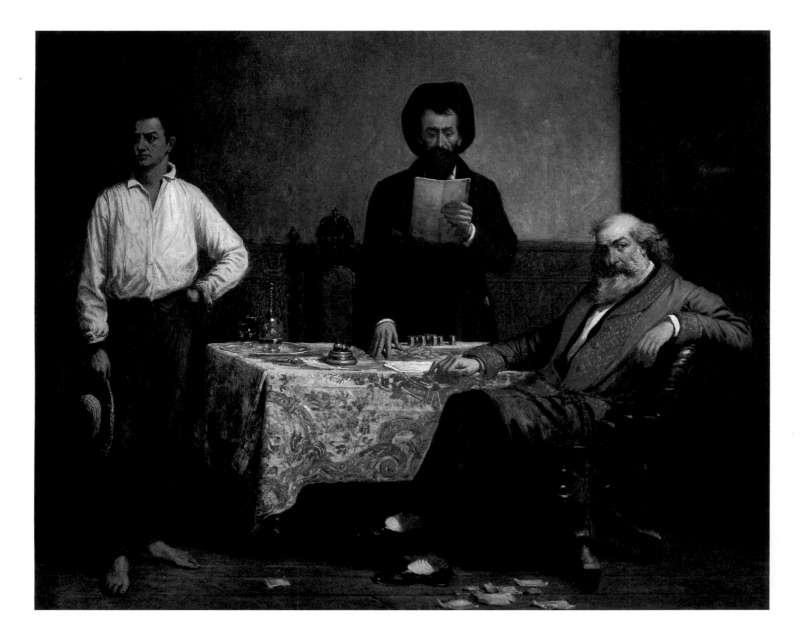

The Price of Blood, 1868
Oil on canvas, 39 ¼ × 49 ½ (99.69 × 125.73). Signed and dated in
the right center: *T. S. Noble/1868*. The Morris Museum of Art,
Augusta, Georgia

The Price of Blood depicts the conclusion of a transaction between
a wealthy planter and a slave trader. The planter waits impatiently
for the finalization of the sale, while the trader busies himself
with a studied reading of the contract. Angry and aloof, the
planter's mulatto son, who is the object of the impending transac-
tion, looks away. Noble's symbolism is quite pointed: on the wall
behind the trader are fragments of a painting of Abraham's
sacrifice of Isaac. In a setting replete with refined household
furnishings and personal belongings, these three detached figures
matter-of-factly participate in a drama that is redolent with the
trauma of impending separation and the unspoken tragedy of
miscegenation.

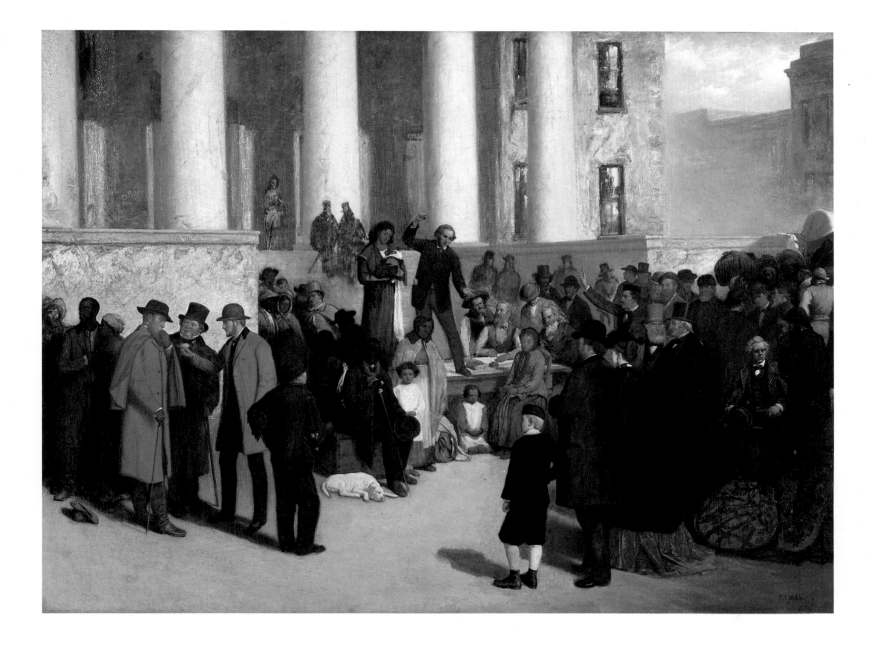

The Last Sale of Slaves in Saint Louis, 1870
Oil on canvas, 60 × 84 (152.4 × 233.4). Signed in the lower right:
T. S. Noble. Missouri Historical Society, St. Louis

The Last Sale of Slaves in Saint Louis records an 1865 slave
auction that took place on the front steps of the city courthouse
(the same courthouse where the Dred Scott case was first argued).
This painting is a second, simplified version of a painting that
was displayed in the United States Capitol Rotunda in 1867
before being destroyed by fire in Chicago in 1880. Exhibited
widely, Noble's second version provoked a protracted debate
between the liberal *St. Louis Guardian* and the conservative *St.
Louis Times* over what was widely perceived in the former border
state as the painting's negative abolitionist message.
J.L.

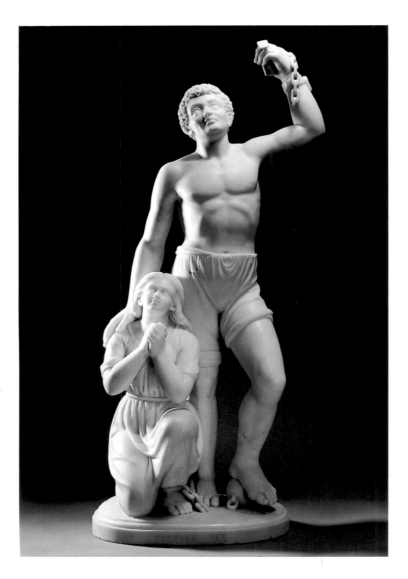

Mary Edmonia Lewis 1843 or 1845-1911

Named Wildfire by her Chippewa mother and black father, Mary
Edmonia Lewis adopted a Christian name upon entering the
Young Ladies Preparatory Department of Oberlin College when
she was thirteen. An extant pencil drawing in the Oberlin College
Archives suggests that Lewis received artistic instruction. While
a student she was beaten after being falsely accused of poisoning
two of her white schoolmates; she left school after a later accusa-
tion of theft. Settling in Boston, she was introduced to the portrait
sculptor Edward Brackett, who lent her sculpture fragments to
copy in clay; his critiques served as her formal training as a
sculptor.

In the Boston city directories of 1864 and 1865, Lewis was
listed as "sculptress"; she was known for medallions of abolition-
ist leaders and a highly praised portrait bust of Colonel Robert
Gould Shaw, the slain leader of the Fifty-fourth Massachusetts
Infantry.

Forever Free, 1867
Marble, 41¼ × 11 × 7 (104.8 × 27.9 × 17.8). Signed and dated on
the lower right of the base. Permanent Collection, Gallery of Art,
Howard University

Forever Free was originally titled *The Morning of Liberty* to
commemorate the passage of the Thirteenth Amendment. Both
the woman who kneels in grateful prayer and the man who raises
his unshackled arm in triumph are inspirational figures that
express a romantic ideal rather than specific individuals. Influ-
enced by the Greco-Roman sculpture she studied after moving to
Rome in 1865, Lewis's ensemble was one of the earliest sculptural
images to deal with themes of human bondage in light of the
abolition of slavery, and the idealized message of *Forever Free* is
no doubt the result of the artist's familial experiences with slavery
and freedom.

J.L.

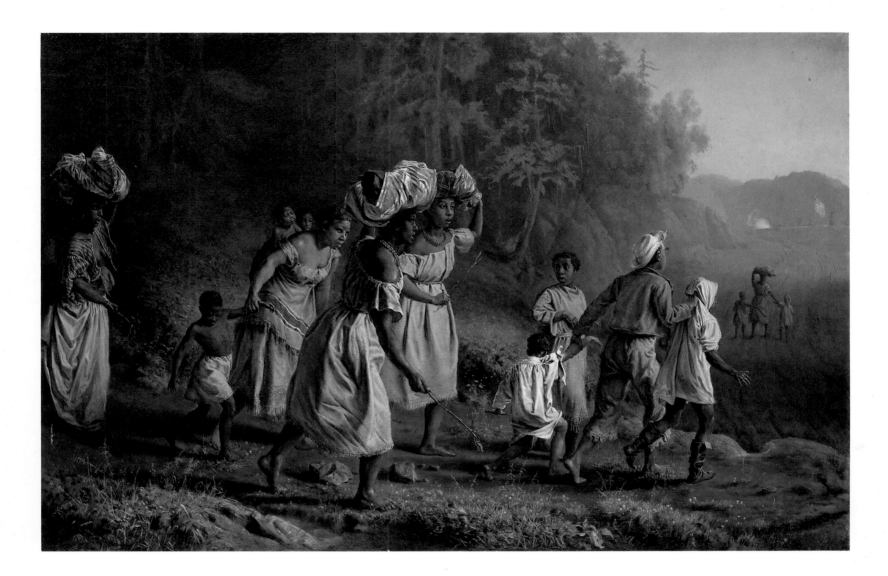

Theodor Kaufmann 1814-after 1877

Theodor Kaufmann was born in Uelzen, Hannover, Germany. Studying in Munich and Hamburg from 1833 to 1846, he worked under Peter Cornelius, Friederich Kaulbach, and Wilhelm Schar. Kaufmann fought in the barricades during the aborted 1848 Revolution in Germany; after the failure of the Prussian Army's rebellion, he fled to Switzerland and then Belgium before relocating to the United States in either 1850 or 1855. Kaufmann established himself as a portraitist and painter of biblical subjects, but a fire destroyed his studio, leaving him destitute. In an effort to support himself, he opened a short-lived art school in New York; after the failure of his school Kaufmann traveled between the major cities of the Eastern seaboard as an itinerant portraitist, occasionally supplementing his meager income with work as a photographic assistant.

Finding a hero in General Charles Frémont, who as commander of the Department of the West declared all slaves in western territories freed as an article of martial law (only to see his action countermanded by President Lincoln), the 46-year-old artist enlisted in the Union Army in 1861. After his military service

Kaufmann advocated the Union cause through a series of writings and lectures, and began a series of paintings describing famous incidents and individuals of the Civil War.

Kaufmann's style is characterized by academic draftsmanship and dramatic contrasts of color that embellish a melodramatic moment. His most celebrated thematic works, such as *Train Attacked by Indians*, *General Sherman and the Watchfire*, and *On to Liberty*, tell their stories through a series of idealized figures. His portrait subjects, which included Admiral David Glasgow Farragut, General William Tecumseh Sherman, Hiram Rhoades Revels, and Abraham Lincoln, gained him an international reputation when the paintings were exhibited in Vienna and Munich in 1869 and were reproduced by Louis Prang as modestly priced chromolithographs.

On to Liberty, 1867
Oil on canvas, 36 × 56 (91.4 × 142.2). Signed in the lower left: *Theo. Kaufmann N.Y. 1867.* The Metropolitan Museum of Art. Gift of Erving and Joyce Wolf, 1982

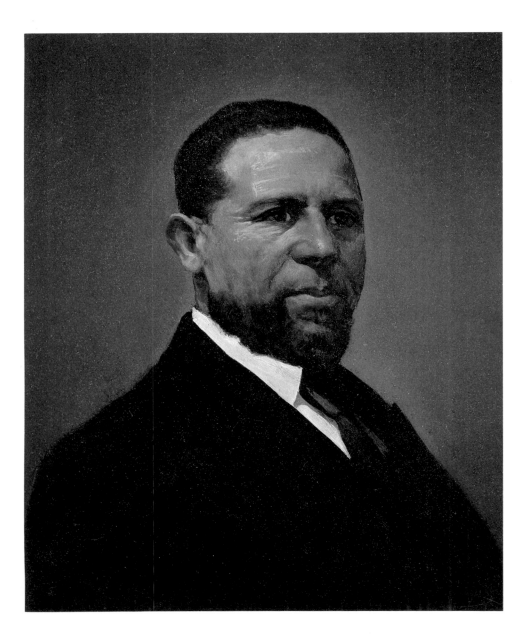

The portentous composition of *On to Liberty* illustrates the Union Army's common practice of confiscating and freeing escaped slaves as war contraband. The group of women and young children struggling to reach the Union lines has an idealized beauty and bearing that is probably as much the result of the artist's desire to ennoble his subjects as the strictures of his academic training. The absence of adult males accurately reflects the widespread conscription of African-American men as laborers for the Southern war effort. Kaufmann's tableau places special emphasis on the intense emotion and psychological stress that were by no means exclusively restricted to the field of battle, and his romantic portrayal of black people suggests the artist's commitment to this still-controversial subject matter after five turbulent years of civil war.

Portrait of Hiram R. Revels, ca. 1870
Oil on millboard, 12 × 10 (30.5 × 25.4). Signed in the lower right: *Th. Kaufmann.* Herbert F. Johnson Museum of Art, Cornell University

Elected during the momentary equality of early Reconstruction, Hiram Rhoades Revels was the first black American to serve in the United States Senate. Representing the state of Mississippi, he occupied the same seat that had been held by Jefferson Davis before he resigned to assume the Presidency of the Confederacy. This portrait was commissioned by Prang's Chromo in 1870 and was reproduced for wide public distribution. Prang's commission reflects the optimism that marked the first years of postwar Reconstruction: both the novelty of Revels's status and his very real accomplishment in gaining a seat in the Senate provided the potential for broad public interest.

Forcefully realized in an arresting counterpoint of earth tones, the work was praised by Revels as "exceedingly lifelike." In his endorsement of the widely distributed print Frederick Douglass thanked the publishing house for "this admirable picture." Observing that many artists deplorably caricatured black subjects, he noted that "We colored men so often see ourselves described and painted as monkeys we think it a great piece of good fortune to find an exception to this general rule."
G.C.M.

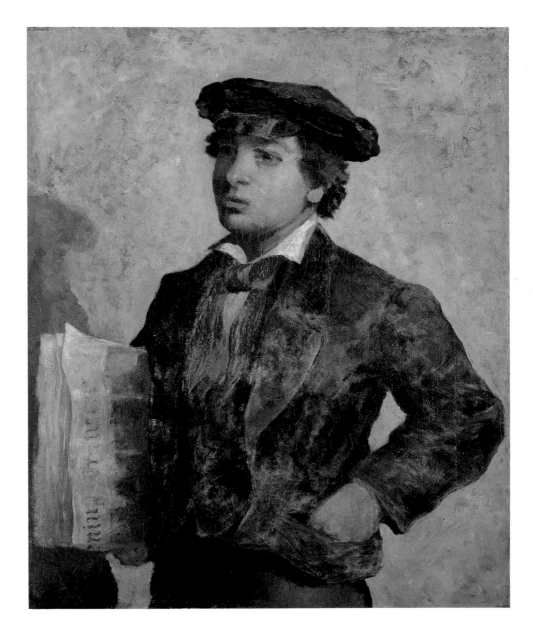

Edward Mitchell Bannister 1828–1901

Edward Mitchell Bannister was one of the few successful African-American artists of the nineteenth century to win national recognition. Born in St. Andrews, New Brunswick, Canada, to a biracial family, he became interested in the arts as a child, sketching and painting under the encouragement of his mother. By 1848 Bannister moved to Boston, where he began painting while working at menial jobs. Working as a barber, he met Christiana Carteaux, owner of several fashionable hair salons in the Boston area. Bannister and Carteaux married in 1857, and their relationship cemented the artist's position in the black middle class, permitting him to pursue a full-time artistic career.

Bannister's exposure to the Boston artistic community, then very much under the influence of the Barbizon school of landscape painting, led to an interest in this expressive style. Visits to the Boston Atheneum allowed him to see works by Jean Francois Millet, Constant Troyon, and Boston artist William Morris Hunt; the work of these artists provided important examples for his maturing style. In 1870 Bannister and his wife moved to Provi-

dence, Rhode Island, where he painted and received private students. His first-place medal at the 1876 Centennial Exposition for *Under the Oaks* made him one of the most celebrated artists in New England and confirmed his commitment to the Barbizon style. Traveling along the New England coast, he repeatedly returned to paint selected sites along Narraganset Bay.

Newspaper Boy, 1869
Oil on canvas, 30⅛ × 25 (76.6 × 63.7). Signed in the lower left: *EMB/69*. National Museum of American Art, Smithsonian Institution. Gift of Frederick Weingeroff

Before Bannister developed his mature landscape style he painted a variety of subjects, including portraits, religious paintings, still lifes, and genre scenes, such as *Newspaper Boy* (1869). The swarthy skin color of the young man in *Newspaper Boy* suggests his mulatto complexion; Bannister so generalized his features that he may have meant to indicate a homily on a theme of industry rather than to portray a specific person. This urban subject is unique in Bannister's artistic production.
G.C.M.

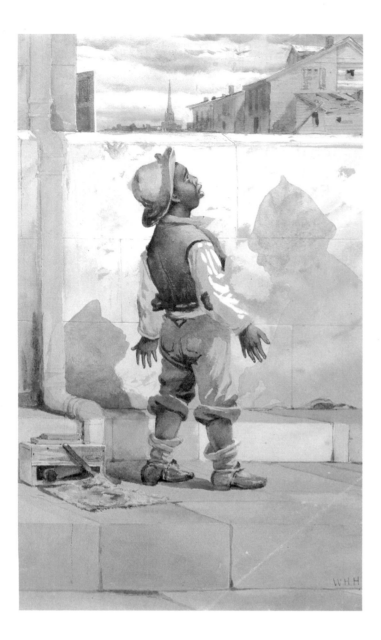

William Henry Holmes 1846-1933

Born on a farm near Cadiz, Ohio, William Henry Holmes was graduated from the McNeely Normal School in Hopedale, Ohio, and joined the faculty as an instructor in painting and natural sciences in 1870. The following year he moved to Washington, D.C., to study with Theodor Kaufmann, and in 1872 he was appointed expedition artist for Ferdinand V. Hayden's geological survey of Yellowstone. As a result of this trip he was appointed assistant geologist at the Smithsonian Institution. Traveling abroad in 1879, Holmes studied for five months at the Munich Academy; returning to Washington in 1880, he exhibited his paintings at The Corcoran Gallery of Art and the Cosmos Club. For the rest of his life art was increasingly a hobby that relieved a succession of governmental positions, including director of the Smithsonian's Bureau of American Ethnology, curator of anthropology at the United States National Museum (now the National Museum of Natural History), and curator and director of the National Gallery (now the National Museum of American Art).

Free Enterprise and the Law, ca. 1871
Watercolor on paper, 9⅜ × 5¾ (23.8 × 14.6). Signed in the lower right: *WHH*. Collection of Eugenia Weathersby

Holmes specialized in landscapes of the hills surrounding his summer home in Rockville, Maryland. He occasionally painted genre subjects, but *Free Enterprise and the Law* is his only work featuring an African-American. Although undated, it is believed to have been painted early in Holmes's career (although some scholars speculate that it could have been painted in the 1890s, when Holmes was director of the Smithsonian Bureau of American Ethnology). *Free Enterprise and the Law* suggests an early experiment by a youthful artist newly settled in Washington. Confronted by a constable with his incriminating tools scattered on the street, a young bootblack has been "caught in the act" of an activity forbidden by the District's postwar Black Codes.

J. L.

Sunday Cock fighting New Orleans — A. R. Waud

Alfred R. Waud 1828-1891

During the 1860s and 1870s Alfred R. Waud was, along with
Winslow Homer and Thomas Nast, one of America's best-known
illustrators – "a universal favorite," in the words of a contempo-
rary. After being trained in London as a decorator, Waud studied
art at the School of Design in Sumerset House and at the Royal
Academy. His original intention was to specialize in marine
subjects, but by 1850 he had immigrated to America to begin a
career as a newspaper artist. Working in Boston, he learned to
draw woodblocks for engravers and moved to New York City in
1855 to begin a free-lance career; by 1860 he had signed a contract
to contribute illustrations for the *New York Illustrated News*.

During the Civil War the illustrated weekly newspaper, a new
feature of the developing American press, was a potent tool for
recording historic events and shaping public opinion. The term
"special artist" was introduced by the editors of Harper and
Brothers to designate staff members assigned to produce a visual
record of the Civil War. The role of the special artist was much

like the role of today's documentary photographer – to provide images that would not only document and authenticate the words of reporters but also provide a graphic, grippingly emotional point of entry to the text. In 1861 Waud was hired by *Harper's Weekly* as a special artist; Waud, along with the photographer Matthew Brady, traveled with the Army of the Potomac, making his most important drawings on the spot (often with accurate detail that suggests that he supplemented his wartime records with photographic evidence). Unlike Homer and Edwin Forbes, Waud specialized in combat scenes, often venturing beyond the picket lines in order to better record the immediacy of battle.

After the war, Waud, like many other artists employed by the illustrated press, traveled westward with charting and surveying expeditions in order to record the Indian wars, skirmishes that flared with increasing frequency between 1862 and 1890. He also traveled throughout the South, contributing to magazines such as *Every Saturday* and *Harper's Weekly*; forty of his drawings of the South appeared in A. D. Richardson's *Beyond the Mississippi* (1869). Waud's assignments were many and varied but, unlike Nast, he produced few paintings in color. He remained essentially a sketch artist, providing pictures ready for the prepublication transformation of the engraver's tools.

Waud was among the first illustrators to exhibit at the National Academy of Design, and, according to *Appleton's Annual Cyclopedia and Register of Important Events of the Year 1891*, he was one of the first artists in the country to paint grisaille versions of his illustrations. He prospered in his later years, maintaining in New York a palatial twenty-two-room house. Plagued by poor health, Waud nevertheless produced illustrations until his death in Marietta, Georgia, in 1891, during a sketching tour of Southern battlefields for a new series of Civil War narratives.

Sunday Cockfighting, New Orleans, ca. 1871
Pencil on gray wove paper, 7¾ × 9⁹⁄₁₆ (19.7 × 24.2). Signed in the lower right: *A. R. Waud*. The Historic New Orleans Collection

In 1871 Waud traveled to New Orleans with the writer Ralph Keeler to report on postwar life in that prominent Southern city. The scene described in *Sunday Cockfighting* shows a cosmopolitan Sunday audience whose racial diversity symbolizes the relative optimism that existed at the height of Reconstruction. Published in *Harper's Weekly* of July 21, 1866, it was accompanied by a text which mentions that "full-blooded negroes and elegant mulattoes sat side by side with whites, and among the latter were Yankee merchants, Southern planters, professional gamblers, Mexicans, Cubans, Frenchmen, and Spaniards."

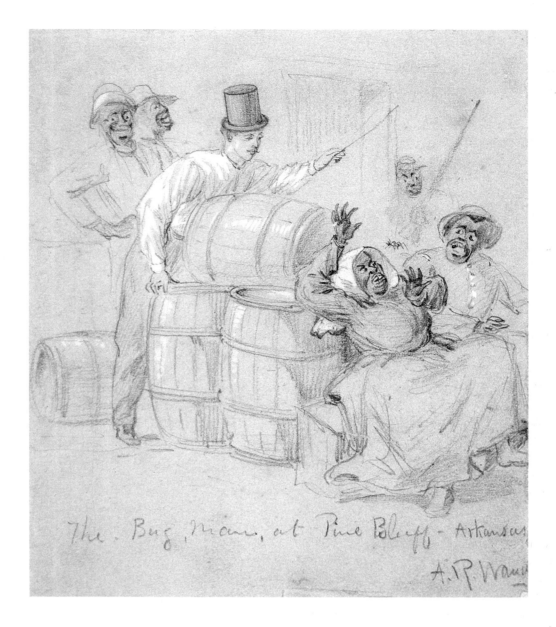

The Bug Man at Pine Bluff, Arkansas, ca. 1871
Pencil and white wash on gray wove paper, 5⅜ × 4¾ (13.6 × 12.1).
Inscribed across the lower portion of the drawing: *The Bug Man
at Pine Bluff, Arkansas, A. R. Waud*. The Historic New Orleans
Collection

Waud sketched this picture of a white man teasing a black woman
with a toy bug around the same time that he drew *Sunday Cock-
fighting, New Orleans*. "Bugman" was a Southern slang expres-
sion used to frighten children, much as the term "bogeyman" has
a similar meaning in this century, and Waud may have intended
a moralist subtext to his sketch. The effects of the prank are
shared by several black men who seem to be especially pleased by
the woman's terror. Strikingly, and in sharp contrast to *Sunday
Cockfighting, New Orleans*, the simplified expressiveness of the
white man differs sharply from Waud's characterization of black
subjects who are described in a series of broadly sketched lines
that identify both animated gesture and the distinguishing char-
acteristics of racial physiognomy.
F.M.

Winslow Homer 1836-1910

Winslow Homer, along with William Sidney Mount, remains an almost archetypical American artist. Born in Boston, Homer was introduced to the arts at an early age by his mother, an ardent amateur watercolorist. In 1855 he began a two-year apprenticeship in the lithography shop of J. H. Bufford, leaving in 1857 for work as a freelance illustrator for *Ballou's Pictorial Drawing-Room Companion*. Homer registered in the Life School Class at the National Academy of Design in 1859; the following year he exhibited his first work at the Academy.

While still a student, Homer had begun freelancing for *Harper's Weekly*; with the outbreak of the Civil War, he was contracted as a "special artist" and sent to cover the front. Like the poet Walt Whitman, Homer was not so much interested in the romance and drama of war as he was attracted to the more mundane realities of army life. During the war Homer produced two series of lithographs for Louis Prang: *Campaign Sketches* (1863) and *Life in Camp* (1864). Some of his earliest oil paintings were based on images first recorded in drawings and reworked in these lithographs.

Homer was elected to the National Academy of Design as an Academician in 1865 and traveled to Paris the following year. Attending the Universal Exposition, he was influenced by the paintings of Edouard Manet and Japanese woodblock prints. The following year he exhibited two of his Civil War paintings, *The Bright Side* (1865) and *Prisoners from the Front* (1866), at the Exposition. Returning to the United States in 1867, Homer began to search out new genre subjects, painting scenes of the Adirondacks and African-American life in Virginia. Developing motifs and figurative groupings that reappear in many of his paintings, Homer recombined images painted from life within larger compositions painted entirely in the studio, creating an evocative naturalism that is in fact a hybrid of observation and carefully realized composition.

In 1884 Homer made the first of several visits to the Caribbean. Toward the end of his life he spent a good part of each winter visiting the Bahamas, Bermuda, or Florida. His sojourns in the Caribbean produced some of his finest paintings; many depict the black inhabitants of the islands in the midst of their daily activities. During this period he returned to a favorite theme: man's struggle for survival against the perils of the sea. *The Gulf Stream* (1899) is a stunning example of Homer's metaphoric approach to subject matter. Informing these late paintings is an emphasis on the loneliness of the human condition, which reflected the artist's last years as a near-recluse.

At a time when most American artists treated blacks with a mixture of clichéd condescension and incomprehension, Homer evolved a personal conception of black identity based on close observation that allowed him to combine physiognomical accuracy and symbolic complexity. After producing a few caricatures as a young artist, his war reportage and early paintings show a growing sophistication in their conception of black subjects. Beginning in the 1870s, Homer's pioneering perceptions of black people deviated significantly from the increasingly negative or limited role accorded African-Americans at the end of postwar Reconstruction.

Homer's conception of African-Americans was shaped by the abolitionist arguments that were a prominent part of the intellectual discourse of pre-Civil War Boston, but he did not make significant personal acquaintances with blacks until he began working as a wartime correspondent. Blacks figure prominently in his war sketches and paintings, but his approach to African-American subjects did not reach maturity until 1875, when he made the first of a series of trips to Petersburg, Virginia.

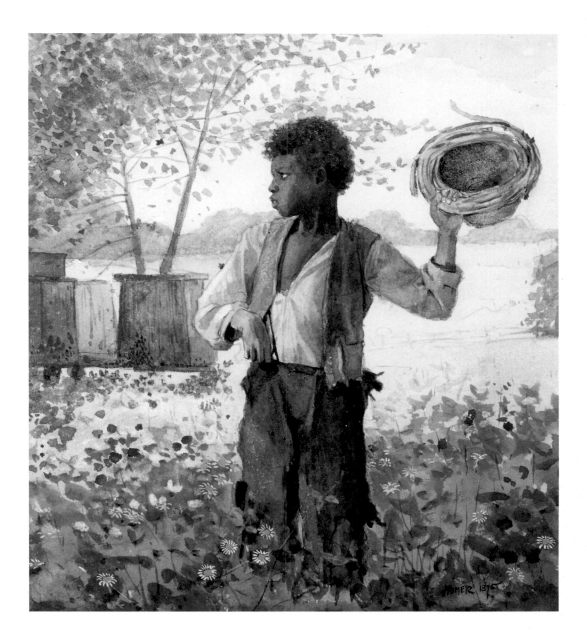

Busy Bee, 1875
Watercolor on paper, 10 ⅛ × 17 ⅝ (25.7 × 44.8). Signed in the lower right: *Homer 1865*. Private Collection, New York

Busy Bee places a young boy, a model Homer used in other works, in front of beehives, a traditional symbol of industry. Standing in a field of daisies, suggestive of simplicity and innocence, the adolescent does not direct his gaze toward the viewer (Homer's work seldom offers a directed gaze) but prepares to defend himself against his tormentor. As with many of Homer's Petersburg paintings, *Busy Bee* is layered with a variety of meanings, from the punning title to the symbolic components of the composition, that can be read naturalistically or as a subtle commentary. Whether seen as a cautionary tale against indolence or an allusion to the increasingly hostile territory that blacks tried to hold as Reconstruction deteriorated, the psychological identity of Homer's subject is nonetheless powerfully palpable.

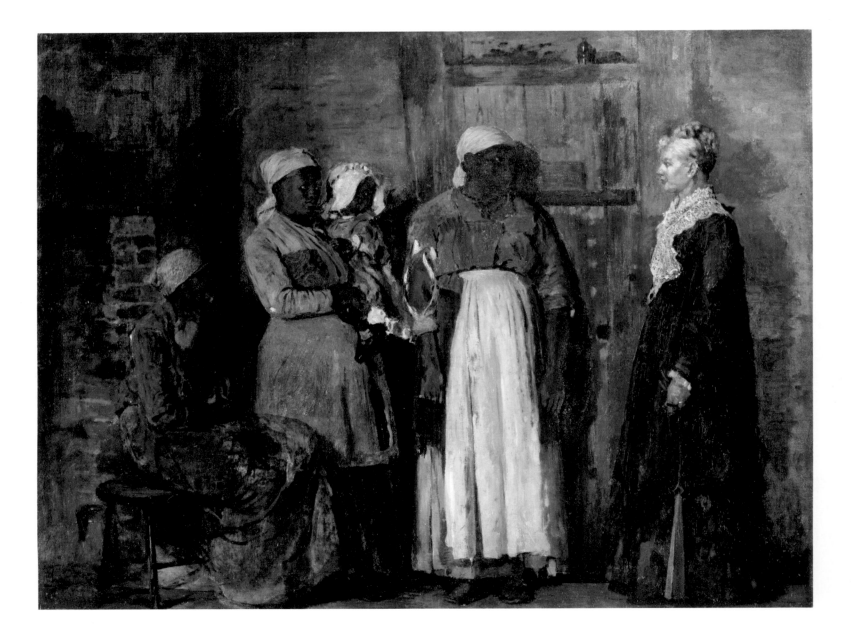

A Visit from the Old Mistress, 1876
Oil on canvas, 18 × 24⅛ (45.7 × 61.3). Unsigned. National
Museum of American Art, Smithsonian Institution. Gift of
William T. Evans

Avoiding excessive anecdotal touches, Homer creates the bare
details of a scene thick with tension. However, how much of an
allegory Homer intended to be read into this staged setting is
unclear. (It is possible that he was pointedly critiquing Sol Eytinge,
Jr.'s, nostalgic fantasy *Virginia One Hundred Years Ago,* which
appeared in *Harper's Weekly* in August 1876.) The awkwardness
between the mistress and her former slaves is discernible through
the tension deliberately displayed in the poses of the figures and in
the narrow space that separates white and black. No one has the
upper hand – these four women, now estranged, exchange gazes
in an ambiguous situation that has not yet deteriorated into
hatred. The painting, as Wood and Dalton point out, "crystallizes
into a single moment the staggering realization faced by all
Southerners after the Civil War – both black and white – that
things will never again be the same, that American society had
been irrevocably changed by the abolition of slavery." Homer
separates the races by a narrow space, an ambiguous territory
that both sides sense but which neither side moves to bridge.

In 1878 Homer sent five paintings, including *A Visit from the
Old Mistress,* to the Paris Universal Exposition; in 1880 he
exhibited the painting again at the National Academy of Design,
where it received critical praise for its freshness and originality.
However, the revolutionary nature of this attitude was more
clearly reflected in the barbed taunts from vocal Virginia white
critics, as well as in complaints from members of the black com-
munity, who, objecting to Homer's depiction of blacks as exclu-
sively poor and rural, noted that "there were plenty of well-
dressed negroes if he would but look for them." Petersburg was a
Republican stronghold during Reconstruction, and blacks held
a variety of political offices, ranging from councilman to deputy
customs collector.

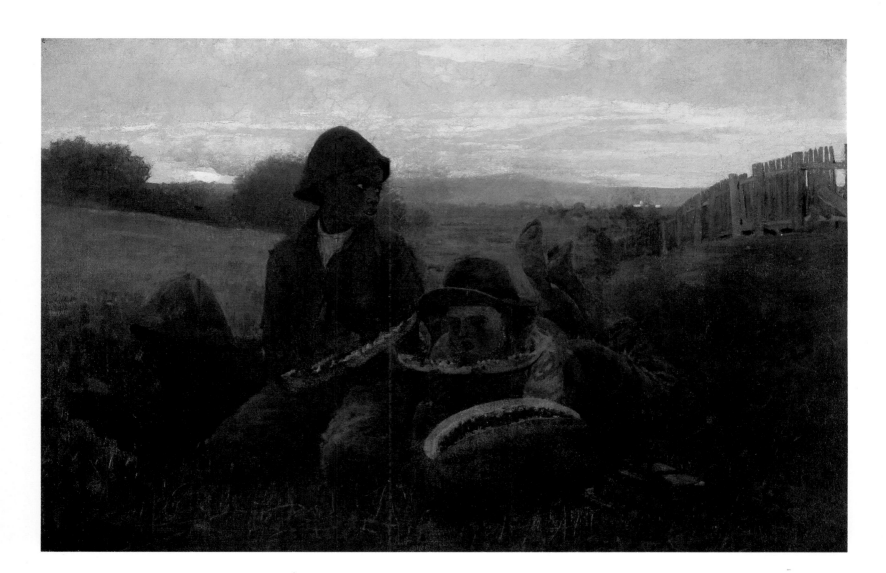

The Watermelon Boys, 1876
Oil on canvas, 24⅛ × 38⅛ (61.3 × 96.8). Signed in the lower left:
"Homer 1876". Cooper-Hewitt Museum, The Smithsonian
Institution's National Museum of Design. Gift of Charles Savage
Homer

The Watermelon Boys was one of Homer's most popular Peters-
burg images. Contemporaries admired it for its sense of humor,
its vitality, and its distinctively American flavor. Homer probably
knew of associations between blacks and watermelon that had
been popularized on the minstrel stage as early as the 1850s;
however, his use of this image predates the explicitly derogatory
linking of the watermelon with blacks that developed in the
1880s after the collapse of Reconstruction.

The youths – two black and one white – who sit in a field
contentedly enjoy the results of what appears to have been a raid
on a neighboring watermelon patch. A bundle of schoolbooks,
alluding to the freedman's hope for public education, sit to
the right of this ensemble, metaphorically suggesting both the
value Reconstruction blacks placed on education as a means of
bettering their position in society and, through their abandon-
ment, the difficulties of gaining education in the face of pleasurable
temptations.

The sentinel-like figure at the apex of the right pyramid of
figures is also the painting's emotional centerpiece. The look on
this boy's face is disturbing, suggesting an anticipation of immi-
nent danger. Homer often altered compositions when transposing
them from one medium to another, and when an engraving of the
painting appeared in August 1878 in *Art Journal*, it included an
old man threatening the boys from the far side of the fence.

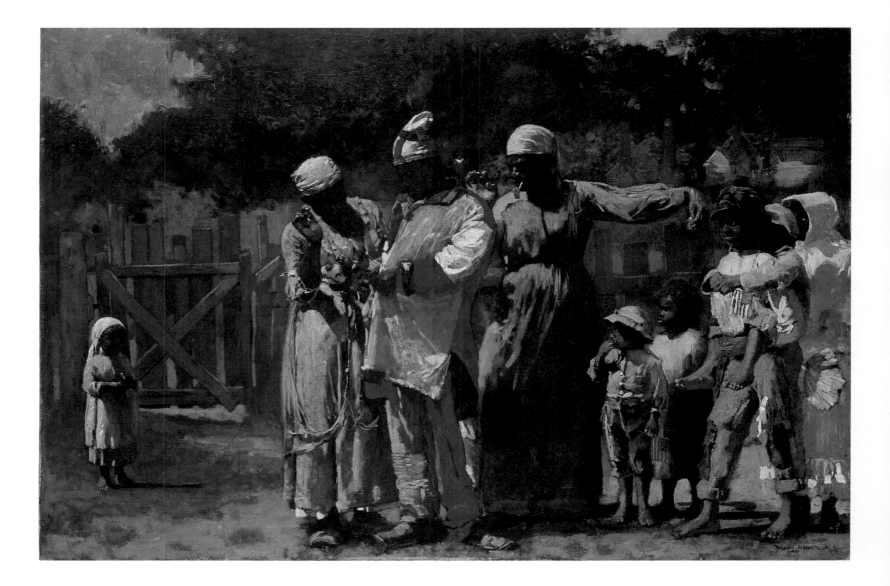

Dressing for the Carnival, 1877
Oil on canvas, 20 × 30 (50.8 × 76.2). Signed in the lower right:
Winslow Homer NA 1877. The Metropolitan Museum of Art.
Amelia B. Lazarus Fund, 1922

The ensemble composition and Japanesque sense of color of
Dressing for the Carnival exemplifies the unconventional tactics
Homer adopted in his effort to develop new genre motifs that
would reflect the details of life he observed in the South. Homer
almost inevitably tied such moments of technical facility to
narrative content. While *Dressing for the Carnival* has been
described as depicting either a Fourth of July celebration or a
Mardi Gras carnival scene, it most probably represents a family
preparing for Jonkonnu (also known as Jonkeroo). This holiday, a
blend of African and Caribbean masquerade originally celebrated
on Southern plantations at the end of the year with a day of
symbolic role reversal, included free passage by blacks to the big
house for entertainment and the demanding of coins and gifts.
After the Civil War Jonkonnu became a celebration of the freedom
granted slaves by the Emancipation Proclamation.

The male figure's harlequin costume is suitable for parade or
carnival, while his headdress is strikingly similar to the Liberty
cap associated with freedom and revolution since the Paris
uprising of 1789. However, his mood, as well as the mood of the
children that cluster around him or watch from a distance, is
strikingly somber, while the women display the preoccupied
concentration required for skilled work. Many of the ancillary
details in this painting – the butterfly that flies away, the closed
gate in the background – can be interpreted as metaphors that
question the lasting ability of Reconstruction, perhaps mocking a
celebration of the freedoms promised by Emancipation, which
by the later years of the 1870s were beginning to be seriously
compromised. True to the experiences of black men and women
in the South after Reconstruction, euphoria has given way to
grimmer realities, and the future looms as a series of questions
with no ready answers.

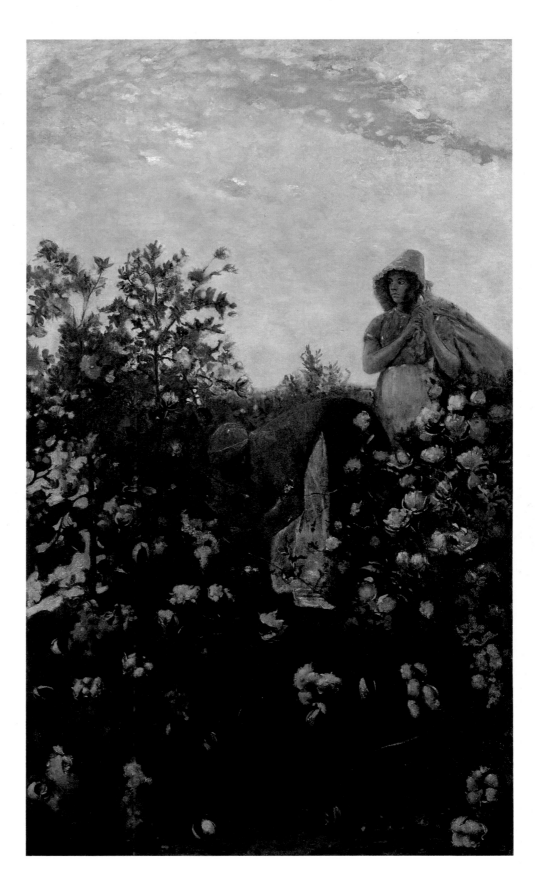

Upland Cotton, 1879-1895
Oil on canvas, 49 × 29¼ (120.5 × 74.3). Signed and dated in the
lower left: *"Homer 1879"*. Courtesy of Weil Brothers

While most of Homer's oils and watercolors from Petersburg
show blacks in more intimate or relaxed situations, *Upland
Cotton* emphasizes the hardships sharecroppers and contract

laborers endured as an isolated, disadvantaged group within Southern society. Painted three years after *The Cotton Pickers*, his first painting depicting rural black women at work in the cotton fields, the figures in *Upland Cotton* have a strongly decorative function. Smaller than the statuesque workers in *The Cotton Pickers*, they recede within the larger perspective of diagonals in the vertically formatted landscape, providing fewer of the details of human presence. Strikingly, the high horizon line diminishes the viewer's perspective of the women to the point where the cotton plants threaten to surround and engulf them.

Homer may have derived some of these compositional tactics from an awareness of Japanese prints gained during his trip to Paris in 1866. In the late 1870s at least one critic pointed out the influence of Japanese art on Homer's work in a review of the National Academy annual exhibition of 1879, specifically mentioning *Upland Cotton*. Homer exhibited this painting so often that one critic commented that it was "too well known to need future allusion." Despite such widespread recognition, however, Homer never sold the painting. He kept it in his personal collection, and evidence suggests that it preoccupied him for many years, as if he were never quite satisfied with the results. Sometime after it was exhibited in Atlanta in 1895 Homer altered it again, creating the painting's final state.

F.M.

Thomas Eakins 1844-1916

Thomas Eakins pioneered an uncompromising, rigorous analysis of life that he considered scientific realism. Born in Philadelphia, he developed interests in both art and science as a child. Enrolling in the Pennsylvania Academy of the Fine Arts in 1861, he studied with Christian Schussele, a specialist in historical anecdote. Eakins supplemented his formal studies with anatomy classes at Jefferson Medical College; in 1866 he traveled to Paris to study at the École des Beaux-Arts with Jean-Léon Gérôme and Léon Bonnat, two of the leading academic teachers of the day.

Eakins returned to Philadelphia in 1870, a time when American art was dominated by nostalgic revivals of the grandiose romanticism of the Hudson River School or the sentimental Americana of genre scenes. His first mature work, *Max Schmitt in a Single Scull* (1871), coupled a precocious, near-photographic precision with an intuitive ability to relate forms in terms of light. Following this early success he embarked on a series of paintings of urban men pursuing recreation that are striking departures from the prevailing views of picturesque rural scenes involving work.

Between 1873 and 1874 Eakins resumed his anatomical studies at Jefferson Medical College; throughout his life he insisted on a firsthand study of human anatomy.

In 1878 Eakins joined the faculty of the Pennsylvania Academy of the Fine Arts. In the early 1880s he began to experiment with photography, and in 1884 he collaborated with Eadweard Muybridge, using sequential still photography to study human and animal motion. In 1896 Eakins resigned from the Academy because of criticisms directed at what were perceived as his radical teaching methods, particularly his use of anatomical studies and nude male models. Loyal students left with him and established the Philadephia Art Students League.

During the 1890s Eakins abandoned all forms of painting except portraiture. In addition to portrait commissions, his sitters included friends, relatives, or fellow artists who are depicted with a combination of concrete form and psychological insight that is rare in American art. If the number of Eakins's black subjects is fairly small (he painted six major oils and watercolors in which African-Americans figure prominently), the range of attributes that he included in his works was by no means as narrow as the simplistic nostalgia or the implicit racism that dominated most post-Reconstruction images of blacks.

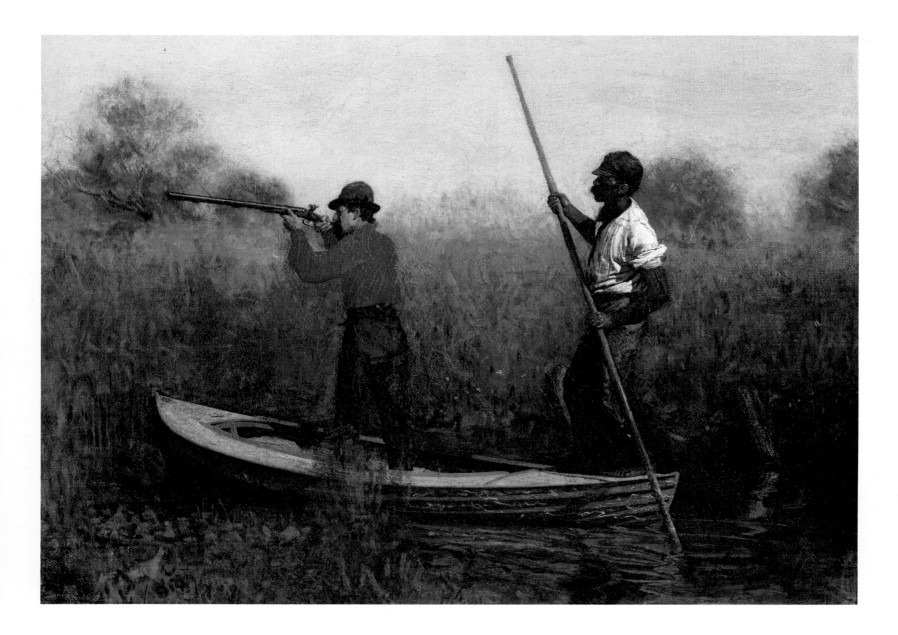

Will Schuster and Blackman Going Shooting (Rail Shooting),
1876
Oil on canvas, 22 ⅛ × 30 ¼ (56.2 × 76.8). Signed in the lower
right: *Eakins 76*. Yale University Art Gallery. Bequest of Stephen
Carlton Clark, B.A. 1903

The title *Will Schuster and Blackman . . .* provides pointed
perspective: the white man is named, while the identity of the
black man remains a mystery; he is identified only in terms
of race. Eakins portrays both of his subjects with careful precision,
describing a service economy that existed for the pleasure of a
growing class of wealthy whites who had the time for leisure and
the desire for recreation in a rural environment. The unspoken
subtext of Eakins's choice of title maximizes the differences in
class between hunter and guide by phrasing the difference between
whites and blacks in terms of an interdependent but clearly
hierarchical economic relationship.

The Poleman in the Ma'sh, ca. 1881
Brown wash heightened with white over graphite and black chalk, 11 × 5⅞ (27.9 × 14.9). Unsigned. National Gallery of Art, Washington, D.C. Julius S. Held Collection, Avalon Fund

Eakins produced a number of illustrations for popular magazines such as *Scribner's Monthly* between 1878 and 1881 in an attempt to broaden the audience for his paintings. *The Poleman in the Ma'sh* illustrated the short story "A Day in the Ma'sh" (*Scribner's*, July 1881). The image is derived from the painting *Pushing for Rail* (1874), but in this drawing Eakins eliminates every reference to the hunt except the poleman, who, as if surprised in the midst of his job, turns his gaze toward the viewer.

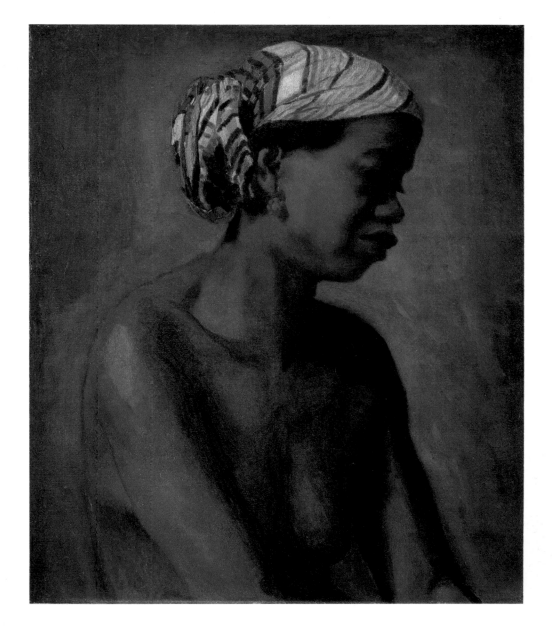

Negress, ca. 1900
Oil on canvas, 23 × 19¾ (58.9 × 50.2). Unsigned. The Fine Arts
Museums of San Francisco. Mildred Anna Williams Collection

Painted at a time when Eakins had concentrated his art exclusively
on portraiture, *Negress* follows the French tradition of highlight-
ing the exotic nature of black subjects. Eakins emphasizes his
subject's multi-colored turban and coral earrings, as well as her
sensuous plastic qualities – skin tone, physiognomy, proportion –
to relate the mood of the sitter to the viewer. Eakins painted
many commissioned portraits, works that often include the
sitter's name in the title. However, many of the subjects of his
studio portraits remain unnamed or named in terms of their
accoutrements. Eakins's choice of title, emphasizing the race of his
sitter, shows that while Eakins titled his portraits of black friends,
such as the artist Henry Ossawa Tanner, his conception of the
identity of this woman was nevertheless marked by the limited
spectrum of attitudes towards race that held sway at the end
of the nineteenth century.
F.M.

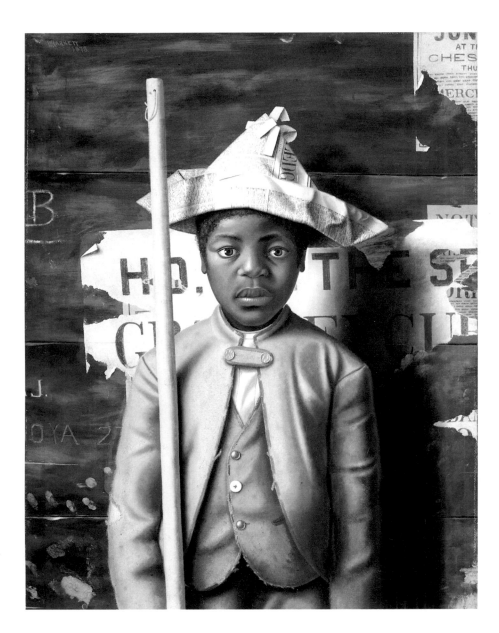

William Harnett 1848-1892

William Harnett was born in Clonakilty, County Cork, Ireland, and emigrated with his family to Philadelphia as a child. By 1865 he had learned silverware engraving; two years later he enrolled in evening classes at the Pennsylvania Academy of the Fine Arts. In 1869 he moved to New York to study at the National Academy of Design, attending night classes at the Cooper Institute. By 1875 Harnett had developed his lifelong specialty, trompe l'oeil still life subjects.

 Traveling to Europe in 1880, Harnett gained commissions in London and Frankfurt before settling in Munich to study at the Munich Academy of Art. In 1885 he left for Paris, where he exhibited *After the Hunt* (1885), a hunting still life patterned after the photographs of Adolphe Braun. *After the Hunt* received favorable notices in Paris and was purchased by prominent New York restaurateur Theodore Stewart, who exhibited it in his popular saloon. Harnett submitted *The Old Violin* (1886) to the 1886 Cincinnati Industrial Exposition, where its vivid realism created such public interest that it was assigned a police guard.

However, by 1886 Harnett was already suffering from the progressive effects of arthritic rheumatism, and from then until his death in 1892 he painted few paintings.

Attention, Company!, 1878
Oil on canvas, 28 × 36 (71.1 × 91.4). Signed in the upper left: [W/M]
HARNETT 1878. Courtesy Amon Carter Museum, Fort Worth, Texas

Attention, Company!, originally titled *Front Face*, is one of only a handful of Harnett's paintings that include people. Painted in Philadelphia two years before he departed for Europe, it reflects the influence of John George Brown's paintings of children, as well as the polished realism of the French artist Jean-Louis-Ernest Meissonier. Harnett uses trompe l'oeil to capture a reflective moment of near-photographic stillness. Ironically contrasting the youth's mock battle dress with fragments of peeling wall advertisements that suggestively proclaim "grand excursion," Harnett's portrait is a moral study in the difference between the fantasy of child's play and the mundane realities of the real world.
C.V.

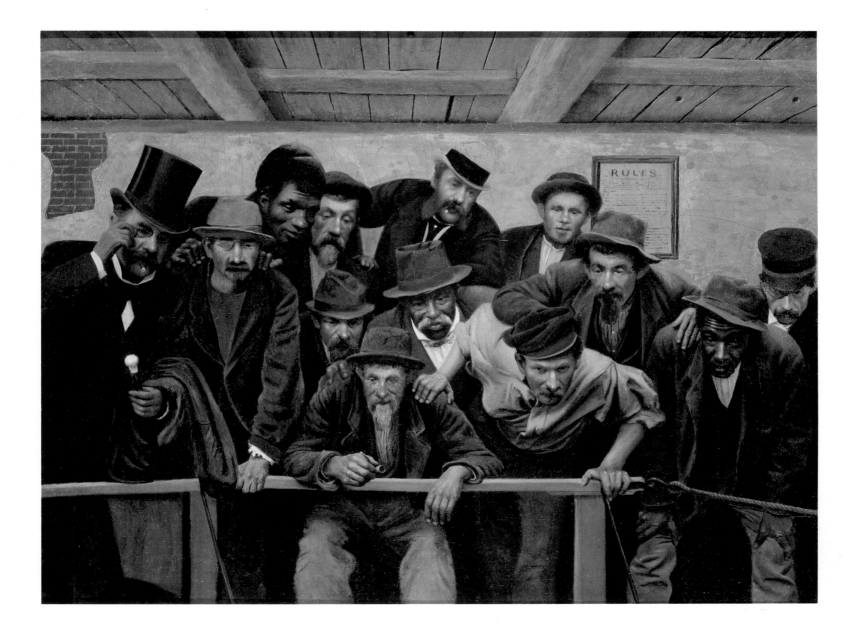

Horace Bonham 1836-1892

Horace Bonham was born in York County, New York. He was admitted to the bar in 1859 but soon decided to pursue a literary career; he purchased and edited a weekly newspaper, the *York Republican*. He was appointed United States Assessor for the York Congressional District, serving throughout the Lincoln administration. Wishing to further his literary pursuits and study painting, Bonham traveled to Paris, where he studied with Léon Bonnat. Returning to York, he worked as a painter, poet, and journalist. From 1879 to 1886 Bonham exhibited his genre paintings at the National Academy of Design in New York, as well as in exhibitions in Boston and Philadelphia.

Nearing the Issue at the Cockpit, 1878
Oil on canvas, 20¼ × 27⅛ (50.8 × 68.6). Signed in the upper right corner: *Horace Bonham*. The Corcoran Gallery of Art

Throughout his career Bonham displayed an interest in the "mixed face" of a primarily rural America, and his Quaker

upbringing probably influenced his choice of genre scenes that depicted a diverse mixture of racial groups. Rendered with detailed realism, African-Americans appear regularly in his paintings. In *Nearing the Issue at the Cockpit*, thirteen figures are clustered in a crowd scene that allows for both an individual and a group identity. Although cockfighting was prohibited throughout the country by the close of the nineteenth century, contests continued to be a popular, if clandestine, spectator sport attended by a wide spectrum of men of all classes and races. Journalists and caricaturists of the day often used the cockpit as a metaphor for the political arena, and Bonham may well have meant to suggest the new identity of the American electorate made possible by the ratification of the Fifteenth Amendment in 1870. The political contest Bonham refers to could have been the hotly contested presidential election of 1876. Achieving a one-vote plurality in a congressional commission, Rutherford B. Hayes gained the presidency, although Samuel J. Tilden had won the hotly contested popular vote by a majority.

J.L.

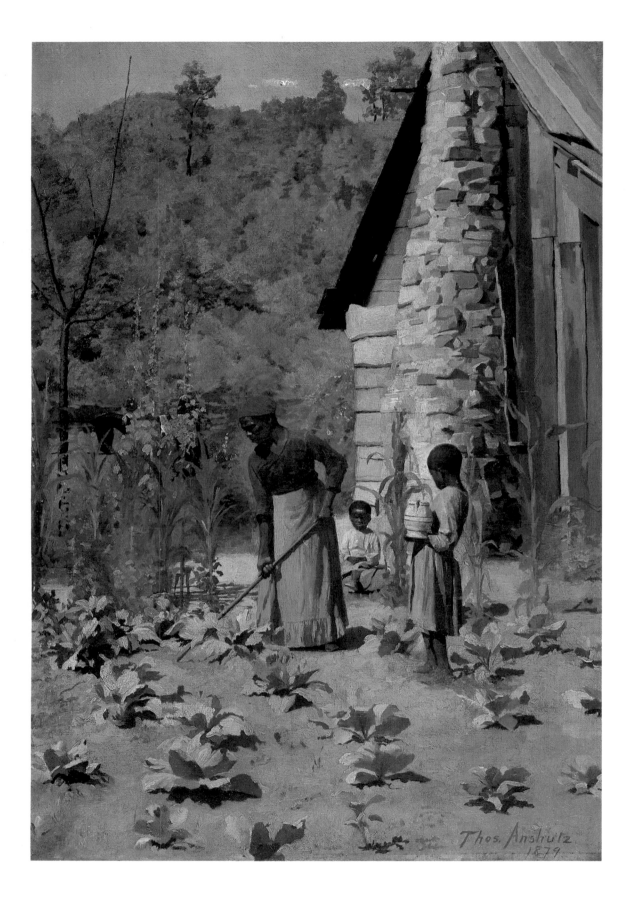

Thomas Anshutz 1851-1912

In a career that spanned four decades, Thomas Anshutz helped reshape realist traditions, both through his innovative use of industrial genre motifs and his dedicated advocacy as a teacher. Born in Newport, Kentucky, Anshutz was raised on his grandfather's farm in Moundsville, Ohio. Encouraged by his uncle, a newspaperman who worked for the *Brooklyn Times*, Anshutz moved to New York City and enrolled in classes at the National Academy of Design, studying under Lemuel E. Wilmarth and William Rimmer. Dissatisfied with the Academy's emphasis on drawing from plaster casts instead of from live models, Anshutz moved to Philadelphia in 1876 and began studying in a life class taught by Thomas Eakins at the Philadelphia Sketch Club.

Eakins's curriculum was based on the rigorous anatomical study of live models, and he used cadavers and skeletons for a scientific scrutiny of human form. Anshutz served as Eakins's assistant at the dissecting table from 1878 to 1879 and became Chief Demonstrator in Life Class dissections and Assistant Professor of Painting and Drawing at the Pennsylvania Academy of the Fine Arts in 1881. In 1891 he traveled to Paris to study at the Académie Julien; he also participated in critiques with Lucian Doucet and William Adolphe Bouguereau, two of the most respected artists at the École des Beaux-Arts. Anshutz also spent time in England, Switzerland, and Italy, and he was profoundly impressed by impressionistic approaches to modeling forms in terms of light. In 1898, with Pennsylvania Academy student Hugh Beckenridge, he opened the Darby summer school in nearby Fort Washington. Anshutz devoted the remainder of his career to education, and his influence was felt by a generation of talented emerging artists. In 1906 he lectured and taught anatomy to Robert Henri's classes at the New York School of Visual Arts in New York. The following year he was elected to the National Academy of Design. Anshutz succeeded William Merritt Chase as director of the Pennsylvania Academy in 1909 and remained as director until 1911.

Anshutz taught anatomy as an objective means of understanding the mechanics of solid form, but he encouraged his students to develop their own approaches to art, believing that originality emerged from an artist's interest in subject matter rather than from unthinking adherence to academic style. His influence can be seen in the work of two of his most successful students, John Sloan and Robert Henri. Anshutz sold the rights to his most widely known painting, *Ironworkers: Noontime* (1880), to a soap manufacturer, and this painting was widely reproduced in advertisements. However, Anshutz's emphasis on faithful representation of the mundane, often unpleasant details of urban life received a poor public reception, and until recently he has been remembered as a teacher instead of for his singular accomplishments as a pioneering urban realist.

The Way They Live, 1879
Oil on canvas, 24 × 17 (60.9 × 43.2). Signed and dated on the lower right: *Thos. Anshutz/1879*. The Metropolitan Museum of Art. Morris K. Jesup Fund, 1940

Anshutz's approach to landscape marked a clear departure from nineteenth century genre narratives that romanticized or sentimentalized the simple joys of agrarian life. The diminutive scale of the garden in *The Way They Live* suggests a subsistence farm. Anshutz began to formulate his documentary approach to painting at the end of Reconstruction, when many black Americans were finding work only as subsistence farmers or sharecroppers. The economic hardships that a farm family often endured are noted in the stiff, insistent postures of the figures and in the sharp contrasts between the bleached color of the garden and the vibrant greens in the trees beyond the fields.

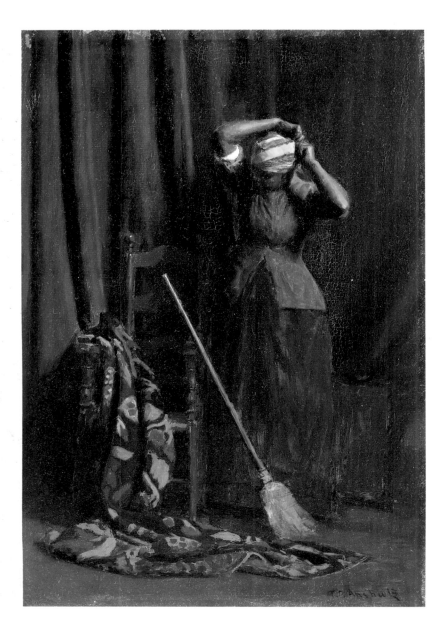

The Chore, ca. 1880
Oil on board, 14¹⁄₁₆ × 9⅞ (35.7 × 25.3). Signed in the lower right:
T. P. Anshutz. Allentown Art Museum. Gift of Mr. and Mrs. J. I.
Rodale

Painted during the late 1870s or early 1880s, the same period that
produced *Ironworkers: Noontime*, Anshutz's *The Chore* is one
of a series of small studies in oil or watercolor that the artist
painted of an African-American woman variously identified as
"Ris" and "Aunt Hannah." Dressed in simple domestic clothing,
and juxtaposed with a few studio props, the sitter embodies the
ambivalent resignation of the poor working class. Rather than
inventorying a wealth of domestic detail in the classic manner of
American genre, Anshutz indicates volumetric forms in a series of
broad color planes. His direct approach to his subject, as well as
his more generalized approach to the details of place, was readily
adopted by students such as Robert Henri and John Sloan as
one of the stylistic cornerstones of the Ashcan School.
C.V.

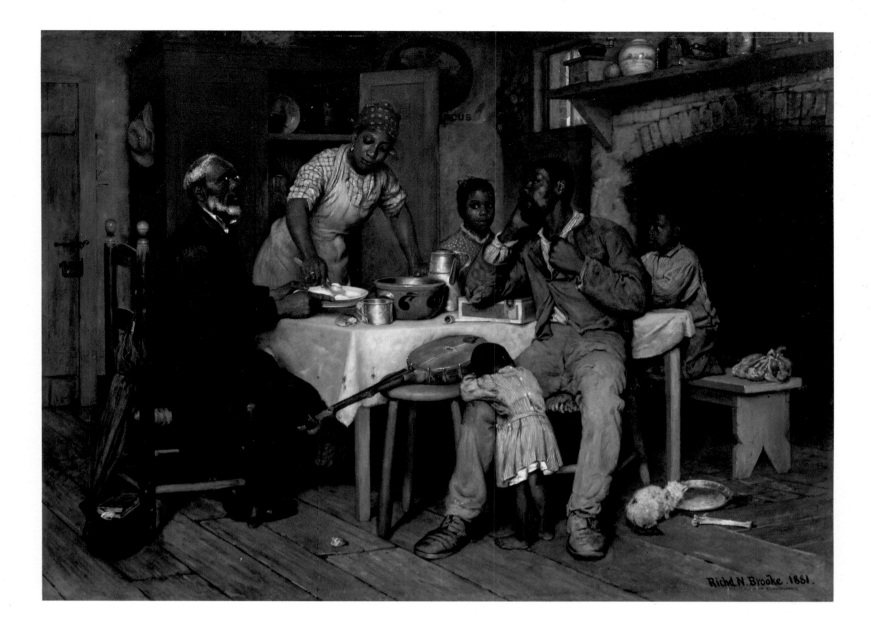

Richard Norris Brooke 1847-1920

Richard Norris Brooke wrote in his autobiography *Record of Work* that *A Pastoral Visit* "was my first decided success and unfortunately fixed my reputation as a painter of negro subjects." Brooke was born in Warrenton, Virginia; as a young man he entered the Pennsylvania Academy of the Fine Arts, where he studied with the illustrator Edmund Bonsall. In 1872 he secured a four-year post as U.S. Consul in La Rochelle, France; he studied briefly in Paris with Léon Bonnat before returning to the United States in 1879. Settling in Washington, D.C., he became vice-president of the Washington Art Club, founding member of the Art Students League of Washington, and President of the Society of Washington Artists.

A Pastoral Visit, 1881
Oil on canvas, 47¾ × 65¾ (121.4 × 164.4). Signed in the lower right: *Richd. N. Brooke. 1881. (Élève de Bonnat – Paris)*. The Corcoran Gallery of Art
Recording the interior of 28 Smith Street in Brooke's hometown, Warrentown, *A Pastoral Visit* picturesquely frames a stylized tableau of black personalities: the spiritual strength of the elderly

pastor Old George Washington, the musical prowess of the host Daniel Brown, and the nurturing motherhood of Georgianna Weeks fulfill roles in a nostalgic view of the gentility of black life. Characterized by stylized activities and stereotypical facial expressions, the benign humor that pervades *A Pastoral Visit* reflects a perspective that many white Americans adopted toward African-Americans after the failure of Reconstruction.

Brooke had strongly contradictory feelings about this painting. In addition to noting how his choice of subject had limited his career, he commented in a letter to the Corcoran Purchasing Board:

It must have struck many of you that the fine range of subject afforded by Negro domestic life has been strangely abandoned to works of flimsy treatment and vulgar exaggeration. That particular humor which is characteristic of the race, and varies with the individual, cannot be thus crudely conveyed.

Brooke's letter may have been necessary to sway the board. One of the museum's curators summed up the negative reaction to the painting in his journal: "Though it is well done, there is *too much nigger* in it for so large a picture."
C.V.

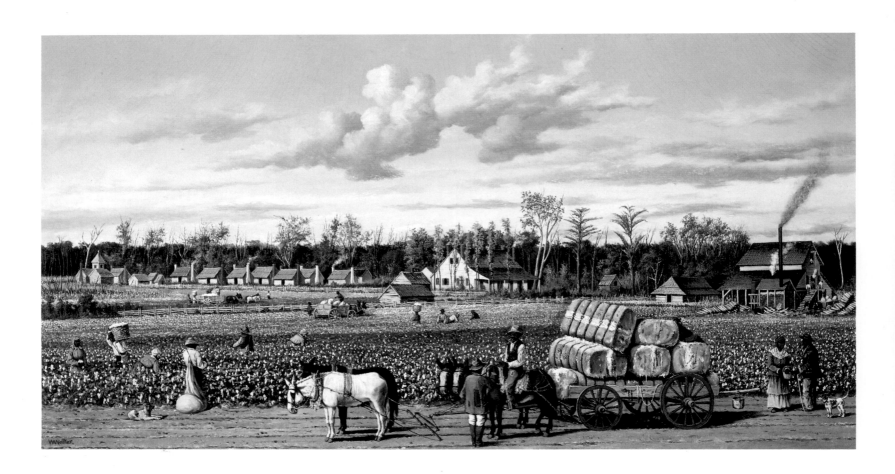

William Aiken Walker 1838-1921

While America's post-Civil War westward expansion was attract-
ing the attention of a host of artists, William Aiken Walker drew
on the life and landscape of his native South to create an extensive
record of rural life from the 1860s to the early 1900s. Walker was
born in Charleston, South Carolina, a principal cultural center
and an important stop on the circuit for many traveling portrait
painters. In 1850, at the age of twelve, he entered his first exhibi-
tion, submitting a painting that included an African-American
subject. For the next ten years his career flourished; however, in
1861, after the wave of Southern optimism that followed the first
battle of Bull Run, Walker enlisted in the Confederate Army,
and by June had been wounded in action and discharged from
service. After the war, he returned to Charleston, but survival in
that devastated city was a major problem, and in 1865 Walker
moved to Baltimore. Walker exhibited his work in major Southern
cities, sold large numbers of his tourist-oriented paintings (often
to passersby on the street), and participated in a variety of local
artistic organizations throughout the South.

Plantation Economy in the Old South, ca. 1876
Oil on canvas, 22 × 42 (55.9 × 106.7). Signed in the lower left:
W. A. Walker. The Warner Collection of Gulf States Paper
Corporation, Tuscaloosa, Alabama

Walker clearly understood the postwar mystique of black subjects
and often took advantage of their appeal by incorporating them
within his compositions. Fascinated by the unsettled condition of
the newly free black population, he treated the black cotton field
worker picturesquely, portraying black workers in the rather
predictable context of an exclusively rural Southern economy.
The panoramic landscape *Plantation Economy in the Old South*
records plantation life in full swing – smoke rises from the stack
of the cotton mill, and workers are grouped around full baskets
and loaded wagons.

Despite the nostalgic picturesqueness of Walker's landscape,
his conception of black life is one-sided and subtly insidious. No
virile young men are shown in his composition – the workers
are older men and women. The people in Walker's picture remain
firmly entrenched within the severe social limitations and de facto
economic servitude of plantation life. Restricting his portraits of
blacks to rural settings, Walker was in effect commemorating a
way of life that remained largely intact despite the trauma of the
Civil War.

F.M.

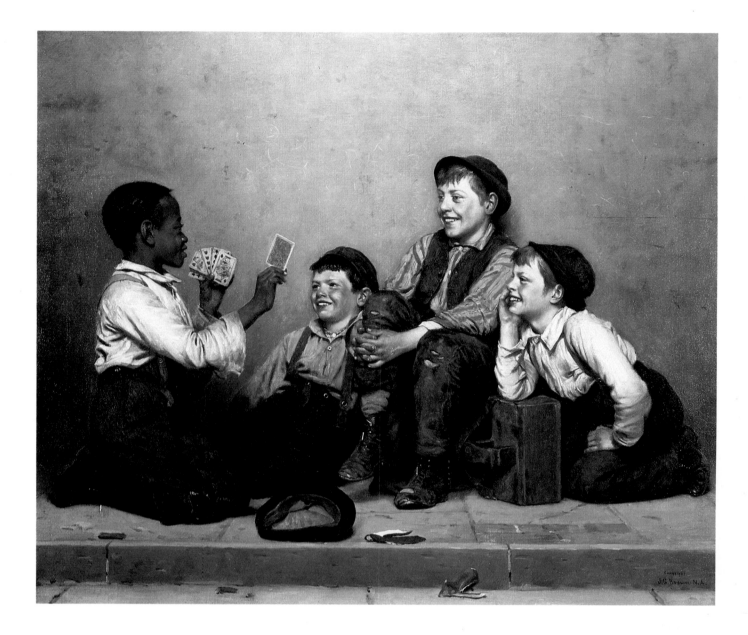

John George Brown 1831-1913

The son of a poor lawyer in Durham, England, John George Brown apprenticed as a child to a Newcastle-on-Tyne glass-works. After gaining his accreditation, he worked in a glassworks in Edinburgh while studying art at the Royal Scottish Academy at night; he moved to London in 1853 and soon immigrated to America. In Brooklyn his designs for the Flint Glass Works so impressed William Owen, one of the owners, that Owen sponsored Brown's study with miniature painter Thomas S. Cummings and provided the financial backing for his portrait studio. Brown's own rags-to-riches story reinforced his preoccupation with subject matter depicting honest, industrious immigrants. His paintings of children were particularly popular, and he obtained copyrights for many of them; in the early 1870s a group of them were made into chromolithographs that sold for between $5 and $15.

The Card Trick, 1880s
Oil on canvas mounted on panel, 26 × 31 (66 × 78.7). Signed in the lower right: *copyright/J. G. Brown N.A.* Collection, Joslyn Art Museum, Omaha, Nebraska. Gift of the Estate of Mrs. Sarah Joslyn

The Card Trick exemplifies Brown's penchant for sentimental or optimistic images of American city life. Four boys, identified as bootblacks by the boxes they sit on or lean against, pass time by watching a card trick performed by a black youth. Support for a date in the late 1800s for *The Card Trick* comes from an engraving of a similar subject published in *Harper's Weekly* (April 18, 1885) entitled *A Jolly Lot*. While the dancing African-American in *A Jolly Lot* can be seen as a remnant of the stereotype of the darkey minstrel, the care that Brown has taken in portraying the card shark in *The Card Trick* acknowledges both his individuality and his skill at gamesmanship – a slightly suspect but nevertheless respectable urban craft.
C.V.

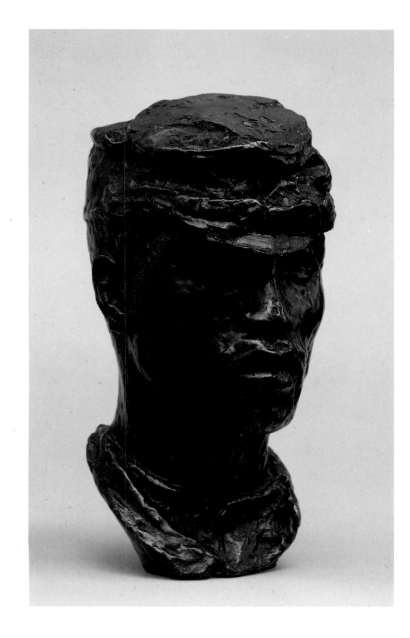

Head of a Young Man/Study for a soldier in **The Shaw Memorial,** ca. 1884-1897
Bronze with marble base, 18 × 8.5 × 11 (45.7 × 21.6 × 27.9).
Unsigned. United States Department of the Interior. National Park Service, Saint-Gaudens National Historical Site, Cornish, New Hampshire

Among Saint-Gaudens's most renowned monuments was his depiction of the Fifty-fourth Massachusetts Regiment, the first African-American volunteer regiment, which fought with courageous distinction during the Civil War. Commanded by Colonel Robert Gould Shaw, the Fifty-fourth Massachusetts Regiment led the second major attack on Confederate forces at Fort Wagner, the defensive linchpin for Charleston, South Carolina. In 1881 Saint-Gaudens was approached by the Shaw Memorial Committee, an organization formed in 1865 by Joshua Smith, a former servant to the Shaw family and a former fugitive slave who established himself as a successful entrepreneur in the years after the Civil War. Saint-Gaudens solicited a wide range of individuals to serve as models for approximately forty clay facial studies that he made as preparatory sketches for the sixteen soldiers in the final version of the monument.

Completed in time for dedication on Memorial Day of 1897, *The Shaw Memorial* was introduced by a parade of veterans of the Fifty-fourth Regiment marching up Beacon Hill. As Saint-Gaudens later wrote:
The impression of these old soldiers passing the very spot where they left for the war so many years before, thrills me even as I write these words. They seemed as if returning from the war, the troops of bronze marching in the opposite direction . . . the young men in the bas-relief showing these veterans the hope and vigor of youth. . . . It was a consecration.
The main speaker, Booker T. Washington, addressed a larger issue:
The black man who cannot let love and sympathy go out to the white man is but half free. The white man who would close the shop or factory against a black man seeking an honest living is but half free. The white man who retards his own development by opposing a black man is but half free. The full measure of the fruit of Fort Wagner and all that this monument stands for will not be realized until every man covered by a black skin shall, by patience and natural effort, grow to the height where no man in our land will be tempted to degrade himself by withholding from his black brother any opportunity he himself would possess.
C.V.

Augustus Saint-Gaudens 1848-1907

The work of Augustus Saint-Gaudens epitomizes many of the essential characteristics of American taste during the last decades of the nineteenth century. Saint-Gaudens was born in Ireland to French and Irish parents; his family emigrated to New York with their six-month-old child to escape the continuing famine plaguing Ireland. At thirteen Saint-Gaudens apprenticed to the cameocutter Louis Avet for three years; in 1865 he enrolled at the National Academy of Design, studying with John Quincy Adams Ward. In 1876 Ward was instrumental in gaining his protégé the Farragut commission, an award that secured Saint-Gaudens's reputation as an emerging talent.

Saint-Gaudens was one of the first Americans to study abroad at the École des Beaux-Arts in Paris, entering the atelier of Francis Jouffroy in 1869. For many of the years spent realizing *The Shaw Memorial* (1884-1897), Saint-Gaudens lived in New York, teaching at the Art Students League and gaining election to the National Academy of Design.

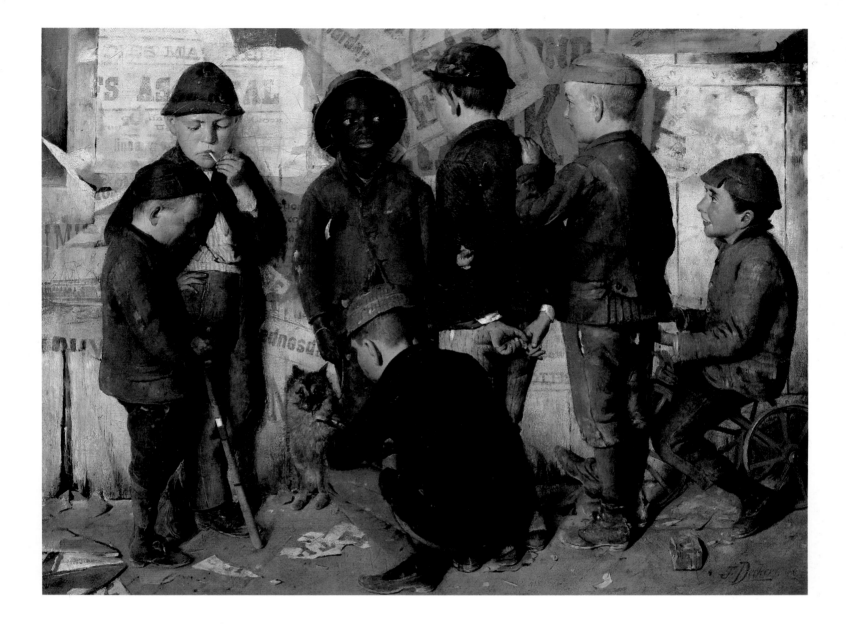

Joseph Decker 1853-1924

Joseph Decker was born in Würtemburg, Germany; emigrating to Brooklyn at the age of fourteen, he apprenticed to a house painter and worked as a sign painter to support himself. He attended evening classes at the National Academy of Design for three years during the late 1870s; during this period he exhibited landscapes and still lifes at the National Academy of Design and the Brooklyn Art Association. Decker went to Munich in 1879 to study for a year at the *Akademie der Bildenden Kunste*, where he worked in an academic style based on the work of Hals, Velázquez, and Goya; by the 1880s he had returned to the United States, and still life subjects began to dominate his work.

Our Gang, 1886
Oil on canvas, 10¾ × 20 (27.3 × 50.8). Signed in the lower right corner: *J. Decker/[illegible]*. Private Collection

Our Gang, Decker's only surviving genre scene, is painted in his early, precisely realistic style. Originally titled *Accused*, it was renamed in the 1930s, probably in response to the short movie serial of the same name. In contrast to the rough and tumble conviviality of the serial, however, Decker's tableau is fraught with tension. The African-American boy who is the focal point of the composition is surrounded, backed up against a wooden fence that is smeared with weathered advertising bills. The outsized letters of these advertisements point accusingly at him, as if substantiating some unstated accusation. Decker has quite sympathetically portrayed someone who is isolated and singled out for being different; the artist seems to have understood this situation well from personal experience. Unable to live continuously either in Brooklyn or Germany, and estranged from his family, Decker seems to express through his subject matter, above all, a personal perspective.

C.V.

97

Edward Lamson Henry 1841-1919

Born in Charleston, South Carolina, Edward Lamson Henry
spent his youth in Brooklyn. In 1858 he studied at the Pennsylvania
Academy of the Fine Arts and exhibited his first paintings at the
National Academy of Design in 1859. Departing for Europe,
he spent the following year in Paris studying in several ateliers,
including Gustav Courbet's. However, although well aware of
modern realist trends, he preferred the polished, detailed realism
of Jean-Louis-Ernest Meissonier. Returning to New York from
the first of four tours of Europe, Henry enlisted as a captain's
clerk for the Union Army, keeping a sketchbook that contains
numerous images of ships, war scenes, and African-American
soldiers. Henry returned to these sketchbooks in later years to
provide authentic details for clients who desired gripping Civil
War scenes. Henry was elected associate member of the National
Academy of Design in 1867 and gained the status of Academician
in 1869.

Kept In, 1888
Oil on canvas, 13½ × 17⅞ (34.3 × 45.4). Signed and dated in the
lower right. New York State Historical Association, Cooperstown

In the late 1880s Henry painted four canvases that described a
one-room district school outside of Cragsmoor, New York. Henry
began this series to address lingering questions over state civil
rights legislation, passed in 1873, that forced five large communi-
ties to close or integrate segregated private and public schools.
One of Henry's least sentimental paintings, *Kept In* reflects much
of the ambivalence with which white Americans regarded the
idea of black education in post-Reconstruction America. Using
an abandoned textbook to symbolize the more uncomfortable
moments of educational discipline, Henry emphasizes the girl's
isolation from her classmates, visible at play through an open
window.
c.v.

Frederic Remington 1861-1909

Frederic Remington's paintings, sculptures, and illustrations brought images of the American West — Indians, soldiers, cowboys, and cattle drives — into vivid existence for Eastern audiences. Born in Canton, New York, Remington studied art at Yale. He made his first trip West in 1881, traveling to Montana to sketch and paint scenes from western life. In 1885 Remington began the first leg of an extensive journey throughout the Southwest, sketching Indians, soldiers, and Mexican *vaqueros* in Arizona, Texas, and Oklahoma. By the end of the year he returned to New York to study at the Art Students League; in 1889 he had won his first silver medal for *The Last Lull in the Fight* at the Paris Exposition, and in 1891 he was elected Associate of the National Academy of Design.

Remington's illustrations of western, war, and sporting events appeared in all the leading periodicals of his day, and his books, *Pony Tracks* (1895) and *Men with the Bark On* (1900), were extraordinarily popular. In 1905 he signed a contract with M. Knoedler & Co., allowing the gallery to represent his bronzes, and in 1909 he had his first solo exhibition with the gallery. The exhibition was a critical and popular success, but Remington suffered an acute attack of of chronic appendicitis; he died before the exhibition's close.

Captain Dodge's Colored Troopers to the Rescue, ca. 1890
Tempera on paper, 19 1/4 × 36 5/8 (49 × 93.2). Signed in the lower right: *FREDERIC REMINGTON*. Loaned by Mrs. C. S. Mott

Remington was not particularly interested in African-American subjects, but he was obsessed with soldiers. His images of black soldiers are full of respect for the men who maintained the profession of soldiering. Despite his own racial views, which verged at times on violent bigotry, Remington steadfastly resisted the use of stereotypes to represent racial characteristics. However, while his attitude toward the black soldier in the field was one of respectful admiration, Remington's art contains no other images of African-Americans.

Remington was fond of recalling anecdotes about the bravery of African-American soldiers in skirmishes with the Apaches. Because of his interest in the soldiers that the Apaches respectfully referred to as the "black buffaloes," Remington completed a number of works in the 1880s and 1890s that preserve important information about the four African-American calvary regiments that were organized as permanent army units by an act of Congress in 1866. Stationed west of the Mississippi River, these units were, with few exceptions, led by white officers.

Leaving the Canyon, ca. 1894

Watercolor, 25 ½ × 20 (64.7 × 51). Signed in the lower right:
Frederic Remington. Gene Autry Western Heritage Museum, Los
Angeles, California

In an age that encouraged artists to specialize, Remington became
America's most popular chronicler of the American West. By the
time he painted *Leaving the Canyon* the West that Remington
had seen in his youth had largely given way to settlements and
farm communities; his paintings and sculptures gained a large
measure of their popularity because their stirring evocations of a
largely mythic western landscape catered to the nostalgia of his
eastern clientele. Even though he made relatively few trips to the
West Remington retained a striking amount of detailed memory
about his journeys, which he augmented with carefully recorded
on-site observations that served as his pattern-book for western
imagery. *Leaving the Canyon* exemplifies Remington's vigorous
portrayal of the African-American soldier, depicting a group of
soldiers from the Tenth United States Cavalry (an all-black
regiment led by white officers) who escort an Apache prisoner up
the steep canyon walls. F.M.

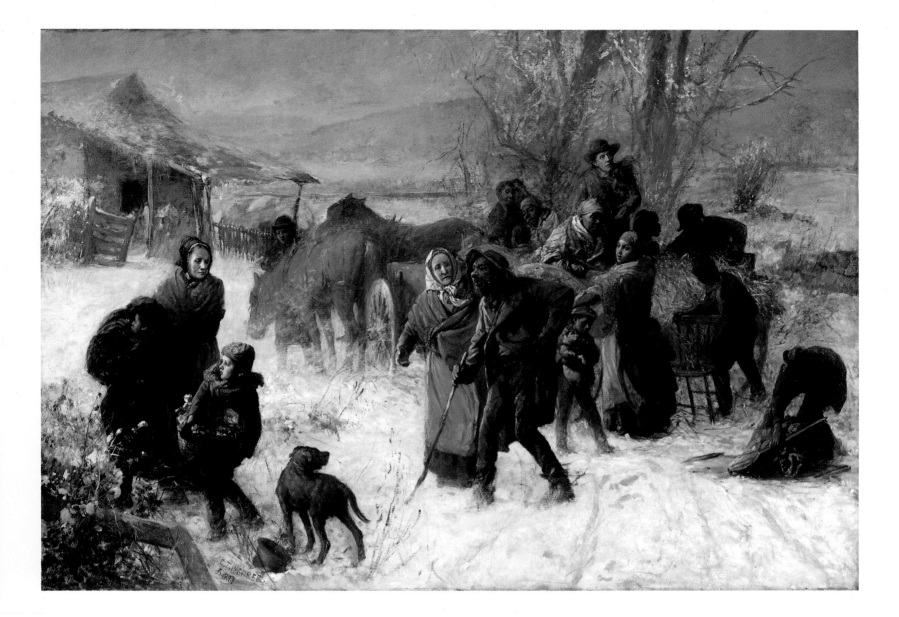

Charles T. Webber 1825-1911

Born and raised on the eastern shore of Cayuga Lake, New York, Charles T. Webber moved to Springfield, Ohio, as a youth. He settled in Cincinnati in 1858 and quickly became a vigorous participant in Cincinnati art circles as a founder of the McMicken School of Art and Design. Primarily a portraitist, he also painted landscapes and occasional historical works. Cincinnati was one of the few cities where educational opportunities were available for African-Americans before the Civil War, and Webber painted several portraits of abolitionist leaders.

The Underground Railroad, 1891 or 1893
Oil on canvas, 52³/₁₆ × 76¹/₈ (132.5 × 193.3). Signed in the lower left: *C. T. Webber/A. 1893; C. T. Webber ???.* On verso: *This picture is painted for the love of my wife Frances Augusta Webber C. T. W. Dec. 22, 1891.* The Cincinnati Art Museum. Subscription Fund Purchase
Painted as a symbolic tribute to the heroism of the abolitionist movement, *The Underground Railroad* was Webber's most famous work. Begun in 1881, it was reworked intermittently for a

dozen years. Completed for exhibition at the 1893 Columbian Exposition in Chicago, *The Underground Railroad* recreates an evening visit to the country home of Levi and Catherine Coffin. Widely viewed as the unofficial "president" of the underground railroad, Levi Coffin is shown with his wife Catherine Coffin and Hannah Haydock, a noted abolitionist. Haydock's presence dates the painting's historical subject to between 1856, when she moved to Warren County, and the end of railroad operations in 1865.

Many of the details of this early dawn scene – the straw-laden wagon, the blankets wrapped around the women and children, the basket of food – can be traced to entries in Levi Coffin's autobiography, published in Cincinnati in 1876. Both clothing and poses link the abolitionists and the fugitives, suggesting the danger of a situation that required disguise but also suggesting the solidarity of compatriots who wear the same uniform.

This work was a personal breakthrough for Webber, marking a departure from his standard commission style. He copyrighted the painting in 1893, noting that it was not quite completed. Photographs record a series of changes he made up until 1911 to enhance the composition. Among the later additions are bushes, suggestive of cotton plants, that create a pathway toward sunlight, symbolizing the goal of liberation.
C.V.

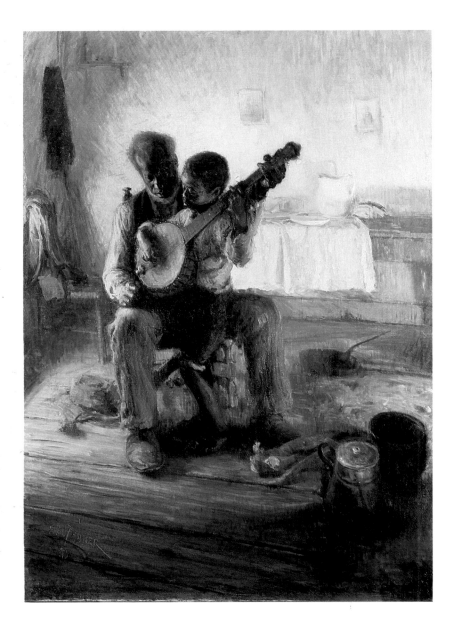

Henry Ossawa Tanner 1859-1937

Henry Ossawa Tanner is widely regarded as the most talented
African-American artist of the nineteenth century. Tanner was
born in Pittsburgh; he and his family moved to Philadelphia when
he was a child. By 1880 Tanner had enrolled at the Pennsylvania
Academy of the Fine Arts to study with Thomas Eakins. Eakins
instilled in him a deep appreciation for drawing the figure in
academic and genre settings, and Eakins and Tanner became
lifelong friends (Eakins painted Tanner's portrait in 1902). After
exhibiting at the Pennsylvania Academy of the Fine Arts and
the National Academy of Design in New York, Tanner moved to
Atlanta in 1888, where he opened a photography salon, hoping to
win a clientele from Atlanta's large affluent black middle class.
This venture failed, and Tanner departed for Paris in 1891; he
remained an expatriate for the rest of his life. Perhaps on the
advice of Eakins, he attended the Académie Julien, where he was
influenced by the conservative approaches to realism of Jean
Joseph Benjamin Constant and Jean-Paul Laurens.

The Banjo Lesson, 1893
Oil on canvas, 48 × 35 (121.9 × 88.9). Signed in the lower right:
H. O. Tanner/1893. Hampton University Museum, Hampton,
Virginia

The Banjo Lesson was executed in Paris from drawings Tanner
made while in the Ozarks prior to his departure for Europe in
1891. The farmhouse interior and household implements that
form the backdrop of *The Banjo Lesson* link Tanner's conception
to the mainstream of American genre painting, as does his
uniquely American theme – rural blacks unified by the common
experience of music. However, as a black artist aware of the
generalizations and misperceptions prevalent concerning the
behavior of African-Americans, Tanner was careful to distinguish
between musical entertainment and education. Images of men
teaching were not at all common in the American genre tradition;
Tanner's strong male figure can be seen as more directly stating a
theme of education that William Sidney Mount described through
a surrogate figure in *Eel Spearing in Setauket*.
G.C.M.

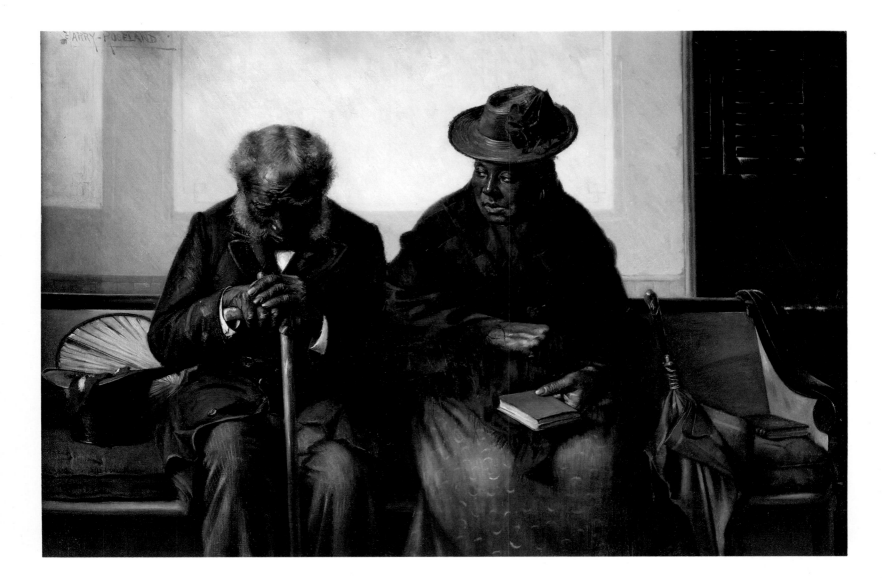

Harry Roseland 1867-1950

Born in Brooklyn to German immigrants, Harry Roseland studied
with J. B. Whittaker at Brooklyn's Adelphi Academy and received
private instruction from J. Carroll Beckwith. His first paintings
were landscapes, portraits, and still lifes; several were lithographi-
cally reproduced as subscription premiums for a New York
newspaper. Roseland began to specialize in African-American
themes in the late 1870s or early 1880s, and these paintings
brought him immediate critical and financial success. Although
he never traveled or lived in the South, his genre scenes were
widely accepted as authentic studies of the life of Southern blacks.
With the rise to prominence in the early twentieth century of the
figurative artists collectively known as The Eight, Roseland's
paintings quickly fell out of favor. Although most of his paintings
of African-American subjects date from between the 1880s and
the 1900s, he continued to experiment with similar themes
into the 1940s.

Wake Up, Dad, ca. 1896
Oil on canvas, 16 × 24¼ (40.7 × 61.6). Signed in the upper left
corner: *Harry – Roseland*. Private Collection

Although *Wake Up, Dad* is undated, it was exhibited at the
National Academy of Design in 1896 and was probably painted
in the decades following Roseland's initial success. The finely
detailed church or waiting room, the style and quality of dress,
and the emphasis on the "personality" of older subjects contrast
strongly with the artist's early emphasis on picturesque landscapes
featuring handsome young subjects. By the time Roseland painted
Wake Up, Dad the popularity of his initial formulation had
probably waned, and he had begun to experiment with different
formats for his African-American specialty. The same polished
realism that illuminates *Wake Up, Dad* appears in *Reading
the Leaves* (1899) and *The Lucky Card* (1908), paintings which
feature one of the oddest genre formulas to involve a black
subject – an exotic elderly fortune-teller who interprets the future
of a beautiful young white woman.
G.C.M.

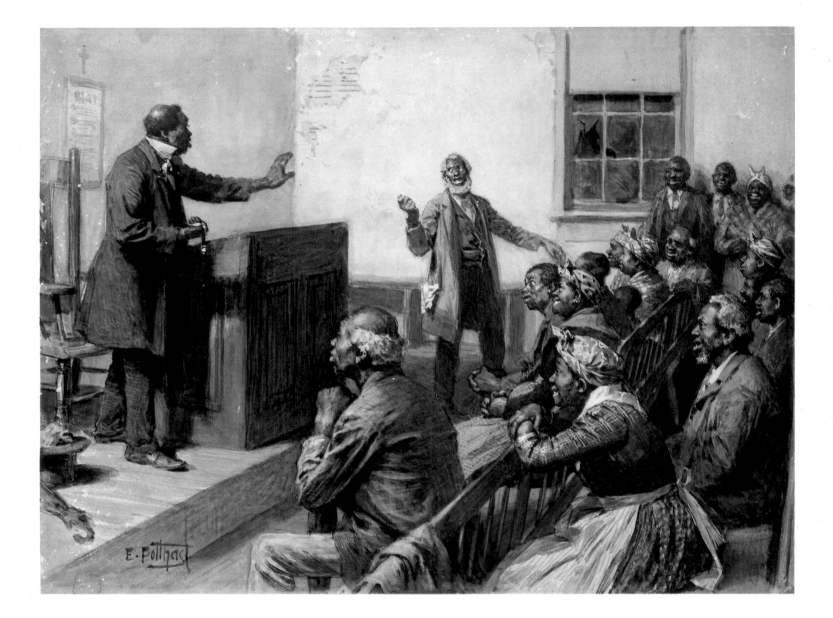

Edward Potthast 1857-1927

Born in Cincinnati, Edward Potthast entered the McMicken School of Design in 1870 and studied drawing and design with Thomas Satterwhite Noble. In 1873 he apprenticed to the lithography firm Ehrgot Crebs, and by 1879 he was working for the Strobridge Litho Company. Departing for Europe in 1882, he studied in Antwerp with Charles Veriat and later went to Munich to study with the academicians Nicolas Gysis and Ludwig von Loefftz. Between 1887 and 1889 he exhibited in the Paris Salon and was introduced to the French impressionists by the American artist Robert W. Vonnoh. After receiving the purchase prize of the 1894 Cincinnati Art Museum Annual Exhibition, he moved to New York, where he established himself as a free-lance illustrator, contributing frequently to *Scribner's*, *Century Magazine*, and *Harper's Illustrated Magazine*. Potthast won the prestigious Clark Prize in the National Academy of Art's 1899 competitive exhibition and was elected an Academician in 1906.

Brother Sims's Mistake, 1899
Black-and-white wash on paper, 16 × 22 (40.6 × 55.9). Signed in the lower left: *E. Potthast*. Courtesy of Illustration House, Inc.

Brother Sims's Mistake illustrates a short story by Harry Stillwell Edwards that appeared in the July 1899 issue of *Century Magazine*. Edwards specialized in humorous anecdotal subjects featuring African-American characters who speak in a stilted dialect, and Potthast's illustration is faithful to the text's description of the last moments of an "experience meeting" at the Holly Bluff congregation. Holding his watch as evidence of the lateness of the hour, the visiting Reverend Sims declares that it is time for him to leave, interrupting the elder Lazarus during the climax of his sermon. Lazarus is pictured acting out the story of a white man who becomes the devil and is about to cast a fishing line to catch Brother Sims with the symbolic bait of his own foibles. Potthast's emphasis on physiognomy to convey the attributes of the congregation (the background figures in particular are a series of repeated caricatures) is faithful to the stilted dialect Edwards uses to narrate the confrontation; like many artist-illustrators, he willingly varied his style and subject matter to conform to the content of the literature he illuminated. C.V.

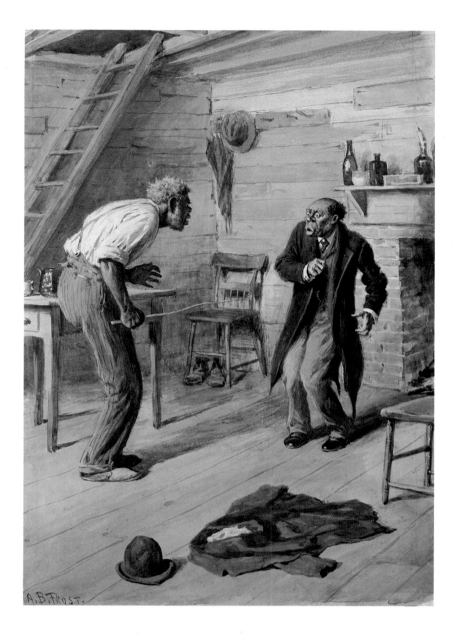

Arthur Burdett Frost 1851-1928

Born in Philadelphia, Arthur Burdett Frost began his career by apprenticing to a wood engraver; after working for several years in a lithographic shop, he contributed illustrations to *Out of the Hurly-Burly* (1874) by Charles Heber Clark (the pseudonym of Max Adeler). Adeler's volume sold more than a million copies and inaugurated Frost's career as a graphic artist. By 1875 Frost had begun to contribute political cartoons to the *New York Daily Graphic*, and the following year he joined the staff of Harper and Brothers. In 1877 he went to London to work and study for a year; upon his return he entered the Pennsylvania Academy of the Fine Arts, where he studied with Thomas Eakins. His only additional formal training was a brief period of study under William Merritt Chase in 1891.

Stan' Up!, 1905
Wash on paper, 21 × 14½ (53.3 × 36.8). Signed in the lower left: *A. B. Frost*. Brandywine River Museum, Chadds Ford, Pennsylvania. The Jane Collette Wilcox Collection

Frost was an excellent watercolorist and painter as well as a gifted pen and ink artist. He was well known for landscapes that prominently featured huntsmen, anglers, golfers, bicyclers, and other sportsmen who displayed an evident joy in their outdoor activity. Frost's conception of the African-American seems to have been at least partially sympathetic, and he generally refrained from stressing the overtly grotesque racial peculiarities that were favored by such artists as Edward Potthast and Thomas Worth. Although much of Frost's work is marked by a technical mastery of illustrative style and an exuberant gusto that strikingly evokes the overwhelming positivism that characterizes the attitude of the majority of white Americans at the end of the nineteenth century, *Stan' Up!* presents a mysterious drama full of implicit violence. Frost's use of extremes is probably related to the text his drawing illustrated; the mood of his conventional genre interior is reinforced through dramatic contrasts in tonality that reduce the features of the aggressor to a silhouette while illuminating the fear of the intended victim.

F.M.

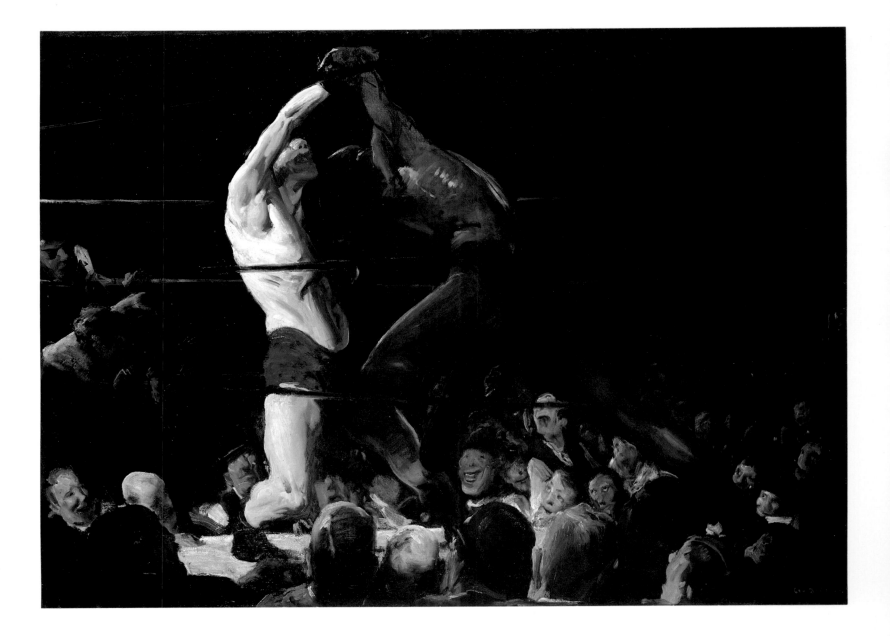

George Wesley Bellows 1882-1925

George Wesley Bellows was the most popular painter associated with the Ashcan School. Born in Columbus, Ohio, Bellows enrolled in the New York School of Art in 1904, studying with William Merritt Chase and Robert Henri. His early works were anecdotal genre studies that continued to romanticize the rural American scene in the tradition of Mount and Homer. However, inspired by Henri and the booming vitality of New York City, Bellows increasingly began to select urban subjects for his paintings. Unlike the older members of the Ashcan School, Bellows quickly gained recognition for his skills; by 1907 he had exhibited at the National Academy, and by 1909 he was made an Associate Academician, becoming a full Academician in 1913.

Both Members of This Club, 1909
Oil on canvas, 45 ¼ × 63 ⅛ (115 × 160.5). Signed in the lower right: *Geo Bellows*. National Gallery of Art, Washington, D.C. Chester Dale Collection

Bellows made his living as a portraitist, but he gained his greatest fame with his boxing pictures. The powerful images in *Club Night* (1907), *Both Members of This Club* (1909), and *Dempsey and Firpo* (1924) reduce figures to slashing forms vigorously described through skeins of agitated paint. Bellows frequented the darkened back room of Sharkey's, a neighborhood bar that assumed the guise of an athletic club to sponsor boxing matches, and *Both Members of This Club* captures the raw violence and furtive, often explosive energy of the clandestine boxing scene in New York prior to the legalization of boxing in that state.

Bellows adopted boxing as a metaphor for the vibrant, often violent immediacy of urban life. The ring was one of the few areas available for advancement for black athletes in the first half of the twentieth century, but black athletic success engendered a backlash of white racial pride captured in the term "Great White Hope." Bellows rarely included blacks in his paintings, and the significance of choosing to represent this conflict in terms of race is suggested by the painting's original title, *A Nigger and a White Man.*

G.C.M.

Robert Lee MacCameron 1866-1912

Robert Lee MacCameron was celebrated in Europe and America for his incisive portraits. Born in Chicago, he was raised in Wisconsin, where his father served in the state legislature. His interest in art was stimulated by a chance meeting with a visiting French artist and drawing instructor. While still in his teens, he moved briefly to Chicago, and later to New York, where he gained employment as an illustrator. Arriving in London in 1888, he briefly illustrated the juvenile publication *The Boys' Own* before moving to Paris after receiving a scholarship to the École des Beaux-Arts.

MacCameron studied with Gérôme and Whistler, and his paintings quickly became popular with French collectors, winning honors in the Paris Salons of 1904, 1906, and 1908. His portrait commissions included European nobility, artists such as Whistler and Rodin, and such prominent Americans as Presidents McKinley and Taft and Chief Justice Harlan. MacCameron maintained studios in London, Paris, and New York. He was a

member of the National Association of Portrait Painters, an Associate member of the National Academy of Design, and a member of the Paris Society of American Painters. In 1912, shortly before his death, MacCameron was awarded the ribbon of the chevalier in the French Legion of Honor.

New Orleans Darkey, ca. 1910
Oil on canvas, 22 × 18 (55.88 × 45.72). Unsigned. Memorial Art Gallery of the University of Rochester. Gift of the Rochester Art Club

In addition to portraits, MacCameron also painted street scenes, often recording the misery of the living conditions of the poor. His subject matter is related to the prominent example of Robert Henri, who often depicted the diverse ethnic mix that inhabited American cities at the turn of the century. Although *New Orleans Darkey* naturalistically describes its subject, the artist's treatment of the young man's broadly grinning, masklike expression, coupled with the overt stereotyping of the title, trivialize the subject in a manner that vividly recalls nineteenth century traditions of representing blacks as simpleminded comics.

J.L.

Robert Henri 1865-1929

Born Robert Henry Cozad in Cincinnati, Robert Henri adopted his name in 1883 after his father killed a man. In 1886 he entered the Pennsylvania Academy of the Fine Arts, studying under Thomas Anshutz and Thomas Hovenden. In 1888 he traveled to Paris, studying at the Académie Julien before gaining admission to the École des Beaux-Arts. Returning to the United States in 1891, he studied with Robert Vonnoh at the Pennsylvania Academy, painting a series of landscapes that reflected his interest in impressionism. After spending much of the 1890s in Europe, he returned to New York City in 1900, where he quickly became an influential figure among contemporary American artists through his teaching, writing, and organization of exhibitions.

Henri became a role model for young talents such as John Sloan, William Glackens, Everett Shinn, and George Luks, artists who, along with Arthur B. Davies, Ernest Lawson, and Maurice Prendergast, would come to be known as The Eight for their inclusion in Henri's 1908 Macbeth Gallery exhibition. Derided by critics, the exhibition was described as representing the "Ashcan School" of painting.

The Failure of Sylvester, 1914
Oil on canvas, 41 × 33 (104.1 × 83.8). Signed in the lower left: *Robert Henri*. Ira and Nancy Koger Collection

In his later years Henri concentrated primarily on portraiture; however, instead of limiting his clientele to the fashionable elite, he painted men and women from all walks of life. Henri painted two portraits of a young boy named Sylvester during a visit to La Jolla, California. One shows his subject awake and alert, regarding the viewer; the second version describes the sitter's "failure." Inherent in Henri's philosophy of naturalism was a wide-ranging curiosity about people that encompassed both formal poses and much more casual portraits.
G.C.M.

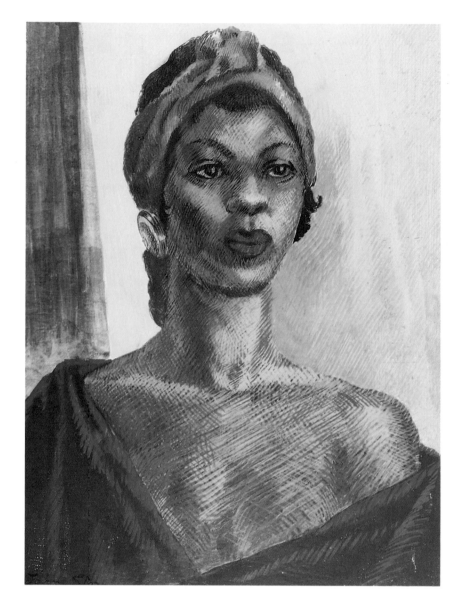

John Sloan 1871-1951

John Sloan was born in Philadelphia. In 1892 he joined the *Philadelphia Enquirer* as an artist-reporter and later worked for the *Philadelphia Press*. Enrolling in Thomas Anshutz's evening drawing class at the Pennsylvania Academy of the Fine Arts, he was influenced by fellow student Robert Henri. Henri included a selection of Sloan's sketches in his groundbreaking 1908 Macbeth Gallery exhibition. Sloan exhibited seven works in the 1913 Armory Show and was profoundly influenced by seeing examples of the work of modernists such as van Gogh, Cézanne, and Matisse.

Artist's Model, n.d.
Tempera on panel, 11 ¹³⁄₁₆ × 8 ¹⁵⁄₁₆ (29.9 × 22.7). Signed in the lower left: *John Sloan*. Springfield Art Association, Springfield, Ohio

In the 1930s, while working from a model, Sloan painted a number of African-American women. *Artist's Model* is dated to this period because of the artist's use of colored cross-hatching to expose layers of color. Sloan clothed his model in a turban, probably to accentuate a sense of the sitter's exoticism and emphasize the stately vertical lines in her neck. Writing in 1946, Sloan stated that

Among all the racial strains we have in this country, the Negro furnishes the most beautiful individuals. . . . They are well termed "colored people," and more artists might find them a rich field for color-sculptural study. C.V.

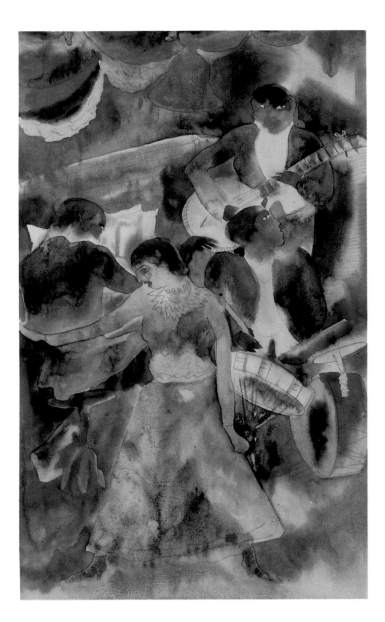

Charles Demuth 1883-1935

Born in Lancaster, Pennsylvania, Charles Demuth painted his first watercolor at thirteen. After completing preparatory school in Lancaster in 1901, he entered the Drexel Institute in Philadelphia to study art. In 1905 he attended the Pennsylvania Academy of the Fine Arts, where he studied under Thomas Anshutz and William Merritt Chase. Between 1907 and 1913 Demuth alternated between stays in Paris and studies at the Pennsylvania Academy; returning to Lancaster shortly before World War I, he also rented an apartment in New York and divided his time between the two cities.

Negro Jazz Band, 1916
Watercolor on paper, 13 × 8 (33 × 20.3). Signed in the lower left: *DEMUTH.* Collection of Irwin Goldstein, M.D.

Demuth was on the forefront of a generation of American artists who used modernist approaches to art-making to interpret American subjects. His early paintings use watercolor imagistically, portraying vaudeville and circus performers, nightclub entertainers, and erotic homosexual encounters to describe the variety of his New York experiences. After leaving New York Demuth increasingly turned to urban or industrial landscapes that depict forms with a unique fusion of planar, proto-cubist principles and precise realism. Painted in his early style, *Negro Jazz Band* evokes the mood, rather than the details, of a three-man band and female singer through amorphous stains of expressive watercolor. Like many artists and intellectuals of his generation, Demuth was drawn to the vibrant artistic community of Harlem. However, *Negro Jazz Band* does not describe the activities or personalities of his black counterparts but expresses an outsider's romance with Harlem nightlife.
G.C.M.

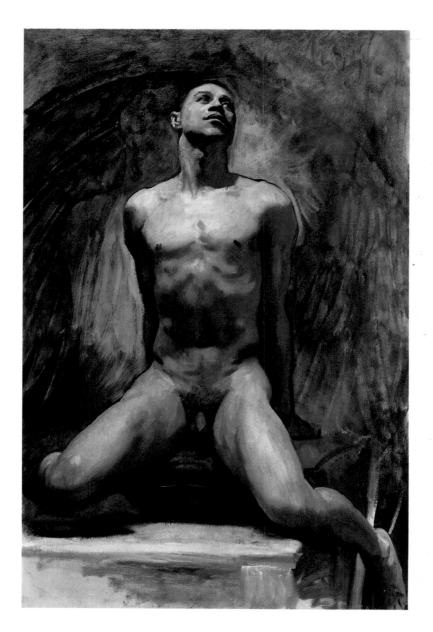

John Singer Sargent 1856-1925

John Singer Sargent was widely traveled and widely honored; his services were sought by an elite class of wealthy Americans and Europeans who wished to have their physical appearances and material status recorded through the brilliant painterly effects of his portraiture. Born in Florence, Italy, to a middle-class expatriate American family, Sargent was a precocious child who began artistic studies with the Swiss painter Joseph Farquharson and the German-American Carl Welsch when he was twelve or thirteen; by 1870 he was enrolled at the Accademia di Belle-Arti. In 1874 he entered the studio of Carolus Durand and subsequently studied at the École des Beaux-Arts. By 1879 Sargent had successfully exhibited a series of bravura portraits at the Paris Salon. Sargent enjoyed a series of successes until the exhibition of *Madame X* at the 1884 Salon created a notorious scandal that forced him to move to London. Dividing his time between studios in London and Boston, Sargent filled his later years with portrait and mural commissions.

Nude Study of Thomas McKeller, 1917
Oil on canvas, 49 ½ × 33 ¼ (125.7 × 84.5). Unsigned. Courtesy, Museum of Fine Arts, Boston. Henry H. and Zoe Oliver Sherman Fund

Among the highlights of Sargent's late career were three large mural projects for the Boston Public Library, The Boston Museum of Fine Arts, and The Widener Library at Harvard University. Thomas McKeller was an elevator operator whom the artist befriended during one of his frequent stays at the Boston Copley Plaza Hotel; McKeller's muscular, well-proportioned physique served as the inspiration for many of the figures in Sargent's Boston Museum mural cycle, including two images of Apollo and a bas-relief of Arion. However, while McKeller's body served as a model for several of the figures in his Boston mural cycles, none of the figures retains the model's African-American identity. Sargent's conception of a black man is redolent with a fluid naturalism and heroic posture, but *Nude Study of Thomas McKeller* was never publicly exhibited. Sargent retained it in his studio until his death, when it was discovered among other drawings and painted sketches of the same model.

Standing Male Nude, Orpheus
Study for the mural, **Classical and Romantic Art,** 1917-1920
Charcoal and stump on beige laid paper, 24¾ × 18⅞ (62.9 × 48).
The Corcoran Gallery of Art. Gift of Mrs. Frances Ormond
(Violet Sargent) and Miss Emily Sargent

Thomas McKeller also served as the model for *Standing Male
Nude, Orpheus,* a drawing that served as a model for Sargent's
mural *Classical and Romantic Art* in his Boston Museum rotunda
cycle. Sargent made several nude studies of McKeller, and while
in this drawing he retains his subject's African-American identity,
the model is transformed into an idealized Anglo-Saxon in the
finished mural.
G.C.M.

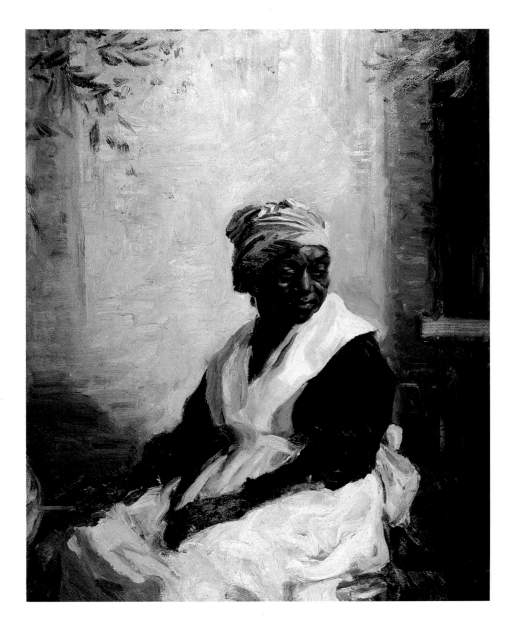

Wayman Adams 1883-1959

Painting in the style of William Merritt Chase and Robert Henri, Wayman Adams specialized in portraits of prominent Americans such as Booth Tarkington, Warren Harding, and Alice Roosevelt. Born near Muncie, Indiana, he was first exposed to art through his father, whose equine portraits recorded the horses he bred for sale. His family moved to Muncie when he was twelve, where his father taught art; Adams's first exhibition was a two-person display with his father in Silverburg's Drug Store in Muncie.

Adams's ability to obtain commissions as a student allowed him to complete a four-year program at the John Herron Art Institute in Indianapolis in 1904. In 1910 he traveled to Italy with William Merritt Chase on a study tour, and in 1912 traveled with Robert Henri through Spain. Adams was a strong advocate of alla prima painting and often completed a portrait in one sitting of three or four hours. By the 1920s Adams had moved to New York and, after participating in several exhibitions at the National Academy of Design, he was elected an Associate in 1926.

New Orleans Mammy, ca. 1920
Oil on canvas, 50 × 40 (127 × 101.6). Signed in the center left: *Wayman Adams*. Morris Museum of Art, Augusta, Georgia

Adams's interest in black subjects was the result of a trip he made to New Orleans in the early 1930s. *New Orleans Mammy* depicts an African-American woman in a fashionably correct three-quarter portrait style, modeled in the tradition of Anshutz and Henri. Her downcast eyes and set mouth create a mood of pensive resignation that is unmitigated by the floral notation that frames her features, or by the sweeping gestural strokes that describe her white pinafore dress. The artist's use of the appellation "Mammy" sixty years after the beginning of the Civil War seems a conscious attempt to establish local color by nostalgically linking the subject with a role fulfilled by female plantation slaves and domestic servants.

c.v.

John Steuart Curry 1897-1946

John Steuart Curry's art narrates the frenzied transformation in American culture from rural communities to urban industrial society. Born on a farm in Dunavant, Kansas, Curry moved to Kansas City in the summer of 1916 to enter the Kansas City Art Institute. By October, however, he had entered the School of the Art Institute of Chicago. After receiving a degree in 1918 Curry contributed drawings to *Boy's Life*, *St. Nicholas*, and *The Saturday Evening Post*. In 1923 he married and moved to New York City.

Curry's first solo exhibition in New York in 1930 was praised by critics as part of the growing trend toward "American scene" painting, and his works began to sell well. After 1934 he increasingly turned his attention to public mural projects sponsored by the Works Progress Administration (WPA). Among Curry's completed murals are the Westport, Connecticut, Department of Justice Building (1936-1937), the Kansas State Capitol Building in Topeka (1938-1940), and the Washington, D.C., Department of Interior Building (1939). Contrary to prevailing modernist opinions, Curry believed that art should grow out of daily experiences. Derived from literary models and American history, his subject matter celebrates a heroic image of America as a fertile land inhabited by honest, hardworking people. Curry also displayed a keen sense of social obligation, and in several cases his work directly confronts issues of equal rights and racial injustice.

Head of a Negro, 1927
Pastel on paper, 20¾ × 15¾ (52.7 × 40). Unsigned. Lent by the Whitney Museum of American Art, New York. Purchase

Drawn from a model, this partially completed study displays the academic rigor that supported Curry's more inventive thematic or allegorical paintings. The subtly expressive distortions of facial geometry that Curry used to accentuate the angles of his subject's face, matching purity of form and line with an evocative personality study, show his awareness of the mechanics of cubism. The pensive look on this handsome young man's face is in keeping with Curry's regard of blacks and other ethnic groups as the true representatives of the simple nobility of the working classes.

The Mississippi, 1935
Tempera on canvas, 36 × 47 ½ (91.4 × 120.6). Signed in the lower left: *The Mississippi/John Steuart Curry/1935*. The Saint Louis Art Museum. Purchase

Curry's definition of individuality was strongly tied to a regional sense of place, and his image of the people who farmed the rich river bottoms of the Mississippi was based as much on myth as reality. Along with Thomas Hart Benton and Grant Wood, Curry strongly believed in the rural family as the embodiment of bedrock American values, virtues, and religious purity. In contrast to studies from life such as *Head of a Negro*, Curry's thematic paintings were often created in the studio as a synthesis of representative forms that, successfully combined, could powerfully express the dynamic interaction between man and nature.

The Mississippi is typical of Curry's approach to figuration: abstracting the individual to suit the needs of his theme, Curry places his family ensemble on the roof of their modest shack. Curry makes a definite allusion to the biblical flood, and in a striking departure from the conception of the black family that dominated the visual arts, it is the man, not the woman, who beseeches the heavens with upraised arms as the family spokesman in time of travail.

F.M.

Andrée Ruellan 1905-1987

Born in New York City to French immigrants, Andrée Ruellan
had her first exhibition of drawings at St. Mark's in the Bowery
before the age of seven. Within two years her work had been
noticed by Robert Henri and George Bellows, who arranged
exhibitions for her at the MacDowell Club. In 1920 she was
awarded a scholarship to the Art Students League, where she
studied with Henri, Maurice Sterne, and Leo Lentelli; in 1922 she
was awarded a scholarship to study in Rome for one year with
Sterne. After her scholarship expired Ruellan moved to Paris, and
in 1929 she married the artist John W. Taylor. Returning to the
United States, the couple settled in Woodstock, New York, where
they participated in the Woodstock Art Colony. One of a number
of art colonies that briefly flourished during the first decades of
the twentieth century, the Woodstock Art Colony was founded on
the principles of John Ruskin; its membership was heavily influ-
enced by the style and subject matter of the Ashcan School
painters.

Ruellan wintered often in Charleston and Savannah, where she
made many of the genre studies of Southern harbors and public
markets that later became the subjects of many of her paintings
and lithographs. During the depression she painted WPA-
sponsored Post Office murals in Emporia, Virginia, and
Lawrenceville, Georgia. Her regional narrative style can also be
seen in murals in the Newark Public Library and the Broadmoor
Art Academy.

Black Youth, 1929
Pencil on paper, 12 × 9¼ (30.5 × 23.5). Signed in the lower right:
Andrée Ruellan. Collection of Angelo R. Mozilo

By the late 1930s Ruellan was increasingly influenced by cubism
and other forms of abstraction. In *Black Youth* the shape of the
boy's head and his features have been stylized to reflect the artist's
emotional or spiritual contact with the sitter (another drawing
by Ruellan of the same model identifies him as "Elijah"). A
committed social realist, Ruellan has said that what motivated
her art "is that in spite of poverty and the constant struggle
for existence, so much kindness and sturdy courage remain."
C.V.

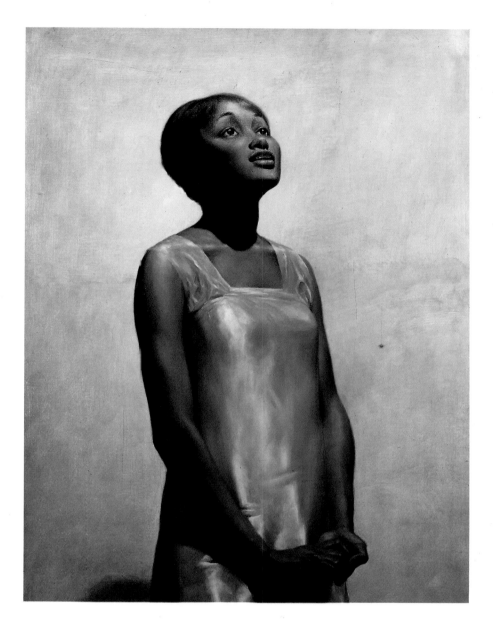

James Chapin 1887-1975

James Chapin was born in West Orange, New Jersey. He distinguished himself at Cooper Union and the Art Students League and then at the Royal Academy in Antwerp. In Paris, he was influenced by the work of Cézanne and other early modernists. After several years in New York, Chapin moved to a cabin in Stillwater, in the northern New Jersey hill country.

Chapin maintained two distinct bodies of work: sharply focused genre realism of working class people, and expressionistic thematic paintings of people at work in the American landscape. Grant Wood later praised Chapin's portraits as
among the best things in American art, strong and solid as boulders. They were full of the pain and bleakness of a frugal existence on the land, yet possessed a subtle, melancholy beauty of their own.

Ruby Green Singing, 1928
Oil on canvas, 38 × 30 (96.5 × 76.2). Signed in the lower right: *James Chapin 28*. Norton Gallery of Art, West Palm Beach, Florida

Painted the year before the 1929 New Gallery exhibition that brought him his initial success, *Ruby Green Singing* may have been included in that exhibition, although reviewers speak only of the "Marvin portraits," which depict Chapin's Stillwater landlords. Unlike the standard genre formulations that Chapin uses to depict working people, his approach to the popular singer and nightclub entertainer Ruby Green is much more idealized. Chapin's workers are recorded in settings that identify aspects of their home or work life; they straightforwardly direct their gaze toward the viewer. In contrast, Green is portrayed against a neutral ground that suggests a studio setting; her uplifted eyes suggest a spiritual or aesthetic quality that Chapin may have associated with her music. Chapin painted several other portraits of African-American women that maintain many of these same qualities, suggesting that he, like many American scene painters, believed that African-Americans and other ethnic groups led lives that embodied many of the best physical characteristics, simple virtues, and spiritual values that he associated with working class men and women.

G.C.M.

Edward Kemble 1861-1933

Edward Kemble belonged to what some historians have termed "the genial school of American caricature." Born in Sacramento, California, he was educated in newspapering by his father, Edward Cleveland Kemble, a pioneer in Pacific Coast journalism. By the early 1870s the Kembles had moved to New York City; Kemble had his first success in 1880 when four of his pen and ink "whims and fancies" were published in *Harper's Bazaar*. On the basis of his success with *Harper's Bazaar*, he was hired as a staff cartoonist for the *New York Daily Graphic*, then the only illustrated daily in New York.

In the winter of 1880, Kemble joined the sketch class at the Art Students League in New York; however, he did not find the League instructive and remained for only a brief period. In 1883 Kemble signed with the newly created *Life* magazine; one of his drawings for *Life* caught the eye of Mark Twain, who contracted him to illustrate *The Adventures of Huckleberry Finn*. The success of *Huckleberry Finn* brought Kemble popular recognition and initiated his long association with *Century Magazine*, where his regular contributions established his reputation as an

illustrator of humorous Southern themes. In addition to his prolific work as a magazine cartoonist and illustrator, he also continued to illustrate the books of many authors, providing drawings for several books by Paul Laurence Dunbar, one of America's first black poets to gain a national reputation.

Black Man with Pipe, 1929
Watercolor and ink on paper, 9 × 6 (22.9 × 15.2). Signed in the lower right: *Kemble/1929*. Courtesy of Illustration House, Inc.

The loose notation of Kemble's brushy watercolor technique uses tone instead of color to describe its subject, but while the features of *Black Man with Pipe* are clearly defined in terms of contrasts of light and dark, the supporting details of Kemble's subject are purposefully kept indeterminate or sketchy. Finally, nothing is revealed about this man except his smile and his pipe, and he stands as a symbol that was probably illuminated by accompanying text.

F.M.

Augusta Savage 1892 or 1900-1962

Augusta Savage's skill as a sculptor was matched by her dedication
to training and promoting African-American artists. Born in
Green Cove Springs, Florida, Savage enrolled in the Tallahassee
State Normal School but left in 1920 to seek more formal training
at Cooper Union in New York, where she became one of the first
women to gain admission into the school. Savage's first major
success came from a 1922 portrait commission of W. E. B. Du
Bois, a prominent educator, founder of the National Association
for the Advancement of Colored People, and editor of *The Crisis*,
the NAACP magazine that was one of the first multiracial forums
to address the issue of black equality.

Savage was awarded a Julius Rosenwald Fund Scholarship to
study with Félix Bueneteaux at the Académie de la Grand
Chaumiere as a result of the critical acclaim for her sculpture
Gamin (1930). She returned to New York to teach art classes in
Harlem in 1932; with the help of Carnegie Foundation funding,
she established the Augusta Savage School of Arts and Crafts,
which offered tuition-free classes to young African-Americans.
Among her students were painters Ernest Critchlow, Norman
Lewis, and Gwendolyn Clarine Knight and the sculptor William
Artis. As the founding director of the Federal Art Project School
Harlem Community Art Center, Savage served as an advocate for
the black visual arts community, securing jobs for many strug-
gling black artists on WPA projects. Commissioned by the New
York World's Fair and Exposition in 1939, *Lift Every Voice*
was Savage's signature artwork. Cast in plaster because of the
high cost of bronze, the sculpture was demolished after the close
of the Exposition.

Gamin, 1930
Bronze, 16 ½ × 9 ¼ × 8 ¼ (41.91 × 23.49 × 20.95). Signed on the
back. Schomburg Center for Research in Black Culture, The New
York Public Library, Art & Artifacts Division

Gamin is carefully modeled in a realistic style that renders the
African-American physiognomy with accuracy and sensitivity.
This portrait bust of an anonymous urchin explores themes of
everyday life, capturing both the innate innocence of youth and
the tough realities of street life. Savage's aesthetic shares affinities
with the proletarian images of Robert Henri and other members
of the Ashcan School, and continues a particularly American
tradition of finding inspiration in the representation of ordinary
people.
J.L.

Charles Burchfield 1893-1967

Charles Burchfield was born in Ashtabula, Ohio; his family moved to Salem, Ohio, when his father died in 1898. In 1912 Burchfield entered the Cleveland School of Art; his principal teacher, Henry G. Keller, encouraged him to study the illustrations of Arthur Rackham and Ivan Bilibine, as well as the poetry of W. B. Yeats and the *Rubaiyat of Omar Khayyam*, sources that became strong influences on his art. Burchfield received a scholarship to the National Academy of Design in New York in 1916 but decided to abandon further studies and left school after the first day of classes. Returning to Salem, he worked as an accountant and painted nights and weekends. Invoking many of his childhood memories of the Salem landscape, he began to experiment with fantasy images as a way of capturing the intensity of his sensory and emotional responses to nature.

Souvenir of South Carolina, 1930
Watercolor on paper, 27 × 33 ½ (68.6 × 85.1). Signed in the lower right: *Chas. Burchfield*. Muskegon Museum of Art. Hackley Picture Fund Purchase

Burchfield's early paintings combine abstract and representational imagery to produce intense evocations of his childhood memories; during the 1930s, he turned to realism, using houses, factories, and stores as surrogates whose exteriors "portray" the lives of their inhabitants. During the 1940s Burchfield returned to his unique synthesis of spiritual abstraction. During a six-month period from July 1918 to January 1919, Burchfield was stationed with the Army in Camp Jackson, South Carolina. He kept a sketchbook/journal during his stay, which includes a small drawing inscribed *Camden, S.C. 1918*. This sketch was reworked in his Buffalo studio into *Souvenir of South Carolina*. Framing the men who take their leisure before a group of storefronts with trees, birds, and draft horses, Burchfield is as interested in how men interact with nature as in the individuality of his figures. The time-worn buildings that are the setting for this gathering speak more eloquently of the strength of the community (and the artist's position as an outsider) than of the personalities of any of the individuals inhabiting it.

J.L.

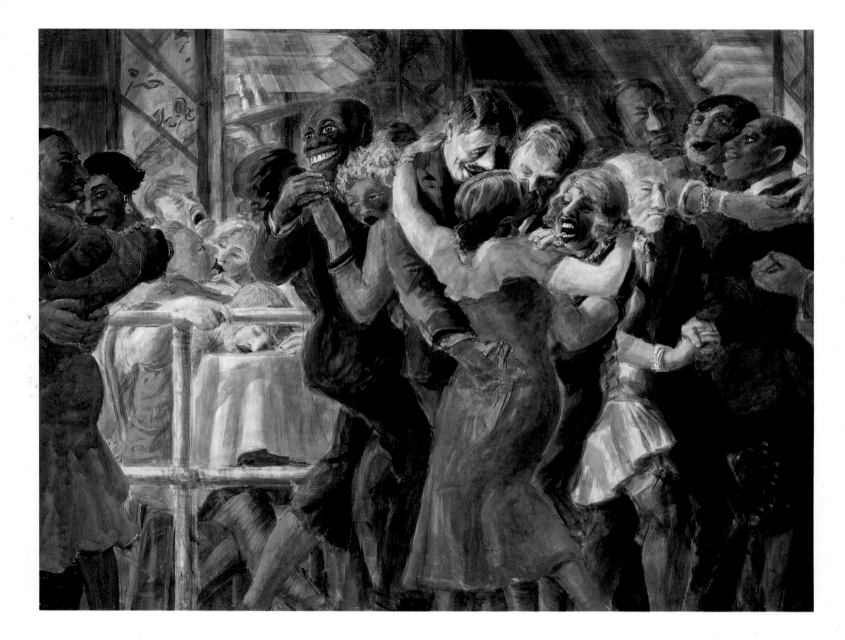

Reginald Marsh 1898-1954

Reginald Marsh maintained an uncannily accurate eye for the variety of human phenomena that characterizes the urban environment. Marsh was born in Paris; both of his parents were successful artists who lived a comfortable expatriate life. The family returned to the United States in 1900 and settled in Nutley, New Jersey, before moving to New Rochelle, New York, in 1914. In 1916 Marsh entered Yale University; in his senior year he was admitted to the Yale Art School, and after graduating in 1920, he enrolled in painting classes at the Art Students League while working as a free-lance illustrator.

Marsh worked as a staff artist for the *New York Daily News* between 1922 and 1925 and held his first one-man exhibition at the Whitney Studio Club in 1924. When the *New Yorker* began publication in 1925 Marsh joined its staff; throughout his career he provided illustrations for a wide variety of periodicals, including *Life*, *Esquire*, *Harper's Bazaar*, and the *New York Herald*. At a time when graphic illustration was becoming increasingly unfashionable, Marsh studied the work of such great English illustrators as Gillray, Cruikshank, Leech, and Tenniel.

Between 1925 and 1926 Marsh spent six months of self-study in Paris, paying particular attention to the collection of the Louvre. Returning to New York, he studied again at the Art Students League and was introduced to the medium of egg tempera, which he continued to use as his primary medium throughout his life. By 1931 he was turning his attention to recording the diverse lives of the inhabitants of New York City. Striving to maintain accuracy and objectivity, he studied anatomy at the Cornell Medical School in New York Hospital. Haunting both working-class and wealthy neighborhoods, he developed special interests in Coney Island, the Bowery, tenement life, and the sleazy glamour of speakeasies.

Perhaps because of his beginnings as a graphic artist, Marsh most often approached art as a draftsman, and it is the fluidity of his expressive line, rather than his painterly abilities, that makes his art unique. Marsh disliked modernist art and considered himself a serious student of a historical artistic tradition that he traced from Michelangelo to Peter Paul Rubens to Eugène Delacroix. Marsh was fascinated by the diverse vitality that he perceived in all working people. Despite established artistic taboos regarding African-American subjects that continued to

inflect the work of conservative artists in the twentieth century, he turned often to African-American themes to reflect the vitality of the modern American city.

Tuesday Night at the Savoy Ballroom, 1930
Tempera on composition board, 36 × 48⅛ (91.4 × 122.2). Unsigned. The Rose Art Museum, Brandeis University, Waltham, Massachusetts. Gift of the Honorable William Benton, New York

The black and white couples in *Tuesday Night at the Savoy Ballroom* bump and grind on the packed dance floor in positions that veer between discrete displays of sensuality and openly erotic embraces. While most of Harlem's clubs remained segregated

into the 1940s, a few, like the Savoy Ballroom, admitted members of all races. Marsh provides only fragments of the informational details of the setting, which in any event are a jumble of near-abstractions that reinforce the painting's sense of hedonism. What interested Marsh was the reality of human contact, and his caricaturish style expressively distorts everyone, black or white, to represent the vices and virtues of the affluent intellectuals and thrill-seekers who favored Harlem nightlife. The tone of *Tuesday Night at the Savoy Ballroom* is a far cry from the attitudes commonly expressed by nineteenth century cartoonists, who used the dance floor as a metaphor to proclaim hysteria over the possibility of racial miscegenation brought about by equal rights in Reconstruction America.

Negroes on Rockaway Beach, 1934
Egg tempera on composition board, 30 × 40 (76.2 × 101.6).
Signed in the lower left: *Reginald Marsh 1934.* Lent by the
Whitney Museum of American Art, New York. Gift of Mr. and
Mrs. Albert Hackett

One of Marsh's most notable bodies of work concerns the human
body, in all its beauty or ugliness, at play on the public beaches of
New York. With its baroque composition of linear forms linked
as a series of fluid rhythms, *Negroes on Rockaway Beach* is a
continuation of Marsh's fascination with ribald or earthy animal
sensualism. Figures populate the entire canvas, entering from all
directions, assuming a dizzying variety of positions that verges on
a single writhing mass of humanity. This alternately exhilarating
and claustrophobic vision of a crowded, noisy New York beach
on a hot summer day is, however, free from white faces, reflecting
the de facto segregation that existed on New York's beaches
during the 1930s. Marsh's figures are alive with a magnetic,
markedly sexual allure that is particularly telling in the range of
women, which includes both slender and statuesque bathers, a
sunbather reading a lurid tabloid, a woman whose playful face is
contorted into a clownlike mask, and a woman who languidly
displays an openly sexual pose. In this mass of femininity, males
seem intent on displaying athletic ability or engage in the mock
combat of wrestling. Race is both incidental and pivotal to
Marsh's scene. The black figures that share this territory with the
rest of the crowd are most probably, like their neighbors, working
men and women who enjoy the right to leisure, but they pointedly
remain segregated from the rest of society.
F.M.

Sargent Johnson 1887-1967

Sargent Johnson was born in Boston to a Swedish father and a mother of Cherokee and African-American ancestry. His parents' marriage was troubled by racial tensions and illness. After the death of his parents he lived for a time with his uncle, Sherman Williams Jackson, an educator and school principal in Washington, D.C. Johnson's first exposure to art came from his aunt, May Howard Jackson, a sculptor who specialized in portrait busts and African-American themes. After graduating from high school he lived for a short time with relatives in Chicago before moving to the San Francisco Bay Area in 1915. Enrolling in the California School of Fine Arts, he studied with Beniamino Bufano and quickly adopted the idiosyncratic stylizations of his teacher's figurative sculpture.

Johnson had his first exhibition in San Francisco in 1925, and a review of his ceramic sculpture *Elizabeth* caught the attention of William E. Harmon, a New York philanthropist and founder of the Harmon Foundation, an organization that supported black artistic expression as a means of individual uplift and racial self-awareness. Johnson began exhibiting with the Harmon Foundation in 1926 and was included in Harmon Foundation exhibitions throughout the 1930s.

Forever Free, 1933
Wood with lacquer on cloth, $36 \times 11\frac{1}{2} \times 9\frac{1}{2}$ ($91.5 \times 29.2 \times 24.2$). San Francisco Museum of Modern Art. Gift of Mrs. E. D. Lederman

Included in a 1935 three-person Harmon Foundation exhibition in New York, *Forever Free* became one of Johnson's signature sculptures. Johnson's unusual surfaces – painted, lacquered, and burnished images over layers of gesso and linen applied to a redwood form – reflect his study of Egyptian and Oriental techniques, as well as his experiences as a picture framer. The static, iconic position of the head, arms, and feet reflects Bufano's influence, suggesting an inner tension that is released only upward, through the eyes. Incised on the skirt of this strong female figure are the outlines of two young children, hopeful symbols of the African-American future. Johnson believed that the visual arts afforded an avenue for the reconstruction of a positive image of African-Americans, saying:
It is the pure American Negro that I am concerned with, aiming to show the natural beauty and dignity in that characteristic lip and that characteristic hair, bearing and manner; and I wish to show that beauty not so much to the white man as to the Negro himself.
G.C.M.

Thomas Hart Benton 1889-1975

Thomas Hart Benton's art vividly captures the changing face of the rural Midwest during the first half of the twentieth century. Born in Neosho, Missouri, to a famous Missouri political family, Benton lived in Washington, D.C., and studied at The Corcoran School of Art during his father's four terms in the United States House of Representatives (1897-1905). Benton attended the School of the Art Institute of Chicago between 1907 and 1908; traveling abroad, he experimented with impressionism at the Académie Julien and the Académie Colarossi. By 1912 he had returned to the United States, settling in New York City. In 1919 Benton began to model preparatory figures in clay, a practice that became a permanent part of his approach to figuration. These models served as guides for the *American Historical Epic* (1919-1926), his first mural on an American theme. In 1926 he began teaching at the Art Students League and began to develop an extensive vocabulary of rural imagery.

Ploughing It Under, 1934

Oil on canvas, 20⅛ × 24¼ (51.2 × 61.6). Signed in the lower right: *Benton*. Lyman Field and United Missouri Bank of Kansas City, N.A., Co-Trustees of the Thomas Hart Benton and Rita P. Benton Testamentary Trusts

Benton's career married the idea of artistic creativity with uniquely American themes. He inherited a homespun rural populism from his father's political career, which he molded into a singular aesthetic that in many ways is the culmination of the American genre tradition. By 1934, when he painted *Ploughing It Under*, he had abandoned the lingering influence of impressionism for a highly personal expressive realism. The richly colored, sinuous landscape is Benton's real subject; his romance of the land is much more compelling than his romantic vision of self-made agrarian toilers in the field. African-Americans figure prominently in Benton's paintings and murals, largely as anonymous figures linked to agriculture and the simple joys of rural life. However, he occasionally produced a painting such as *Negro Soldier* (1942), which uses close-up, sharply focused social realism to emphasize the bravery of black soldiers, a premise that was still questioned almost one hundred years after the Civil War.

G.C.M.

125

Paul Cadmus 1904-

Paul Cadmus was introduced to the arts by his parents. His
father, a student of Robert Henri, worked as a lithographer, while
his mother was an illustrator of children's books. A precocious
teenager, he began studies with Charles Hinton at the National
Academy of Design when he was fifteen; he studied printmaking
with William Auerbach-Levy and soon began publishing illustra-
tions for the *New York Herald Tribune Book Review*. In 1931
Cadmus began a tour of Europe, settling in Mallorca to paint for
two years. Returning to New York, he was drawn toward the
social realism of the American scene painters. During the Depres-
sion Cadmus was hired by the newly formed Public Works of
Art Project, but in 1934 his satire *The Fleet's In* was removed
from the first Washington PWAP exhibition, creating a highly
public scandal. Several of his post office mural commissions were
subsequently rejected, and a 1940 *Life* magazine commission
documenting the labor struggle was refused on political grounds.

To the Lynching!, 1935
Pencil and watercolor on paper, 20½ × 15¾ (52.01 × 40). Signed
in the bottom center: *Paul Cadmus*. Lent by the Whitney Museum
of American Art, New York. Purchase

During the period following postwar Reconstruction, lynching
became a common form of mob anger against blacks. In the last
sixteen years of the nineteenth century more than 2,500 men,
women, and children were lynched. Such violence continued well
into the twentieth century: at least 1,100 lynchings occurred in
the years before World War I, and repeated attempts at prohibitive
federal legislation were defeated as late as 1940. The social
realists frequently used the image of a lynching to symbolize the
entire spectrum of violence against blacks; treatments of this
subject can also be seen in the work of Thomas Hart Benton,
Julius Bloch, and Louis Lozowick.

 To the Lynching! creates a savage visual commentary on racial
prejudice in America. The artist's polemic is reinforced by a host
of exaggerated expressions and grotesquely clenched hands;
the well-muscled forms of writhing men in this rhythmically
interwoven composition merge with a struggling horse, equating
the brute force of mob action with animal behavior.

J.L.

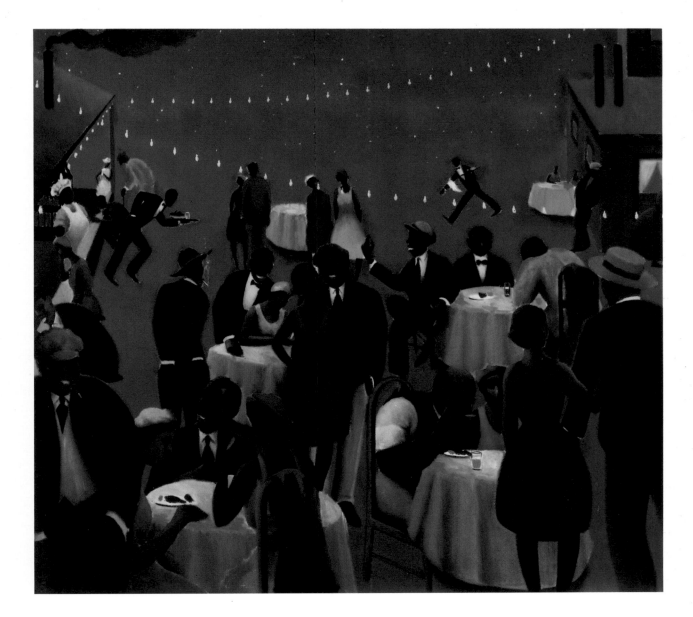

Archibald J. Motley, Jr. 1891-1981

Born in New Orleans, Archibald J. Motley, Jr., studied at the School of the Art Institute of Chicago. He successfully advocated the use of black models in figure classes and participated in a 1917 exhibition sponsored by the Chicago Arts and Letters Society, the first exhibition to feature art by Chicago African-American artists. In 1928 his former teacher, Robert B. Harsche, helped him obtain his first New York exhibition. Motley's New York exposure led to exhibitions at the Harmon Foundation and was instrumental in helping him obtain a Guggenheim fellowship (1929), which he used to study and work in Paris for a year.

Returning to Chicago in 1930, Motley became active in Gertrude Abercrombie's cultural salon, a diverse group of Chicago's musical, literary, and artistic figures that included Dizzy Gillespie, Sarah Vaughn, and Studs Terkel. In 1935 he moved to Washington, D.C., to teach at Howard University and was commissioned to create murals (now destroyed) for Frederick Douglass Hall. Returning to Chicago, he continued to paint distinctively African-American subjects, always using the city of Chicago as a backdrop for the interactions of his characters. In a 1978 interview Motley said of his work:

I was trying to fill what they call the full gamut, the race as a whole, not only, you know, being terribly black, but those that were very light and those that were in-between . . . I try to give each one of them character as individuals.

Barbecue, ca. 1935
Oil on canvas, 36 × 40 (91.5 × 101.6). Signed in the lower left: *A. J. Motley, Jr.* Permanent Collection, Howard University Gallery of Art, Washington, D.C.

The wide range of individuals in *Barbecue* testifies to the variety of the black community in cities such as Chicago, New York, and Washington during the 1930s. *Barbecue* was painted during the 1930s, when Motley lived and worked in Washington, D.C. Unlike many of his other paintings, this setting is not a specific neighborhood; except for a few details to establish a landscape context, it shows a succession of figures in a largely abstract field.
G.C.M.

Ben Shahn 1901-1969

Ben Shahn was born in Kovno, Lithuania; his family immigrated
to Brooklyn in 1906. From 1919 to 1922 he attended New York
University and City College of New York, winning a summer
scholarship to Woods Hole, Massachusetts, to study botany. At
the end of his scholarship he enrolled in the National Academy of
Design, and for the next five years he divided his time between
travels throughout Europe, where he studied the artists of the
School of Paris, especially Rouault, and work as an artist and
lithographer in New York. When he returned to the United States
in 1929, his first one-person exhibition brought a crisis of confi-
dence that resulted in his rejection of purely decorative theories of
modern art. Working in watercolor, gouache, and tempera, he
produced two series based on overtly political themes: the Dreyfus
scandal in nineteenth century France, and the 1921 trial and
conviction and the 1927 execution of Sacco and Vanzetti for
murder. Exhibited in 1933, the Sacco-Vanzetti series brought
Shahn immediate critical and financial success.

Following the Sacco-Vanzetti series, Shahn was hired by the
Mexican social realist Diego Rivera as his assistant for his

Rockefeller Center frescoes. After Rockefeller's rejection of
Rivera's mural because of its inclusion of socialist political con-
tent, Shahn found work in the federally funded Public Works
of Art Project; among his murals are frescoes in the Bronx Central
Post Office (1939), a canvas mural in the Jamaica, Queens, Post
Office (1940), and frescoes in what is now the Federal Security
Building in Washington, D.C. (1940-1942).

Willis Avenue Bridge, 1940
Tempera on paper over composition board, 23 × 31⅜
(58.4 × 79.7). Collection, The Museum of Modern Art, New
York. Gift of Lincoln Kirstein
Shahn's brilliance as an artist lay in his ability to adapt expres-
sionistic techniques to create a sharply focused emotional social
polemic. Painted at the end of the Great Depression, *Willis Avenue
Bridge* uses individual figures to symbolize the social marginali-
zation of urban African-Americans. This seated couple displays
both resignation and determination, but Shahn inverts the nine-
teenth century genre tradition of isolating blacks from the main-
stream of American society, using the constricting geometry of
the bridge to turn their isolation into a pointed moral question
about a society that allows marginalization based on race.
G.C.M.

Jacob Lawrence 1917-

Jacob Lawrence is one of the best known of a generation of black artists who, beginning in the 1920s and 1930s, pioneered the use of visual mediums to explore and assert their African-American heritage. Lawrence's paintings, often produced and exhibited in series, combine modernist design and aesthetic concepts with events in black history and contemporary life. Lawrence was born in Atlantic City; his parents were separated in 1924, and his mother took her children to New York in 1930. In New York Lawrence studied with Charles Alston and Henry Bannarn in WPA-sponsored art classes at the Harlem Art Workshop from 1934 to 1937, and after six months in a Civilian Conservation Corps work camp, he obtained a scholarship to the American Artists School.

Around this time he began painting the *Toussaint L'Ouverture* series, the first of his series to deal with themes of black history and famous black leaders. Lawrence held his first one-person exhibition at the Harlem YMCA in 1938, and by the end of the year he was hired as an easel artist by the WPA Federal Art Project. Lawrence married the painter Gwendolyn Clarine Knight in 1941; after a series of prizes and fellowships that included a Julius Rosenwald Fund Fellowship, he had his first major one-man exhibition in 1941 at New York's Downtown Gallery. Featuring works from *The Migration of the Negro* series, it was a critical and financial success; portions of the series were purchased by the Museum of Modern Art in New York and The Phillips Collection in Washington, D.C.

Lawrence's early work restates many of the concerns of social realism and the American scene painters in terms of the colors and forms of his Harlem neighborhood. Beginning with the *Toussaint L'Ouverture* series (1937-1938), Lawrence worked serially, connecting images and text to create a narrative that identifies and describes a black hero. The *Frederick Douglass* series (1938-1939) and the *Harriet Tubman* series portray African-American figures who played pivotal roles in this country's history. By the time Lawrence completed *The Migration of the Negro* series (1940-1941), he had begun to speak more generally about the present, grounding his reflections on the black experience in images that were increasingly abstract. Lawrence has said of his work:

My pictures express my life and experience. I paint the things I know about and the things I have experienced. The things I have experienced extend to my national, racial, and class group. So I paint the American scene.

No. 1 **During the World War there was a great Migration North by Southern Negroes, The Migration of the Negro** series, 1940-1941
Casein on hardboard, 12 × 18 (30.5 × 45.7). The Phillips Collection

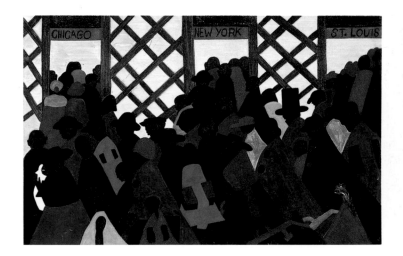

No. 3 **In every town Negroes were leaving by the hundreds to go North to enter into Northern industry, The Migration of the Negro** series, 1940-1941
Casein on hardboard, 12 × 18 (30.5 × 45.7). The Phillips Collection

The Migration of the Negro series was featured in Lawrence's 1941 Downtown Gallery exhibition, and the successful critical and financial response to this work solidified Lawrence's status as one of the foremost African-American artists working in the United States. Introducing a thematic approach to history that stresses the transition from a rural to an urban habitat, *The Migration of the Negro* series was a major break from previous series such as *Toussaint L'Ouverture*, *Frederick Douglass*, and *Harriet Tubman*, which deal with historical events through the lens of one person's life. More overtly abstract, the figures and landscapes in this series show Lawrence's increasingly confident manipulations of the conventions of synthetic cubism in the service of a social realism firmly rooted in present events.

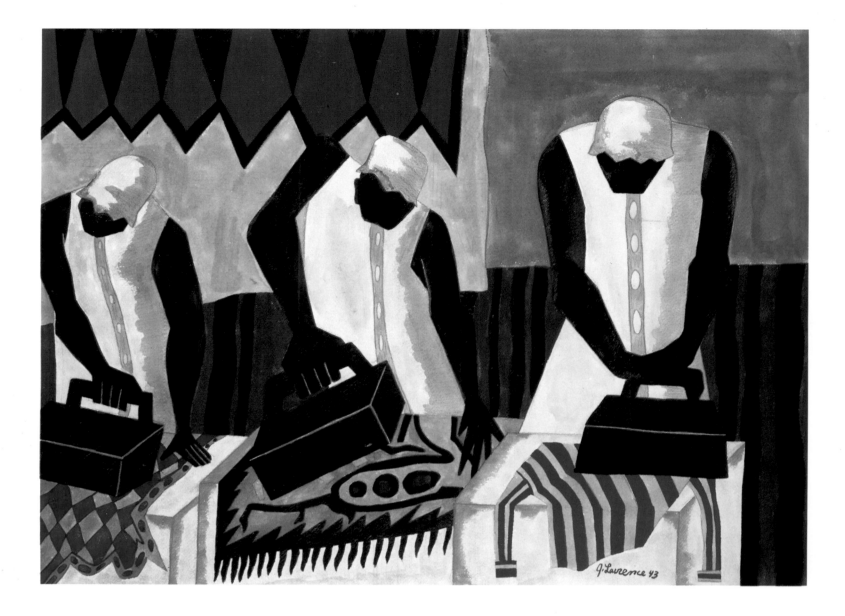

Ironers, 1943
Gouache on paper, 21 ½ × 29 ½ (54.6 × 74.9). Signed in the bottom
right: *J. Lawrence 43*. Private Collection

Painted while Lawrence was working on the *Harlem* series and
shortly before he was inducted into Coast Guard service, *Ironers*
may have been intended originally for inclusion in the *Harlem*
series, a group of thirty paintings depicting the daily life of the
working-class residents of Lawrence's neighborhood. *Ironers*
vividly shows Lawrence's ability to fuse boldly colored design and
figurative elements as rhythmic integers in a dynamic composi-
tion. Exaggerating and intensifying the forms of his figures, he
simplifies features to intensify his focus on the theme of work, one
of the continuing concerns of his art.
G.C.M.

Selected Bibliography

Books and Exhibition Catalogues

ADAMS, Karen M. *Black Images in Nineteenth-Century American Painting and Literature* [doctoral dissertation, Emory University]. Atlanta, 1977.

American Folk Portrait Painting and Drawing from the Abby Aldrich Rockefeller Folk Art Center. Boston, 1981.

The American Personality [exh. cat., Grunwald Center for the Graphic Arts]. Los Angeles, 1976.

BAIGELL, Matthew. *Charles Burchfield*. New York, 1976.

———. *Dictionary of American Art*. New York, 1982.

———. *Thomas Hart Benton*. New York, 1974.

BAKER, Ray Stannard. *Following the Color Line*. New York, 1908.

BALL, Thomas. *My Three Score and Ten – An Autobiography*, 2d ed. New York, 1977.

BARBER, John. *A History of the* Amistad *Captives*. Amherst, Massachusetts, 1969.

BAUR, John I. H. *Charles Burchfield* [exh. cat., Whitney Museum of American Art]. New York, 1956.

———. *John Quidor, 1801-1881* [exh. cat., The Brooklyn Institute of Arts and Sciences]. Brooklyn, 1942.

BEAM, Philip C. *Winslow Homer's Magazine Engravings*. New York, 1979.

BELLOWS, Emma, ed. *George Bellows: His Lithographs*. New York, 1927.

BENTON, Thomas Hart. *An American in Art: A Professional and Technical Autobiography*. Lawrence, Kansas, 1969.

———. *An Artist in America*, 4th ed. Columbia, Missouri, 1983.

BIDDLE, Edward, and FIELDING, Mantle. *The Life and Works of Thomas Sully 1783-1872*. New York, 1970.

BIRCHFIELD, James D., BOIME, Albert, and HENNESSEY, William. *Thomas Satterwhite Noble 1835-1907* [exh. cat., The University of Kentucky Art Museum]. Lexington, Kentucky, 1988.

BOIME, Albert. *Thomas Couture and the Eclectic Vision*. New Haven, Connecticut, 1980.

BOLGER-BURKE, Doreen. *American Paintings in The Metropolitan Museum, Volume 3: A Catalogue of Work by Artists Born Between 1846-1864*. New York, 1980.

BOLTON-SMITH, Robin, and TRUETTNER, William H. *Lilly Martin Spencer 1822-1902: The Joys of Sentiment* [exh. cat., National Museum of American Art, Smithsonian Institution]. Washington, D.C., 1973.

BONTEMPS, J. F. *Forever Free: Art by African-American Women 1862-1980*. Alexandria, Virginia, 1980.

BOSKIN, Joseph. *Sambo: The Rise and Demise of an American Jester*. New York, 1986.

BROOKE, Richard Norris. *Record of Work: Surviving to some extent as a history of my professional life . . . especially since my departure for Paris in 1878*. Washington, D.C., 1918.

BULLARD, F. Lauriston. *Lincoln in Marble and Bronze*. New Brunswick, New Jersey, 1952.

BUTCHER, Margaret J. *The Negro in American Culture*, 2d ed. New York, 1972.

CARMEAN, E. A., Jr. *Bellows: The Boxing Pictures* [exh. cat., National Gallery of Art]. Washington, D.C., 1982.

CASSIDY, David. *Works in the Collection of Stony Brook*. Stony Brook, New York, 1983.

Charles Demuth of Lancaster [exh. cat., William Penn Memorial Museum]. Harrisburg, Pennsylvania, 1966.

CHASE, Hal S., and PENDERGRAFT, Norman E. *Duncanson: A British-American Connection* [exh. cat., Museum of Art, North Carolina Central University]. Durham, North Carolina, 1984.

CHASE, Judith Wragg. *Afro-American Art and Craft*. New York, 1971.

COEN, Rena Neumann. *The Black Man in Art*. Minneapolis, 1970.

COFFIN, Levi. *Reminiscences*, 2d ed. Cincinnati, 1880.

COLWILL, Stiles Tuttle. *Francis Guy, 1760-1820* [exh. cat., Museum and Library of Maryland]. Baltimore, 1981.

———, and WEEKLY, Carolyn, Jr. *Joshua Johnson: Freeman and American Folk Painter* [exh. cat., Abby Aldrich Rockefeller Folk Art Center]. Baltimore, 1987.

COSENTINO, Andrew J., and GLASSIE, Henry H. *The Capital Image: Painters in Washington, D.C. 1800-1915* [exh. cat., National Museum of American Art, Smithsonian Institution]. Washington, D.C., 1983.

COWDREY, Mary Bartlett. *The American Academy of Fine Arts and American Art-Union*, 2 vols. New York, 1953.

———, ed. *National Academy of Design Exhibition Record, 1826-1860*, 2 vols. New York, 1943.

———, and WILLIAMS, Herman Warner, Jr. *William Sidney Mount, 1807-1867, an American Painter*. New York, 1944.

CRAVEN, Wayne. *Sculpture in America*, 2d ed. New Brunswick, New Jersey, 1984.

CROWE, Eyre. *With Thackeray in America*. London, 1893.

CZESTOCHOWSKI, Joseph S. *John Steuart Curry and Grant Wood: A Portrait of Rural America*. Columbia, Missouri, 1981.

DAWSON, William Forrest. *A Civil War Artist at the Front: Edwin Forbes' Life Studies of the Great Army*. New York, 1957.

DIJKSTRA, Bram. *The Hieroglyphic of a New Speech: Cubism, Stieglitz, and the Early Poetry of William Carlos Williams*. Princeton, New Jersey, 1969.

DRISKELL, David C. *The Toussaint L'Ouverture Series by Jacob Lawrence* [exh. cat., The Art Gallery, Fisk University]. Nashville, 1968.

———. *Two Centuries of Black American Art* [exh. cat., Los Angeles County Museum of Art]. New York, 1976.

DRYFHOUT, John H. *The Work of Augustus Saint-Gaudens*. Hanover, New Hampshire, 1982.

DU BOIS, W. E. B. *The Souls of Black Folk*. Chicago, 1903.

DUNLAP, William. *A History of the Rise and Progress of the Arts of Design in the United States*, 2d ed., 2 vols. New York, 1969.

ELIASOPH, Philip. *Paul Cadmus: Yesterday and Today* [exh. cat., Miami University Museum]. Oxford, Ohio, 1981.

ELLISON, Ralph. *Invisible Man*. New York, 1952.

FELD, Stuart, and TEN EYCK GARDNER, Albert. *American Paintings: A Catalogue of the Collection of The Metropolitan Museum of Art, Volume 1*. Greenwich, Connecticut, 1965.

FIELDING, Mantle. *Dictionary of American Painters, Sculptors, and Engravers*. New York, 1965.

FINCH, Christopher. *American Watercolors*. New York, 1986.

FLEXNER, James Thomas. *The Light of Distant Skies 1760-1835*, 2d ed. New York, 1969.

———. *The World of Winslow Homer*. New York, 1966.

FONER, Eric. *Reconstruction: America's Unfinished Revolution, 1863-1877*. New York, 1988.

FORNHAM, Emily Edna. *Charles Demuth: Behind a Laughing Mask* [exh. cat., University of Oklahoma]. Norman, Oklahoma, 1971.

FOX, James Edward. *Iconography of the Black in American Art* [doctoral dissertation, The University of North Carolina at Chapel Hill]. Chapel Hill, North Carolina, 1979.

FRANKENSTEIN, Alfred. *After the Hunt: William Harnett and Other American Still Life Painters 1870-1900*. Berkeley, 1969.

———. *William Sidney Mount*. New York, 1975.

FRANKLIN, John Hope, and MOSS, Alfred A., Jr. *From Slavery to Freedom: A History of the Negro American*, 6th ed. New York, 1981.

FRICK, John W., and WOOD, Carleton, eds. *Directory of Historic American Theaters*. New York, 1987.

GARDNER, Albert Ten Eyck. *Winslow Homer, American Artist: His World and His Work*. New York, 1961.

GATES, Henry Louis, Jr. *The Signifying Monkey: A Theory of Afro-American Literary Criticism*. New York, 1988.

GEBHARD, David, and PLOUS, Phyllis. *Charles Demuth, the Mechanical Encrusted on the Living* [exh. cat., The Art Galleries, University of California]. Santa Barbara, 1971.

George Bellows: Paintings, Drawings and Prints [exh. cat., Columbus Museum of Art]. Columbus, Ohio, 1979.

GOODRICH, Lloyd. *John Sloan, 1871-1951* [exh. cat., Whitney Museum of American Art]. New York, 1952.

———. *Reginald Marsh*. New York, 1972.

———. *Thomas Eakins: Retrospective Exhibition* [exh. cat., Whitney Museum of American Art]. New York, 1933.

———. *Winslow Homer* [exh. cat., Whitney Museum of American Art]. New York, 1973.

GRAHAM GALLERY. *Thomas P. Anshutz, 1851-1912* [exh. cat.]. New York, 1963.

GREYWACZ, Kathryn B. *James Chapin* [exh. cat., State Museum, Trenton, New Jersey]. Trenton, 1955.

GRIME, Philip N., and MAZZA, Catherine L. *John George Brown, 1831-1913, A Reappraisal* [exh. cat., The Robert Hall Fleming Museum, The University of Vermont]. Burlington, 1975.

GROCE, George C., and WALLACE, David H. *The New York Historical Society's Dictionary of Artists in America: 1564-1860.* New Haven, Connecticut, 1957.

GRUBAR, Francis S. *Richard Caton Woodville: An Early American Genre Painter* [exh. cat., The Corcoran Gallery of Art]. Washington, D.C., 1967.

GRUVER, Rebecca Brooks. *An American History*, 2 vols., 2d ed. Reading, Massachusetts, 1976.

HALEY, Alex. *Roots.* New York, 1976.

HARRIS, Gene E. *Arthur Burdett Frost, 1851-1928: Artist and Humorist.* Chadds Ford, Pennsylvania, 1986.

HARTIGAN, Lynda Roscoe. *Sharing Traditions: Five Black Artists in Nineteenth-Century America* [exh. cat., National Museum of American Art]. Washington, D.C., 1985.

HARTMANN, Sadakichi. *A History of American Art*, 2 vols. Boston, 1932.

HASKELL, Barbara. *Charles Demuth* [exh. cat., Whitney Museum of American Art]. New York, 1987.

HASKELL, Francis, and PENNY, Nicholas. *Taste and the Antique: The Lure of Classical Sculpture.* New Haven, Connecticut, 1981.

HEARD, Sandra Denney. *Thomas P. Anshutz, 1851-1912* [exh. cat., Pennsylvania Academy of the Fine Arts]. Philadelphia, 1973.

HELLER, Nancy, and WILLIAMS, Julia. *The Regionalists.* New York, 1976.

HENDRICKS, Gordon. *The Life and Work of Winslow Homer.* New York, 1979.

HENRI, Robert [Margery Ryerson, ed.]. *The Art Spirit.* Philadelphia, 1923.

HILLS, Patricia. *Eastman Johnson* [exh. cat., Whitney Museum of American Art]. New York, 1972.

———. *The Genre Painting of Eastman Johnson: The Sources and Development of His Style and Themes.* New York, 1977.

———. *John Singer Sargent* [exh. cat., Whitney Museum of American Art]. New York, 1986.

———. *The Painter's America: Rural and Urban Life 1810-1910* [exh. cat., Whitney Museum of American Art]. New York, 1974.

HOLLAND, Eugenia C., et al. *Four Generations of Commissions: The Peale Collection of the Maryland Historical Society* [exh. cat., Maryland Historical Society]. Baltimore, 1975.

HOMER, William Innes. *Robert Henri and His Circle.* Ithaca, New York, 1969.

HONOUR, Hugh. *The Image of the Black in Western Art, Volume 4*, 2 parts. Cambridge, Massachusetts, 1989.

HOOPES, Donelson F. *Eakins Watercolors.* New York, 1971.

HOUSE, Kay Seymour. *Slavery, Security, and Doubt in Cooper's "Americans."* Columbus, Ohio, 1965.

JACOBOWITZ, Arlene. *Edward Henry Potthast 1857 to 1927* [exh. cat., Chapellier Galleries]. New York, 1969.

JOHNSON, Allen, and MALONE, Dumas, eds. *Dictionary of American Biography*, 11 vols. New York, 1964.

JOHNSON, Barbara. *A World of Difference.* Baltimore, 1989.

KAPLAN, Sidney. *The Black Presence in the Era of the American Revolution, 1770-1800.* Greenwich, Connecticut, 1973.

———. *Portrayal of the Negro in American Art* [exh. cat., Bowdoin College]. Brunswick, Maine, 1967.

KELLER, Morton. *The Art and Politics of Thomas Nast.* New York, 1968.

KELLEY, James C., and PENNINGTON, Estill Curtis. *The South on Paper: Line, Color and Light* [exh. cat., Robert M. Hicklin Jr., Inc.]. Spartanburg, South Carolina, 1985.

KEYES, Donald D. *Aspects of the Development of Genre Painting in the Hudson River Area before 1852* [doctoral dissertation, New York University]. New York, 1973.

KIRSTEN, Lincoln. *Lay This Laurel.* New York, 1973.

KLETZING, Henry F., and CROGMAN, W. H. *Progress of a Race.* New York, 1897 (rev. ed., 1920).

KOKE, Richard J. *American Landscape and the Genre Paintings in the New York Historical Society, A Catalogue of the Collection Including Historical, Narrative and Marine Art.* Boston, 1982.

LANIER, Henry Wysham. *A. B. Frost: The American Sportsman's Artist.* New York, 1933.

LANING, Edward. *The Sketchbooks of Reginald Marsh.* Greenwich, Connecticut, 1973.

LARKIN, Oliver. *Art and Life in America*, 2d ed. New York, 1960.

LEWIS, Samella. *Art: African-American.* New York, 1978.

LIPKE, William C. *Thomas Waterman Wood, PNA, 1823-1903* [exh. cat., Wood Art Gallery]. Montpelier, Vermont, 1972.

LIPMAN, Jean, and WINCHESTER, Alice. *Primitive Painters in America, 1750-1950.* New York, 1950.

LOCKE, Alain. *Negro Art: Past and Present.* Washington, D.C., 1936.

———. *The Negro in Art: A Pictorial Record of the Negro Artist and of the Negro Theme in Art*, 2d ed. New York, 1969.

———. *The New Negro Comes of Age: A National Survey of Contemporary Artists* [exh. cat., Albany Institute of History and Art]. Albany, New York, 1945.

LOGAN, Rayford W. *The Betrayal of the Negro.* New York, 1965.

LYNES, Russell. *The Art-Makers of the Nineteenth Century.* New York, 1970.

M. and M. Karolik Collection of American Painting, 1815-1865. Boston, 1976.

MABEE, Carleton. *Black Education in New York State, From Colonial to Modern Times.* Syracuse, New York, 1979.

MACKAY-SMITH, Alexander. *The Race Horses of America, 1832-1872; Portraits and Other Paintings by Edward Troye* [exh. cat., The National Museum of Racing]. Saratoga Springs, New York, 1981.

MANUEL, Frank E., and MANUEL, Fritzie P. *Utopian Thought in the Western World.* Cambridge, Massachusetts, 1979.

MARLING, Karal Ann. *Woodstock, an American Art Colony – 1902-1977* [exh. cat., Vassar College Art Gallery]. Poughkeepsie, New York, 1977.

MARLOR, Clark S., ed. *A History of the Brooklyn Art Association with an Index of Exhibitions.* New York, 1970.

MARTIN, Francis, Jr. *The Image of Black People in American Illustration from 1825 to 1925* [doctoral dissertation, University of California at Los Angeles]. Los Angeles, 1986.

MATTHEWS, Marcia M. *Henry Ossawa Tanner.* Chicago, 1969.

MCCAUSLAND, Elizabeth. *The Life and Work of E. L. Henry.* New York, 1970.

MCCRACKEN, Harold. *Frederic Remington, Artist of the Old West.* Philadelphia, 1947.

MCELROY, Guy C. *Robert S. Duncanson: A Centennial Exhibition* [exh. cat., The Cincinnati Art Museum]. Cincinnati, 1972.

MOAT, Louis S., ed. *Frank Leslie's Illustrated History of the Civil War. . . .* New York, 1895.

MONTGOMERY, Evangeline J. *San Francisco Art Commission Honor Award Show.* San Francisco, 1977.

———. *Sargent Johnson: Retrospective* [exh. cat., The Oakland Museum]. Oakland, 1971.

NAEVE, Milo M. *John Lewis Krimmel: An Artist in Federal America.* Newark, Delaware, 1987.

National Cyclopaedia of American Biography, 62 vols. New York, 1891-1984.

NICHOLS, J. D., and CROGMAN, W. H. *The New Progress of a Race.* New York, 1920 [1902].

NOVAK, Barbara. *American Painting of the Nineteenth Century: Realism, Idealism, and the American Experience.* New York, 1969.

NYGREN, Edward. *John Singer Sargent Drawings from The Corcoran Gallery of Art* [exh. cat., The Corcoran Gallery of Art]. Washington, D.C., 1983.

———, and MARZIO, Peter C. *Of Time and Place: American Figurative Art from The Corcoran Gallery* [exh. cat., The Corcoran Gallery of Art and the Smithsonian Traveling Exhibition Service]. Washington, D.C., 1981.

O'BRIEN, Maureen C. *James Chapin, The Marvin Years* [exh. cat., Montclair Art Museum]. Montclair, New Jersey, 1974.

ORMOND, Richard. *John Singer Sargent: Paintings, Drawings, Watercolors.* New York, 1970.

OTT, J. K. *Edward Mitchell Bannister, 1828-1901* [exh. cat., Olney Street Baptist Church]. Providence, Rhode Island, 1965.

PAINE, Albert Bigelow. *Thomas Nast: His Period and His Pictures.* New York, 1904.

PARK, Marlene, and MARKOVITZ, Gerald E. *New Deal for Art: The Government Art Projects of the 1930s . . .* Hamilton, New York, 1977.

PARKS, James Dallas. *Robert S. Duncanson: Nineteenth-Century Black Romantic Painter.* Washington, D.C., 1984.

PARRA, Kaycee Benton. *The Works of E. L. Henry, Recollections of a Time Gone By* [exh. cat., The R. W. Norton Gallery]. Palm Beach, Florida, 1987.

PARRY, Ellwood C., III. *The Image of the Indian and the Black Man in American Art, 1590-1900.* New York, 1974.

PERLMAN, Bennard B. *The Immortal Eight: American Painting from Eakins to the Armory Show.* New York, 1962.

———. *Robert Henri, Painter* [exh. cat., The Delaware Art Museum]. Wilmington, Delaware, 1984.

PICKENS, William. *The New Negro.* New York, 1916.

PLEASANTS, J. Hall. *An Exhibition of Portraits by Joshua Johnson* [exh. cat., Peale Museum]. Baltimore, 1948.

POESCH, Jessie. *Painting in the South: 1564-1950* [exh. cat., Virginia Museum of Fine Arts]. Richmond, Virginia, 1983.

PRESCOTT, Kenneth W. *James Chapin 1887-1975* [exh. cat., Yaneff Gallery]. Toronto, 1975.

PROWN, Jules David. *John Singleton Copley.* Cambridge, Massachusetts, 1966.

RADL, Maureen, and CHRISTMAN, Jan P. *E. L. Henry's Country Life, an Exhibition* [exh. cat., The Cragsmoor Free Library and the New York State Museum]. New York, 1968.

RAY, Frederick E. *Alfred R. Waud: Civil War Artist.* New York, 1974.

REED, Henry M. *The A. B. Frost Book.* Rutland, Vermont, 1967.

RIBEIRO, Aileen. *Dress and Morality.* New York, 1986.

Robert Lee MacCameron, American Artist [biographical sketch prepared for the Memorial Art Gallery of the University of Rochester]. New York, 1974.

ROLLINS, Daniel. *Edward Mitchell Bannister, 1828-1901: Providence Artist* [exh. cat., Rhode Island School of Design for the Museum of African Art, Frederick Douglass Institute]. Washington, D.C., 1966.

RUBINSTEIN, Charlotte Streifer. *American Women Artists: From Early Indian Times to the Present.* Boston, 1982.

SAINT-GAUDENS, Augustus [edited and amplified by Homer Saint-Gaudens]. *Reminiscences.* New York, 1913.

SAMUELS, Peggy. *The Illustrated Biographical Encyclopedia of Artists of the American West.* New York, 1976.

———, and SAMUELS, Harold. *Frederic Remington: A Biography.* New York, 1982.

SASOWSKY, Norman. *The Prints of Reginald Marsh.* New York, 1976.

SCHMECKEBIER, Laurence. *John Steuart Curry's Pageant of America* [exh. cat., The Joseph and Emily Lowe Art Center]. Syracuse, New York, 1943.

SCHOEN, Jason. *American Paintings of the Depression Era, 1930s-1940s.* Galveston, Texas, 1988.

SCOTT, David W., and BULLARD, John E. *John Sloan 1871-1951* [exh. cat., National Gallery of Art]. Washington, D.C., 1971.

SEARS, Clara Endicott. *Some American Primitives: A Study of New England Faces and Folk Portraits.* Port Washington, New York, 1968.

SEVERENS, Martha R. *The Miniature Portrait Collection of the Carolina Art Association* [exh. cat., Gibbes Art Gallery]. Charleston, South Carolina, 1984.

SHARP, Lewis I. *John Quincy Adams Ward, Dean of American Sculpture.* Newark, New Jersey, 1985.

SHIKES, Ralph. *The Indignant Eye: The Artist as Social Critic in Prints and Drawings from the Fifteenth Century to Picasso.* Boston, 1969.

SIMPSON, Marc, et al. *Winslow Homer: Paintings of the Civil War* [exh. cat., The Fine Arts Museums of San Francisco]. San Francisco, 1988.

SIMS, Patterson. *John Sloan* [exh. cat., Whitney Museum of American Art]. New York, 1980.

SLOAN, John. *Paintings, Prints, Drawings* [exh. cat., Hood Museum of Art]. Hanover, New Hampshire, 1981.

———. *Robert Henri Memorial Exhibition* [exh. cat., The Metropolitan Museum of Art]. New York, 1931.

———, and FARR, Helen. *The Gist of Art, Principles and Practises Expounded in the Classroom and Studio,* 3d rev. ed. New York, 1977.

SOBY, James Thrall. *Ben Shahn.* New York, 1963.

SOKOL, David M. *John Quidor: Painter of American Legend* [exh. cat., The Wichita Art Museum]. Wichita, Kansas, 1973.

SOUTHERN, Eileen. *The Music of Black Americans: A History,* 2d ed. New York, 1983.

SPASSKY, Natalie, et al. *American Paintings in The Metropolitan Museum, Volume 2: A Catalogue of Work by Artists Born Between 1816-1845.* Princeton, 1984.

STALLYBRASS, Peter, and WHITE, Allon. *The Politics and Poetics of Transgression.* Ithaca, New York, 1986.

STAUFFER, David McNeely. *American Engravers upon Copper and Steel.* New York, 1907 and 1964.

STEBBINS, Theodore E., TROYEN, Carol, and FAIRBROTHER, Trevor F. *A New World: Masterpieces of American Painting 1760-1910* [exh. cat., The Corcoran Gallery of Art and Museum of Fine Arts, Boston]. Boston, 1983.

STEIN, Roger. *Copley's "Watson and the Shark" and Aesthetics in the 1770s.* Albany, New York, 1976.

STILES, Henry R. *A History of the City of Brooklyn, Volume 2.* Brooklyn, New York, 1969.

STOKES, I. N. Phelps, and HASKELL, Daniel C. *American Historical Prints, Early Views of American Cities.* New York, 1932.

STOWE, Harriet Beecher. *Uncle Tom's Cabin.* New York, 1969 [reprint of 1854 ed.].

SWEENEY, J. Gray. *American Painting* [museum cat., Muskegon Museum of Art]. New York, 1956.

TAFT, Robert. *Artists and Illustrators of the Old West.* New York, 1953.

TATHAM, David. *A Note About David Claypoole Johnston with a Check List of His Book Illustrations* [exh. cat., The Joseph and Emily Lowe Art Center]. Syracuse, 1970.

TOLL, Robert C. *Blacking Up: The Minstrel Show in Nineteenth-Century America.* New York, 1974.

TROVAIOLI, August P., and TOLEDANO, Roulhac B. *William Aiken Walker: Southern Genre Painter.* Baton Rouge, Louisiana, 1972.

VINSON, J. Chal. *Thomas Nast – Political Cartoonist.* Athens, Georgia, 1968.

WALLACE, David H. *John Rogers: The People's Sculptor.* Middletown, Connecticut, 1967.

WASHINGTON, Booker T. *A New Negro for a New Century.* Chicago, 1900 (2d ed., 1969).

WEHLE, Harry Brandeis. *American Miniatures, 1730-1850* [exh. cat., The Metropolitan Museum of Art]. New York, 1927.

WEINTRAUB, Linda, et al. *Thomas Hart Benton: Chronicler of America's Folk Heritage* [exh. cat., Edith C. Blum Art Institute, Bard College]. Annandale-on-Hudson, New York, 1984.

WHEAT, Ellen Harkins. *Jacob Lawrence, American Painter* [exh. cat., Seattle Art Museum]. Seattle, 1986.

WILKINSON, Burke. *Uncommon Clay, The Life and Works of Augustus Saint-Gaudens.* San Diego, 1985.

WILLIAMS, Hermann Warner, Jr. *The Civil War: The Artist's Record.* Meriden, Connecticut, 1961.

———. *Mirror to the American Past: A Survey of American Genre Painting, 1750-1900.* Greenwich, Connecticut, 1973.

WILMERDING, John. *Winslow Homer.* New York, 1972.

WOOD, Peter H., and DALTON, Karen C. C. *Winslow Homer's Image of Blacks: The Civil War and Reconstruction Years* [exh. cat., The Menil Collection]. Austin, Texas, 1989.

YARNALL, James L., and GERDTS, William H. *The National Museum of American Art's Index to American Art Exhibition Catalogues, From the Beginning Through the 1876 Centennial Year,* 6 vols. Boston, 1986.

YOUNG, Mahonri Sharp. *The Paintings of George Bellows.* New York, 1973.

Articles

ANONYMOUS ARTIST. "Following the Advice of the 'Old Crowd' Negro," and "The 'New Crowd Negro' Making America Safe for Himself." Illustrations in editorial "The Cause and Remedy of Race Riots." *Messenger.* September 1919. 16-17.

ABRAMS, Ann Uhry. "Politics, Prints, and John Singleton Copley's 'Watson and the Shark.'" *The Art Bulletin.* Vol 61. June 1979. 265-276.

ADAMS, John Henry, Jr. "Rough Sketches: The New Negro Man." *Voice of the Negro.* October 1904. 447-452.

———. "Rough Sketches: A Study of the Features of the New Negro Woman." *Voice of the Negro.* August 1904. 323-326.

ADAMS, Karen M. "The Black Image in the Paintings of William Sidney Mount." *American Art Journal*. November 1975. 42-59.

BAIGELL, Matthew. "Thomas Hart Benton in the 1920s." *Art Journal*. Summer 1970. 422-429.

BAUR, John I. H. "John Quidor: Pioneer Romanticist." *The American Collector*. March 1942. 6-7; 13.

———. "Unknown American Painters of the 19th Century." *The College Art Journal*. Summer 1947. 277-282.

BENJAMIN, Samuel G. W. "A Painter of the Streets." *Magazine of Art*. Vol. V. 1882. 265-270.

BERMAN, Avis. "Jacob Lawrence and the Making of Americans." *ARTnews*. February 1984. 78-86.

BLOCH, E. Maurice. "The American Art-Union's Downfall." *The New York Historical Society Quarterly*. Vol. 37. 1953. 331-359.

BOIME, Albert. "Blacks in Shark-Infested Waters." *Smithsonian Studies in American Art*. Winter 1989. 19-47.

BOWEN, J. W. E. "An Appeal to the King." Lecture delivered to the Atlanta Exposition, October 21, 1895.

BREUNING, Margaret. "A Young Painter of American Labor." *International Studio*. April 1926. 75-79.

BRIGHAM, Clarence S. "David Claypoole Johnston, The American Cruikshank." *American Antiquarian Society Proceedings*. Vol. 50. 1941. 98-110.

BROWN, Sterling A. "Negro Character as Seen by White Authors." *Journal of Negro Education*. April 1933. 179-203.

CALO, Mary Ann. "Winslow Homer's Visits to Virginia During Reconstruction." *American Art Journal*. Winter 1980. 5-27.

COOPER, Helen A. "The Rediscovery of Joseph Decker." *American Art Journal*. May 1978. 55-71.

COWDREY, Bartlett. "Richard Caton Woodville: An American Genre Painter." *The American Collector*. April 1944. 6-20.

DAVID, Beverly R. "The Pictorial Huckleberry Finn: Mark Twain and His Illustrator, E. W. Kemble." *The American Quarterly*. October 1974. 331-351.

DOMINGO, W. A. "A New Negro and A New Day." *Messenger*. November 1920. 144-145.

EDITORIAL. *Cleveland Gazette*. June 29, 1895. 2.

EDWARDS, Harry Stillwell. "Brother Sims's Mistake." *Century Magazine*. July 1899. 354-361.

ELLIS, Anita. "'The Underground Railroad' by Charles T. Webber." *The Cincinnati Historical Society Bulletin*. Summer 1979. 127-143.

FAIRBROTHER, Trevor J. "John Singer Sargent's 'Gift' and His Early Critics." *Arts*. February 1987. 52-63.

FLETCHER LITTLE, Nina. "William M. Prior, Traveling Artist." *Antiques*. January 1948. 44-48.

FORTUNE, T. Thomas. "Dearth of Afro-American Writers." *New York Age*. April 20, 1905. 2.

FRANKENSTEIN, Alfred. *San Francisco Chronicle*. October 6, 1935. D3, col. 4.

FREELON, Allan R. "The New Negro." Cover illustration for *Carolina Magazine*. 1928.

G. M. S. "Art Gossip." *The Brooklyn Daily Eagle*. August 20, 1989. 17.

GATES, Henry Louis, Jr. "The Trope of the New Negro and the Reconstruction of the Image of the Black." *Representations*. Fall 1988. 129-156.

GIARUSO, Edward A. "Reclaiming a Lost World: Nineteenth-Century Providence Art." *Rhode Island Review*. Summer 1983. 5-10.

GIESE, Lucretia H. "James Goodwyn Clonney: American Genre Painter." *The American Art Journal*. October 1979. 4-31.

GREENE, Carroll, Jr. "The Search for Joshua Johnson." *American Vision*. February 1988. 14-19.

HASKER, Leslie A., and GRAFFAGNINO, J. Kevin. "Thomas Waterman Wood and the Image of Nineteenth-Century America." *Antiques*. November 1980. 1032-1042.

HENRI, Robert. "My People." *The Craftsman*. February 1915. 459-469.

JACKSON, Joseph. "Krimmel, 'The American Hogarth.'" *International Studio*. June 1929. 33-36; 86-88.

JAFFE, Irma B. "John Singleton Copley's 'Watson and the Shark.'" *American Art Journal*. May 1977. 15-25.

KEARNEY, Carol. "Horace Bonham." *Susquehanna*. August 1985. 34-41.

LOCKE, Alain. "Harlem: Mecca of the New Negro." Special Issue, *Survey Graphic*. March 1925.

LYMAN, Grace Adams. "William Prior, The 'Painting Garrett' Artist." *Antiques*. November 1934. 180.

MANN, Maybelle. "Francis William Edmonds: Mammon and Art." *American Art Journal*. Fall 1970. 92-106.

MARTIN, Francis, Jr. "Edward Windsor Kemble, a Master of Pen and Ink." *American Art Review*. January-February 1976. 54-67.

MCCLINTON, Katherine M. "John George Brown, Sentimental Painter of the American Scene." *Connoisseur*. April 1979. 242-247.

MCDERMOTT, John Francis. "Charles Deas: Painter of the Frontier." *Art Quarterly, The Detroit Institute of Arts*. Autumn 1950. 293-311.

"NOTES." *Metropolitan Museum Art Bulletin*. May 1940. 117-118.

PARRY, Ellwood C., III, and CHAMBERLIN-HELLMAN, Maria. "Thomas Eakins as an Illustrator, 1878-1881." *American Art Journal*. May 1973. 20-45.

PLEASANTS, J. Hall. "Four Late 18th-Century Anglo-American Landscape Painters." *The American Antiquarian Society*. October 1942. 55, 116.

———. "Joshua Johnson: The First American Negro Portrait Painter." *The Maryland Historical Society*. June 1942. 121-129.

———. "Justus Englehardt Kuhn, an Early Eighteenth-Century Maryland Portrait Painter." *The American Antiquarian Society*. 1937. 243-280.

PROWN, Jules D. "The Rediscovery of America," *ARTnews*. May 1968. 30-33.

QUICK, Michael. "Homer in Virginia." *Los Angeles County Art Museum Bulletin*. XXIV. 1978. 61-81.

RANDOLPH, A. Phillip. "The New Negro – What Is He?" *Messenger*. August 1920. 73-74.

ROBINSON, Jontyle Theresa. "Archibald J. Motley, Jr.: Pioneer Artist of the Urban Scene." *Afro-American Art*. February 1987. 28-34.

ROOSEVELT, Theodore. "Rough Riders." *Scribners Magazine*. Serialization: January-June 1899. 25: 2-20, 131-51, 259-277, 420-440, 565-585, 677-693.

ROSENBERG, Harold. "Ben Shahn." *New Yorker*. December 13, 1976. 156-161.

SCARBOROUGH, Katherine. "An Early Negro Portrait Artist." *Negro Historical Bulletin*. February 1968. 15-16.

SEMON, Kurt M. "Who Was Robert Street?" *The American Collector*. June 1945. 6-7; 19.

SHARP, Lewis I. "John Quincy Adams Ward: Historical and Contemporary Influences." *American Art Journal*. November 1972. 71-83.

SMITH, Robert C. "Liberty Displaying the Arts and Sciences." *Winterthur Portfolio II*. Winterthur, Delaware, 1985-1986. 85-106.

SOBY, James Thrall. "Ben Shahn." *Bulletin of the Museum of Modern Art*. Summer 1947. 3-6.

TANNER, Henry Ossawa. "The Story of an Artist's Life, I." *The World's Work*. June 1909. 11661-11666.

WATSON, Ernest W. "An Interview with Andrée Ruellan." *American Artist*. October 1943. 8-13.

WEEKLEY, Carolyn J. "Portrait Painting in 18th-Century Annapolis." *Antiques*. Fall 1977. 345-353.

WEITENKAMPF, Frank. "A. B. Frost." *Arts*. March 1929. 168-172.

WILLIAMS, Fannie Barrier. "The Colored Gal." *Voice of the Negro*. June 1905. 400-403.

WILLIAMS, Herman Warner. "Notes on William Harnett." *Antiques*. June 1943. 260-262.

WHITAKER, George W. "Reminiscences of Providence Artists." *Providence Magazine, The Board of Trade Journal*. February 1914. 138.

WOLF, Bryan. "All the World's a Code: Art and Ideology in Nineteenth-Century American Painting." *Art Journal*. Winter 1984. 328-337.

WUNDERLICH, Rudolph. "Thomas Hovenden and the American Genre Painters." *Kennedy Quarterly*. April 1962. 2-11.

ZUCKER, A. E. "Theodor Kaufmann, Forty-eighter Artist." *The German-American Review*. October 1950. 17-24.

Index

Italic page numbers indicate illustrations.

Photography Credits

The transparencies and photographs for this book have been furnished by the owners of the works, with the following exceptions:

Transparencies

Cooper-Hewitt Museum, Smithsonian Institution/Art Resource, New York: Winslow Homer, *Watermelon Boys*

Flint Institute of Arts: Frederic Remington, *Captain Dodge's Colored Troopers to the Rescue*

Robert Hicklin, Inc.: Thomas Satterwhite Nobel, *The Price of Blood.* John William Hill, *View of Richmond.* William Holmes, *Free Enterprise and the Law*

Janet Marqusee Fine Arts Ltd.: Andrée Ruellan, *Black Youth*

North Carolina Museum of Art, Raleigh: Winslow Homer, *Upland Cotton*

The Seattle Art Museum: Jacob Lawrence, *Ironers*

Photographers

Geoffrey Clements, Inc., New York: Paul Cadmus, *To the Lynching!* John Steuart Curry, *Head of a Negro*

Mike Fischer: Henry Ossawa Tanner, *The Banjo Lesson*

Jeff D. Goldman: Justus Engelhardt Kühn, *Henry Darnall III as a Child.* Robert Street, *Children of Commodore Daniel Danels*

Jarvis Grant: Archibald J. Motley, Jr., *Barbecue*

Robert E. Mates: Reginald Marsh, *Negroes on Rockaway Beach*

Muldoon Studio: Reginald Marsh, *Tuesday Night at the Savoy Ballroom*

Jeffrey Nintzel: David Claypoole Johnson, *Bee Catching.* Augustus Saint-Gaudens, *Head of a Young Man*/Study for a soldier in *The Shaw Memorial*

William K. Sacco: Nathaniel Jocelyn, *Cinque*

Ruth Tabor: Unknown artist, *Flora*

This book was designed by Jack Werner Stauffacher
of The Greenwood Press, San Francisco, California.
Display type is Kis-Janson, and the text type is Sabon,
designed by Jan Tschichold. Digital composition by
Wilsted & Taylor Publishing Services, Oakland,
California. Printed and bound in Japan.